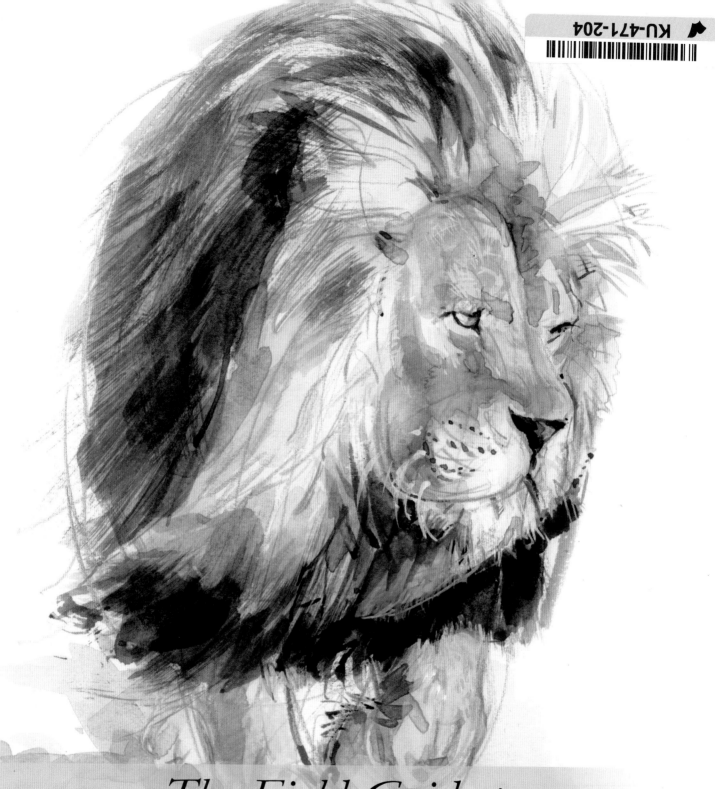

The Field Guide to
Drawing &
Sketching Animals

ACKNOWLEDGEMENTS

Thanks to Jon Bielby, Conservation Biologist; Dr Grace Mackintosh Sim, Outreach Development Manager, The Royal Veterinary College (RVC), London; Lucy Eckersley, RVC; Mr Andrew Crook MBE FRSA, Head of Anatomy, RVC; Jack Ashby, Manager of the University Museum of Zoology, Cambridge; Paolo Viscardi; Dr Ben Garrod, Anglia Ruskin University, Cambridge; Dr Sarah Durant, ZSL, London; Dave Clarke, *BUGS!*, ZSL, London; SEA LIFE, Brighton; the family of Dick King-Smith; Helen Scales; Mark Simmons, illustrator; The Aspinall Foundation.

For motivation and inspiration, thanks to Sir David Attenborough, Professor Alice Roberts and John Muir Laws.

Thanks to my agent, David Lewis.

A very special thanks to my editor Edward Ralph, who saw the potential of this book and helped to bring it to life.

For their continual love and support, my family and friends; in particular their patience at listening to me witter on, for example, about just how fascinating it is that a bat is the only mammal adapted for true flight. I must give a special mention to friends who endured more than most, David, Claire, Tony, Dany and Christian.

Last but not least, thanks to my Mum, without whom this book would not have been possible, in more ways than one!

First published in 2019

Search Press Limited
Wellwood, North Farm Road,
Tunbridge Wells, Kent TN2 3DR

Text copyright © Tim Pond 2019
Design copyright © Search Press Ltd 2019

ISBN: 978-1-78221-512-7

The Publishers and author can accept no responsibility for any consequences arising from the information, advice or instructions given in this publication.

Suppliers
For details of suppliers, please visit the Search Press website: www.searchpress.com

You are invited to the author's website: www.timpond.co.uk

Printed in China by 1010 Printing International Ltd

The Field Guide to
Drawing &
Sketching Animals

Tim Pond

SEARCH PRESS

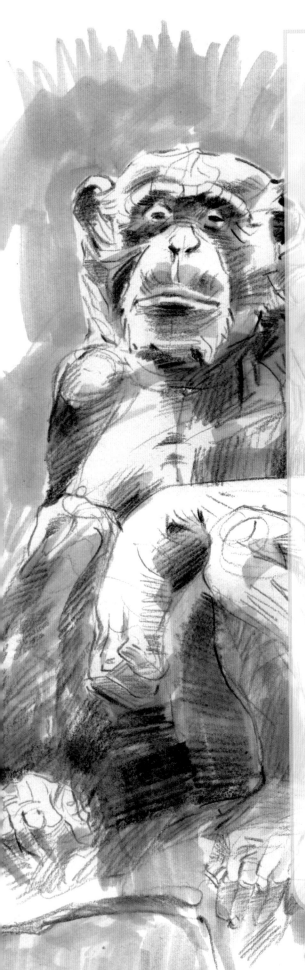

FOREWORD

Art is for all of us. I've even seen members of the animal kingdom, such as elephants and chimps, have a good go at putting paint to paper, with rather mixed results. We can all express ourselves artistically, it's a wonderfully innate drive.

More difficult is the ability to artistically recreate something accurately. It takes practice but is, to a degree, something that can be helped with a lot of patience and time. What is incredibly rare, however, is to see something that has been drawn or painted so well that you think you are right there in the canvas; feeling the ripple of tropical waters as a majestic humpback whale glides by, seeing the beautiful ephemeral dance of a monarch butterfly, or hearing the breath of a crouching, motionless tiger behind you. This is a rare and wonderful skill and one most definitely possessed by the author of this book. Within the pages of his book, Tim takes the reader on a journey through the animal kingdom, where you are not only expected to look at the world around you but, it is hoped, actually see it, also.

It is clear that Tim is in love with nature and that his love is not merely skin deep. To gather a full appreciation of all that nature has to offer, he strips his subjects down to their bare bones – and in some instances, bear bones. While some illustrative guides to the natural world offer a nod to the anatomy and physiology of an animal, so that any would-be artist might ensure the finished piece is filled out in all the right places, this wonderful guide almost takes us on a virtual tour of a dissection lab, looking at the muscular anatomy and skeletal systems of a wide range of species and taxa, not only to better understand the animal as a whole but to relish the sheer beauty inherent within the muscles, skin and bones.

I work with a wide range of animals in numerous ways and fundamental to understanding them is an intimate understanding of their behaviour. Many artists can teach you how to draw a horse but few manage to help you convey the playfulness of a horse breaking into a canter, or a zebra giving itself a dust bath, for example. By combining the necessary artistic tricks of the trade with a need to consider the anatomy and behaviour, this field guide is not only perfect for anyone wanting to develop or improve their artistic animal skills but also for those wishing to understand the world around them from a slightly different, more aesthetic, approach. Not only do I think this is a good book on a technical level, I actually like it, too – and there's no point in having a good book that you just don't bond with. However, the style, commitment and the passion of the author all come shining through, easily as vibrant as the toucan's bill or as dazzling as the alien-like mantis shrimp. I guarantee that not only will reading this book help you become a better artist but shall give you a deeper appreciation for the wildlife around you. Enjoy.

DR BEN GARROD
BROADCASTER AND EVOLUTIONARY BIOLOGIST

Chimpanzee ZSL Whipsnade Zoo.

CONTENTS

INTRODUCTION

'Our task must be to free ourselves… by widening our circle of compassion to embrace all living creatures and the whole of nature and its beauty.' Albert Einstein

For me, drawing is about capturing a fragment of nature on the page. It is a practical activity, an act of doing something that brings me closer to nature. This book is about opening up an activity sometimes seen as reserved for the select few, or something that only established artists can do. On the contrary, drawing is something that can be beneficial to everyone, and is an activity that can deepen our appreciation of the natural world.

The subject of art is one that is very dear to my heart. It allows anyone to have a go. Drawing is a vital part of the curriculum, as understood by artists as far back as Leonardo da Vinci (1452–1519). It is something we all should do, as it can help your creative thinking. Rather than thinking in a linear way, drawing allows us to make connections that we might not otherwise have seen – which is very much how our brain has evolved.

In this book we will explore a variety of ways of capturing form on the page from contour drawing to dynamic drawing, along with advice on putting into practice what you have learnt. You will learn to explore the variety of mark-making that is at your fingertips from dry, hard marks to ones that are soft and fluid, to develop your repertoire. It is quite possible to look at the pictures and learn from them without reading the words at all. Perhaps the practice

'The best way to get acquainted with an animal is to spend time observing it through drawing. You don't really know the characteristics of an animal until you have spent time sketching it.'

that has helped me most to sketch animals is looking at other artists' work; both historical – such as Rembrandt (1606–1669) and his beautiful elephant sketches – and contemporary concept artists working in the film industry.

This book is also a personal journey of my own discovery into the natural world, filled with tips to quickly improve your field and studio work. I have been drawing since childhood, enjoying the magic of sketching and seeing an animal come alive on the paper. I believe anyone can learn to draw and it is simply a matter of practice – albeit good directed practice – so that energy is placed on getting positive developments. I want you to start afresh, getting away from any negative thoughts about your ability to use drawing as a tool.

Understanding some of the 'blueprints' that are behind evolution on our blue planet unlocks a world of discovery that can be applied across different species. Simple guides to the muscles and bones accompany the animals in this book, to help you make comparisons and learn to see quickly enough to draw moving creatures. These are supported by nose-to-tail run throughs of the animals to get you familiar with their physical make-up and character.

Sketching animals from life is a unique and richly rewarding experience. It is also highly challenging: at times you only have a matter of seconds to capture the gesture of the animal in movement. Drawing

wildlife is therefore a different kind of life drawing. You can't ask animals to stand still, and you are set at the mercy of their moods and movements. However, it allows the sketcher to share an experience with a wild animal and capture something of its spirit. Each time you draw an animal you get to know it more closely. The shapes will become more familiar and your marks should evolve to capture the character of the animal.

Spending time with many and varied lifeforms that inhabit this planet will delight, absorb and occasionally frustrate you, but will ultimately give you a feeling of deep satisfaction and deeper understanding.

To truly observe animals, we need to slow down from our hectic lives. The behaviour of animals does not fit into our modern timetable. Sketching from life is a two-way process and we can not push the animals into a specific pose to fulfil our expectations.

When someone loves something they tend to create a more interesting drawing of the subject. A person in love with trains, for example, will create a more fascinating drawing of a train, as they pore over all the details they are in love with. This is true of the naturalist, whose fascination with the natural world can be expressed in their drawings and quick sketches. When drawing from the natural world, we embark on a journey of discovery aided by both scientific and cultural connections.

Finally, then, this book is about enabling people with a genuine love of nature to sketch and capture some of the wonders of the natural world. There is an immense biodiversity on the earth, and as guardians of planet earth, this book encourages a greater sympathy and a deeper appreciation of our fellow creatures, with which we share this planet.

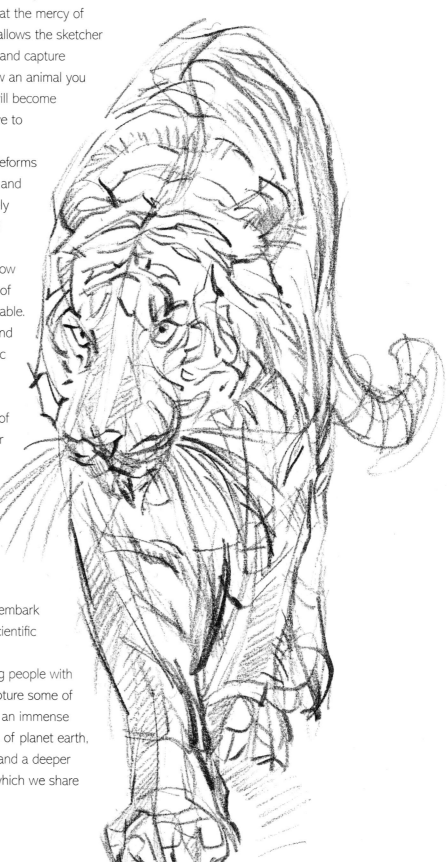

THE BLANK PAGE

'The activity of sketching is to record the encounter. In some respects, this is more important than the drawing itself.'

LOOKING AND MARK-MAKING

Drawing wildlife is a combination of close observation and translating what you see into marks on the page. I try to draw wildlife in an uninhibited way. I seek the various shapes of the animals and strive with a dip pen, ink, markers and wash to try to capture the, in order to make the animal come alive on the page. I experiment and change my media depending on the qualities of the species of animal that I am drawing. For example, mixing charcoal with lighter fluid enables me to paint with the charcoal – a technique is particularly good for feathers or the smoky grey fur of a ring-tailed lemur. I might also use wax resist with watercolour to capture the silvery scales of a fish, for example.

It is through drawing that I get to know the animal closer. Whilst sketching penguins I am searching for the 'Humboldtness' of a Humboldt Penguin. I try to get my line to capture the character of the beak, the way the animal holds itself. Drawing wildlife for me is a search, an investigation into what makes that animal unique. There is an indefinable quality of a particular species beyond its shape, size and colour. Drawing wildlife for me is trying to capture the magical qualities of each animal.

I find a rich, satisfying reward in the value of patience and the repetition of looking. I try to be as curious as possible about an animal's behaviour, for example if I see mangabey monkeys playing with a fly, I will include that in the sketch. The activity of sketching is to record the encounter. In some respects, this is more important than the drawing itself. I try to capture the movement and feeling of weight as the animal moves through space. I fill a page with quick sketches from many different angles, returning to sketch as the animal returns to that position. It is a challenge that connects me closely with the animal I am sketching.

This book will introduce you to new ways of drawing and techniques. From quick gestural sketches, linear and tonal studies. The class will get you thinking about the different patterns of animal's coats; how to capture the bright plumes of exotic birds in watercolour, through to learning to sketch a hippopotamus' hooves. This book is for all abilities, whether you are entirely new to drawing, or an experienced professional.

Learning to draw wildlife can be fulfilling, frustrating and challenging. Whether you are a beginner and feel that you would like to be supported one-to-one whilst you sketch, or are more independent and would like to use this as an opportunity to develop a range of first-hand observational studies, this book will help.

What we see and what we know

For artists in the Renaissance, drawing was a combination of what they saw and what they knew. For this reason, they studied anatomy. One of the key features of this book is that sketchers will be introduced to interesting and fascinating information about the animal while you are drawing it. That familiarity will inform your artwork and make things more relatable.

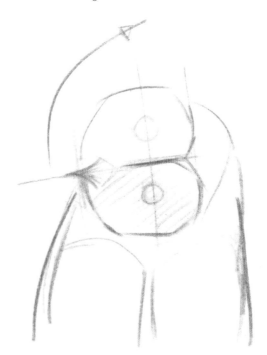

'To draw is to learn to see.' Leonardo da Vinci

SKILLS BUILDERS

The aim of these introductory exercises is to build your confidence with your drawing materials, and give you a set of mark-making skills that will improve your drawing; in particular your quick sketching skills.

It is very important that you enjoy the drawing process. Any memories of previous failures are often associated with the material we have used before, so for these exercises I recommend starting fresh with a good quality colouring pencil, such as a Faber-Castell Polychromos pencil, rather than graphite. There can be some trepidation – even fear – attached to sketching with the graphite line so try changing it to a coloured line.

These exercises will develop your hand–eye coordination and get you to start thinking about how you can visually dissect a form.

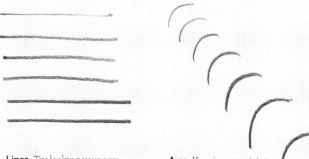

Lines Try locking your arm at the elbow to help draw straight lines consistently.

Arcs Keeping your joints locked while you move your arm is important.

Exercise 1: Dynamic lines

Create seven straight lines, moving from a light mark to a darker line. Maintain a straight, consistent and accurate line by drawing from the elbow. Draw with a steady pace and then try to speed up. Draw both short and long lines. Repeat this exercise several times.

Exercise 2: Arcs

Using your natural radial geometry to help draw smooth arcs, by locking your wrist and elbow. Create small arcs with a wrist motion and large arcs from the elbow. Practise repeatedly, so that you are able to create these marks accurately without looking at the page.

Exercise 3: Ellipses

Freehand ellipses are the hardest part of these exercises and will always be challenging. They are a fundamental element of drawing biological forms. Go through the motion and 'air draw' before your pencil touches the paper, so that you are confident about the smoothness and symmetry of the mark before you make it. You can sketch the first line lightly and then refine the ellipse. Make sure that the shapes have round corners and are not spiky.

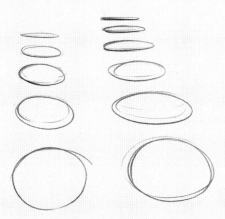

Ellipses You can start from the narrowest angle and then open the circle wider, or work the opposite way around.

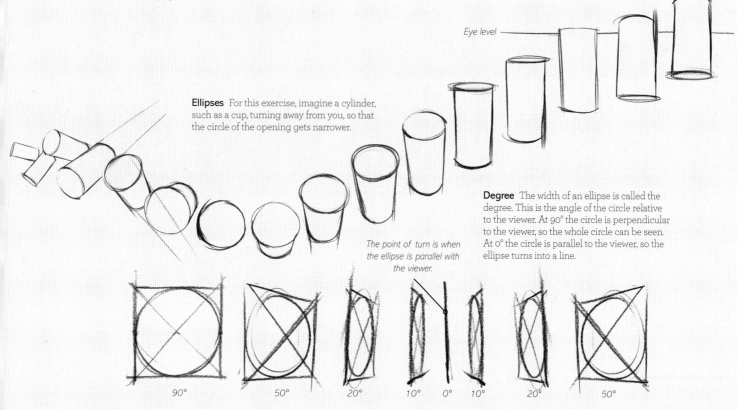

Ellipses For this exercise, imagine a cylinder, such as a cup, turning away from you, so that the circle of the opening gets narrower.

Eye level

Degree The width of an ellipse is called the degree. This is the angle of the circle relative to the viewer. At 90° the circle is perpendicular to the viewer, so the whole circle can be seen. At 0° the circle is parallel to the viewer, so the ellipse turns into a line.

The point of turn is when the ellipse is parallel with the viewer.

90° 50° 20° 10° 0° 10° 20° 50°

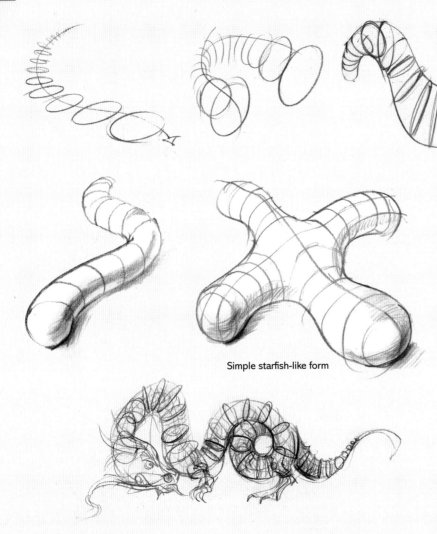

Exercise 4: Ellipses into organic forms

Imagine dissecting a worm so that it is sliced up into short cylindrical pieces. By joining up a series of ellipses that twist and turn away from you, you will create organic worm-like forms. Start by drawing a single worm, then experiment by combining two worms moving in different directions – that will give you something that looks like a very basic starfish.

Simple starfish-like form

Chinese Dragon This illustration shows how a loose line of ellipses can be a simple way of building up form without getting into more complex perspective.

Exercise 5: Shading and fundamental forms

There are two main different types of shadow:

Shadow of form The shadow on the subject itself. This helps you to model and sculpt the form.

Cast shadow A shadow that extends from the object onto its surroundings. This can help add drama to your drawing and can help place the object in its environment.

Try rendering (adding shadow to) basic shapes so that they have a three-dimensional quality. Turn a square to a cube, a circle to a sphere, triangle to a pyramid and also render a cylinder and cone. These are the fundamental forms.

Predict what you think will happen when these forms are lit from the same light source. In objects that have sharp planes, such as the cube and pyramid, the tonal value will remain unified across the plane in shadow. Round objects, like spheres, are slightly different and have another shadow, a core shadow (see right).

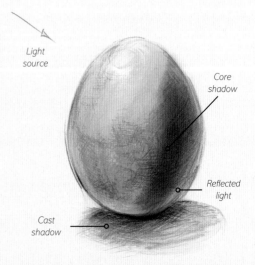

Light source

Core shadow

Reflected light

Cast shadow

Core shadow on round objects Reflected light will bounce back from objects in the environment into the shadows. This gives the appearance of the darkest value (the core shadow) being a band, rather than being on the far edge.

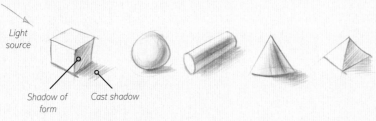

Light source

Shadow of form

Cast shadow

Time of day Objects at the end of the day, when the sun is low in the sky, will have a more monumental quality. Try lighting your objects from a low angle by altering the light source. A low light angle will create a strong cast shadow.

Exercise 6: Organic marks and animal elements

Just as the most complex forms of life developed from simple single-cell organisms (see page 22), your drawing skills can quickly build up from simple dots and lines to producing convincing and complex three-dimensional shapes that relate to biological forms. Try copying the examples on this page to build your skills.

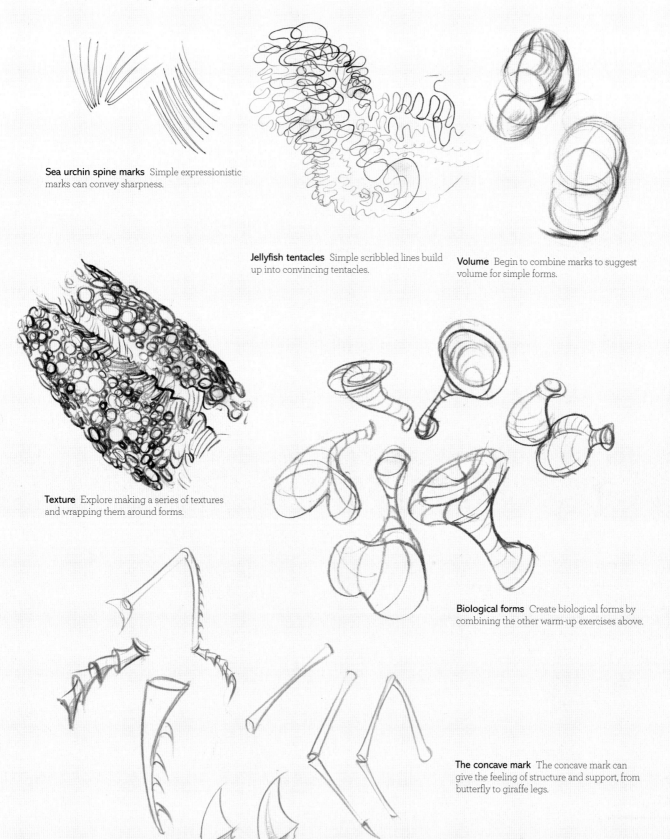

Sea urchin spine marks Simple expressionistic marks can convey sharpness.

Jellyfish tentacles Simple scribbled lines build up into convincing tentacles.

Volume Begin to combine marks to suggest volume for simple forms.

Texture Explore making a series of textures and wrapping them around forms.

Biological forms Create biological forms by combining the other warm-up exercises above.

The concave mark The concave mark can give the feeling of structure and support, from butterfly to giraffe legs.

PERSPECTIVE

The ability to combine fundamental forms and create the illusion of them in space is one of the foundations of being able to sketch.

Although it may seem far removed from sketching wildlife, a good understanding of perspective can really help with all your drawings. The understanding gained from using architectural two-point perspective (see right) can be applied to help us sketch organic forms.

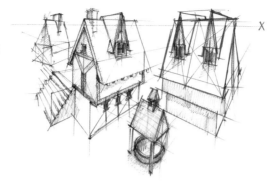

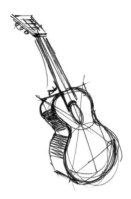

Identify the fundamental forms All sorts of everyday objects can be broken down into the five basic elements of form (see page 10). It is simple to see the shapes of buildings, so they are a great place to start (see above). However, even seemingly complex forms can be broken down. A guitar, for example, can be broken down into two ellipses for the body; attached to a cuboid for the neck. A central line of symmetry runs through it, just as for most animals. This is known as bilateral symmetry.

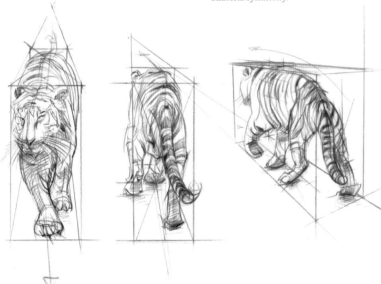

Using framework blocks

By placing animals in a block, it is easier to be able to see how you can use perspective to create the illusion that your subject is moving through space on the flat, two-dimensional surface of your paper.

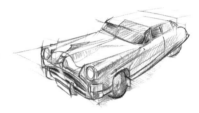

The three-quarter view, below the eye line
I find it easier to draw objects below the eye line. Often, I will place the object at a three-quarter angle and use this angle as a default. You will notice that a lot of concept artists do the same thing.

Foreshortening

Foreshortening happens when you looking at something from different views. As the angle changes, the object will appear more compressed. Foreshortening is one of the hardest skills to master in drawing, but constructing a box first will help in both observed drawings and imagined sketches. This is a great enabler to rotating and spinning an object in space. Try placing an organic forms, such as the skull of a horse, into a frame and drawing it from different angles.

Foreshortening practise Spin and rotate simple forms around a central axis (right) before moving on to more complex animal forms (below).

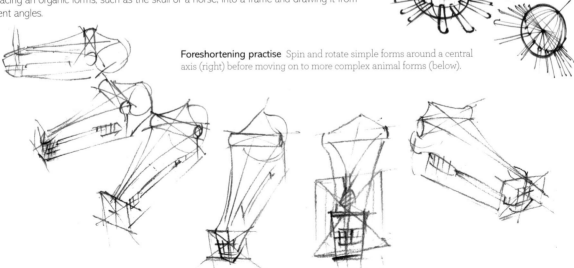

Visualization skills

Spend time practising combining the fundamental forms (see page 10), and working out what you would be able to see, and what would remain hidden.

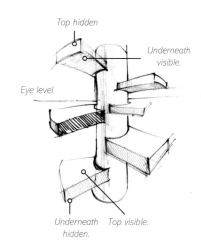

Top hidden

Eye level

Underneath visible.

Underneath hidden.

Top visible.

Try cutting sections out of the fundamental forms.

Experiment with more abstract organic forms. Drop and rotate the forms through space; imagining them from different angles.

WIDGETS AND GIZMOS

Throughout the book, I have included examples of widgets and gizmos that will help your sketching. These are simple collections of shapes or forms that are easy to remember and understand, and which will aid your sketching by providing a quick-start framework for you to build upon.

Widgets

Widgets are specific combinations of basic three-dimensional forms. Easy to remember, you can carry gizmos with you in your head, where they will be really powerful tools to use when sketching from life. These enabling little devices will have a dramatic effect on speeding up your sketching skills, and accuracy when working from moving animals.

Using widgets will help you get the underlying structure of an animal (or part of an animal) correct, giving you more time to refine and build the specific individual in front of you when sketching.

Gizmos

Gizmos are essentially flat, abstract versions of the widget. These little devices are more of an aid to understanding than directly relatable to things you wish to sketch; such as this pentagonal dog foot gizmo. Drawing a simple pentagon is much easier and less intimidating than trying to establish the paw freehand, and it will help you to bring biological facts about the animal – such as the two front claws being in front of the others – into your drawings.

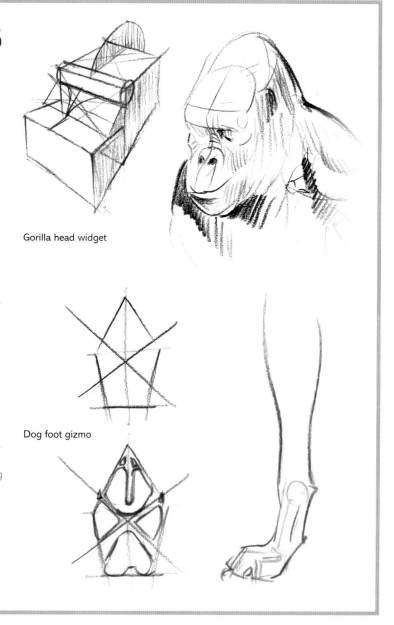

Gorilla head widget

Dog foot gizmo

FINDING SPACE AND DEPTH IN THE FLAT PAPER SURFACE

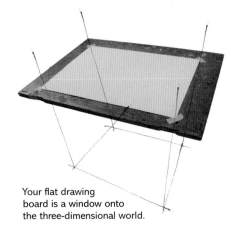

Your flat drawing board is a window onto the three-dimensional world.

'A line is a dot that went for a walk' Paul Klee

When we draw, we are abstracting information from the three-dimensional natural world. There are conventions that we can play with to help us create the illusion of space and form. When one line is in front to the other, the implication is clear to the viewer: one thing is in front of the other. This convention is a way of reading form and space without shading.

Warm up exercise: landscape doodle

Before tackling the shells below, use the pen to create a landscape doodle on your page. Imagine hills rolling away from you. Vary the thickness of the line – thick at the front and thin at the back – and see how much of an illusion of space you can create simply by using overlapping lines.

Illusion in line: seashells in pen and ink

A topographic map describes the surface of the earth using contour lines; a technique we can use for drawing animals. I used a dip pen and Indian ink for this example. Pick a point to start from, then imagine that the nib of your pen is touching the outline of the shell rather than the paper. As you work, imagine the nib is you, traversing your way along a rocky escarpment.

1 Create the silhouette by imagining your nib racing the contours, like a bug going for a walk. If you feel the form going away from you, ease off on the nib; press down on your nib where you feel the weight is being supported. There is a great range of thick and thin lines you can produce.

2 Break the silhouette: create the illusion that one shell is in front of the other by drawing the lines of contour where the forms overlap. Look more at the shell than the paper and maintain a conviction that your nib is touching the shell.

3 Not all contours lie on the outer edge on the shells. The inner contours help us to sense the physical form of the shell. As you draw these contours, follow the form of the shell, imagine holding the shell in your hand. Feel these growth ridges that wrap themselves around the form. Follow these lines sensitively and with patience, so that the forms of the shells begins to emerge on your paper.

Topographic shell Explore the topology of another, more complex shell. Feel your way around the form from the front to the back.

Applying your skills to other animals

Unlike seashells, animals rarely sit for a portrait; and nor will they be standing in the animal equivalent of the Vitruvian Man. However, when animals are still, the topographical method of drawing outlined above remains a great approach. Feel your way around the form, overlapping lines to imply one form is in front of the other. The challenge of the field artist is to record what you see happening in front of your eyes with, honest natural observation. Each little sketch gets you closer to knowing your subject.

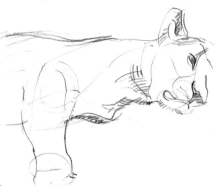

Sleeping Barbary lion Howletts Wild Animal Park, Kent.

Green sea turtle in pencil

Using perspective (see page 12) we can create a rendering of a sea turtle swimming over our head.

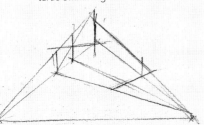

1 Create a framework block above your eye level and find the centre line.

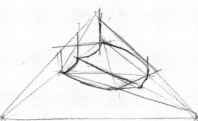

2 Round off the corners and morph the box to a more organic form.

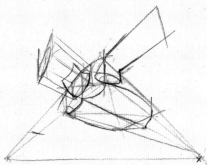

3 Add a box for the head and neck, using your eye to judge the distance proportionally on either side of the centre line. Make sure the division at the front line is a little wider than at the back.

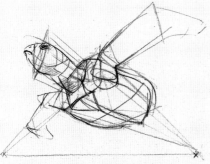

4 Create a framework for the fore flippers, then draw organic shapes to start to capture the character of a green sea turtle. Use the framework to help manage the proportions.

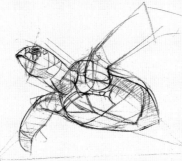

5 Sketch up the jigsaw-like parts of the plastron (the flat underside of the shell).

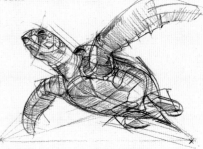

6 To finish the drawing, model and sculpt the form of the bottom of the shell. Adding the small frontal scales on the head helps to give scale to the sea turtle.

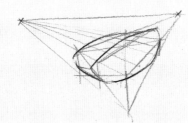

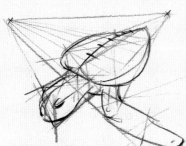

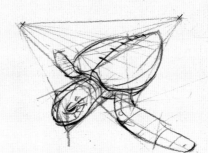

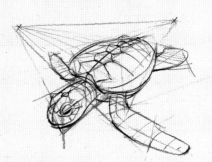

Another angle The same principles and techniques can be used to draw the sea turtle from other angles – in the example here, beneath our eyeline.

STUDY SHEETS

'Not once in describing the shape of that mass did I shift my eyes from the model. Why? Because I wanted to be sure that nothing evaded my grasp of it. Not a thought about the technical problem of representing it on paper could be allowed to arrest the flow of my feelings about it, from my eye to my hand. The moment I drop my eyes that flow stops.' Auguste Rodin

When creating sketches, we all have successes and failures, so don't be afraid of making mistakes or getting something wrong. Drawing is to be considered a journey of enquiry.

There is no better way to develop our observational skills and hand–eye coordination than with study sheets. They offer an opportunity to familiarize yourself with the animal or group in front of you; and to investigate its character, posture and movement.

CREATING A STUDY SHEET

Working from live animals connects you with their individual character. Do not worry about creating a perfect photographic drawing whilst sketching in the field. This time is about speed drawing and getting down the main impression of an animal. The drawings you produce will come together as a study sheet that will have an energy and dynamism which cannot be created when working from photographs.

You will experience – over and over again – the animal changing position before you have time to draw it. Don't worry, move on: start a new drawing each time the animal moves into a new position. Try to flow with the positions that the animal gives you and try to get the information down as quickly as possible. A study sheet for me is not about creating a single drawing, but a host of observations that create one big joined-up study.

A study sheet can be a combination of quick gestural studies and more sustained work. It can include details and acts as an enquiry a search in the character of the animal. Study sheets help us to learn to work for a discovery and not a polished result.

Tools for study sheets I find it is important to provide myself with a large drawing area. This large working area will give you space for more than one drawing as the animal inevitably moves to another position. I typically use an A2 – 42 x 60cm (16½ x 23½in) – drawing board, comfortably positioned on a tripod easel, so I don't have to worry about holding anything other than a pencil.

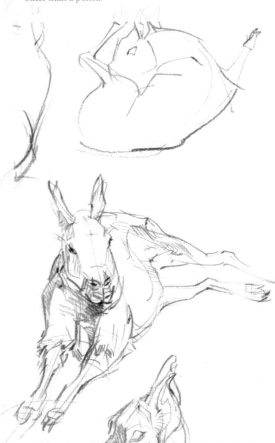

Tips for study sheets

- The first sketch of the day is never the best and can be thought of as a warm up while your hand and eye get tuned in. There is no correct starting point, although I tend to rough out the head and move from nose to tail for side- and forward-facing positions.

- Try starting out with a side-on view and progress to more challenging gestural positions – such as back views – as the drawing session progresses and you get more ambitious at capturing what you are seeing.

- Throughout your study, draw without stopping. Move rapidly from one sketch to the next on the same sheet. Animals are in continual motion and quick sketches have a lively, attractive quality to them. On your study sheet your drawings will gradually improve as you become more familiar with the subject.

- Explore mark-making. Study sheets are very powerful tools to get us closer to the subject in a liberated way, helping us to deal with the continual movement of the animal. Every time the animal moves, stop and start another sketch, then return to the original as the animal returns to a similar position.

- Don't get worried about the result. This drawing is a by-product of your investigation. What is important is that your hand has been activated, that it feels like you are touching the animal while you sketch, and that everything is being engaged. The study sheet itself becomes the work, rather than a single drawing.

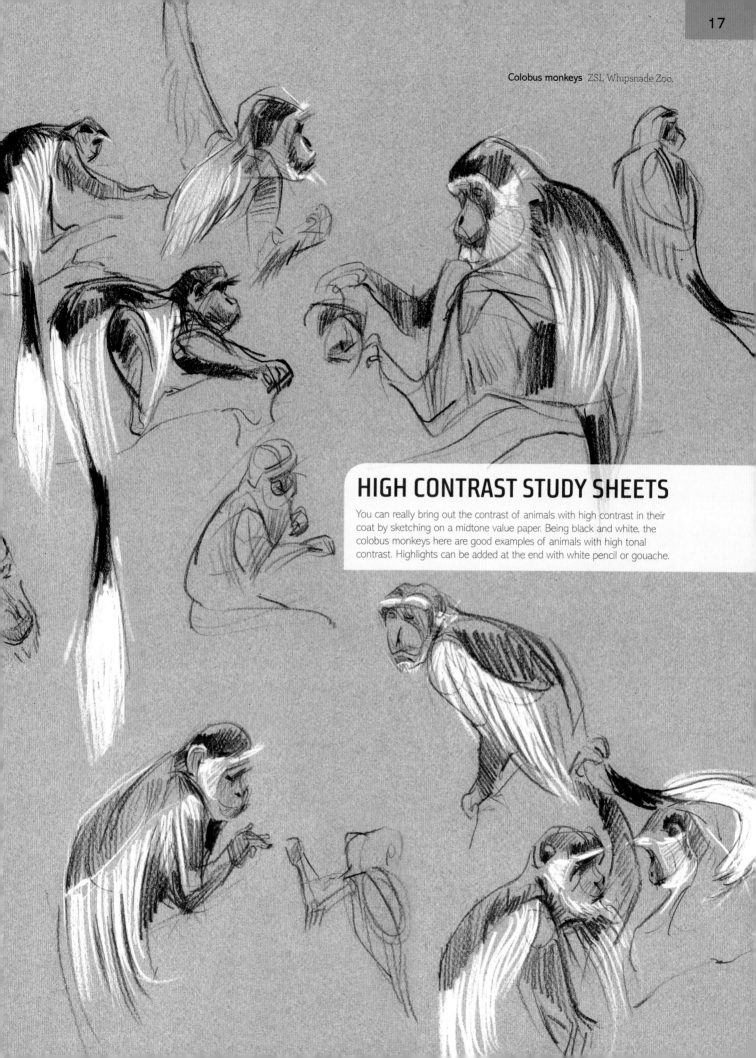

Colobus monkeys ZSL Whipsnade Zoo.

HIGH CONTRAST STUDY SHEETS

You can really bring out the contrast of animals with high contrast in their coat by sketching on a midtone value paper. Being black and white, the colobus monkeys here are good examples of animals with high tonal contrast. Highlights can be added at the end with white pencil or gouache.

THE IMPORTANCE OF INFORMALITY

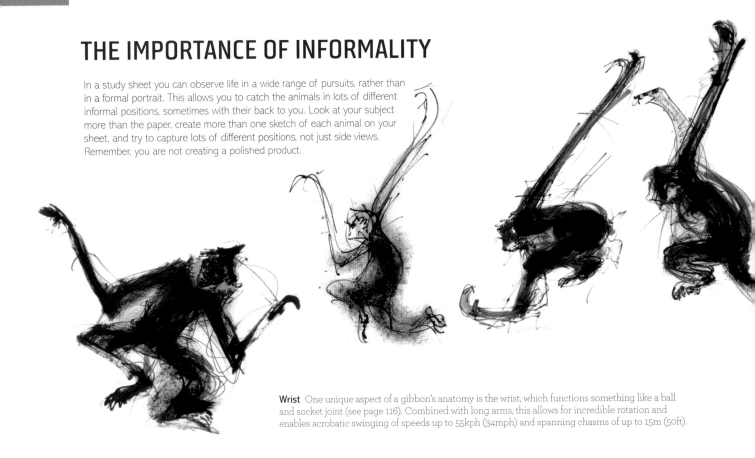

In a study sheet you can observe life in a wide range of pursuits, rather than in a formal portrait. This allows you to catch the animals in lots of different informal positions, sometimes with their back to you. Look at your subject more than the paper, create more than one sketch of each animal on your sheet, and try to capture lots of different positions, not just side views. Remember, you are not creating a polished product.

Wrist One unique aspect of a gibbon's anatomy is the wrist, which functions something like a ball and socket joint (see page 116). Combined with long arms, this allows for incredible rotation and enables acrobatic swinging of speeds up to 55kph (34mph) and spanning chasms of up to 15m (50ft).

Capture the unexpected and stay curious

Don't be afraid of drawing new animals and enjoy the experience of discovering new subjects on a day out sketching. You might even see a species new to you out of the corner of your eye, as I did with these mudskippers.

Mudskippers are quite literally walking fish, so they give us a good idea of the evolutionary steps that brought life out of the oceans. This fish-out-of-water has adapted to living mostly on land, using their pectoral fins to walk about on intertidal zones. Mudskippers spend ninety per cent of their time out of the water. In order to keep their skin moist, they roll around in wet mud and can absorb air through their capillary-rich skin. Their eyes move independently and are perched on top of their heads, giving them fantastic panoramic vision.

As you sketch mudskippers you will notice them hop and skip with a simple flick of the tail. This is a good escape mechanism; and males also jump to get the attention of females. Some of the thirty-two species alive on the planet can jump as high as 60cm (2ft).

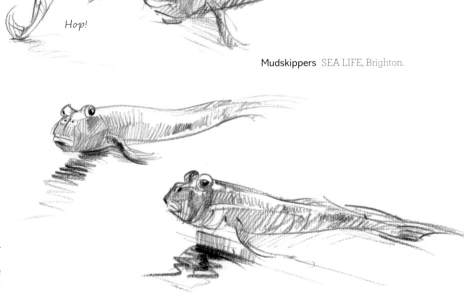

Hop!

Mudskippers SEA LIFE, Brighton.

Blink in amazement

Most fish do not have eyelids as they are kept moist by being submerged in water. The mudskipper is the only fish that can blink. To keep their eyes moist out of water they retract their prominent eyes into special fluid-filled cups, which creates a blink-like effect.

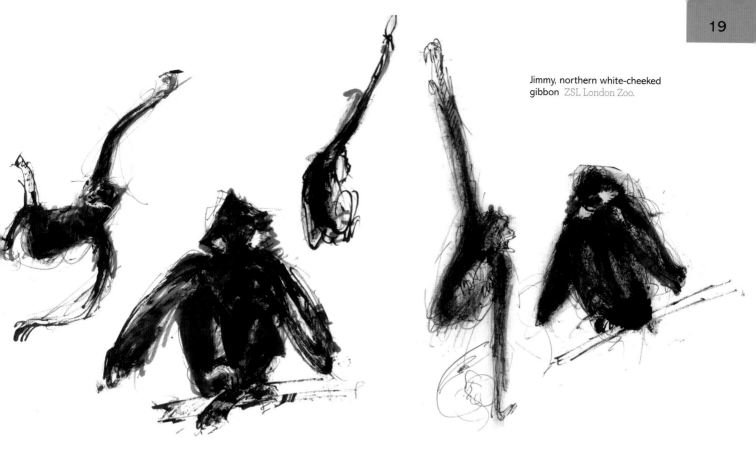

Jimmy, northern white-cheeked gibbon ZSL London Zoo.

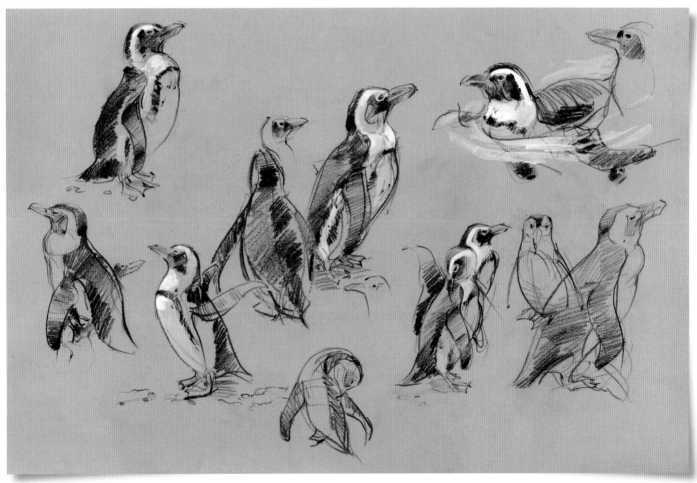

African black-footed penguins ZSL Whipsnade Zoo.

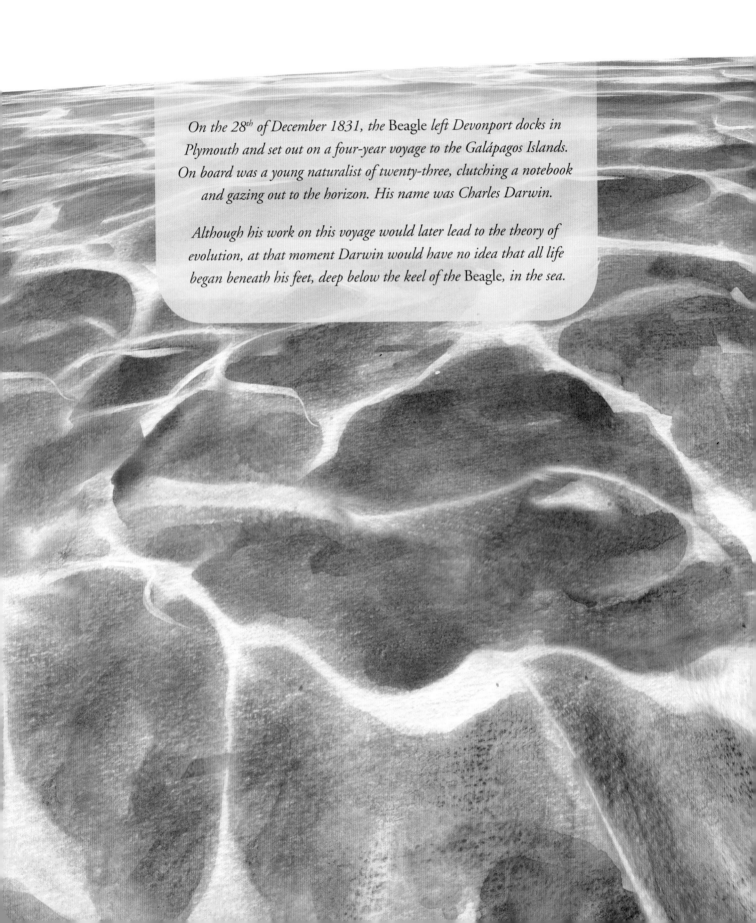

On the 28th of December 1831, the Beagle left Devonport docks in Plymouth and set out on a four-year voyage to the Galápagos Islands. On board was a young naturalist of twenty-three, clutching a notebook and gazing out to the horizon. His name was Charles Darwin.

Although his work on this voyage would later lead to the theory of evolution, at that moment Darwin would have no idea that all life began beneath his feet, deep below the keel of the Beagle, in the sea.

THE SEA, AND LIFE

An estimated 1.9 million different forms of life – plants, animals and others – have been described by science, and this may be just the tip of the iceberg. Modern genetics confirm that this abundance of life is all related.

Some 3,000 million years ago, the great diversity of modern life began with some mysterious yet humble beginnings, as molecules began to clump together to form cells. These were the seeds from which all life has grown.

The foundations of the ecosystem on which all land animals, including us, depend, were laid some 480 million years ago with the evolution of land plants. However, complex life began some 200 million years prior to this – in the sea, where more stable conditions for life existed.

For many millennia the earth was a barren and hostile place with fierce winds, a baking sun and freezing nights; too inhospitable for life to take root. Only when the land had became green, following the evolution of land plants, were some animals at last able to clamber up from the ocean and begin to take advantage of land plants instead of those in the sea.

Ancestors similar to present-day millipedes, with segmented and armoured bodies, were some of the earliest to venture onto land. The hard carapace of their shell, the exoskeleton, now did a good job of keeping them moist. Their legs, evolved to work in the sea, now began to adapt to the challenges of the land.

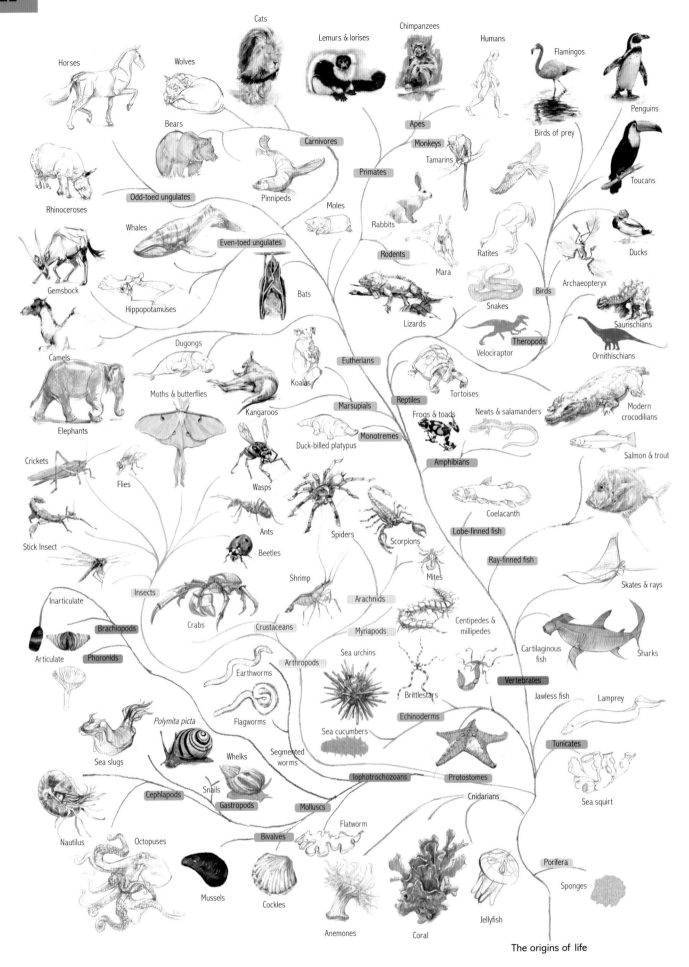

Horses

Wolves

Cats

Lemurs & lorises

Chimpanzees

Humans

Flamingos

Penguins

Bears

Carnivores

Apes

Birds of prey

Toucans

Odd-toed ungulates

Primates

Monkeys

Tamarins

Pinnipeds

Rhinoceroses

Moles

Ratites

Ducks

Whales

Rabbits

Even-toed ungulates

Rodents

Mara

Birds

Archaeopteryx

Gemsbock

Hippopotamuses

Bats

Snakes

Saurischians

Lizards

Theropods

Camels

Dugongs

Eutherians

Tortoises

Velociraptor

Ornithischians

Koalas

Moths & butterflies

Reptiles

Modern crocodilians

Elephants

Kangaroos

Marsupials

Frogs & toads

Newts & salamanders

Monotremes

Amphibians

Salmon & trout

Crickets

Duck-billed platypus

Wasps

Flies

Spiders

Scorpions

Coelacanth

Lobe-finned fish

Stick Insect

Ants

Beetles

Mites

Ray-finned fish

Shrimp

Inarticulate

Insects

Arachnids

Centipedes & millipedes

Skates & rays

Brachiopods

Crabs

Crustaceans

Myriapods

Sea urchins

Cartilaginous fish

Sharks

Articulate

Phoronids

Arthropods

Earthworms

Vertebrates

Sea slugs

Polymita picta

Flagworms

Brittlestars

Jawless fish

Lamprey

Echinoderms

Sea cucumbers

Whelks

Segmented worms

Tunicates

Cephlapods

Snails

lophotrochozoans

Protostomes

Gastropods

Molluscs

Cnidarians

Nautilus

Octopuses

Bivalves

Flatworm

Sea squirt

Porifera

Mussels

Cockles

Sponges

Jellyfish

Anemones

Coral

The origins of life

CONNECTIONS

Life on Earth began some 3.7 billion years ago. Simple and undifferentiated, life developed over countless generations and diversified into increasingly more complex forms – a journey we will follow in this book. The 'animal tree of life' on the opposite page shows how the animal kingdom has expanded and branched out. Today, the relationships between the resultant highly varied species of plants and animals are the basis of the earth's ecosystems. All life ultimately depends on these connections.

WHY CHANGE?

Charles Darwin set out a theory in *On the Origin of Species* (1859) to explain how the vast diversity of life could have all arisen from a single common ancestor: as each new generation succeeds the one before, the offspring can have physical changes from their parents. These naturally occurring mutations can be very slight, but over millions of years they can add up to completely alter the way the creature looks and behaves (equally, there can be little or no change, even over the same long period). Where there is change, this process is called evolution.

Some of these mutations prove beneficial in improving the animal's ability to survive, breed or compete for food or other resources. When resources are scarce, adaptation can happen relatively quickly as less fit individuals fail to pass on their genetic information. However, if an animal has found a successful niche, with few competitors and plentiful resources, then it has less pressure to compete and evolve. Some animals thus appear largely unchanged from their ancestors. The woodlouse that now inhabits our gardens, for example, resembles forebears very similar to sea-dwelling shrimp, though the species has adapted to be able to breathe air. Even in such well-adapted animals, evolution continues; merely less obviously. Charles Darwin persistently said, 'Nature does not make leaps!' He came to his theory after studying both natural selection – most famously in his study of Galápagos finch beaks – and artificial selection, in the form of specialist breeding of domesticated pigeons. In wild animals, where animals are faced with the forces of daily survival for life, the tiny changes are almost imperceptible. In domesticated species, however, Darwin witnessed that the speed of change could be sped up by breeding animals with similar characteristics. We can witness the effects of this artificial selection in dogs. All dogs have a common ancestor, similar to the timber wolf, which was domesticated around 14,000 years ago. The myriad of vastly different shapes and sizes of modern dogs, however, has been bred into the species over just a few generations.

The most common misconception about Charles Darwin's phrase the 'survival of the fittest', is that it makes evolution sound like a boxing match between the biggest and most strong. While we can see this clearly in animals such as deer, this isn't the whole story. For example, why do we get all those little fish in coral reefs? Charles Darwin's prescient statement simply meant that reproductive success is for the individuals that best fitted to their environment. Those little fish, for example, are able to swim between gaps in the coral and gain shelter from predators, which is their niche.

Horseshoe crabs (see page 50) are sometimes called 'living fossils', but this term is misleading, as it suggests the animal is identical to an ancestor who lived hundreds of millions of years ago, when there are some subtle changes for those who look closely. Evolution works by adapting pre-existing characteristics of the animal's ancestor. No animal arrived on the planet without having a long line of parental lineages. Every animal comes from somewhere; and this has enabled scientists to piece together the paths of evolution, finding the links that prove birds, for example, have evolved from dinosaurs: their hips and feet are so incredibly similar, that birds could have come from nowhere else.

Habitats and adaptations

Earth is the only planet in the universe known to support life. Animals and other living organisms exist here in a rare habitable zone of oxygenated air and water, which stretches from the deep and largely unexplored floors of the oceans to the rarified air of the upper reaches of the troposphere. It is extraordinary to think that the only life that exists in the universe lives in this relatively narrow band of atmosphere. Nevertheless, the variety of forms animal life takes is astonishing.

Animals live in many different places and types of environment within the habitable zone. They are able to do this because they have special adaptations to the surroundings they live in. The appearance and behaviour of an animal is intrinsically linked to the nature of their habitat. The earth has a great diversity of habitats, from rolling rivers and the open seas, to plains, mountains and forests. Across the world – from the humid, warm conditions of the tropics, to the extreme climates of the sun-baked deserts and the frozen poles, where the conditions are harsher, life survives – and even thrives. In these extreme environments animals have evolved specialist adaptations to be able to pioneer these places.

Bones and understanding Fossils have given scientists some of the best clues about the evolution of life on earth. It is through fossilized bones that scientists have been able to connect animals alive today with those in the distant past. In the rare instances that a dead body of an animal was not scavenged; and after the soft parts of the body (such as muscles) had rotted away, the skeleton would get covered in layers of sediment over millions of years and become fossilized. As a result, fossils are only found in sedimentary rocks.

How did life emerge? Scientists have explored several possible locations for the origin of life, including tide pools and hot springs. Charles Darwin speculated that life evolved in 'warm little ponds', which gives us our first hypothesis, which is driven by the moon. In this model, tidal sea water, left in rock pools, is baked by the sun. By modelling the process of continual wetting and drying (representing the tide ebbing and flowing) scientists have managed to create some of the basic building blocks of life, called RNA, an acid essential for all living cells.

Another model hypothesises that life originated near a deep sea hydrothermal vent. The chemicals found in these vents and the energy they provide could have fuelled many of the chemical reactions necessary for the evolution of life. However, the actual site itself still remains uncertain.

COMMON FEATURES

Drawing and sketching relies primarily on observation; but having an understanding of what gives an animal its shape – the underlying structures of its bones and muscles – will help the artist immensely, and assist in making sense of the sometimes bewildering structures and forms that animal life displays. Learning to visualize the basic form beneath the skin will give you a powerful tool to help with your artwork. The bones and their joints form common structural landmarks, such as the wrist, elbow, shoulder, hip, knee and ankle, which can help you traverse your way through the structure for accuracy in sketching. These landmarks are exceptionally helpful, breaking the body down into manageable parts. From these main pivotal points, we can look deeper and see more subtle details.

While the muscles and bones of a particular species will vary in bulk, shape or position from other species, we can look for similarities between them. Animals are all ultimately related to one another, and as a result we can look for telltale surface shapes created by these structures, and recognize them in other animals – or ourselves.

HOMOLOGOUS AND ANALOGOUS STRUCTURES

Many species of animals have physical structures that are similar, but use them for different functions – the structures that make up our arms make up the wings of birds and the flippers of seals, for example. These are called homologous structures; which means they are broadly similar in position, structure, and evolutionary origin, but not necessarily in function. Being aware of this can help inform our artwork, helping us to draw parallels between structures in our own bodies and those of the animals in front of us.

Convergent evolution is the process whereby organisms that are not closely related, independently evolve similar traits as a result of having to adapt to similar environments or ecological niches. This is like a parallel evolution! Examples of this might be human and squid eyes or human and insect ears, both have evolved independently of each other but have the same function. Other examples might be the prickly spikes of echidnas and hedgehogs or the fins of whales and sharks. These animals have converged useful traits in response to environmental stimuli and similar biological goals. These are known as analogous structures.

SUPPORTING STRUCTURES

Bones are the internal architecture of all vertebrates. This substance can be solid and strong enough to support the weight of an elephant, or honeycombed with air pockets, light enough to enable a bird to fly.

Bones allow frogs to jump, snakes to slither, tigers to prowl and a fish to swim. It is a unique compound substance of minerals and organic proteins. The mineral substance, calcium phosphate, gives bone its hardness and strength; while the organic compound, collagen, gives bones their flexibility. Take away the mineral compound and the skull would take on the bendy quality of a rubber duck; remove the organic compound and the bone would shatter from the slightest impact. So this combination allows for both strength and flexibility under a variety of stresses of walking, running, swimming, sliding or flying.

Bones are a living structure and regrow throughout our lives. They change as we grow up and mature. Bones can even get bigger when repeated force is acted on them, just like muscles.

Vertebrates: the spine

All vertebrates have a spine, this acts as a central column to which the fore and hind limbs are attached – anchoring the four legs of quadrupeds, and helping to hold the body upright in humans. This simple symmetrical system seems to be very efficient at enabling animals to move through space and go about their lives.

Invertebrate support

Invertebrates do not have a spine. Instead, they support their bodies in a variety of ways. Arthropods, like insects and crabs, have a rigid exoskeleton (see page 56). Sponges use a structure of spicules to give them rigidity. Some invertebrates, like jellyfish, molluscs and similar soft-bodied invertebrates, rely on being surrounded by buoyant water, which provides most of the support they need.

It is the pillar-like legs of the elephant that have allowed them to grow so large. I have a personal fascination with elephant skeletons, at workshops I often get children to see if they are strong enough to be able to lift even the weight of a single leg bone by themselves.

It is striking to compare this great weight with the bones of a bird's leg, which you can barely feel in your hand. This just goes to show what incredible stuff bone is, and how diverse its applications can be.

The versatile skeleton

As you can see below, bones have adapted in a fantastic array of different ways to allow animals to take the very best advantage of their particular habitat; whether that is a northern white-cheeked gibbon swinging high up in the rainforest overstorey; a blue whale diving down to the bottom of the ocean; or a bee hummingbird hovering in front of a flower.

Even snakes have skeletons, they have lost their four limbs to enable them to move almost anywhere with an undulatory wave movement – up trees, across sand, through small spaces and in some strange cases, through the air: the paradise snake can launch itself from trees and glide safely to the ground by spreading its ribs to gain lift.

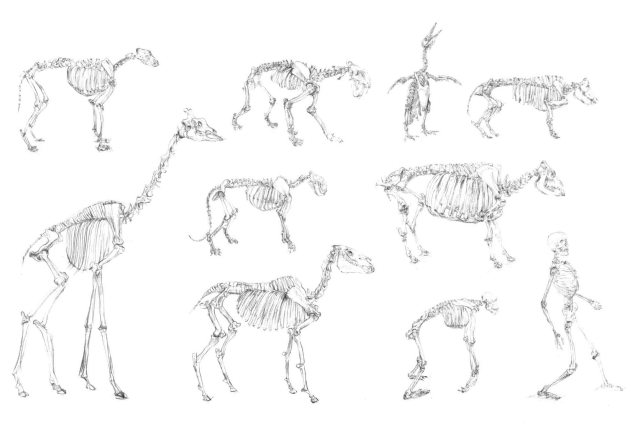

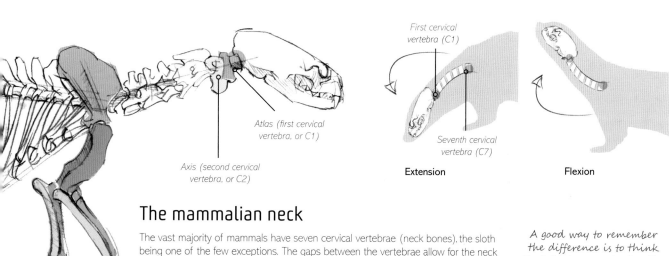

First cervical vertebra (C1)

Atlas (first cervical vertebra, or C1)

Axis (second cervical vertebra, or C2)

Seventh cervical vertebra (C7)

Extension

Flexion

The mammalian neck

The vast majority of mammals have seven cervical vertebrae (neck bones), the sloth being one of the few exceptions. The gaps between the vertebrae allow for the neck to bend, and the gap between the first cervical vertebra (the Atlas, or C1) and second cervical vertebra (the Axis, or C2) allows the head to rotate. The first cervical vertebra (the Atlas) also allows for the rocking motion of the head. The Atlas bone can, on some species, be as wide as the skull and can look like it is part of the skull.

A good way to remember the difference is to think that C1 is named after the titan Atlas, who held up the heavens in Greek mythology; because it supports the whole head.

ARMS AND LEGS

The evolution of limbs or leg-like appendages began about 400 million years ago with our aquatic ancestors, the fish. Their descendants evolved into all amphibians, reptiles, birds, and mammals. Today, the only vertebrates that do not have four limbs are fish. On a bird the forelimbs are the wings, while on humans they are our arms. The term used to describe four-limbed animals is 'tetrapod'. A quadruped is a tetrapod that uses its four limbs for locomotion; moving around on all fours like a horse or deer.

The versatile pentadactyl limb

'Penta' means five and 'dactyl' means fingers. The number and the size of the bones in a pentadactyl limb can vary but every pentadactyl limb has the same original format no matter what the function is.

The pentadactyl limb can be found, in various forms, in animals ranging from humans and bats to antelopes and whales. The homologous structure of each species' pentadactyl limb is proof that the organisms have common ancestors. Pentadactyl limbs have adapted differently, helping each species to best survive in their respective habitats.

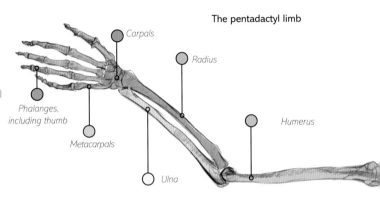

The pentadactyl limb

Carpals

Radius

Phalanges, including thumb

Humerus

Metacarpals

Ulna

Modes of motion

When animals are moving in the field it is very helpful to know what is going on underneath the skin – for example, sometimes the subject's foot is hidden in long grass and you simply can't see how many toes the animal has. It is satisfying to know that your mark-making is being reinforced by a deeper understanding of what you are looking at.

On initial appearance, quadrupedal mammals seem incredibly diverse. One might assume that we have to learn a new set of bones and muscles before we sketch each new species. However, there are three defining groups that provide some common ground. These groups are dependent on how the animal holds its hand and foot, or fore- and hind-limb:

Plantigrade This group of animals walks on the sole of the foot with a rolling motion, their heel planted on the ground. Humans and bears are examples of plantigrade animals.

Digitigrade This second group of animals walk on their toes or digits, as if on tiptoe. A lot of predators are digitigrade, as it lends itself to moving quietly. Digitigrade locomotion is responsible for the distinctive hooked shape of dog legs that is often mistakenly thought of an as a backwards-facing knee.

Unguligrade The last group are animals walk on their toenails. This group is called unguligrade from the Latin *unguis*, meaning 'nail'. Three ungulates – the horse, the donkey and the zebra – walk on a single hoof, while others, such as deer and giraffe have cloven hooves.

Draw what you already know!

Before we were primates, the tree of life suggests that we were once quadrupedal. This is useful in that we already have a basic understanding of human anatomy and we can relate this to other animals.

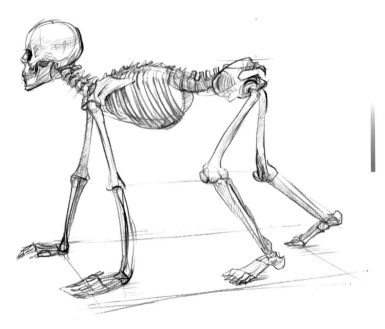

Imagine where your ankle bone is when placing your own foot in these different positions. Bearing this in mind can help when sketching animals.

Different gaits

Plantigrade In this motion, the animal plants its ankle (or heel of the hand, in the human example above) flat on the ground.

Digitigrade The animal walks on its digits or toes; as though sneakily tip-toeing. Notice that the thumb does not touch the ground – this is why the footprint of a digitigrade animal shows only four paw and claw marks, despite having five digits.

Unguligrade The animal walks on the very tip of its digits, or its toenails. Think of the motion as similar to a ballet dancer *en pointe*.

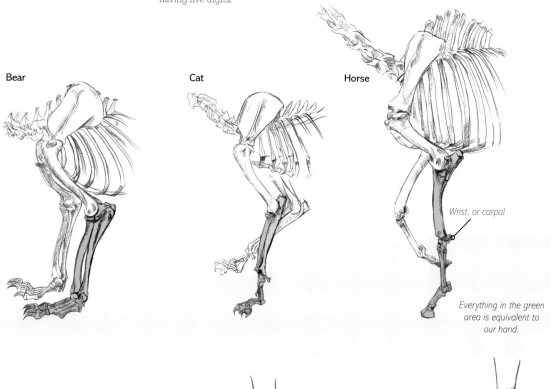

Bear

Cat

Horse

Wrist, or carpal

Everything in the green area is equivalent to our hand.

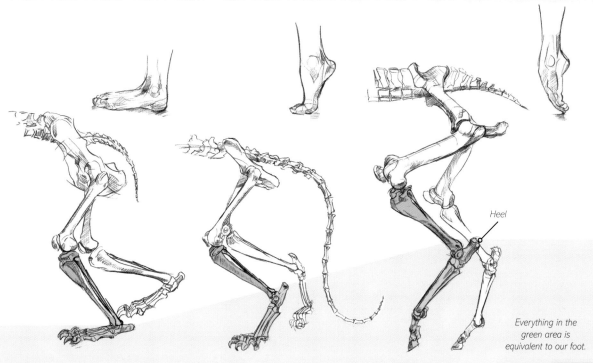

Heel

Everything in the green area is equivalent to our foot.

THE SENSORY SKULL

Protection with access

Getting a sense of the skull beneath the head is a fundamental skill for drawing animals. For the character and soul of the animal begins beneath the surface. If you compare a goat skull with that of a Barbary lion, the animal is already recognisable. When sketching, it is important to be reminded that we a sketching a cranium rather that the face of the animal.

Skulls have evolved to create a protective cavity for the brain, but they also house the sensory organs with which animals make sense of the environment they live in. A sense of smell relies on a pathway through the nose; sound goes in through the ears; taste on the tongue; sight via the eyes; and so on. Similarly, animals get a sense of temperature, pain, touch and vibrations through nerves that run through the spinal column and go into the brain via the *foramen magnum*, the large hole that is at the base of the skull.

On first appearance when we look at the features of an animal with extraordinary sensory adaptation, such as the nose of a giant anteater (see opposite), we can get the impression that it is soft tissue and fur that created these weird and wonderful shapes to draw. In truth, the skull always provides the architecture behind even the most incredible of surface adaptations.

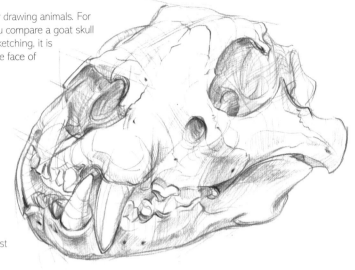

African lion skull
What can this reveal about how animals
make sense of the world around them?

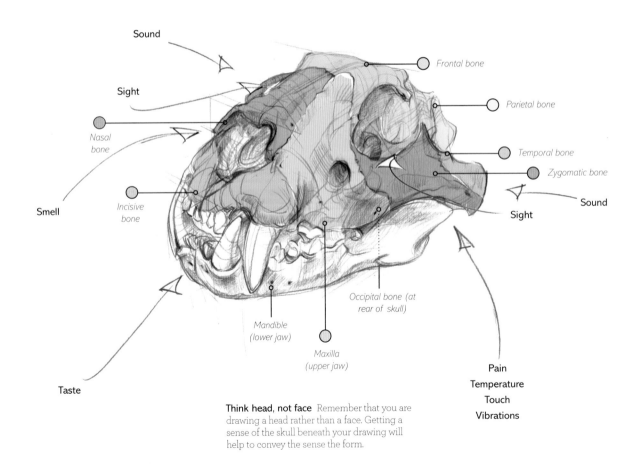

Sound

Sight

Smell

Nasal
bone

Incisive
bone

Taste

Frontal bone

Parietal bone

Temporal bone

Zygomatic bone

Sound

Sight

Mandible
(lower jaw)

Maxilla
(upper jaw)

Occipital bone (at
rear of skull)

Pain
Temperature
Touch
Vibrations

Think head, not face Remember that you are drawing a head rather than a face. Getting a sense of the skull beneath your drawing will help to convey the sense the form.

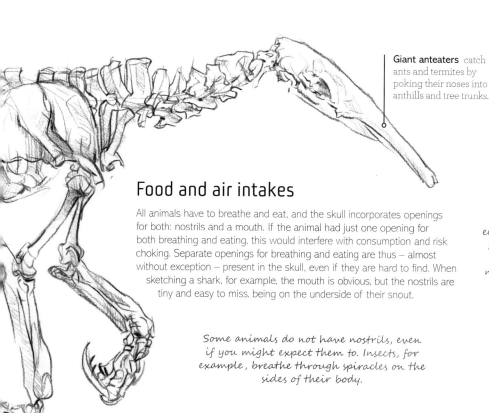

Giant anteaters catch ants and termites by poking their noses into anthills and tree trunks.

Food and air intakes

All animals have to breathe and eat, and the skull incorporates openings for both: nostrils and a mouth. If the animal had just one opening for both breathing and eating, this would interfere with consumption and risk choking. Separate openings for breathing and eating are thus – almost without exception – present in the skull, even if they are hard to find. When sketching a shark, for example, the mouth is obvious, but the nostrils are tiny and easy to miss, being on the underside of their snout.

Some animals do not have nostrils, even if you might expect them to. Insects, for example, breathe through spiracles on the sides of their body.

Strange senses

Scientists have discovered that eels have evolved a magnetic 'sixth sense' that enables them to detect the earth's magnetic field and navigate across the Atlantic, from their birthplace in the Sargasso Sea, a migration of 5,000km (3,100 miles).

The eyes

We can read animals from the outside in and from the inside out. From looking at an animal's skull, we can start to gather information. We can work out what that animals might eat by looking at its teeth – large, blunt teeth for eating tough vegetation; or sharp fangs for cutting meat, for example. Similarly, if an animal's skull has large eye sockets, we might suppose that it hunts at night or in dark murky water, where large, well-developed eyes prove an advantage.

The placement of the eyes on the skull will also reveal clues to an animal's behaviour (see page 32). Predators need precise binocular vision, so their eyes are nearer the front of the skull to give a large overlapping field of vision that helps them to judge distance precisely. In contrast, prey animals often have eyes set on the sides of their skulls, to give the broadest possible field of vision. They don't need the precision at the front, but want to be alerted to the possibility of something creeping up behind them!

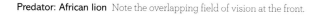

Predator: African lion Note the overlapping field of vision at the front.

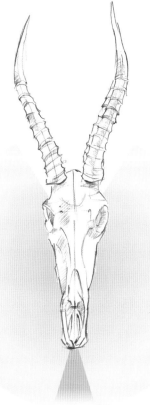

Prey: Blesbok antelope Note the broader range of vision afforded by the side-mounted eyes.

THE MUSCLES

In the Renaissance many artists were also keen anatomists. To create more lifelike portrayals of the human body, they studied how the bones and muscles worked. As artists, we do not need the level of knowledge of a veterinarian, but awareness of the main surface muscles will give you more understanding of what you are looking at, and confidence when creating grooves and shading.

Anatomy is merely a tool for making the animal articulate and clear. The anatomy in this book is quite sufficient without any special study.

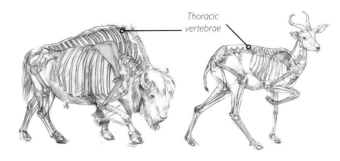

Thoracic vertebrae

Musculoskeletal Muscles and bones are connected, and influence one another. Many grazing animals have surprisingly heavy heads on the ends of long necks. To help the animal lift its head and keep it steady when running, these animals have a particularly thick nuchal ligament, that extends between the upper back vertebrae to the base of the skull. This is anchored to higher thoracic vertebrae (see above), creating a distinctive hump on their shoulders.

Antagonistic muscles

Muscles are attached to the skeleton by strong tendons. They contract, or get shorter, to work. Muscles can only pull and cannot push: if a bone were powered by just one muscle, the bone would have no way of returning to its original position after the muscle had contracted. The problem is solved by having muscles in pairs, called antagonistic muscles. As one contracts, the other relaxes. Examples of antagonistic pairs of muscles are: the quadriceps and hamstrings in the leg; and biceps and triceps in the arm.

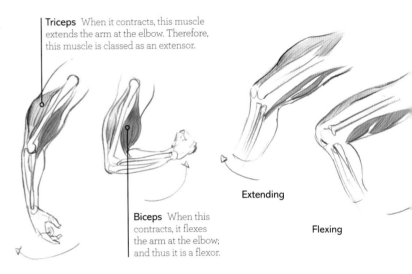

Triceps When it contracts, this muscle extends the arm at the elbow. Therefore, this muscle is classed as an extensor.

Biceps When this contracts, it flexes the arm at the elbow; and thus it is a flexor.

Extending

Flexing

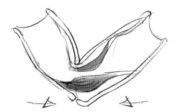

Arthropod muscles Arthropods don't have bones, but they do still have antagonistic muscles. They are attached to the inside of their rigid exoskeleton, rather than internal bones.

COMPARATIVE ANATOMY

Looking at muscle charts can be helpful for your drawing, by letting you identify and compare the position, shape and size of muscle groups. Familiarity with common muscles can help with knowing where to apply your shading and grooves, and allow you to work more quickly and naturally.

Throughout the book, muscle diagrams of the animals (like this giant panda) share a common colour scheme. The intention is to help you quickly recognize and compare the shapes, sizes and arrangements of animals' musculature without needing to learn the biological terms by heart. This will aid observation and help you to draw the animal accurately, even if you catch only a glimpse of it.

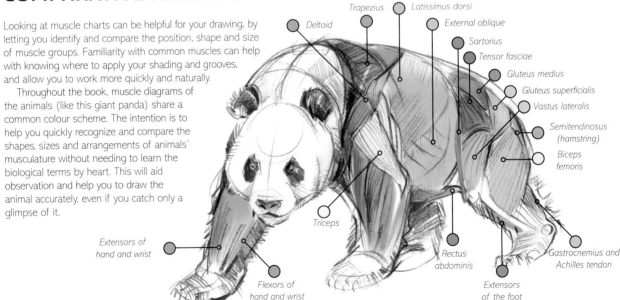

Trapezius

Latissimus dorsi

Deltoid

External oblique

Sartorius

Tensor fasciae

Gluteus medius

Gluteus superficialis

Vastus lateralis

Semitendinosus (hamstring)

Biceps femoris

Triceps

Rectus abdominis

Extensors of the foot

Gastrocnemius and Achilles tendon

Extensors of hand and wrist

Flexors of hand and wrist

Common ground

The paired antagonistic muscles on the foreleg and rear legs of these animals work exactly as they do in humans' arms and legs (see opposite); differing mostly in bulk and shape. Look for commonalities between your anatomy and the animal you are drawing. While the names of the muscles are included for reference, do not feel that you have to learn them all. The charts in this book have been coloured for simplicity and to emphasize the similarities between animals.

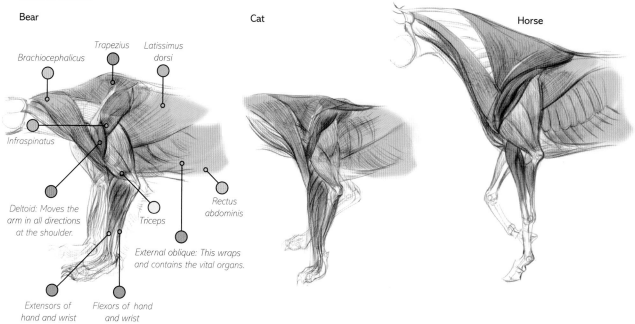

Bear

Brachiocephalicus

Trapezius

Latissimus dorsi

Infraspinatus

Deltoid: Moves the arm in all directions at the shoulder.

Triceps

Rectus abdominis

External oblique: This wraps and contains the vital organs.

Extensors of hand and wrist

Flexors of hand and wrist

Cat

Horse

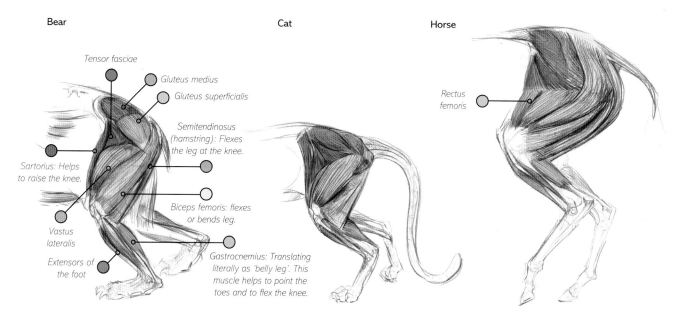

Bear

Tensor fasciae

Gluteus medius

Gluteus superficialis

Semitendinosus (hamstring): Flexes the leg at the knee.

Sartorius: Helps to raise the knee.

Biceps femoris: flexes or bends leg.

Vastus lateralis

Extensors of the foot

Gastrocnemius: Translating literally as 'belly leg'. This muscle helps to point the toes and to flex the knee.

Cat

Horse

Rectus femoris

Notes on muscle labelling

The glutes are a complex group of muscles. You may be familiar with the gluteus maximus, gluteus medius, and gluteus minimus. Some animals share this arrangement, but others have additional or different specific muscles. While these distinctions are made because they are important biologically, for the purposes of sketching animals it is usually enough to simply refer to the 'glutes', which is the approach I have taken throughout.

An exception is made for the gluteobiceps, a muscle present on some animals such as the hippopotamus, camel, deer, giraffe, and pig. It consists of the biceps femoris fused to the rear portion of the gluteus superficialis. In other animals, such as the horse, dog, or cat, the gluteus superficialis and biceps femoris muscles are separate.

A similar simplification is made for the extensors and flexors of the foot/hand (to extensors/flexors) in the rest of the book.

ANATOMICAL ADAPTATION

Evolution often occurs when animals are competing for limited food and resources or habitat change. The arrival of predators in the Cambrian period – the first thought to be *anomalocaris*, an ancestor of the mantis shrimp (see page 52) – added a new pressure. Now prey animals had to adapt to outwit these predators in the form of an adaptation arms race.

Stereoscopic vision With binocular vision you have a much greater chance of judging depth in front of you. To test this, shut one eye and hold your arm out straight with your index finger extended. Now take the other arm, also with it's index finger extended, and see if you can touch the tips of your fingers together. The chances are that you will not be able to judge the distance with just one eye open, and miss.

PREDATOR AND PREY

As seen on page 29, there is a fundamental difference in where the eyes are located between prey and predator animals. On an antelope's skull, the eye sockets are situated on the side of the head. This is because this animal spends a lot of its time with its head bent down to eat a low-nutrient food; grass. While the animal is busy grazing, there will be predators out stalking for their food, so the antelope needs the greatest possible range of vision so that it has the maximum chance of seeing its predator and making an escape. With the eye sockets at the back of the head and on the side, it can see nearly 360° around itself. The eye of the antelope is also at the back of its head, giving them a long nose. If the eyes were at the front of the skull, vision would be obscured by long grass, so its long nose also gives an evolutionary advantage. Prey animals also often move in herds, which creates a 'flight ring': many pairs of eyes are better than one in spotting predators and signalling to flee.

Predators have different needs: to be able to see where they are headed and judge the distances to their prey. Being able to see how far away something is very important when moving in on a kill, and closer-set front-facing eyes means that there is overlap between what each eye can see. This creates binocular, or stereoscopic, vision. With no overlap in its widely-placed eyes, there would be little point in taking a horse to the cinema to watch a 3D movie!

Through the animal kingdom, prey animals tend to have their eyes on the side whereas predators like big cats, birds such as hawks or owls have their eyes facing forward. There is a trade off between amazing profile vision and stereoscopic, both trying to out compete one another between staying alive and getting a kill.

It is this driver between predator and prey that acts as an escalated arms race. Prey species need to move fast to avoid getting eaten, so their legs tend to lengthen. The need to rotate fore- and hind-limbs is negated for longer, faster running limbs. The radius and ulna, fibula and tibia fuse and stretch to create a long pole that acts a vault to propel the animal ever faster forward. The olecranon (at the elbow and knee), and the heel bone become longer to acts as levers with greater flex. To give maximum acceleration and speed, the number of toes becomes reduced from five to two (as in the cloven hoof) – or even one, in the case of the horse, zebra and donkey. A modern horse can reach speeds of up to 80km/h (50mph), roughly twice the speed of Olympic champion human sprinter Usain Bolt, recorded running at 45km/h (28mph).

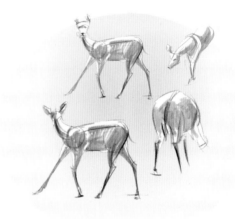

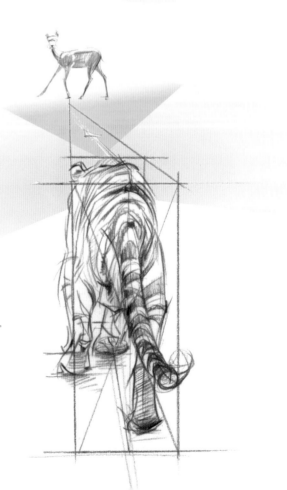

BEAUTY IS SKIN DEEP

These skulls are colour-coded to show how the same underlying bones have developed in different species. Try drawing each one in turn, and try to work out what you can about their lifestyle from the shape of their skulls and the arrangement of bones as you do so.

Use tubes A good technique when sketching eyes on the sides of the skull is to join up the eyes with a tube shape. This helps to ensure that they are in line with each other.

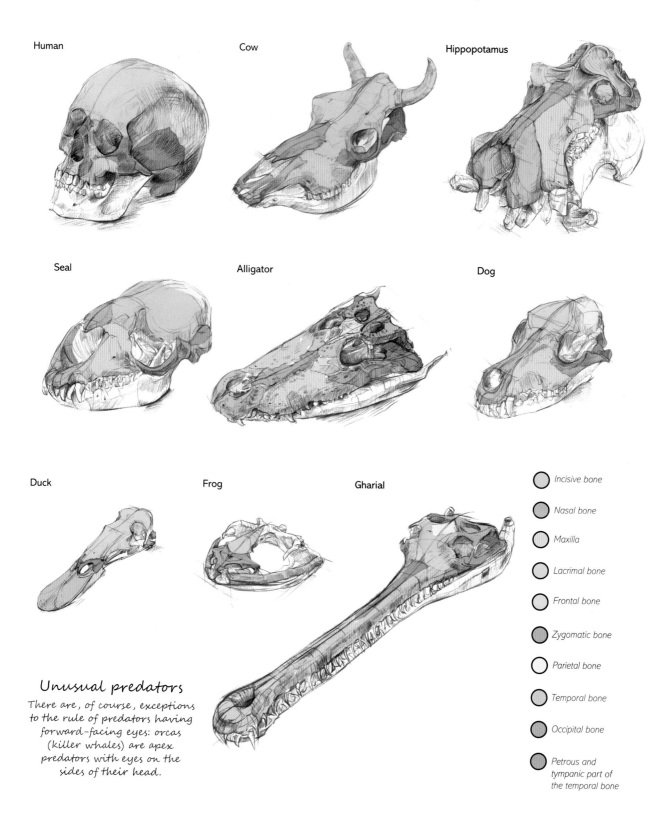

Human

Cow

Hippopotamus

Seal

Alligator

Dog

Duck

Frog

Gharial

Unusual predators

There are, of course, exceptions to the rule of predators having forward-facing eyes: orcas (killer whales) are apex predators with eyes on the sides of their head.

- Incisive bone
- Nasal bone
- Maxilla
- Lacrimal bone
- Frontal bone
- Zygomatic bone
- Parietal bone
- Temporal bone
- Occipital bone
- Petrous and tympanic part of the temporal bone

WELCOME TO THE ANIMAL KINGDOM

Animals have evolved to live on this planet along with plants, fungi, algae, protozoans, bacteria and archaea. These are called the seven kingdoms, which make up all life on Earth.

Under the microscope, all lifeforms can be seen to be made up of one or more cells. Over billions of years, animal life has diversified from the modest beginnings of microscopic single cells into a dazzling array of different life forms. Today, these organisms

all play a vital role in their natural communities; from flies, cleaning up bacterial material, to apex predators on the top of the food chain. This book is about sketching all of these animals, and the discoveries that can be made through a simple pencil and paper.

The animals are arranged into an approximate developmental timeline, in order to give an insight into the evolutionary journeys animals make, for example, from fish to amphibians, to reptiles and finally to birds.

WHAT MAKES AN ANIMAL?

All animals share the following key characteristics. Understanding them will help to inform your artwork, by making you think about how a particular creature meets the particular challenge and achieves the characteristic:

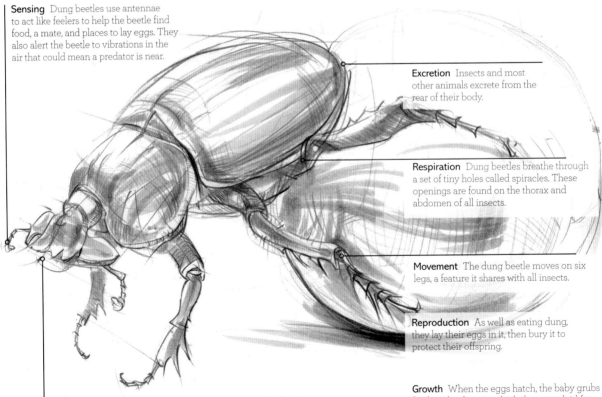

Dung beetle A typical dung beetle has a grooved shield; large, strong front limbs for digging and fighting; and elongated back legs for holding on to dung balls whilst rolling them along.

Sensing Dung beetles use antennae to act like feelers to help the beetle find food, a mate, and places to lay eggs. They also alert the beetle to vibrations in the air that could mean a predator is near.

Excretion Insects and most other animals excrete from the rear of their body.

Respiration Dung beetles breathe through a set of tiny holes called spiracles. These openings are found on the thorax and abdomen of all insects.

Movement The dung beetle moves on six legs, a feature it shares with all insects.

Reproduction As well as eating dung, they lay their eggs in it, then bury it to protect their offspring.

Food Dung beetle have found an unusual niche and feed on faeces, which makes them useful recyclers and gives them a special role in sustaining healthy natural communities. This successful niche has led them to live on every continent in the world, except Antarctica.

Growth When the eggs hatch, the baby grubs feed on the dung in which they were laid for their first meal. Beetles have to shed their skin to be able to grow.

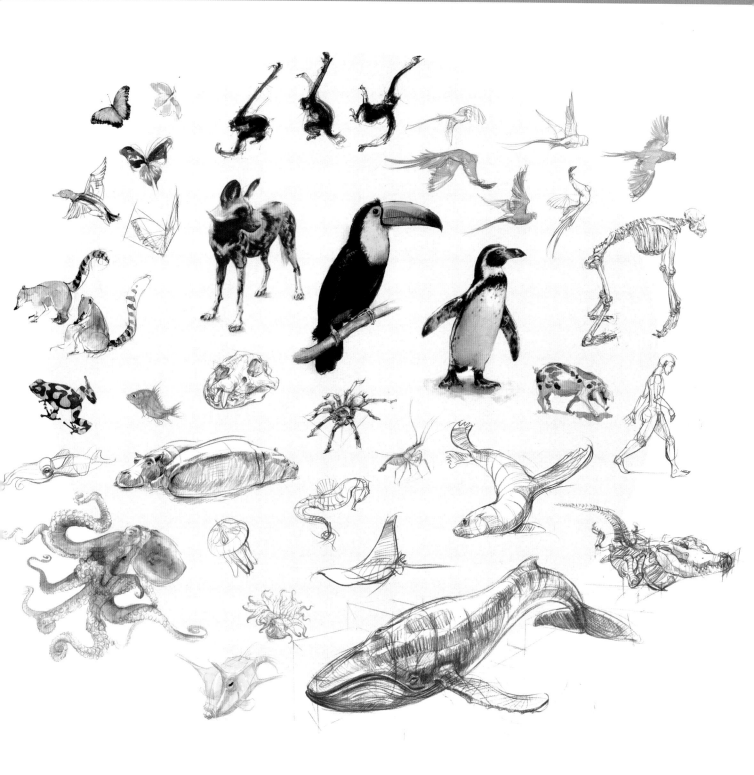

'The Earth is the only world known so far to harbour life. There is nowhere else, at least not in the near future, to which our species could migrate. Visit, yes. Settle, not yet. Like it or not, for the moment the Earth is where we make our stand.' Carl Sagan, *Pale Blue Dot*, 1994

Sponges

All life on earth emerged from single-celled organisms roughly 3.5 billion years ago. Billions of years after these first organisms, one species in particular – cyanobacteria – began to bloom in the oceans. A by-product of its feeding was oxygen, which eventually created conditions for all animal and plant life to evolve into the complex web of connectedness and interdependence we know today.

With the benefit of oxygen, single-celled organisms began to clump together in the sea, creating simple multicellular organisms. Sponges are one of the candidates for the earliest complex lifeforms, dating back some 640 million years. Modern sea sponges are descendants of these early plant-like animals, and still share the characteristics of these pioneering creatures. Sketching sea sponges is thus an opportunity to use our imagination to go back to this early chapter in evolution.

PORIFERA

Porifera, or animals that bear spores, are primarily marine creatures, with only a few found in freshwater habitats. Although today scientists can study their genes and see that they are those of an animal, until the 1820s, most considered sea sponges to be plants. Robert Grant, a creative thinker of his day and founder of the Grant Museum of Zoology, had a particular fascination with sea sponges. One of the characteristics of animal life is that of movement and whilst an adult sea sponge cannot be said to move, in their reproductive process he witnessed their baby larvae swimming around.

Sea sponges don't have any organs; no eyes nor mouth, no circulatory or nervous system. They do, however, come in a great variety of colours, shapes and sizes. They get their food and oxygen from acting as a filter, a bit like one in an aquarium. They have pores and channels through which the water can flow to obtain food and remove waste. In many species, water is taken in from the side and expelled through the top opening. This current is created by a row of single hair-like flagella that line inner channels. These have a tiny tail that they waggle to draw water in through their pores and circulate through their body.

Differences

All sea sponges are held together by crystal structures called spicules, which form the structure of their bodies. The consistency of these spicules determines the characteristics of the sponge's body. Whilst sketching you will notice that some are rock-like and others are soft. Sea sponges can be broken down into three groups based on this physical characteristic.

Calcareous sponges have crystals created from calcium carbonate. Similar to chalk, this is the same material as sea shells.

Glass sponges have spicules of silica, the main component of glass; hence the name. These sponges can create astonishing geometric structures. Silica spicules can be sketched by using dynamic drawing techniques.

Demosponges make up around four-fifths of all the sea sponges and include the elephant ear sponge and the most immediately familiar: the bath sponge. The latter has no hard parts and is frequently used by watercolour artists to sensitively mop up without damaging the surface of their watercolour paper. Besides using other minerals to create their bodies, collagen (also known as spongin) gives these sponges flexibility.

Regeneration

Sponges are known for their ability to regenerate themselves from a piece that has been broken off. A sea sponge can be pushed through a sieve to break the animal down into individual cells. Rather astonishingly, the cells will begin to move towards each other and create increasingly large clumps as other single cells join them. After a few weeks a new miniature sponge will have formed.

Bath sponge *Spongia officinalis.*

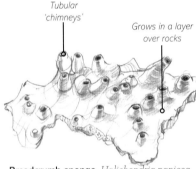

Tubular 'chimneys'

Grows in a layer over rocks

Breadcrumb sponge *Halichondria panicea.*

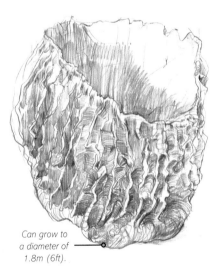

Can grow to a diameter of 1.8m (6ft).

Giant barrel sponge *Xestospongia muta.*

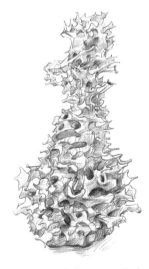

Tubular sponge *Callyspongia plicifera.*

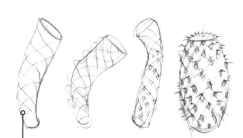

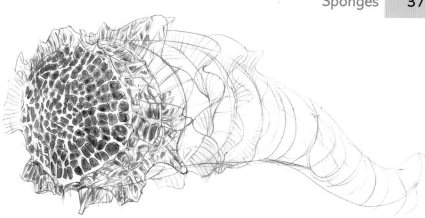

Built for strength Helical ridges, made of spicules, form on the surface of the tube-shaped structure of sponges, spiralling around in opposite directions. As well as providing support, these ridges help the skeleton resist crushing or twisting forces.

Venus' flower basket The elaborate geometrical scaffolding of the Venus' flower basket sponge (*Euplectella aspergillum*), a glass sponge, has inspired architectural forms such as of the Gherkin building in London, UK.

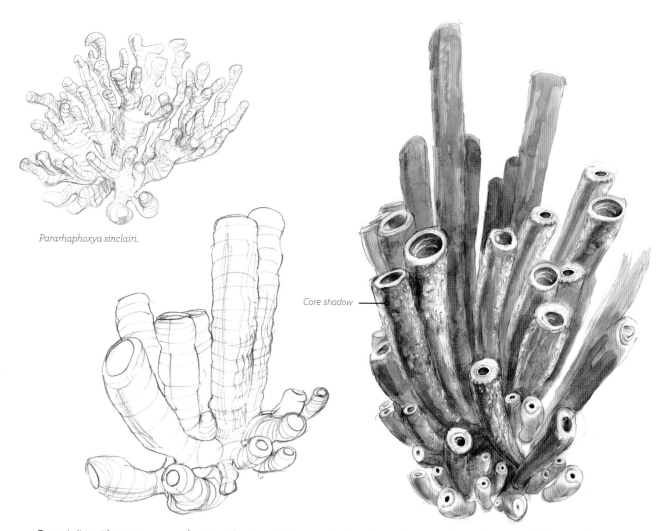

Pararhaphoxya sinclairi.

Core shadow

Dynamic lines The sea sponges are fantastic subjects on which to employ dynamic drawing techniques. In your initial sketches, create lines that wrap around the form to sculpt these creatures.

Stove-pipe sponge *Aplysina archeri.*

Predators

You might think the ten thousand or so species of sea sponges have little to worry about in the way of predators, but the sharp beak of the hawksbill turtle can bite through even their tough structure to provide a tasty meal.

Collagen At the microscopic level, sponge cells are bound together by a tangle of hairy, stringy organic molecules called collagen. This collagen glue is found only in animals, and nowhere else. Collagen is sometimes called the sticky tape of the animal world and gives elasticity. It is found in your ligaments, tendons and skin.

Jellyfish

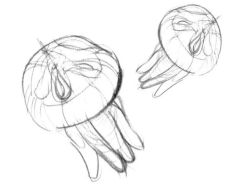

Jellyfish were one of the first animals to evolve muscle-powered movement. Part of a group of animals that are thought to have evolved some 500 million years ago (and possibly even earlier), jellyfish are amongst the oldest animals with multiple organs. These floating blobs of jelly have even mastered immortality.

At first it is hard to see what coral, jellyfish and anemones have in common. They belong to a group called cnidarians, also known as 'nettle animals' because they have stinging tentacles. The name comes from the Greek for 'knife'.

Despite their stinging reputation, they can be incredibly beautiful. Their umbrella-like pulsating bell creates forward propulsion, while their trailing tentacles can be sketched with a great fluidity of movement. In addition, many jellyfish have bioluminescent organs, which emit light for attracting prey or distracting predators. The soft, gelatinous bodies of jellyfish are almost transparent, which can make them seem challenging to sketch at first. Watercolour is a good medium to capture these luminous qualities.

Versatile swimmers Jellies can swim upright, to the side or even upside-down. Try sketching them from above and below.

SKETCHING JELLIES

Start by sketching the ellipse of the muscle ring, then use this as reference to add the dome shape of the bell.

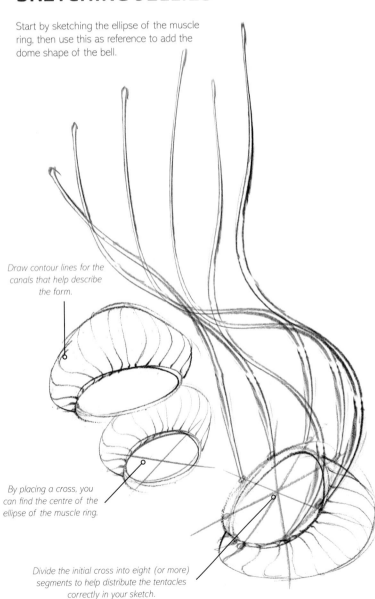

Draw contour lines for the canals that help describe the form.

By placing a cross, you can find the centre of the ellipse of the muscle ring.

Divide the initial cross into eight (or more) segments to help distribute the tentacles correctly in your sketch.

Jellyfish in watercolour

1 Paint a light, bright wash over the entirety of your jelly.

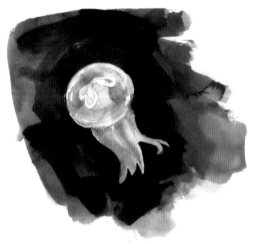

2 Surround the jellyfish with a dark wash of ivory black and French ultramarine in the background. This helps to create the impression of light.

ABOUT THE JELLYFISH

Jellyfish are found in the oceans all around the world. With no spine, they are invertebrates, and so are not truly fish. Like true fish, jellyfish can shoal in a group, called a swarm or bloom, for there is safety in numbers.

We often think of jellyfish as simple gelatinous bodies washed up on the seashore, but they have a life cycle that is as complex as that of a frog: they have six different developmental stages from fertilized egg to mature adult. Part of this lifecycle is the stationary, sexually immature polyp state. during which the jellyfish is attached to a hard surface on the ocean bed, rather than swimming freely.

Scientists have discovered a species that can live forever. *Turritopsis dohrnii*, rather than ageing, can revert to its polyp state. Under laboratory conditions an adult *Turritopsis* was observed undergoing this change over and over again. The jellyfish would age as normal, then when it reached adulthood, it would retract its tentacles, shrink in size, then would drop to the ocean floor to start its lifecycle all over again.

Oral arms Distinct from the thinner tentacles, oral arms bear stinging cells. They emerge from the central body of the jelly.

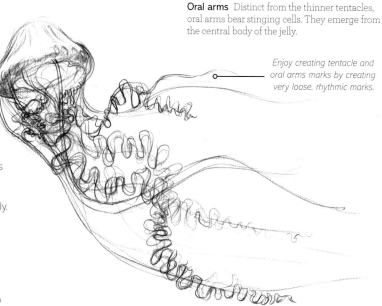

Enjoy creating tentacle and oral arms marks by creating very loose, rhythmic marks.

NOSE TO TAIL: JELLYFISH

Lacking both nose and tail, perhaps 'end to end' might be a better way to describe these animals!

Placing the tentacles in front of the body in pink shadow helps to capture the feeling of luminosity by creating contrast with the white of the body behind. Ivory black, mixed with French ultramarine and alizarin crimson, was used to create the contrasting dark background.

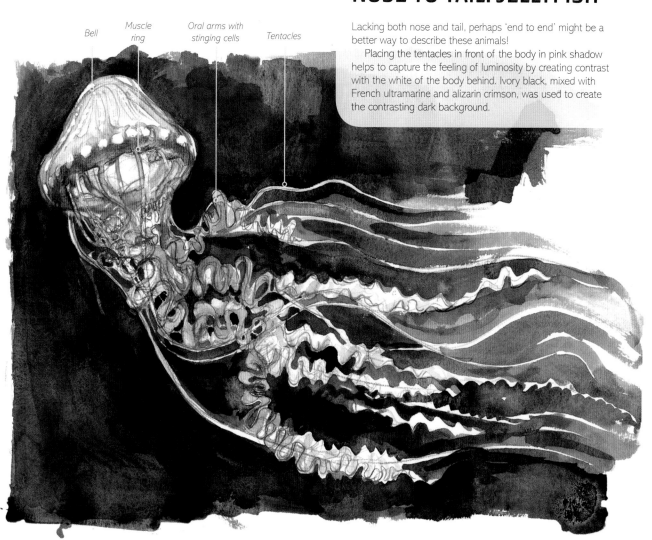

Bell

Muscle ring

Oral arms with stinging cells

Tentacles

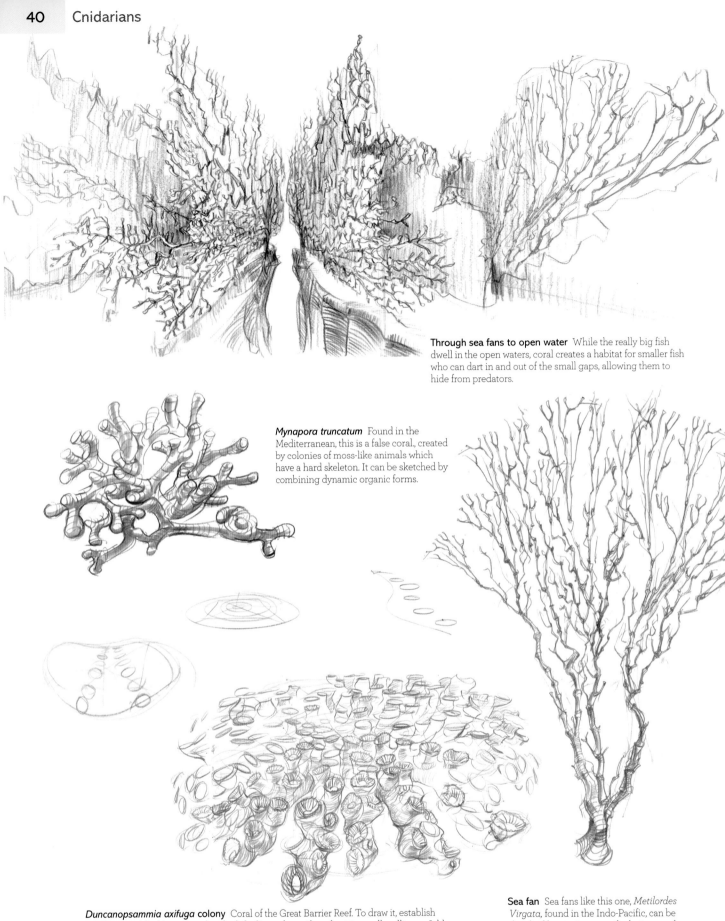

Through sea fans to open water While the really big fish dwell in the open waters, coral creates a habitat for smaller fish who can dart in and out of the small gaps, allowing them to hide from predators.

Mynapora truncatum Found in the Mediterranean, this is a false coral., created by colonies of moss-like animals which have a hard skeleton. It can be sketched by combining dynamic organic forms.

Duncanopsammia axifuga colony Coral of the Great Barrier Reef. To draw it, establish an ellipse and find its centre, then look for lines of growth and put in smaller ellipses. Add concave marks to create the crinkly shape of the food-seeking insides.

Sea fan Sea fans like this one, *Metilordes Virgata*, found in the Indo-Pacific, can be sketched by starting near the bottom and combining concave segments upwards; following the way the coral grows from polyp to polyp.

Corals

Despite their very different appearances, coral, anemone, and jellyfish are all related. They have very different body types: in contrast to the soft body of a sea anemone or jellyfish, coral has a hard skeleton of calcium carbonate. These physical characteristics can be captured in your sketches by the quality of line you create to define the boundaries of form. Different species of coral can suggest different approaches and before starting a sketch it is worth thinking of a strategy.

Appearing overwhelmingly complex, there is always a strategy which will enable you to break any coral down into small repeating activities. Breaking it down through dynamic drawing techniques can give you a framework of observation which will enable satisfying results. I like to use different colouring pencils that relate to the colour of the coral.

ABOUT CORAL

Corals first appeared some 542 million years ago in the Cambrian period, and were one of the earliest complex creatures to develop. Today, the warm waters of the tropical oceans harbour these creatures, forming some of our planet's brightest, most colourful and delightful communities of creatures.

From a single coral larva, a new reef can be formed. In just a few days a coral larva can graduate to the state of becoming a polyp. Surrounding itself with a hard exoskeleton, identical copies then bud off from this initial element. The growing skeleton of this colony is made up of these replicated parts, which create branches as they layer on top of one another. In this way, coral can grow as much as 15cm (6in) per year, and over thousands of years, it can become an enormous habitat for fish and other species. None of our tropical fish would be here if it were not for the coral.

Corals thus create the foundations of an ecosystem that other species rely upon and take advantage of to survive. Some species, such as Christmas tree worms, even live within the coral organisms themselves, filtering their food from water that passes through their host. Coral creates a variety of habitats for both small and larger animals, which in turn display myriad fantastic – and sometimes bizarre – adaptations. At first appearance, reefs may seem an underwater paradise, but these are also battlegrounds for space.

Approaching sketching coral as repeated structures is a particularly useful strategy when using perspective.

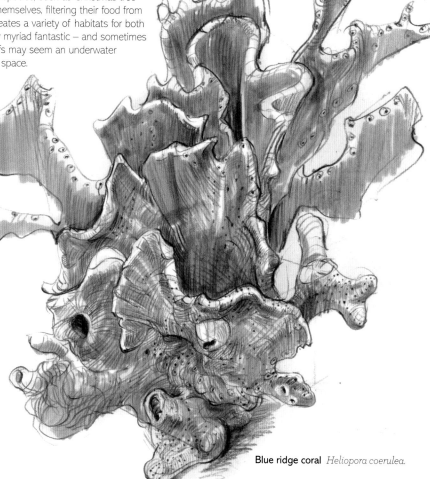

Backlighting

I had this piece of coral in the studio and intentionally lit it from behind. This created an almost proscenium-like effect with the vertical planes of the ear-like lobes of coral. For this drawing I started at the base and sculpted the lobes with a blue pencil and light grey markers.

Blue ridge coral *Heliopora coerulea.*

CEPHALOPODS

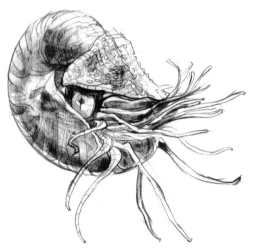

*'Down in the sea, another form of intelligence
has evolved, with alien eyes'*

The enigmatic cephalopods are a fascinating group of marine invertebrates, which include octopus, squid and cuttlefish. All are simply wonderful to draw: indeed, they are one of my favourite class of animals to sketch and we can approach drawing them in a similar way once we have understood the foundations of this species.

ABOUT CEPHALOPODS

Cephalopods are molluscs. They first appeared about 500 million years ago in the Upper Cambrian period. The largest invertebrates on earth, they are unlike other molluscs in having neither an internal nor external skeleton. As a result, cephalopods like octopuses can squeeze through the smallest gaps. All cephalopods have a number of appendages that are attached directly to their heads, usually with suckers or hooks on their undersides.

What cephalopods choose to eat depends on the particular species and its size, but all are strict carnivores. They have hard beaks – much like those of birds, but made out of horn and lacking an outer covering of keratin – which are particularly useful for tearing at and devouring their prey, which includes various fish, crustaceans and other molluscs.

Cephalopods are able to change the colour of their skin very rapidly and at will – even producing intricate patterns and shapes on the surface. This is achieved using chromatophores, which are bags filled with pigment located in the skin. These chromatophores can be controlled by nerves to change the colour of the skin.

All cephalopods have similarities in certain organs. They have three hearts, two of which move blood to the gills while the other pumps blood to the rest of the body. Their blood is blue. Their brains are much larger than those of other invertebrates and most species are able to learn and remember information. They have two eyes, which are extremely complex, perhaps even as sophisticated as the human eye.

Arms or tentacles? While appearing superficially similar, cephalopod appendages have subtle differences. Arms have suckers along their entire length, while tentacles only have suckers at the tip. Most squid have eight arms and two longer tentacles they use for feeding; octopuses have eight arms, and no tentacles; while nautiluses have multiple cirri, which are non-elastic and lack pads or suckers, but are far greater in number and have a very powerful grip.

SQUID ANATOMY

There are around three hundred different species of squid. Just like other cephalopods squid have bilateral symmetry – that is, if sliced vertically through the middle and the mantle, the two halves are mirror images. Squid are very strong swimmers and certain species are able to project themselves out of the water and fly for short distances through the air.

Attached to the main body or mantle is a swimming fin, although this is not the only method of propulsion. At the front of the mantle cavity lies the siphon, which squid (and octopuses) use for locomotion via precise jet propulsion. In this form of locomotion, water is sucked into the mantle cavity and expelled out of the siphon in a fast, strong jet. The direction of the siphon can be changed, to suit the direction of travel.

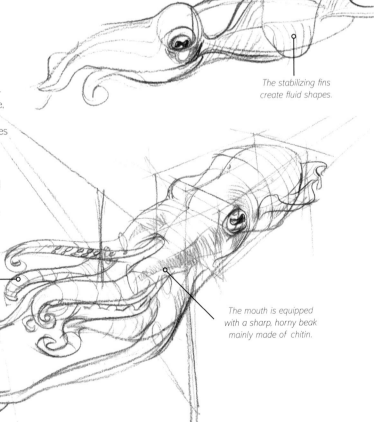

The stabilizing fins create fluid shapes.

The mouth is equipped with a sharp, horny beak mainly made of chitin.

Arms Each of the eight arms are covered in suckers on one side.

Tentacles Sucker-covered clubs are at the end of the two tentacles found on most squid.

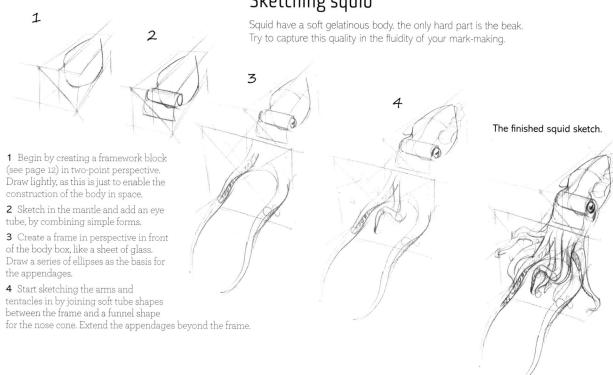

Sketching squid

Squid have a soft gelatinous body, the only hard part is the beak. Try to capture this quality in the fluidity of your mark-making.

1 Begin by creating a framework block (see page 12) in two-point perspective. Draw lightly, as this is just to enable the construction of the body in space.

2 Sketch in the mantle and add an eye tube, by combining simple forms.

3 Create a frame in perspective in front of the body box, like a sheet of glass. Draw a series of ellipses as the basis for the appendages.

4 Start sketching the arms and tentacles in by joining soft tube shapes between the frame and a funnel shape for the nose cone. Extend the appendages beyond the frame.

The finished squid sketch.

Invisibility abilities The skin of squid is covered in chromatophores, which enable the squid to change colour to suit its surroundings, making it practically invisible. The underside is also almost always lighter than the topside, to provide camouflage from both prey and predator.

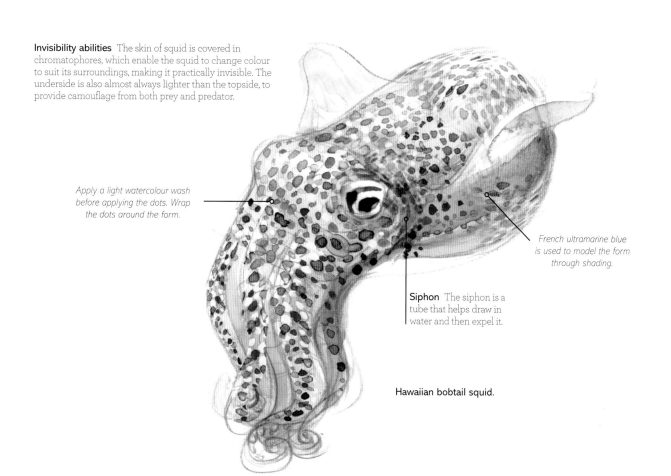

Apply a light watercolour wash before applying the dots. Wrap the dots around the form.

French ultramarine blue is used to model the form through shading.

Siphon The siphon is a tube that helps draw in water and then expel it.

Hawaiian bobtail squid.

Octopuses

Some meek and mild, others bold and brassy, all octopuses are highly individual. Around three hundred species of these molluscs are grouped within the class *Cephalopoda*, along with squid, cuttlefish and nautilus. Octopuses are full of rich behavioural characteristics and really interesting forms and shapes to draw, from their bulb-like oval body form to their slender, searching arms. Despite their apparent size, their soft body enables them to squeeze through incredibly small spaces – restricted only by their beak, the lone hard part of their body.

OCTOPUS SCHOOL: SKETCHING TIPS

To distribute the eight arms evenly, divide a circle in half, then into quarters. Using the circle divided into eight as reference, you can place the shape in perspective.

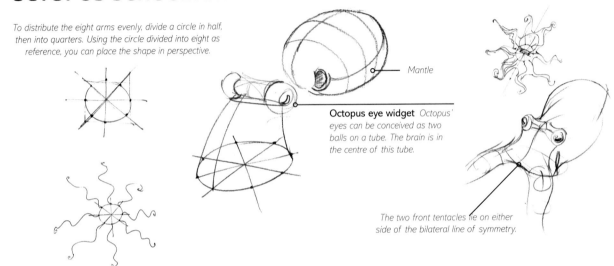

Mantle

Octopus eye widget *Octopus' eyes can be conceived as two balls on a tube. The brain is in the centre of this tube.*

The two front tentacles lie on either side of the bilateral line of symmetry.

Start with a series of ellipses to help guide you when drawing the tentacles. Being very flexible and having a gelatinous body these ellipses can also be rotated vertically.

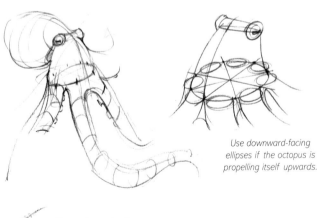

Use downward-facing ellipses if the octopus is propelling itself upwards.

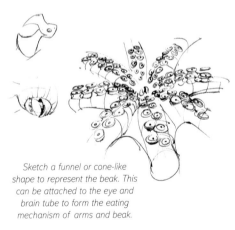

Sketch a funnel or cone-like shape to represent the beak. This can be attached to the eye and brain tube to form the eating mechanism of arms and beak.

The suckers twist like a roller coaster!

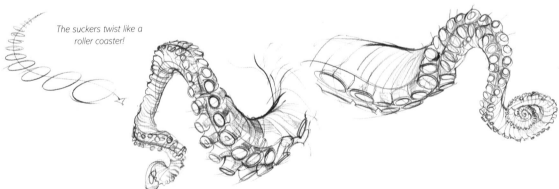

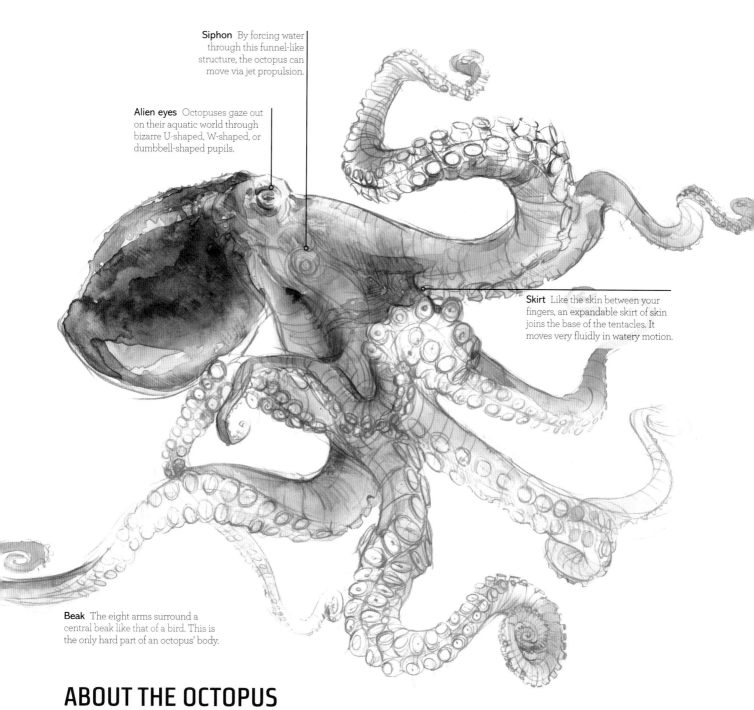

Siphon By forcing water through this funnel-like structure, the octopus can move via jet propulsion.

Alien eyes Octopuses gaze out on their aquatic world through bizarre U-shaped, W-shaped, or dumbbell-shaped pupils.

Skirt Like the skin between your fingers, an expandable skirt of skin joins the base of the tentacles. It moves very fluidly in watery motion.

Beak The eight arms surround a central beak like that of a bird. This is the only hard part of an octopus' body.

ABOUT THE OCTOPUS

Solitary creatures that live in dens amidst the rocky nooks of coral reefs and the sea bed, octopuses are both predator and prey. From the safety of its den, an octopus will wait with the patience of an ambush predator. Its dynamic arms are armed with paired rows of suckers that can dart out incredibly quickly and catch prey – a formidable catching mechanism.

In turn, however, octopuses share the seas with animals such as seals and sharks, which all eat these soft-bodied invertebrates. Fortunately, octopuses are masters of camouflage, able to blend into their environment by changing not only their colour and pattern of their skin, but also its texture, allowing them to match rocks, corals and other items nearby. This incredible chameleon-like ability is a fantastic defence to keep them off the dinner plate. The common octopus supplements this ability by gathering shells to create their own reef-like disguise.

If the octopus can't hide, then it can release a blast of ink to mask its escape. Fishermen sometimes call them inkfish for this reason; it is an ability octopuses shares with squid. Incredible as it might seem, there is even footage of octopuses killing small sharks: when attacked by them, the octopus puts its arms in their gills, starving them of oxygen and forcing them to let them go.

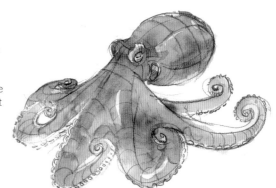

Slugs and snails

GASTROPODS

All snails and slugs are classed as gastropods, which translates to 'stomach-foot', because their stomach and foot are contained within the same body part, which they use to move. Gastropods are also invertebrates, which means they lack a backbone; nor do not have any bones in their large foot which makes up the majority of all gastropods' body mass.

Although sometimes thought to be insects, gastropods are not insects at all, instead belonging within the phylum *Mollusca*. We mostly think of molluscs as being sea-dwelling creatures –the group contains the bivalves, oysters, cockles and clams, after all – but gastropods can be found both on land and in underwater environments. Some, such as sea slugs, cowries and freshwater snails, live permanently submerged in water; while others, like limpets, straddle the two environments.

Typical gastropods have a spiral shell and move around on a muscular foot, to protect their soft body parts, while other gastropods, such as slugs, have no shell at all. Snails that live in dry climates tend to have thicker shells, which help them retain moisture.

ABOUT THE PAINTED SNAIL

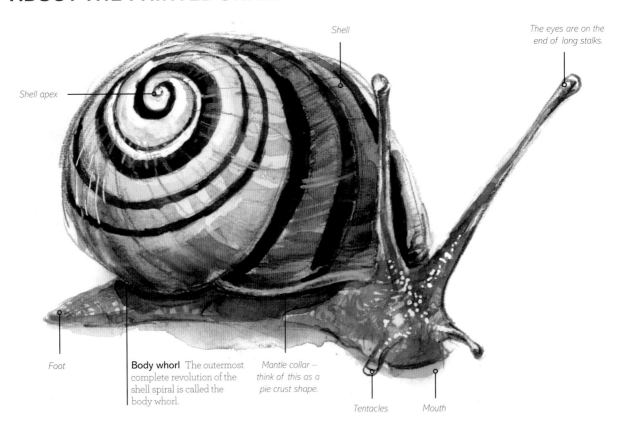

Shell

The eyes are on the end of long stalks.

Shell apex

Foot

Body whorl The outermost complete revolution of the shell spiral is called the body whorl.

Mantle collar – think of this as a pie crust shape.

Tentacles Mouth

Cuba is known as the paradise of snails. The species of snail *polymita picta*, also known as the painted snail or Cuban land snail, exhibits a wide range of brightly and beautifully patterned shells. They use their brightly coloured shells to attract a partner. Their colours range from brilliant yellows and acidic greens to rich purples, and are patterned with swirling markings that follow the clockwise growth of their shell.

Like many snails, painted snails are hermaphrodites, meaning that they are both male and female, hence any snail can be a potential mate. After mating both snails go on to lay eggs.

Painted snail in watercolour

In most snails, the shell is secreted from the mantle. This causes it to coil – usually in a clockwise spiral, though occasionally anti-clockwise. Each complete revolution of the spiral is called a whorl. The gradual development of the shell, which is mostly made of calcium carbonate, creates growth lines in the material. These growth lines create ridges that catch the light. I sketch these in the direction of growth before adding watercolour.

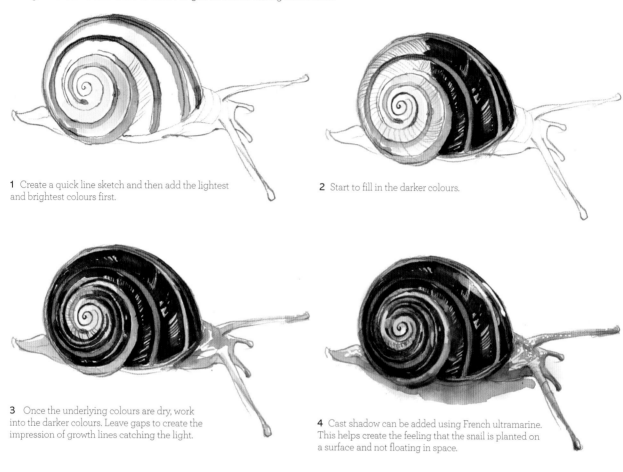

1 Create a quick line sketch and then add the lightest and brightest colours first.

2 Start to fill in the darker colours.

3 Once the underlying colours are dry, work into the darker colours. Leave gaps to create the impression of growth lines catching the light.

4 Cast shadow can be added using French ultramarine. This helps create the feeling that the snail is planted on a surface and not floating in space.

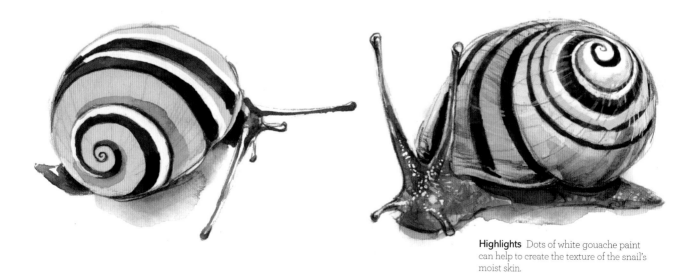

Highlights Dots of white gouache paint can help to create the texture of the snail's moist skin.

ARTHROPODS

The arthropods make up around eighty per cent of all known species on the planet. These are a vast group of animals characterized by having a jointed foot, which is the literal meaning of the word 'arthropod'. Scientists have described around 1.2 million arthropod species, but it is likely that there are substantially more.

WHAT MAKES AN ARTHROPOD?

All arthropods have an exoskeleton made of chitin and sclerotin. This hard outer casing acts as a rigid structure for the muscles to attach to and must be shed in order for arthropods to grow. This exoskeleton provides the animal with a suit of armour for protection, like a samurai warrior, and prevents dehydration on land. These adaptations, in combination with a light, rigid structure to support their weight, allowed arthropods to be the first animals to colonize the land – and later to become the first animals to take to the air, in the shape of the insects.

Arthropods: land and sea

Crabs, shrimp and lobsters, arachnids, centipedes and millipedes, and all insects, are classed as arthropods. Land arthropods evolved from sea arthropods crawling out of the sea some 480 million years ago, at the same time that the first land plants started to emerge. The arthropods' hard exoskeleton, which evolved to protect the animal when in water, now helped to retain moisture as the arthropods pioneered the land.

Insects evolved at the same time as the earliest plants on land and took to the air some 80 million years later. Insects were amongst the first animals on land, as early plants such as horsetails and ferns created a habitat for them to dwell within. Insects are likely to have originated from a little-known group of venomous crustaceans called remipedia. Creatures with backbones, who were our ancestors, came onto the land sometime later about 385 to 375 million years ago, some 100 million years later.

Important arthropods

We are connected to insects in a more complex and intrinsic way that at first we might think. Arthropods play a vital role in virtually all ecosystems. Insects in particular are behind the scenes in much of our daily lives. They provide a source of food for many other species, including humans. While some spread disease – as in the case of mosquitos and malaria – many others, like the dung beetle, are scavengers that act as waste cleaners, preventing the spread of disease. Many insects act as pollinators, making farming possible. Others play a role in aerating the soil. In short, if we and the other backboned animals vanished overnight, then the world would get on fine, but if insects disappeared then that would be a different story.

Drawing arthropods

Capturing their segmented bodies and legs with a pencil is a challenge and it is fascinating to see similarities in their jointed legs between land arthropods and their ancestors of the sea.

One of the best ways to draw animals is to think in segments. This is fundamental to drawing the human form as with other animals. Their bodies are made up of three sections called the head, thorax, and abdomen. All insects will have a pair of antennae on their head. To be able to draw the legs it is helpful to understand that all insects have six legs connected to the thorax.

Arachnids, such as spiders, are similar, except that they have eight legs and just two main body parts. Anatomically, spiders differ from other arthropods in that the usual body segments are fused into two parts: the cephalothorax (made up for the head and thorax) and abdomen. Unlike insects, spiders do not have antennae.

Arthropod eyes

Arthropods have different eyes to sketch, which are primarily compound eyes, which give good all round vision and the ability to detect movement. They are made up of sometimes thousands of tiny independent photoreceptor units that create a very wide viewing angle although poor image resolution. Arachnids are an exception and have simple eyes, believed to have evolved from the compound eye. Most arachnids have eight eyes, although some species can have as many as twelve.

Look for links

At first arthropods may seem almost alien to us, but if we look closer we witness in them many similarities – not just physical, but in social behaviour, too. Some insects, ants, bees, hornets and termites create empires and defend their territories with queens and soldiers.

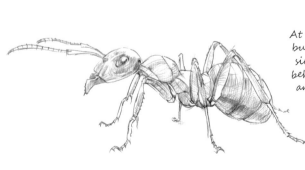

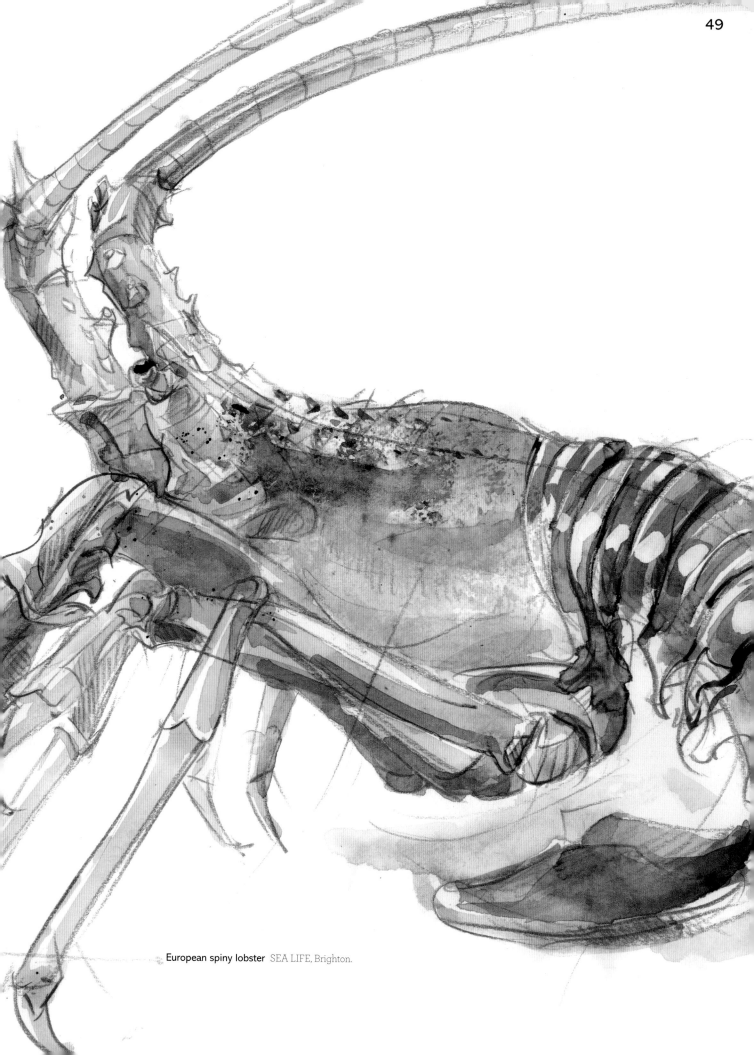

European spiny lobster SEA LIFE, Brighton.

HABITAT: COAST

The coasts and beaches are the transition between air and sea environments. Shoreline animals have an ever-changing habitat. Powered by the gravitational pull of the moon, animals have to adapt to this twice-daily occurrence of the tide going in and out, the continual crashing of waves and the rhythmic movement of the tidal current.

INTERTIDAL ZONES

An intertidal zone can be broken down into three parts. The first section, nearest the land, is just beyond the reach of being fully submerged by water during the highest of tides. It is an area where plants tolerant of this salty sea spray thrive, and scavenging crabs can take advantage of the feeding opportunities on dry land. The middle zone is one of continual flux where animals and plants lead a double life of wet and dry and have to be able to survive being alternately submerged and in the air. Animals such as limpets, crabs, mussels and starfish occupy this zone. Some birds have special adaptations for this zone, with long specialized beaks to dip in the water, and long legs for wading that keep their bodies away from the water and their feathers dry. Curlew, whimbrel and godwit are larger waders with mottled brown plumage and long curved or straight beaks. These birds also forage in the third zone: the shallows of the sea, which is always submerged. This area has its own challenges with crashing waves. From here we go on out to the ocean.

Carapace In horseshoe crabs (above) and many other crustaceans, a hard shell called the carapace covers the cephalothorax. The horseshoe crabs we see today are all but identical to their ancient relatives, which pre-dated the dinosaurs by some 200 million years. Despite their physical similarities, horseshoe crabs are more directly related to arachnids than true crabs.

ECHINODERMS

The echinoderms are a group of invertebrates that emerged in the lower Cambrian period; and around 7,000 echinoderm species are alive today. Echinoderms are familiar to us from the intertidal zone, but they are found at every ocean depth. There are no freshwater or terrestrial members of this group.

Their bodies are typically covered in spines – hence their name, which means 'spiny-skin' – and the group includes brittle stars, starfish, sea urchins and cucumbers. Typically, as with the majority of starfish, echinoderm bodies are divided into five segments, arranged in radial symmetry around a central point. Most echinoderms are able to reproduce asexually and regenerate tissue, organs, and limbs; in some cases, such as the starfish, they can undergo complete regeneration from a single limb.

Sea urchins Typical sea urchins have a spherical skeleton, covered in movable spines. Sea urchins move slowly, crawling with their tube feet. They use sharp spines as a defence, which are sometimes toxic. Most people will have experienced having the spines stuck in their feet after a day out at the seaside. The name 'urchin' is an old word for hedgehog. There are about 950 species of urchins, which can be found all across the world's oceans.

Starfish gizmo

The small hole you see on top of the starfish is its anus. Its mouth is underneath.

Starfish Radially symmetrical, starfish have no front or back, and lack a head with a centralized brain. As a result, they cannot plan their actions; instead relying on their nervous system. They also don't have any blood: seawater is pumped throughout their body as a replacement.

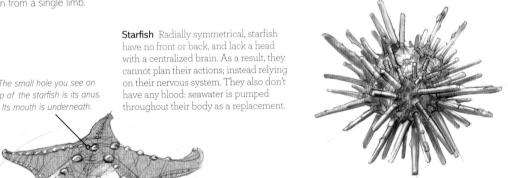

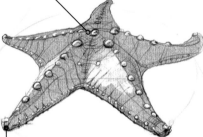

Eyes Able to detect different shades of light, rudimentary eyes allow a starfish to navigate their surroundings. Starfish have an eye at the end of each arm; which means that while a five-armed sea star has five eyes, the forty-armed sun star has forty!

Pencil sea urchin *Phyllacanthus imperialis.*

Sea urchin widget

CRUSTACEANS

Crustaceans are a large, diverse group of arthropods which includes decapods, shrimp, and krill. Some members, such as the woodlice and land crabs, live on land for all or part of their life. Arthropods have a segmented body, jointed limbs, and a chitinous shell that undergoes moultings for them to able to grow.

Crabs

There are about 850 different species of crabs that live in all the world's oceans, in fresh water, and on land. Crabs are omnivores, feeding primarily on algae but will feed on a wide variety of other foods, depending on the species. One of the smallest is the pea crab at just a few millimetres wide.

　　When sketching crabs I find it useful to conceive of the legs as simple tube shapes that attach onto the cephalon (head) via the thoracic sterna. Think of joining jointed tubes together.

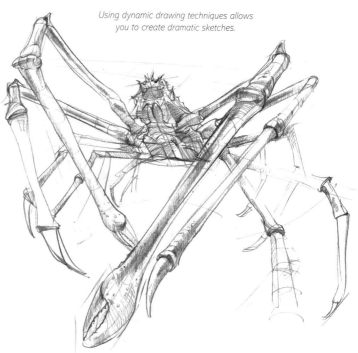

Using dynamic drawing techniques allows you to create dramatic sketches.

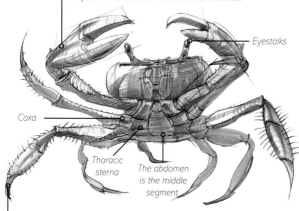

Strong arm On crabs the first pair of arms have pincers at the end. Some species, such as fiddler crabs, have one claw larger than the other, which they use to attract females and deter rivals.

Eyestalks

Coxa

Thoracic sterna

The abdomen is the middle segment.

Movement Although a few species are capable of walking forwards and backwards, crabs typically walk sideways, because of the articulation of the legs which makes a sidelong gait more efficient.

Spider crabs Spider crabs are a family of over 700 species, all with long, skinny legs. This family contains the largest known arthropod, the Japanese spider crab, which can have a leg span of up to 4m (13ft).

Bilateral symmetry If you were to cut a lobster or crab from head to tail, you would come up with two equal halves, owing to its line of bilateral symmetry. I sketch this guideline in with many animals; not just crustaceans.

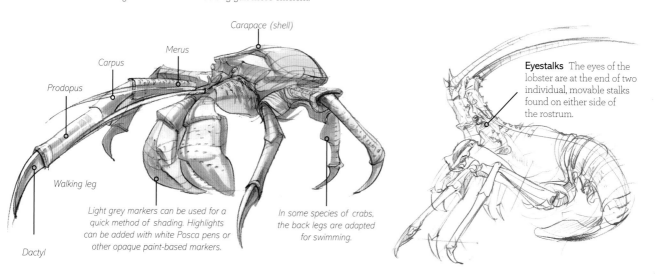

Carapace (shell)

Merus

Carpus

Prodopus

Walking leg

Dactyl

Light grey markers can be used for a quick method of shading. Highlights can be added with white Posca pens or other opaque paint-based markers.

In some species of crabs, the back legs are adapted for swimming.

Eyestalks The eyes of the lobster are at the end of two individual, movable stalks found on either side of the rostrum.

Lobster A lobster consists of two main parts. The first part, the cephalothorax, is made up of the cephalon (head) and the thorax (mid-section), which are fused together.

Shrimp

Shrimp are a member of the *Decapoda*, an order of crustaceans which contains all the familiar species such as hermit crabs, lobsters and prawns. All the members of the group have ten legs, hence the scientific name: 'deca' meaning ten and 'pod' meaning foot. In many species, the front pair of legs has a set of pincers on the end.

ABOUT THE SCARLET SKUNK CLEANER SHRIMP

Scarlet skunk cleaner shrimp (*Lysmata amboinensis*) exhibit cleaning symbiosis (see pages 76–77): a relationship in which individuals from different species benefit from cleaning. The fish benefit by having parasites removed from them, and the shrimp gain the nutritional value of the parasites. In many coral reefs, cleaner shrimp congregate at cleaning stations. This is an amazing sight to watch!

The cleaner shrimp gives us a glimpse into the world of the relationship some sea arthropods have with other animals in the sea; a relationship similar to that between land plants and insects in the act of pollination.

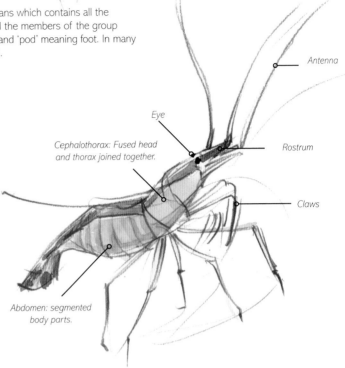

Antenna

Eye

Cephalothorax: Fused head and thorax joined together.

Rostrum

Claws

Abdomen: segmented body parts.

Predatory adaptations

Not all shrimp are co-operative: take for example the formidable and predatory mantis shrimp. As beautiful as they are feisty, mantis shrimp are capable of a strike so quick that they momentarily superheat the water around their spring-loaded club. Mantis shrimp have eight pairs of legs (the first five pairs are equipped with claws) plus modified legs known as pleopods on their abdomen, which are used for swimming. It takes these characteristics from one of its early ancestors, *anomalocaridid*, considered to be one of the first large predators. This might help to explain their feisty temperament!

Stomatopod Despite the name, mantis shrimp are not decapods; instead belonging to the order Stomatopoda. Their obvious physical similarities, however, mean that the lessons learned in drawing and sketching shrimp apply just as well to them.

Mantis shrimp in watercolour

This illustration is a composite, assembled from a number of photographs. I used dynamic drawing techniques to assemble a composite, placing it below the eyeline in my three-quarter angle default (see page 12). Mantis shrimp use iridescent colour to communicate with each other. However fantastic they look to us, to other mantis shrimp, they are even more spectacular: with up to sixteen photoreceptors compared with our three, they can see into the ultraviolet part of the spectrum.

1 Start by sketching a light box to use as a construction framework. Add the body first, then the various limb appendages.

2 Mantis shrimp come in a host of different colours. Using clean water and high quality watercolour, lay in the brightest and lightest colours first. Simply use clean water to allow the paint to bleed to a lighter shade.

3 Use a mix of cadmium red with a touch of alizarin crimson to paint in the pleopods (swimmerets).

4 Add the darker notes. Be careful not to overwork. All the techniques I use are for the briefest of field sketches and work that can mostly be completed in one sitting. Avoid the temptation to fiddle too much.

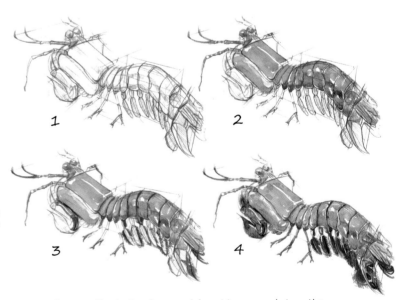

The mantis shrimp's record breaking punch has the same acceleration as a .22 calibre bullet, and has been known to break the glass of aquariums.

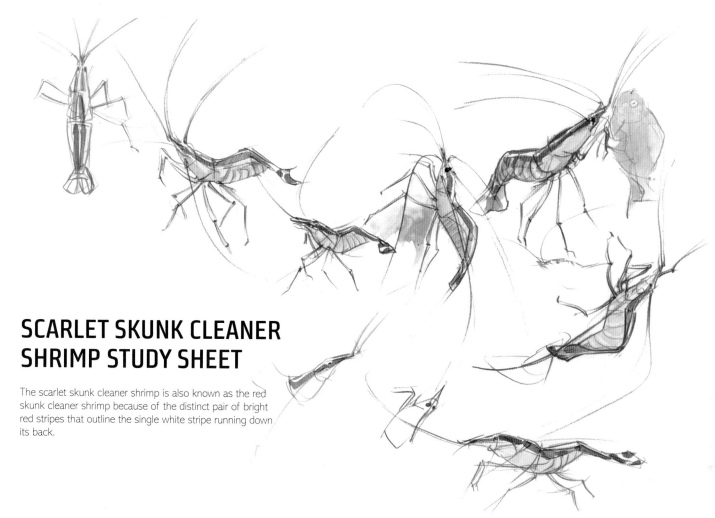

SCARLET SKUNK CLEANER SHRIMP STUDY SHEET

The scarlet skunk cleaner shrimp is also known as the red skunk cleaner shrimp because of the distinct pair of bright red stripes that outline the single white stripe running down its back.

Using your sketchbook

Through your sketchbook you can witness and sketch symbiotic relationships in action. Create lively sketches on the spot and watercolour at home using photographs as reference for colour. I have always thought that working under pressure from a live animal, which is in continual movement, gives intensity and life to the sketches you make.

With shrimp, start by sketching the characteristic shape of the rostrum or beak. This is a rigid forward extension of the carapace, and can be used for attack or defence.

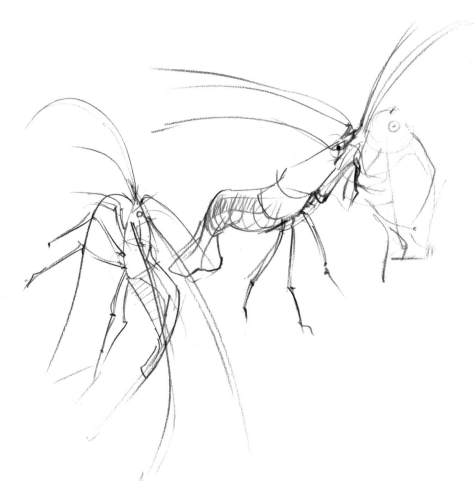

Scarlet skunk cleaner shrimp Kew, London.

INSECTS

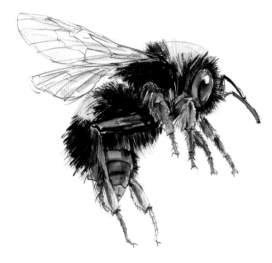

Insects are amongst the most successful and widespread of all animals. Roughly half of all the species on Earth are insects – 950,000 have so far been defined. Insects are part of the arthropod phylum (a phylum is the over-arching category of animals in biological classification). The defining characteristics of arthropods – their jointed limbs and segmented bodies – applies to insects. All are protected by a chitinous exoskeleton which is moulted at intervals to allow them to grow larger.

In all continents of the world, even Antarctica, insects have found a place and created a marvellous array of different appearances, their quick reproduction life span means that adaptations have happened more quickly. Some of these are beyond the imagination, such as the dead leaf butterfly that has adapted fantastic camouflage and behaviour to remain hidden from predators.

All insects have six legs, and are the only type of invertebrate which has evolved the ability to fly. Insects are not to be confused with the other bugs I have included in this section for easy reference. Centipedes and millipedes, although also arthropods, are not insects as they do not have six legs. Arachnids are another class of land arthropod, easily identified by having eight legs. The arachnids include species such as spiders and scorpions. Finally, slugs and snails are gastropod molluscs – it is not hard to imagine slugs coming out of the water to take up residence on land.

Bees, wasps and ants: Hymenoptera These insects have two pairs of wings that hook together. Primarily this group work in colonies, with the females often having a sting in the tail.

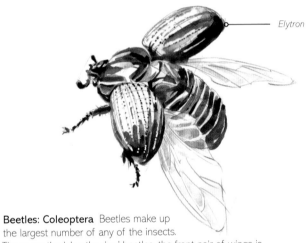

Elytron

Beetles: Coleoptera Beetles make up the largest number of any of the insects. These are the 'sheath-wing' beetles, the front pair of wings is hardened to become protective outer cases called elytra (sing. elytron). Not used for flight, the elytra cover the fragile wings when the beetle is on the ground.

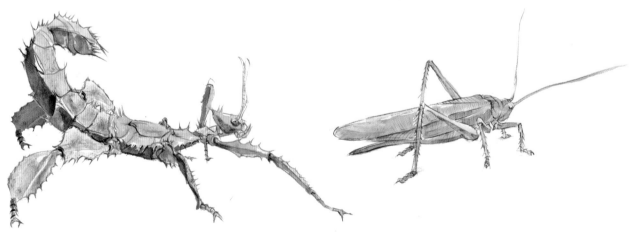

Stick and leaf insects: Phasmida These insects are truly the masters of disguise and are able to resemble sticks and leaves and even leaf damage with breathtaking ability. They can even swing gently from side to side, to impersonate twigs and leaves in a breeze.

Grasshoppers, katydids and crickets: Orthptera These have an enlarged pair of back legs for jumping, and can rub their legs against their wings to form a sound known as 'stridulation'. Crickets have long antennae, grasshoppers have short ones.

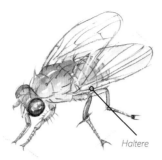

Haltere

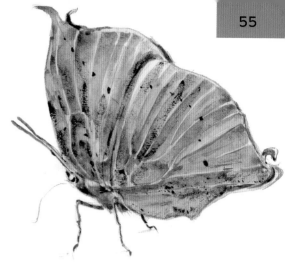

Mayflies: Ephemeroptera Adults only survive for a couple of days to mate and lay eggs. They hatch from underwater larvae, mate, lay eggs and die. They have long thread-like legs and two long tail strands.

True flies: Diptera With only two wings, true flies can be incredibly acrobatic. Behind their wings they have two stabilizers called halteres, which help in-flight manoeuvres. The word diptera means 'two-wings'. This class of insects have short antennae.

Butterflies and moths: Lepidoptera These insects subsist on nectar and have appropriate coloration depending on whether they feed during the day or night. Their larvae are caterpillars which are either primarily or exclusively leaf eaters. Both moths and butterflies have scaly wings and clubbed antennae.

The mantises and cockroaches: Dictyoptera This superorder contains over 2,400 species in about 430 genera in fifteen families. They are distributed worldwide in temperate and tropical habitats. It includes termites, cockroaches and the distinctive praying mantis; so-named because their front arms fold together in a gesture suggesting an act of devotion. However this benign image is anything but the truth – mantises are carnivores and an ambush predator with incredible skills and a breathtaking strike.

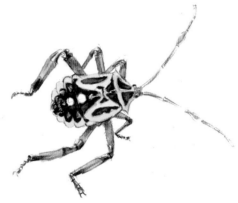

True bugs: Hemiptera Most hemipterans use their sucking and piercing mouthparts to extract sap from plants. Some are parasitic while others are predators that feed on other insects or small invertebrates. The wings create a strong X pattern on the back, with a central V section that does not open in flight, hence 'half wing', which is what hemiptera means.

Dragonflies and damselflies: Odonata This ancient group of carnivorous insects forms a clade which has existed since the Triassic period. These insects have large eyes, with two independently working pairs of wings. With long legs they are able to grab prey in mid-flight. Dragonflies are generally larger, and perch with their wings held out to the sides; damselflies have slender bodies, and hold their wings over the body at rest.

Odonata wings After sketching the main branches of the veins, create marks like stained glass panels to fill in the wings,.

INSECT ANATOMY

Exoskeleton One of the secrets of the success of insects and their ability to colonize every continent on the planet is the exoskeleton. The exoskeleton is made of a strong substance called chitin. This is mostly rigid, although is more flexible in parts such as the mouth to allow for eating movements. The exoskeleton can be thought of as a suit of armour that protects the soft inner workings of the insects – some species have a pitted exoskeleton, which gives it extra strength – and also prevents water loss. As with the insects' ancestors, the sea arthropods, to be able to grow means shedding the old exoskeleton.

Compound eyes Imagine lots of little eyes on a dome shape. This hemispheric shape gives all-round vision: good at detecting motion and spotting a predator approaching, even from behind.

Mandibles vary widely in different species. A mosquito's mandibles, for example, have developed into a syringe-like needle to puncture the skin and draw up blood, while many butterflies have a long proboscis for an entirely liquid diet sucking nectar from flowers.

Legs All insects have six legs, which are made up of rigid segments with flexible joints or pivot points. These join the thorax and have two sharp claws at the end for grip.

Antennae are made up of jointed segments attached to the head, and always come in pairs. Beyond this, they come in all shapes and sizes. They are especially good at picking up smells.

Ants touch antennae when greeting each other, allowing them to recognize if another ant is from the same colony. They also help it feel to make sense of its environment. Male moths' antennae are large and feathery to help pick up the scent of females and help track down a mate. In some species they can also sense wind direction, temperature and vibrations and can be adapted for an array of other purposes – even swimming.

Wings Insects were the first animals to evolve flight. Fossil records date the earliest flying insect to be around 400 million years ago. Permanently terrestrial insects have no wings at all, whereas all the flying ones have either two or four wings.

Like legs, all insects' wings attach to the thorax. In the case of the beetles; the front pair of wings is modified and hardened to create a protective outer shield called elytra.

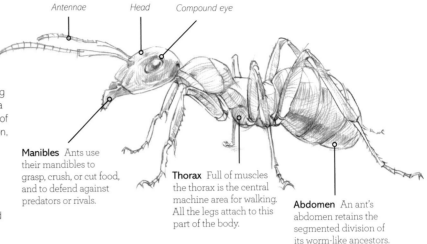

Antennae *Head* *Compound eye*

Manibles Ants use their mandibles to grasp, crush, or cut food, and to defend against predators or rivals.

Thorax Full of muscles the thorax is the central machine area for walking. All the legs attach to this part of the body.

Abdomen An ant's abdomen retains the segmented division of its worm-like ancestors.

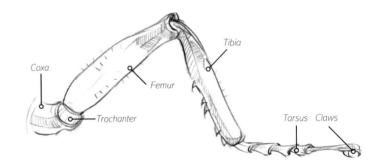

Coxa *Femur* *Tibia* *Trochanter* *Tarsus* *Claws*

Break it down When drawing, think of the insect's leg in four main parts: the coxa and trochanter; the femur; the tibia; and the tarsus and claws. The number of tarsi varies between species and may be used as a way of identifying an insect. The trochanter acts as a ball and socket joint, giving radial movement. Note the spiky 'hairs' – these provide the insect with the sense of touch and act as a form of defence.

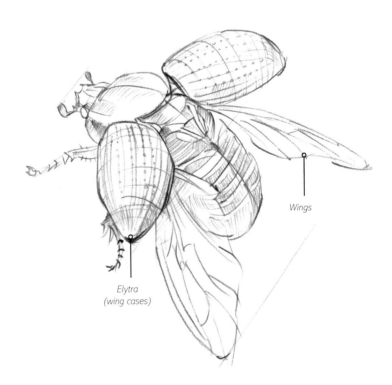

Wings

Elytra (wing cases)

HOW INSECTS WALK

An insect's body can be broken down into three main parts. The head with its antennae, the thorax or body and abdomen. Both the legs and wings attach to the thorax or middle segment.

This little bit of prior information can prevent falling into one of the most common pitfalls: that of creating the appearance that the legs also attach to the head and abdomen region.

Note, however, that this not does mean that we should draw the legs bunched up at the thorax region. As you can see from the bottom (or ventral) view of the stag beetle here, the thorax is a longer region than you might expect to see from above, and the length of the femurs should also be taken in account.

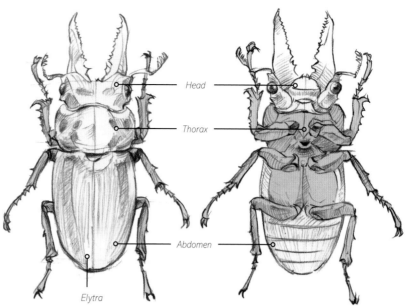

Head

Thorax

Abdomen

Elytra

Bronze metallic stag beetle.

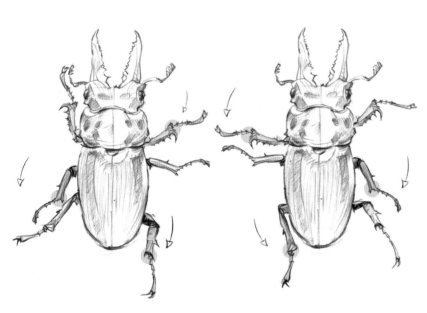

Co-ordinating six legs

Insects move their front and back legs on one side of their body in sync with the middle leg on the other side.

The front and back legs on one side and the middle leg on the other side stay still to anchor the insect; while the remaining legs go forwards. Those legs then stop and anchor the insect, while the corresponding legs move.

Insect muscles

Whilst we cannot see the muscles of an insect, it is interesting as a point of curiosity to understand their basic function. The muscles attach to the inside walls of the exoskeleton and by contracting (getting shorter), they either extend or flex the limbs to create movement. These muscles work in pairs and against each other, which is why they are called antagonistic muscles.

Antagonistic muscles These diagrams of a locust's leg shows the flexor muscles in blue, and the extensor muscles in yellow.

Flexion (bent)

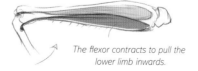

The flexor contracts to pull the lower limb inwards.

Extension (extended)

The extensor contracts to pull the lower limb outwards.

Praying mantises

Named for the prayer-like position of its prominent front legs, the praying mantis is rather more predatory than priestly – this is the mantis's stalking position. It is a formidable predator, made more effective by its incredible camouflage ability.

The praying mantis has some really unusual adaptations: they only have one ear and that is on their chest. They have acute vision: some experts believe that they could be capable of seeing 20m (65½ft) in front of them. Best-known for their ability to snatch prey with their highly mobile front legs, which move with incredible agility, the strike of a praying mantis lasts a fraction of a second.

PRAYING MANTIS STUDY SHEET

Before illustrating a studio portrait, it is beneficial to spend time with a live mantis to get accustomed to its behaviour. When sketching from life, look for posture, position and line of action. They have triangular heads poised in a high position of power on a long 'neck', which is actually an elongated thorax.

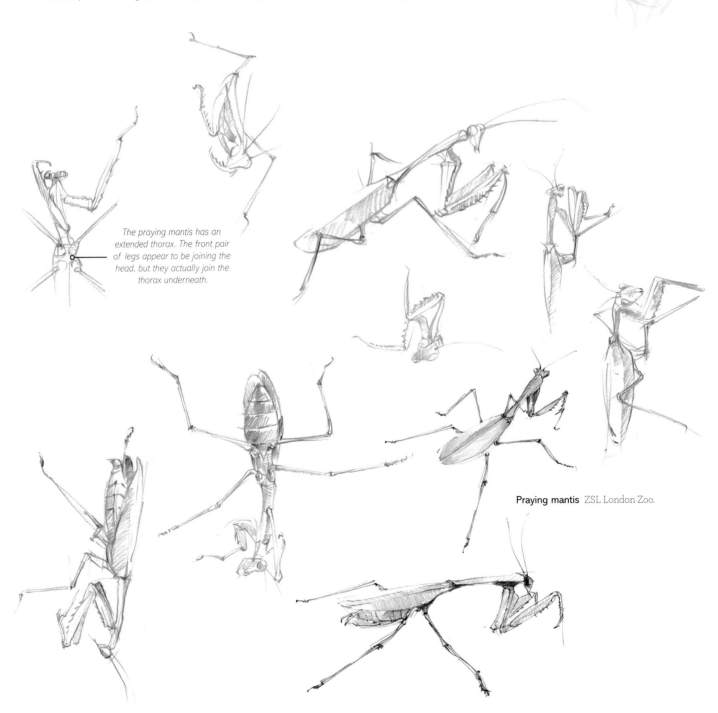

The praying mantis has an extended thorax. The front pair of legs appear to be joining the head, but they actually join the thorax underneath.

Praying mantis ZSL London Zoo.

Praying mantis in watercolour

Mantises are typically green or brown and incredibly well camouflaged to merge in with the plants among which they live. This camouflage helps the mantis lie in wait to ambush or patiently stalk its prey.

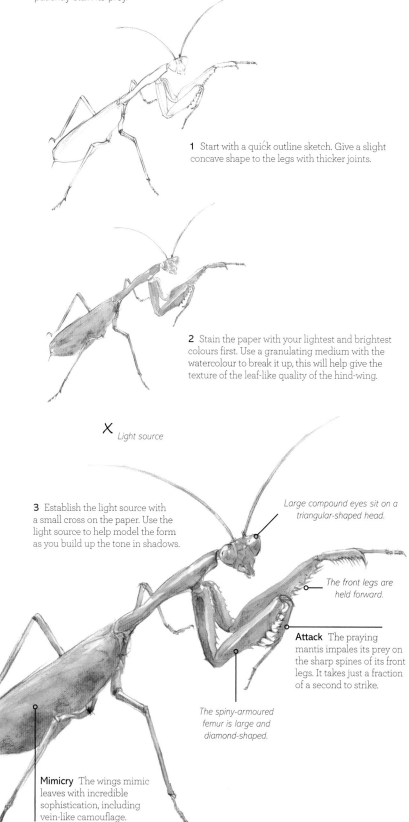

1 Start with a quick outline sketch. Give a slight concave shape to the legs with thicker joints.

2 Stain the paper with your lightest and brightest colours first. Use a granulating medium with the watercolour to break it up, this will help give the texture of the leaf-like quality of the hind-wing.

X *Light source*

3 Establish the light source with a small cross on the paper. Use the light source to help model the form as you build up the tone in shadows.

Large compound eyes sit on a triangular-shaped head.

The front legs are held forward.

Attack The praying mantis impales its prey on the sharp spines of its front legs. It takes just a fraction of a second to strike.

The spiny-armoured femur is large and diamond-shaped.

Mimicry The wings mimic leaves with incredible sophistication, including vein-like camouflage.

ABOUT THE PRAYING MANTIS

The praying mantis is of the order mantodea, which is broken down into over 2,400 different species over fifteen families. They have populations worldwide in temperate and tropical habitats. Females are considered to be *femme fatales* as they are sometimes known to eat the males after copulation.

Mantids may or may not have wings. In those species that have wings, the front pair of wings is toughened to protect the membranous hind wings underneath.

Eyes Praying mantises have five eyes: two large compound eyes and three simple eyes located between them.

Mantids can turn their heads through 180° to scan their surroundings.

How the mantis hides

Praying mantises can remain motionless for long periods, like a statue, which helps prevent them being detected. When they do move, they often travel forward while gently rocking back and forth. This helps them emulate the swaying leaves and branches in the breeze and helps to fool prey.

METAMORPHOSIS

Metamorphosis is the amazing transformation of one creature into a totally different being: one life, two bodies. The process occurs in many invertebrates, and also some vertebrates – such as frogs. Amongst the most striking examples of metamorphosis can be seen in lepidoptera – the butterflies and moths – which change dramatically from fleshy land-bound caterpillars into delicate flying adults. It is interesting to think of metamorphosis as an evolutionary adaptation or advantage.

The earliest insects did not metamorphose; they hatched from eggs, essentially as miniature adults. Scientist believe a shift started taking place some 300 million years ago. They have speculated that this resulted in the young and old not competing for the same resources. Complete metamorphosis is likely to have evolved gradually from an incomplete one, which eventually resulted in the spectacular transformations we see today.

BUTTERFLIES AND MOTHS

The life cycle of moths and butterflies includes the following stages.
- **Stage 1** The egg.
- **Stage 2** The eggs hatch into caterpillars or silkworms and immediately start eating, to quickly grow.
- **Stage 3** Once fully grown the caterpillar forms itself into the 'pupa' stage, which may last around a couple weeks to several months depending on the species. During this time a shell, called the chrysalis, forms around the pupa for protection.
- **Stage 4** Once the butterfly is ready to emerge it breaks through the shell. This is one of the shortest parts of the life cycle.

The caterpillar stage

As insects, caterpillars have three parts to their body segments: a head; a thorax, made of three segments; and an abdomen, divided into ten segments. On their head they have six pairs of simple eyes called *ocelli*. Very hard to see, they can be added simply as dots. Most use their mandibles for munching plant matter, but approximately one per cent of caterpillars are insectivorous – some are even cannibalistic.

Caterpillars appear to have lots of legs, but like all insects, have only six true legs: each of the three thoracic segments has a pair. The remaining leg-like parts in the abdominal region are stubby prolegs. The number of prolegs a caterpillar has differs according to its species.

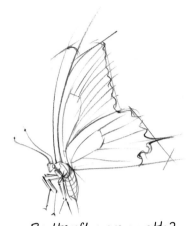

Butterfly or moth?
Most moths rest with their wings folded flat, whereas butterflies fold theirs together, upright.

The pupa stage

Contrary to popular belief, the chrysalis is not a 'resting' stage. Quite to the contrary, a lot is happening to the pupa within. The body of the caterpillar is transforming into an adult butterfly.

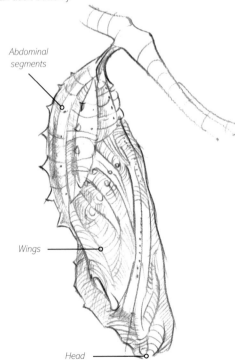

Abdominal segments

Wings

Head

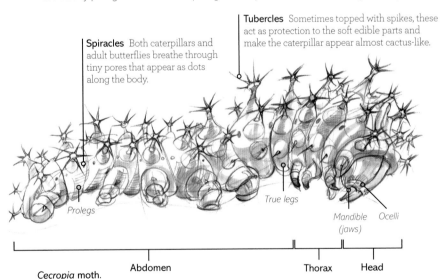

Spiracles Both caterpillars and adult butterflies breathe through tiny pores that appear as dots along the body.

Tubercles Sometimes topped with spikes, these act as protection to the soft edible parts and make the caterpillar appear almost cactus-like.

Prolegs

True legs

Mandible (jaws)

Ocelli

Abdomen

Thorax

Head

Cecropia moth.

The adult stage

When a butterfly emerges from the chrysalis, fluid is pumped through veins that unfold the wings by a hydraulic action. Once open, the wings dry and the butterfly is able to take to the air. These veins help to give the wing structure; which helped to inspire the struts in Leonardo da Vinci's designs for his flying machines.

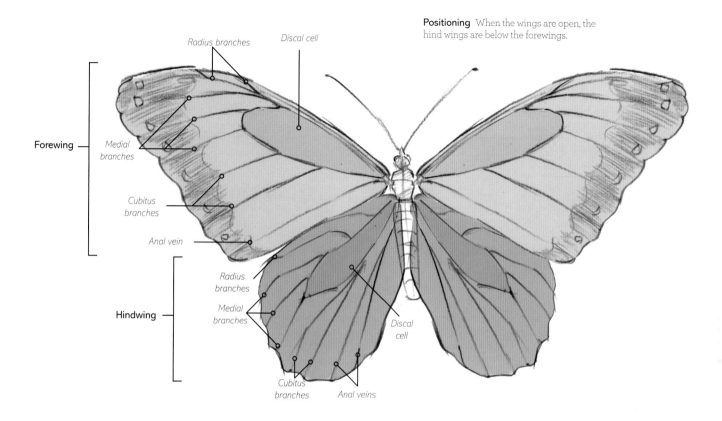

Positioning When the wings are open, the hind wings are below the forewings.

Radius branches

Discal cell

Forewing

Medial branches

Cubitus branches

Anal vein

Hindwing

Radius branches

Medial branches

Discal cell

Cubitus branches

Anal veins

Hide and seek

When a moth or butterfly first lands, it will rest with its wings open. In a natural position, butterflies will normally close their wings after a while, primarily for camouflage. When folded upright, the wings will be roughly be in line with the head, if a little forward. Seen from the side, this will expose the entirety of a butterfly's hindwing, which will overlap the forewing from the outside view. Moths tend to close their wings horizontally, so that they are lying flat.

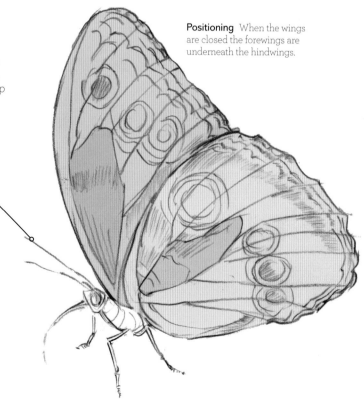

Positioning When the wings are closed the forewings are underneath the hindwings.

Antennae are very short projections found close to the caterpillar's mouth, these small projections are used to find and identify food.

Why can I only see four legs on some butterflies?

All butterflies have six legs, but those in the Nymphalidae family, also called brush-footed butterflies, have two undersized front legs. The 'missing' pair is small, tucked up in front, and you don't really see them.

Butterflies and moths

An extensive family of nearly 150,000 insects that are found in most countries in the world, butterflies and moths are of the order *Lepidoptera*, which means 'scaly-winged'. Thousands of microscopic scales, split into two to three layers, cover butterfly wings. These scales detach easily when you touch one of their wings, and are so small that they feel like a fine powder on your fingers.

SKETCHING BUTTERFLIES AND MOTHS IN FLIGHT

Butterflies and moths can be drawn in the classic museum-style approach of being pinned flat (see top right) but, as with all living things, we rarely see them this way. Try to see your paper as a picture space that these insects can fly through, twisting and turning in dynamic angles at the same time opening and closing their wings.

To be able to visualize a butterfly or moth in different flying position, I find it helpful to sketch a flat plan of a butterfly on a small piece of paper. This piece of paper can then be folded and rotated so that you will get a good idea of how the foreshortening works in different positions.

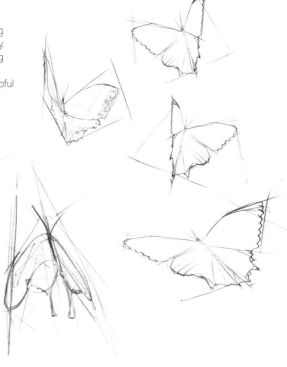

Morpho butterflies Sketch in the line of action or direction of travel.

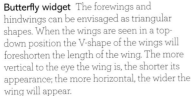

Butterfly widget The forewings and hindwings can be envisaged as triangular shapes. When the wings are seen in a top-down position the V-shape of the wings will foreshorten the length of the wing. The more vertical to the eye the wing is, the shorter its appearance; the more horizontal, the wider the wing will appear.

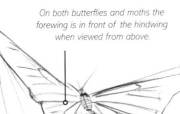

On both butterflies and moths the forewing is in front of the hindwing when viewed from above.

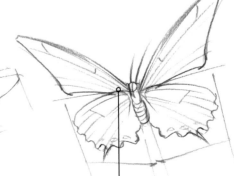

This is reversed in the view from below.

IRIDESCENCE

The combination of a butterfly's structural and pigmented colour can create fascinating effects. Each scale on their wing has multiple layers separated by air. When light hits the different layers of the butterfly wing, it is reflected numerous times, creating an effect called iridescence, in which the hue of the wing changes depending on the observer's viewing position. The combination of all these reflections causes the very intense colours that you can see in many species.

Able to see further into the spectrum than humans, one shortfall of butterfly vision is their difficulty in focussing: there is a lot of scattered light in the ultraviolet (UV) end of the spectrum. Butterflies thus use iridescent colour to get themselves noticed by potential mates. As you sketch butterflies, you will observe that they are attracted to bright colours.

This effect also helps butterflies to feed. The bright pigments in flower petals that absorb UV light create patterns visible to insects, but invisible to humans. These patterns are sometimes referred to as 'honey guides' or 'nectar guides' that serve to direct the pollinators toward the centre of flowers.

Male luna moth Butterflies differ from moths structurally in that their antennae are clubbed at the end. Butterflies have slender bodies, are brightly coloured and fly in the daytime, whereas moths typically have stouter bodies, duller colours and usually fly at dusk or at night.

Capturing light: iridescence in watercolour

Watercolour paint is one of the best mediums to capture the light and colours of iridescence. This medium is uniquely suited to insect illustration as it can simulate iridescence. Unlike an opaque medium, such as pencil, some light is reflected from the white paper beneath watercolour paint. It bounces back through the pigment on the surface of the paper, creating luminosity and making watercolour illustrations seem to glow, an effect famously seen in J.M.W. Turner's beautiful watercolours.

Using high quality watercolour is important. I prefer a thick quality cartridge over watercolour paper to allow for detail. The attempt is to create the illusion that light itself is coming out of the paper.

Paintbox of light Only the part of the spectrum visible to our eyes can be captured in watercolour. A watercolour paint box of shimmering colour is a sketching tool to help capture the brilliance of these colours.

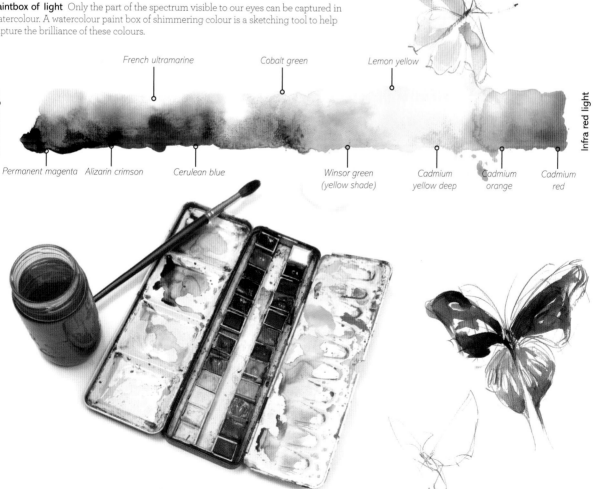

Ultraviolet light

French ultramarine Cobalt green Lemon yellow

Infra red light

Permanent magenta Alizarin crimson Cerulean blue Winsor green (yellow shade) Cadmium yellow deep Cadmium orange Cadmium red

Monarch butterflies

The monarch's orange colour is a warning for predators to stay away, as the chemicals they get from feeding on milkweed plants makes the butterflies poisonous. To create the bright orange used here, I mixed cadmium yellow deep with cadmium red. I used granulating medium to help break the paint up to give the impression of the minuscule scales.

It is the relationship between the bright pure colour in light and the degraded shadow colour that helps create the illusion of the luminosity of the wings. A dulled orange can be created by adding some complementary French ultramarine blue to the orange mix described above.

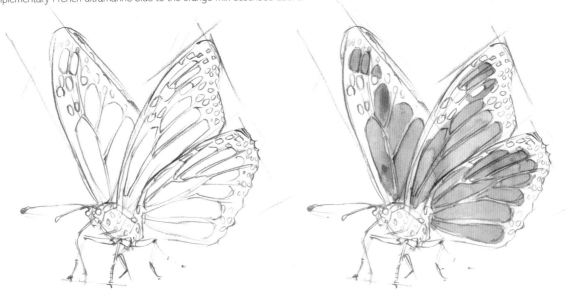

1 Create a sketch of your subject. In this position, the forewings are seen from the inside; so make sure that the hindwing overlaps the forewing.

2 Add the lightest and brightest colours first, using clean water and brushes. The orange mix is described above.

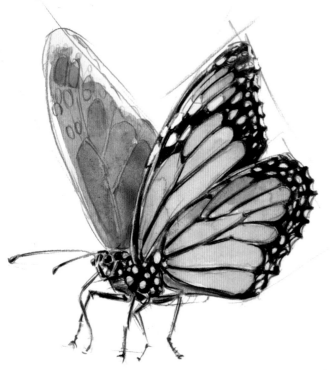

3 Adding the fine detail of a butterfly's veins is difficult even with a fine brush like a rigger. These black lines were initially added using a very sharp watercolour pencil.

MIGRATION

4.5 billion years ago Earth was struck by a Mars-sized body called Theia. In addition to a huge amount of rubble being ejected into orbit, which in time became our moon, the Earth's axis was permanently knocked off vertical. The result is that, in the northern hemisphere, the Earth is tilted toward the sun during the summer, resulting in warmer weather; and away from the sun during the winter, resulting in cooler weather. The opposite is true for the southern hemisphere. These seasonal changes affect animal's behaviour: some hibernate or migrate. Many plants, and some animals, become dormant.

One of the most spectacular natural phenomena in the world is the annual migration of the monarch butterflies across North America. This spectacular migration starts in September in Southern Canada and takes the butterflies several months to arrive in Central Mexico around November. No individual completes the entire trip; rather the butterflies reproduce along the way – at least four generations are required to enable the butterflies to complete this incredible journey.

It is interesting to think that the sole reason for this, and all other, migration patterns, was the enormous collision of Theia with the primordial Earth.

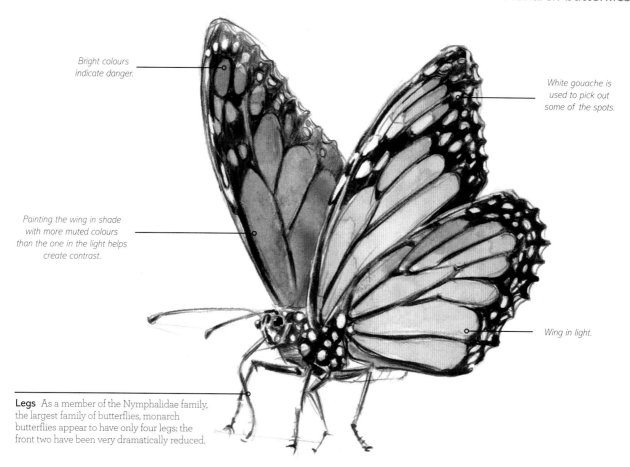

Bright colours indicate danger.

White gouache is used to pick out some of the spots.

Painting the wing in shade with more muted colours than the one in the light helps create contrast.

Wing in light.

Legs As a member of the Nymphalidae family, the largest family of butterflies, monarch butterflies appear to have only four legs: the front two have been very dramatically reduced.

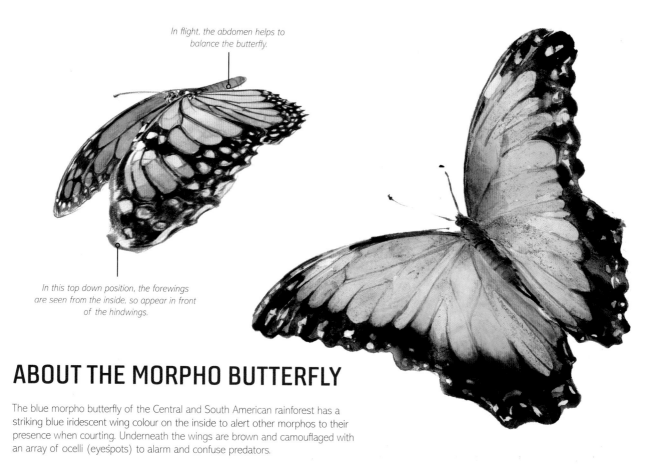

In flight, the abdomen helps to balance the butterfly.

In this top down position, the forewings are seen from the inside, so appear in front of the hindwings.

ABOUT THE MORPHO BUTTERFLY

The blue morpho butterfly of the Central and South American rainforest has a striking blue iridescent wing colour on the inside to alert other morphos to their presence when courting. Underneath the wings are brown and camouflaged with an array of ocelli (eyespots) to alarm and confuse predators.

Spiders and scorpions

ARACHNIDS: THE EIGHT-LEGGED

Arachnids are a diverse group that includes a far wider range of animals than the familiar spider. Scorpions, harvestmen, ticks and mites are also arachnids. Arachnids evolved from a sea dwelling crab-like ancestor some 400 million years ago and have a different evolutionary track on the tree of life than insects. Arachnids are almost exclusively known to be land creatures, although one species of spider is found in fresh water, along with potentially more undiscovered arachnids. Most arachnids are predators, spiders and scorpions inject venom into their prey.

Drawing frames

This is a great technique for drawing animals with lots of limbs, like arachnids. Drawing out a frame in perspective before you start sketching can help with the impression of the legs moving through space. Extend beyond this frame and use it as a guide.

Since most animals are bilaterally symmetrical (i.e. the halves of the body are mirrored along a central line), you can establish the position of the body by drawing a line through the centre of the drawing frame to the vanishing point – this will help you place the core mass of the body.

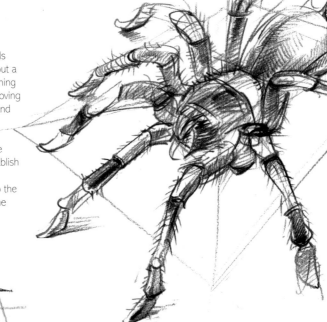

Hair-like marks can be created by making flick marks with a sharp pencil.

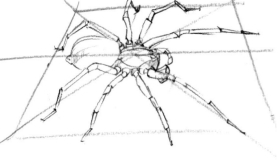

Drawing frames are a quick way to help establish or adjust your viewpoint when sketching.

Striking scorpions These ancient-looking creatures are easily identified by their long claw-like pedipalps and their stinging tail, which can strike with incredible speed.

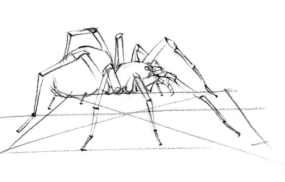

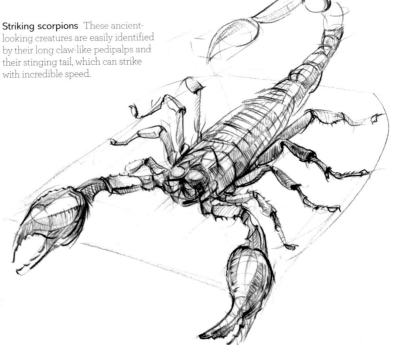

ARACHNID ANATOMY

All arachnids have two main body parts and four pairs of legs. This differs from the insects which have three main body parts and three pairs of legs. Unlike insects, arachnids do not have antennae.

Spinnerets are the silk-spinning organs of a spider. Many spiders spin elegant and complex webs. Some spiders sit on the side of the web and wait to feel the vibrations of an insect caught in the web through their legs.

The 'fangs' are actually appendages called chelicerae. Those found in spiders are hollow and contain or are connected to venom glands, used to inject venom into prey.

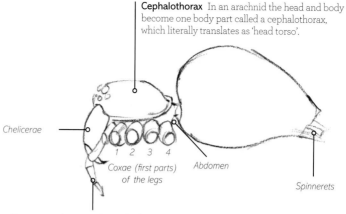

Cephalothorax In an arachnid the head and body become one body part called a cephalothorax, which literally translates as 'head torso'.

Chelicerae

Coxae (first parts) of the legs

Abdomen

Spinnerets

These appendages are the pedipalps, used rather like arms. Spiders often use them to hold insects to help eat them.

Arachnid eyes

Most spiders have eight eyes. Some species have no eyes and others have as many as twelve. The eyes are arranged in distinct patterns on different types of spider. Scorpions have two eyes on the top of the cephalothorax, and usually two to five pairs of eyes along the front corners.

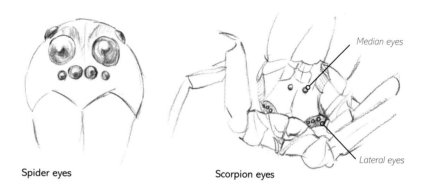

Spider eyes

Median eyes

Lateral eyes

Scorpion eyes

Arachnid legs

A spider's leg can essentially be thought of in four parts, with the patella and tibia forming the same limb region.

Spider leg

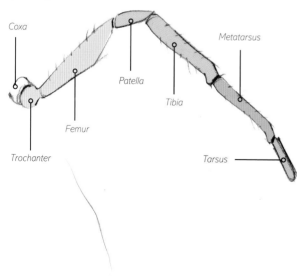

Coxa

Metatarsus

Patella

Tibia

Femur

Trochanter

Tarsus

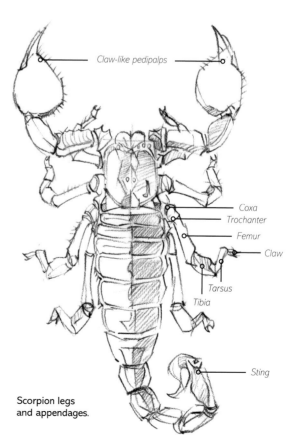

Claw-like pedipalps

Coxa

Trochanter

Femur

Claw

Tarsus

Tibia

Sting

Scorpion legs and appendages.

FISH

The first animals to appear on the planet with a central flexible column of vertebrae were the fish. The first fish evolved some 480 million years ago and since then have diversified into by far the largest group of vertebrates on the planet. Fish live in just about all the aquatic habitats on Earth. Different species are adapted for living in different environments. Unlike other types of animals, fish are so diverse that they are loosely bracketed into four informal families (see page 70); however, there are a few rules that apply to them all.

All fish are primarily adapted to a life of swimming and have streamlined bodies with fins (in various combinations) to control movement and gills for breathing underwater. Fish are cold-blooded. This means that their inside body temperature is dependent on the environment they are in. Cold-blooded animals do not have the ability to regulate their temperature internally, so their body temperature matches that of their surrounding water.

All fish uses gills to breathe. The transition of extracting oxygen from water to that of breathing air might not seem quite so far-fetched when you watch some fish gulp air from the surface of a fish tank when oxygen levels are low. The gills are located on either side of the head in front of the pectoral fin. On most fish water enters the fish via its mouth and leaves via the gill openings, where oxygen is transferred across a thin membrane of capillaries to allow oxygen to enter the bloodstream.

While not truly warm-blooded, some top predatory fish maintain a temperature different to their surroundings. White sharks, for example, have a unique system called a 'counter-current heat exchange,' which keeps their body warmer than the outside conditions.

Fish live in the sea, freshwater and brackish environments, and most spend their lives fully submerged in oxygen-rich water, although some – such as eels and the mudskipper – can spend a long time on land, by keeping their skin and gills moist. Some fish even take to the air: flying fish can glide up to 200m (218yd) to escape underwater predators.

Lookdown fish SEA LIFE, Brighton.

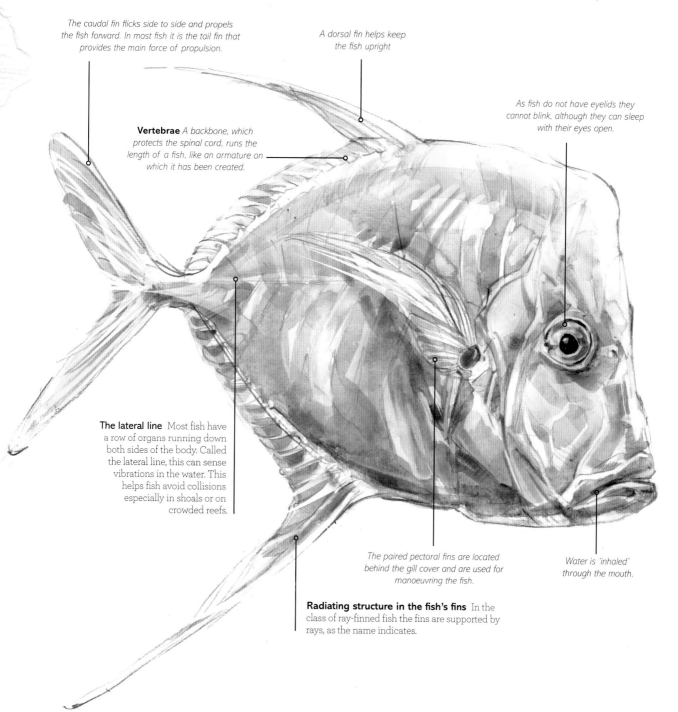

The caudal fin flicks side to side and propels the fish forward. In most fish it is the tail fin that provides the main force of propulsion.

A dorsal fin helps keep the fish upright

As fish do not have eyelids they cannot blink, although they can sleep with their eyes open.

Vertebrae *A backbone, which protects the spinal cord, runs the length of a fish, like an armature on which it has been created.*

The lateral line Most fish have a row of organs running down both sides of the body. Called the lateral line, this can sense vibrations in the water. This helps fish avoid collisions especially in shoals or on crowded reefs.

The paired pectoral fins are located behind the gill cover and are used for manoeuvring the fish.

Water is 'inhaled' through the mouth.

Radiating structure in the fish's fins In the class of ray-finned fish the fins are supported by rays, as the name indicates.

Blood and heat

The only two true warm-blooded groups are mammals and birds. Regardless of the temperature of their surroundings, they can maintain a constant body temperature by heating themselves with energy from food. As a result, they need to eat more regularly than cold-blooded animals.

THE FOUR FISH CLASSES

There are almost 30,000 species of known fish. Amongst all these species there are a lot of differences in appearance. Scientists use specific differences to put fish into four classes, or groups, by looking at their skeletons and the structure of their mouths. These four groups are the jawless, the cartilaginous, ray-finned and lobe-finned. Whether fish are marine or found in freshwater (or, as with some species, migrating between both) all fish will fit into one of these four groups. Seahorses, for example, have rayed fins and a bony skeleton, and so fit into the ray-finned class.

Jawless fish: Superclass agnata

The first group of fish are the jawless fish; which are very primitive. As their name suggests, what they have in common is that they don't have any jaws. In fact, their mouths don't have any movable parts, like a tongue. Many of these ancient jawless fish have died out.

Today, there are only two kinds of agnata remaining: lampreys and hagfishes. These do not qualify as true vertebrates, as they have only a very rudimentary cartilagineous spine, called a notochord. Both lampreys and hagfish lack scales and feel slimy. They are long fish and look like eels. They're also scavengers and parasites, which means that they feed upon other fish by sticking onto them and sucking their blood.

Hagfish are an eel-like fish that excrete a slimy substance from their skin to evade predators. Except for their tail, this ancient fish lacks scales and fins. Their jawless mouth is surrounded by whisker-like barbels. Lampreys are also eel-like in appearance. Adults have a sucker-like mouth, ringed with rows of sharp teeth.

Lamprey These fish act in a vampire-like manner, sucking onto to other fish to drink their blood. So strong is the suction that other fish are seldom able to free themselves.

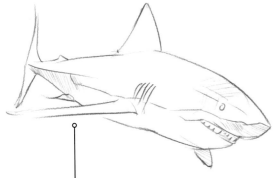

Sharks have a conveyor belt-like system of teeth, regularly losing them and having them replaced with new. ones emerging from the back of the gum and moving to the front.

Cartilaginous fish: Chondricthyes

Unlike the jawless fish, which have only holes for mouths, the cartilaginous fish have both upper and lower jaws that are full of teeth. This class includes sharks, rays, sawfish and chimaeras. All these fish have a skeleton that, rather than being made of bone, is made of a pliable cartilage. Most cartilaginous fish are predators with fantastically acute senses: sharks, for example, are renowned for their ability to smell blood. There are approximately 600 different species of rays and skates, 400 shark species and about 34 species of chimaeras. Chimaeras are also known as rabbitfish because of their fused plate of teeth.

The tough skin of all cartilaginous fish is covered with dermal teeth, making it feel like sandpaper. In most species, all dermal denticles are pointed in one direction, making the skin feel very smooth if rubbed in one direction and very rough if rubbed in the other. Denticles provide protection and, in most cases, streamlining. While rays are flat and prefer the sea bed, the larger predatory sharks roam and hunt in open water. Sharks and rays have five to seven gill slits.

Lobe-finned fish: Sarcopterygh

The lobe-finned fish include the coelacanth and lungfish. This class of fish are considered to be the ancestors of land vertebrates. Lobe-finned fish have fins that resemble primitive limbs, with a fleshy trunk at the base.

Ray-finned fish: Actinopterygh

This is the largest class of living fish, with a fantastic array of different body shapes and fin arrangements. The class includes some 24,000 different species of which about sixty per cent are marine. Ray-finned fish are characterized by having a hard calcified skeleton. Their fins are supported by a fan of vein-like spikes called rods, made of either bone or cartilage.

The ray-finned fish are highly mobile with a myriad of fin arrangements – some species being able to hover, brake and even swim backwards. With the exception of bottom-dwelling species, most ray-finned fish have a buoyancy aid that takes the form of a gas-filled bladder. This allows them to maintain a certain depth and to rise and fall in the water by adjusting the gas pressure.

NOSE TO TAIL: PERCH

When sketching moving animals, it is really helpful to have a nose to tail run through. This helps you get the body parts in the right order and can give you confidence that you are placing the fins in the right place.

This perch has a fairly standard fin arrangement for a ray-finned fish. However, you will notice a fantastic variety of fin arrangements in this class when drawing.

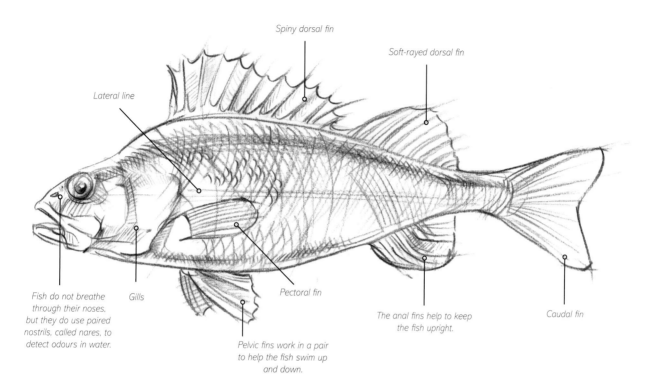

Spiny dorsal fin

Soft-rayed dorsal fin

Lateral line

Fish do not breathe through their noses, but they do use paired nostrils, called nares, to detect odours in water.

Gills

Pectoral fin

Pelvic fins work in a pair to help the fish swim up and down.

The anal fins help to keep the fish upright.

Caudal fin

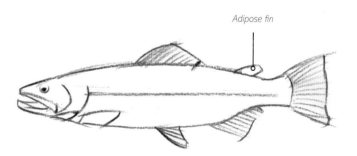

Adipose fin

Scales Covering the bodies of most fish, scales act as a protective coating. When drawing scales, think of them as overlapping roof tiles. The overlap creates a continuous layer of armour, leaving no vulnerable points for a tooth to be able to break though.

Not all ray-finned fins are rayed Trout, salmon and catfish possess a small nub-like fin instead of having the soft-rayed dorsal fin. This fin is called the adipose fin and differs because it is not rayed. Scientists have speculated that this might act as a water flow sensor.

Sharks

Sharks are a group of fish that are highly varied in appearance and behaviour. They form one of the earth's most ancient classes of life. Fossil remains show a long history on the planet: their prehistoric ancestors first appeared during a period called the Silurian, some 420–450 million years ago – 200 million years before the dynasty of the dinosaurs. At this time, before animals had started to colonize the land, sharks shared the sea with other early species, such as the sea arthropods, molluscs, and crinoids.

Sharks can appear as terrifying creatures of the deep; their large mouths and triangular-shaped dorsal fins made iconically sinister through their portrayal in films like *Jaws*. However, there is more to this class of fish than the frightening, torpedo-shaped killing machine of popular culture. We know of just over 500 different species of sharks alive today, although scientific research suggests more than 3,000 different species have existed here on earth, each highly adapted to their habitat.

All members of the shark family are predatory. They have several adaptations to help them, from their sleek body shape to their incredible teeth, which continually grow from the inside of their mouths outwards in a sort of conveyor belt system that creates formidable pronged rows of flesh-eating teeth.

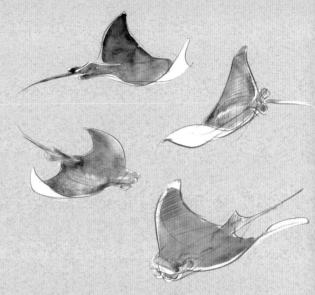

Rays There are almost five hundred different species of rays and skate in our oceans and rivers. Like their close relatives the sharks, they have a skeleton made of cartilage rather than bone, which makes it easier for rays to glide through the ocean. To swim, they flap their fins like a bird, and are incredibly fast and agile under the water.

GREAT HAMMERHEAD SHARK STUDY SHEET

Rather than approach sharks with a round, tube-like torso. I prefer to sculpt them with angular planes that help to capture the muscularity of the body.

NOSE TO TAIL: GREAT HAMMERHEAD SHARK

Before you start sketching, make sure that you know the nose to tail running order of vital body parts.

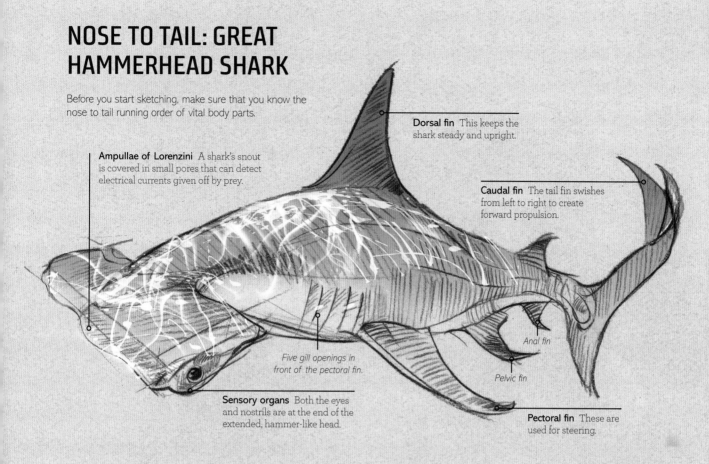

Dorsal fin This keeps the shark steady and upright.

Ampullae of Lorenzini A shark's snout is covered in small pores that can detect electrical currents given off by prey.

Caudal fin The tail fin swishes from left to right to create forward propulsion.

Anal fin

Five gill openings in front of the pectoral fin.

Pelvic fin

Sensory organs Both the eyes and nostrils are at the end of the extended, hammer-like head.

Pectoral fin These are used for steering.

Dappled light

To create the feeling of dappled light falling on the back of the shark, first create soft out of focus wavy patterns by using the warp tool in Photoshop (A). Next, scan white gouache paint splatters to help create the illusion of falling light that is in focus (B). Again, use the warp tool to wrap these around the form.

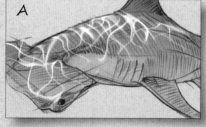

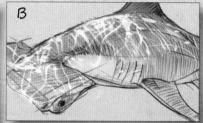

ABOUT THE GREAT HAMMERHEAD SHARK

The great hammerhead is the largest of the nine identified species of this type of shark. It can grow up to 6m (20ft) in length and weigh up to 455kg (1,000lb) although most hammerhead species are considerably smaller. These sharks are found in temperate and tropical waters across the globe. Very few attacks on man from this species have ever been recorded, and no fatalities. During the day, hammerheads school in groups, sometimes numbering more than a hundred. In the evening, like other sharks, they become solitary hunters.

Their distinctive, oddly-shaped heads have a practical function. Being so widely-set on their mallet-shaped head, their eyes have a better range of binocular vision than other sharks. This means they can more accurately judge distance to any prey they hunt, giving them an advantage when scanning for food.

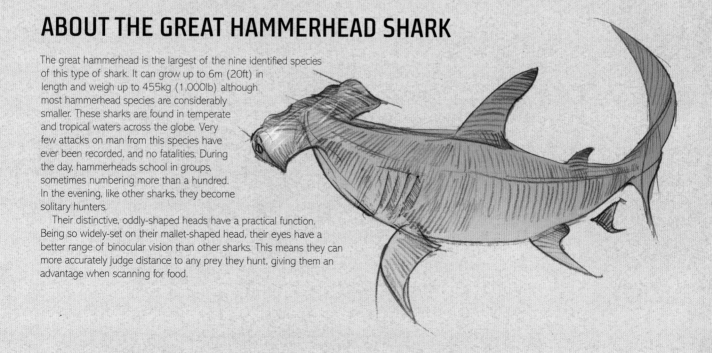

Boxfish

Boxfish (*Ostraciidae*) have a fantastic warm character to sketch with charming behavioural characteristics, appearing inquisitive even about human interactions. Closely related to pufferfish, boxfish stand out from most other fish owing to their hard, box-like carapace that acts as armour. This structure means that they can be sketched almost like a box and placed in perspective easily.

ABOUT THE BOXFISH

This species of fish goes by various names, including trunkfish and cowfish. The latter refers specifically to a subspecies with hornlike projections above their eyes, which make it too large to fit in the mouths of most fish, meaning only very large predators can hope to make a meal of it. All boxfish are relatively small; even the largest, the longhorn cowfish, reaches only 50cm (19½in).

All twenty-five species of boxfish are adapted to warm and tropical sea environments. They prefer the shallow areas of the warmer parts of the world's oceans, like coral reefs and seagrass beds. They are adapted for habitats that provide some shelter and are different from those that cruise the large, open waters of the ocean.

Despite being slow movers, boxfish have a repertoire of survival strategies in their armoury that belie their initially sweet appearance. Their rigid carapace is made up of fused plates, which form rough squares, triangles or pentagons in cross section, making the fish difficult for predators to swallow. When a boxfish feels threatened, it secretes poison from its skin, which is very dangerous to other fish. The boxfish warns its predators of its unflavoursome qualities as a meal through warning colours, an adaptation known as aposematism.

BOXFISH: NOSE TO TAIL

Rather than creating a flat illustration. Simplify the boxfish down into fundamental forms and use dynamic drawing techniques to suggest three-dimensional form.

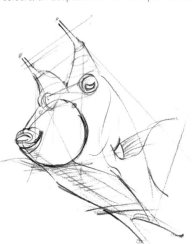

Cowfish seen from below the eyeline.

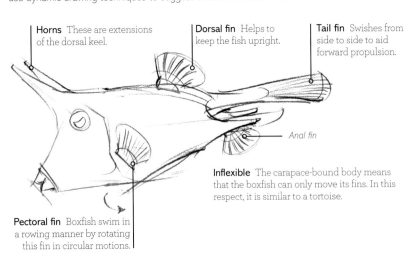

Horns These are extensions of the dorsal keel.

Dorsal fin Helps to keep the fish upright.

Tail fin Swishes from side to side to aid forward propulsion.

Anal fin

Inflexible The carapace-bound body means that the boxfish can only move its fins. In this respect, it is similar to a tortoise.

Pectoral fin Boxfish swim in a rowing manner by rotating this fin in circular motions.

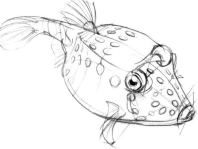

Yellow boxfish seen from above the eyeline.

Boxfish head widget

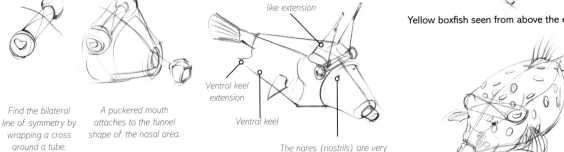

Find the bilateral line of symmetry by wrapping a cross around a tube.

A puckered mouth attaches to the funnel shape of the nasal area.

Dorsal keel and horn-like extension

Ventral keel extension

Ventral keel

The nares (nostrils) are very high up and close to the eyes

Yellow boxfish in watercolour

When using watercolours, It is the relationship between colours in the light and shade that gives the impression of luminosity coming out of the paper. To achieve this, you need to keep clean colours, and incorporate complementary colours to shade, saving black for details.

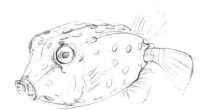

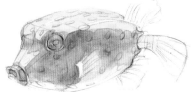

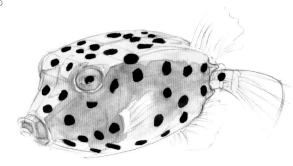

1 Sketch out the line work using a blue pencil.

2 Using artists' quality watercolour, lay down the lightest and brightest colours first. Use clean water and add a diminished shade by including complimentary colours such as purple in this case to create a shadow of form colour.

3 Using ellipses, add the spots with contrasting black paint. Narrow the apertures of the ellipses to follow the form as they turn away from view. Try to suggest smooth, round edges.

The finished painting

Leave highlights around the eye to suggest the skin overlapping the pupil and to give the eyes a sense of life.

Warning signs The bright yellow colour and black spots are a form of warning coloration to any potential predators: a signal of its toxicity and its unprofitability as prey.

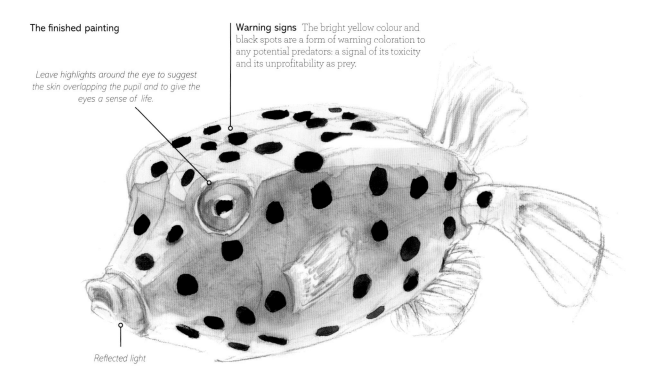

Reflected light

Hexagonal scutes In order to minimize weak points, most fish have overlapping scales which prevent a predator's teeth finding gaps between individual scales. The boxfish have a different scale strategy, with a boxy carapace composed of roughly hexagonal scutes that provide body support and armoured protection. These scutes are connected by tooth-like joints called sutures, which provide flexibility, and each one has a thickened star shape in the middle providing strength.

SYMBIOSIS

Symbiosis simply means living together. Symbiotic relationships are close or intimate relationships between members of two different species. These relationships have co-evolved. This means that the relationship and dependency has developed over many millions of years. Symbiotic relationships usually benefit at least one of the individuals involved.

CLOWNFISH AND SEA ANEMONE

Bright orange, with three distinctive white bars, clownfish are among the most recognizable of all reef-dwellers. They are remarkable in turning the stinging sea anemone, a cnidarian invertebrate into their home, in a relationship which benefits both the fish and the invertebrate. There are at least thirty known species of clownfish, most of which live in the shallow waters of the Indian Ocean, the Red Sea, and the western Pacific.

Clownfish live within the anemone's tentacles, getting protection from predators. In return, the clownfish drives off intruders and preens its host by removing parasites. The anemone also devours scraps of the clownfish's meals.

Before taking up residence in their anemone of choice, the clownfish appears to perform an elaborate dance with its stinging partner. In reality the fish is gently touching the tentacles with different parts of its body, acclimatizing itself to its host-to-be.

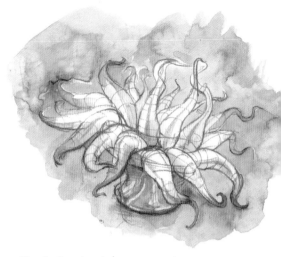

Firm footing A typical sea anemone is a single polyp attached to a hard surface by its foot. The polyp has a columnar trunk topped by an oral disc with a ring of tentacles and a central mouth.

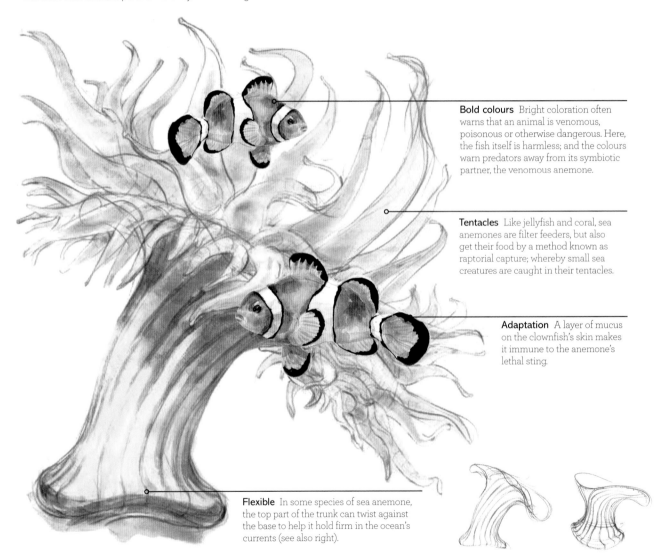

Bold colours Bright coloration often warns that an animal is venomous, poisonous or otherwise dangerous. Here, the fish itself is harmless; and the colours warn predators away from its symbiotic partner, the venomous anemone.

Tentacles Like jellyfish and coral, sea anemones are filter feeders, but also get their food by a method known as raptorial capture; whereby small sea creatures are caught in their tentacles.

Adaptation A layer of mucus on the clownfish's skin makes it immune to the anemone's lethal sting.

Flexible In some species of sea anemone, the top part of the trunk can twist against the base to help it hold firm in the ocean's currents (see also right).

Clownfish in watercolour

When sketching any fish — but particularly
highly mobile reef fish, try to get some feeling
of the form. Even a slight flick of the tail will
help to ensure your sketch does not feel too
flat — like a dead fish!

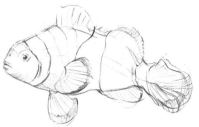

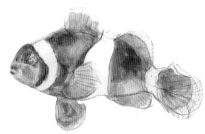

1 Sketch out an underlying drawing, making
sure to delineate any information that you
will need later, such as the position of the
white stripes.

2 Lay in the lightest and brightest colours
first. Here, we start by laying in a watercolour
wash with a mix of cadmium red and cadmium
yellow deep. Use clean water to modulate the
colour so that it is not completely flat.

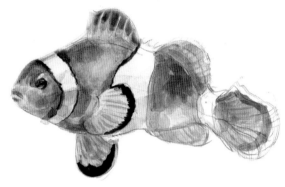
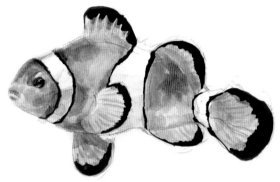

3 Use dilute French ultramarine blue to add shading to both the orange
and white areas, then develop the three distinctive white bars by adding
black stripes with dilute ivory black.

4 Once the watercolour is dry the darker notes can be strengthened by
overlayering more ivory black. This contrast brings out the character of
the fish.

DRAWING SEA ANEMONES

There are a fantastic array of more than 1,000 different species of
these tentacled flower-like sea creatures. The colourful appearance
of these creatures led to them being named after the anemone, a
terrestrial flowering plant. Like the jellyfish, sea anemones have a
similar ring of stinging tentacles. A sea anemone can be thought of
as a single polyp that attaches itself to a hard surface, such as a rock
at its base or foot.

Like jellyfish, their bodies are soft. This primarily takes the form on
an adhesive pedal disc or foot, which can be conceived as a cylinder.
In the centre of the cylinder is the mouth, surrounded by a ring of
tentacles which wave in the ocean's currents. These tentacles are
armoured with stinging cells that contain a neurotoxin, which can
paralyse small prey on contact. The prey can then be guided to the
sea anemone's mouth by its flexible tentacles.

*Create a lightly-sketched framework block to help
rough out the food-searching tentacles.*

Seahorses

HIPPOCAMPUS: THE HORSE MONSTER

This curious class of fish takes its name from its resemblance to a horse – in Ancient Greek *Hippocampus* means 'horse sea-monster'. Seahorse species are widespread around the globe, but mainly found in shallow, tropical waters. They prefer sheltered coastal areas with sea grass, coral reefs or mangroves, as they don't do well in choppy waters, often fleeing to deeper waters when a storm approaches. Seahorses have even been discovered living in the Thames estuary in the UK.

Start learning to sketch seahorses by practising creating marks that capture their trunk rings and ridges.

Trunk ring and ridge shapes Try to capture the concave shapes of the carapace, by articulating shapes around an organic columnar form.

SEAHORSE: NOSE TO TAIL

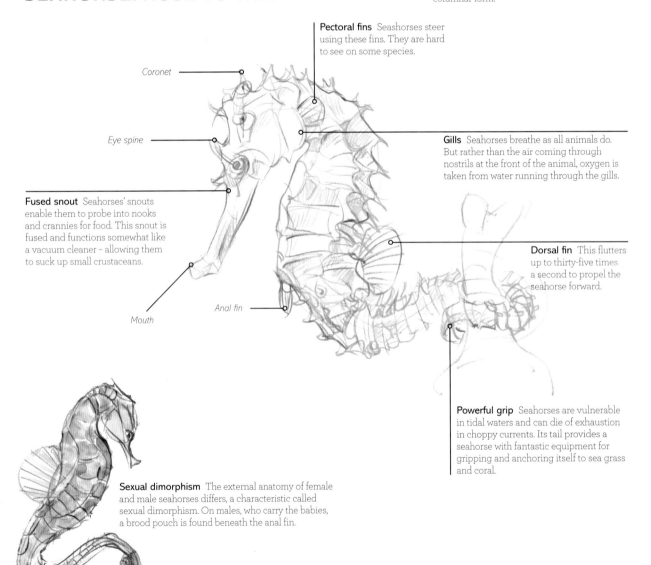

Coronet

Pectoral fins Seahorses steer using these fins. They are hard to see on some species.

Eye spine

Gills Seahorses breathe as all animals do. But rather than the air coming through nostrils at the front of the animal, oxygen is taken from water running through the gills.

Fused snout Seahorses' snouts enable them to probe into nooks and crannies for food. This snout is fused and functions somewhat like a vacuum cleaner – allowing them to suck up small crustaceans.

Dorsal fin This flutters up to thirty-five times a second to propel the seahorse forward.

Mouth

Anal fin

Powerful grip Seahorses are vulnerable in tidal waters and can die of exhaustion in choppy currents. Its tail provides a seahorse with fantastic equipment for gripping and anchoring itself to sea grass and coral.

Sexual dimorphism The external anatomy of female and male seahorses differs, a characteristic called sexual dimorphism. On males, who carry the babies, a brood pouch is found beneath the anal fin.

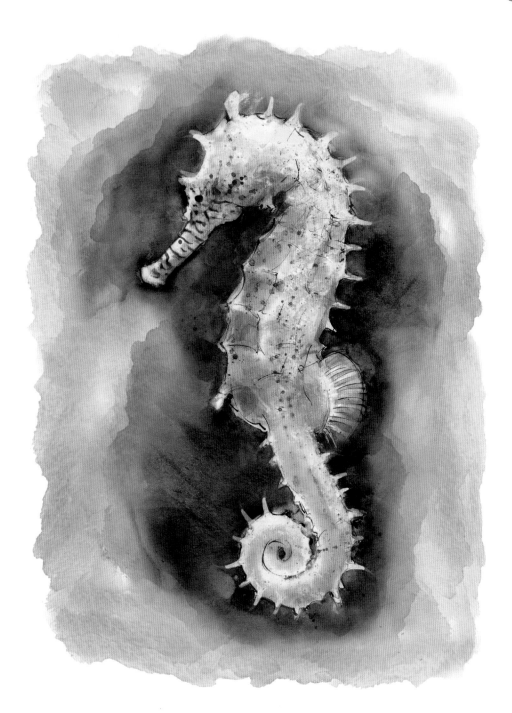

ABOUT THE SEAHORSE

Seahorses have a spine so are classed as vertebrates. Unlike most other fish, seahorses do not have scales, instead possessing an exoskeleton – their bodies are made up of hard, external, bony plates that are fused together with a fleshy covering.

Seahorses range in size from smaller than a human fingernail to over a foot in length. Denise's pygmy seahorse, or the yellow pygmy seahorse, averages 1.6cm (¾in) from tip to tail. This tiny fish inhabits coral reefs that surround East Indonesian islands. Besides being the smallest seahorse, it also ranks as one of the smallest vertebrates. Being so small acts as an advantage, as the seahorse can dive between gaps in the coral reef when predators attack. At the other end of the scale, the Australian big-belly seahorse, or pot-bellied seahorse, is one of the largest seahorse species in the world measuring up to 35cm (13¾in).

Whatever their size all seahorses share the same pony-like features that make them a delight to sketch from their horse-shaped snout to their gripping tail.

Eyesight Seahorses are able to move their eyes independently on either side of their head. This means they can look forwards and backwards at the same time. This is particularly useful as they hunt for food by sight.

Seadragons

FAIRYTALE FISH

Many beautiful creatures live under the sea,
and few are more enchanting than these
fish. As if from a fairytale, the seadragons
are marine fish related to the seahorse;
as such, they share many characteristics
including a similar bony-plated body and the
elongated snout. The concave trunking of
their elongated body can be approached in a
similar manner to that of the seahorse.

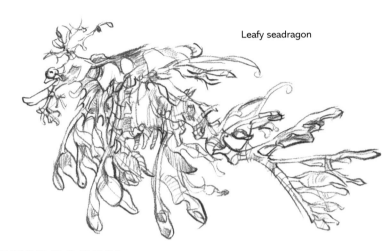

Leafy seadragon

ABOUT THE WEEDY SEADRAGON

Weedy seadragons are one of only three species of seadragons that
we know of. The second is known as the leafy seadragon and the
third is the recently discovered ruby seadragon, discovered off the
western coast of Australia in 2015.

Being a slow swimmer and lacking scales, the weedy seadragon
relies heavily on its camouflage for protection. All seadragons are
ornately camouflaged to blend in with seaweed and outwit their
predators. Even their gentle swimming action – propelled by tiny
fins – matches the swaying of seaweed in the ocean's currents. The
long leaf-like appendages are actually skin and they too sway with a
gentle leaf-like movement.

All seadragons live in the coral reefs and sea grass beds off
the southern and western coasts of Australia. Like their seahorse
relatives, male seadragons incubate the eggs in brood pouches
beneath the upper part of the tail. Once a baby seadragon is born
the reed beds and gaps in the coral will provide shelter.

Eyes The eyes can move independently,
allowing the seadragon to see in front and
behind at the same time.

Gill slit

Pectoral fins These
enable the seadragon
to steer.

Size Seadragons can grow to 45cm (18in) in length.

*Camouflage
appendages*

Weedy seadragon in watercolour

When working from photographic reference it is easy to make the subject look flat so apply dynamic drawing techniques from the earlier classes. Be careful not to lose the underlying drawing and structure of the animal as you apply the paint along the ridges of the carapace shapes..

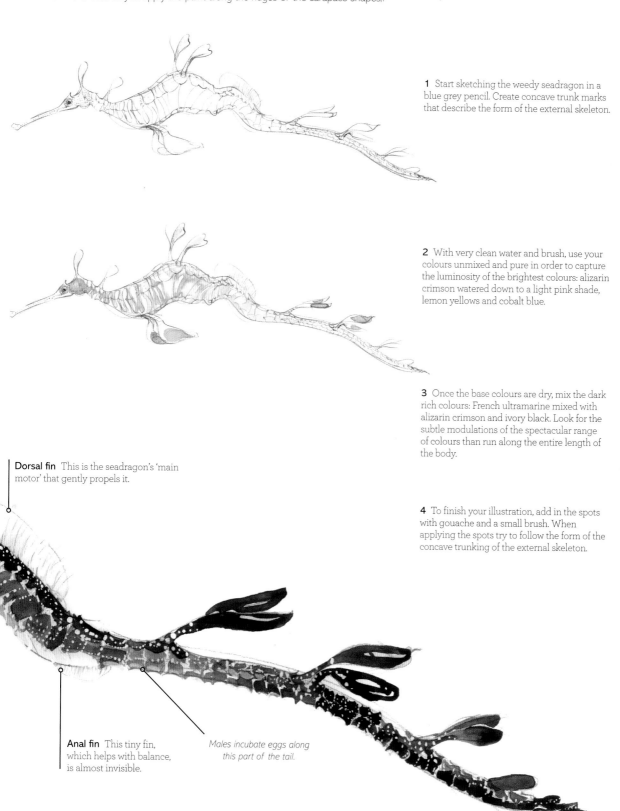

1 Start sketching the weedy seadragon in a blue grey pencil. Create concave trunk marks that describe the form of the external skeleton.

2 With very clean water and brush, use your colours unmixed and pure in order to capture the luminosity of the brightest colours: alizarin crimson watered down to a light pink shade, lemon yellows and cobalt blue.

3 Once the base colours are dry, mix the dark rich colours: French ultramarine mixed with alizarin crimson and ivory black. Look for the subtle modulations of the spectacular range of colours than run along the entire length of the body.

4 To finish your illustration, add in the spots with gouache and a small brush. When applying the spots try to follow the form of the concave trunking of the external skeleton.

Dorsal fin This is the seadragon's 'main motor' that gently propels it.

Anal fin This tiny fin, which helps with balance, is almost invisible.

Males incubate eggs along this part of the tail.

HABITAT: CORAL REEFS

The warm waters of the tropics create coral habitats that provide a home for some of the most colourful creatures on the planet. These rich environments are teeming with a huge diversity of animal forms, all looking for a niche in an environment with limited space. This has led to the creation of some of life's most exquisite and curious creations, all with their own individual specialized way of surviving.

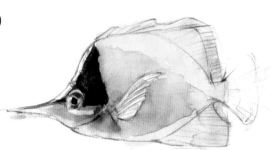

THE RAINFORESTS OF THE SEA

Coral provides the foundations on which all other life in the reef depends, creating a variety of habitats for both smaller and larger animals in a myriad of fantastic adaptations. Although coral covers less than one percent of the world's surface, these rich habitats support around a quarter of all marine life. The truth is that none of the many and varied creatures that make their homes in the reef would be here if it wasn't for the coral habitat. The reefs themselves are created by coral polyps, which can be thought of as a tiny jellyfish sitting in a stony cup, living together they create tower blocks of stony colonies.

In turn, these animals have adapted to depend on each other for their very survival. Symbiotic relationships (see pages 76–77) are plentiful in coral reefs. These alliances, in concert with the eternal arms race between predators and prey, has, over millions of years, produced today's extraordinary diversity of form in this environment.

'Coral reefs are sometimes referred to as the rainforests of the sea owing to the rich diversity of life they support.'

When sketching at a tropical aquatic tank, you will notice that many of the fish have elongated snouts to be able to probe into the nooks and crannies of the coral reefs. Thin, laterally-flattened bodies enable fish to move easily through confined spaces. The colours are also hard to miss: bright colours, spots and stripes of reef fish act both as camouflage and to confuse predators.

The reef is a world of continual change, as the coral responds to the ocean's currents and the cycles of the sun and moon. In some areas, mass coral spawning events occur on one particular night per year and scientists can predict exactly when this will happen, by the light of a full moon. Trillions of eggs and sperm are simultaneously released into the water in one of the most astounding acts of synchronicity in the natural world.

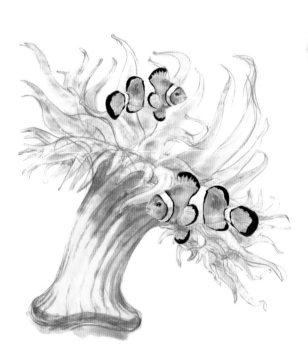

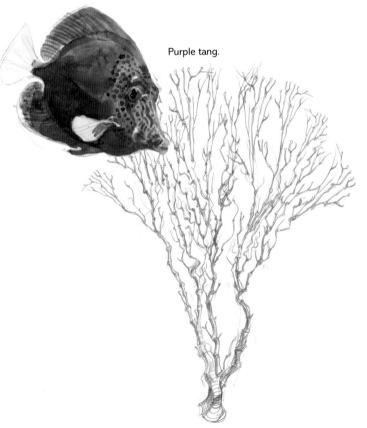

Purple tang.

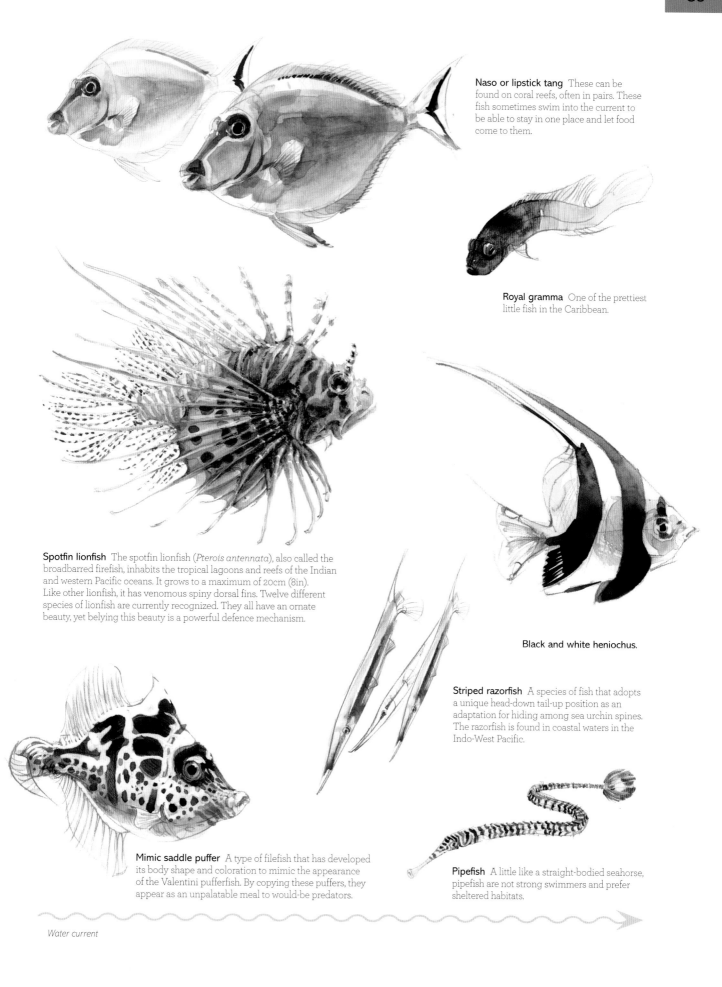

Naso or lipstick tang These can be found on coral reefs, often in pairs. These fish sometimes swim into the current to be able to stay in one place and let food come to them.

Royal gramma One of the prettiest little fish in the Caribbean.

Spotfin lionfish The spotfin lionfish (*Pterois antennata*), also called the broadbarred firefish, inhabits the tropical lagoons and reefs of the Indian and western Pacific oceans. It grows to a maximum of 20cm (8in). Like other lionfish, it has venomous spiny dorsal fins. Twelve different species of lionfish are currently recognized. They all have an ornate beauty, yet belying this beauty is a powerful defence mechanism.

Black and white heniochus.

Striped razorfish A species of fish that adopts a unique head-down tail-up position as an adaptation for hiding among sea urchin spines. The razorfish is found in coastal waters in the Indo-West Pacific.

Mimic saddle puffer A type of filefish that has developed its body shape and coloration to mimic the appearance of the Valentini pufferfish. By copying these puffers, they appear as an unpalatable meal to would-be predators.

Pipefish A little like a straight-bodied seahorse, pipefish are not strong swimmers and prefer sheltered habitats.

Water current

Porcupine fish

A FANTASTIC DEFENCE ADAPTATION

One of nature's curiosities, the porcupine fish's body is covered with sharp spines, which can grow up to 5cm (2in) long. Like a real porcupine, the porcupine fish has the ability to flatten or raise these spines. In a distressed state, the fish inflate their bodies by swallowing water or air, thereby becoming rounder and bigger.

Once the fish is inflated, the spines become erect and stick out at every angle. This means that the porcupine fish has very few predators – imagine trying to catch an orange covered in cocktail sticks – and even once caught, the flesh of the porcupine fish is poisonous.

Porcupine fish in watercolour

Adding texture medium to your watercolour gives a greater fluency and emulates the quality of the fish's skin. The Impressionist group of artists realized the value of French ultramarine and how it can create the feeling of light and shade. Overlay your initial underpainting to beef up the shadow contrast.

Line of symmetry

1 Draw a smooth circle (you can use your own natural radial geometry by drawing from the elbow) then find the line of bilateral symmetry.

2 Add eyes and mouth to the sphere along the line of symmetry. As you sketch it is a good idea to rest your hand on some scrap paper to stop the drawing from smudging.

3 Start adding spikes. There is a headdress-like arrangement of four forward-facing spikes between the eyes. Distribute two spikes equally either side of the central axis.

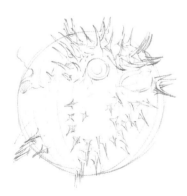

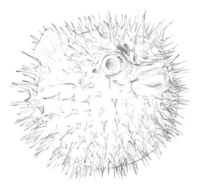

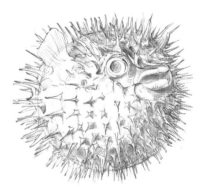

4 Add more spikes. What initially appears chaotic often has an underlying rhythm. Look for patterns in natural growth. The spines are distributed along lines like the lines of longitude.

5 Continue adding spikes – they are like lines of little Eiffel towers disappearing over the horizon. Use perspective to enhance the illusion of roundness.

6 Add modelling to the form by putting in shadow of the form with a cerulean blue.

ABOUT THE PORCUPINE FISH

The pectoral fins of the porcupine fish are relatively large, there are no pelvic fins, and the anal and dorsal fins are close to the caudal peduncle – the narrow part of the fish where the tail joins the main body.

Charles Darwin noted in *The Voyage of the Beagle* (1905, though first published as *Journal and Remarks* in 1839) how the porcupine fish can swim quite well when inflated even though the altered buoyancy requires it to do so upside-down.

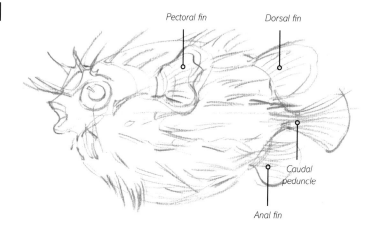

Pectoral fin Dorsal fin

Caudal peduncle

Anal fin

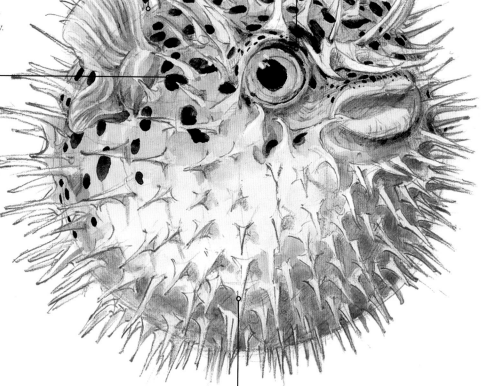

Air and water in.

Countershading adaptation To blend into the seabed from above, the top of the porcupine fish is a yellow olive.

Highlights As finishing touches, add tiny white gouache marks to make the eyes come alive. Note that the eyes may have more than one reflection, depending on the light source.

Pectoral fin Puffers primarily use their pectoral fins for locomotion; and the tail fin only when they need to move quickly.

Disruptive spots These spots act to confuse a predator. Paint these at the final stage of the illustration on top of the underpainting. Notice that they get smaller near the eyes and mouth.

Hidden gills The gills are soft openings located close to the pectoral fins but not easily seen.

Core shadow Core shadow on a sphere is the dark band of shadow of form. Reflected light on the underside of the spherical fish, means the darkest shading is often the core shadow, rather than the far edge of the sphere.

Common goldfish

The natural world is full of wonder and we don't need to go to great lengths to find the most exotic animals to draw. The common goldfish, a small freshwater ray-finned fish, is an equally fascinating animal that requires attention.

1

WHY SKETCH?

The goal of sketching animals, particularly from life, is not to create perfect photographic likeness, but to develop your powers of observation. The representations of this are created through the movement of your hand.

By keeping a sketchbook, you will be able to look back and see your progress. Over time, your skills of mark-making and being able to capture the character of form will improve, and your sketches will start to take on more and more of the character of the animal you are drawing. Don't worry at what stage your sketching skills are, you will develop as you go and become more confident with each sketch you make.

Goldfish in watercolour

Often being found in small glass bowls or aquaria, goldfish are a great opportunity to sketch from a variety of angles. I often start sketching an animal from the side (top row) to help me get to grips with its basic body plan. Once I have done that, I move on to more ambitious viewpoints and gestures.

1 When observing the goldfish, start with a side-on view (top row); then practise other angles – towards you or away from you, for example – as you get more familiar with the animal. These will reveal new details about the animals, and allow you to produce more ambitious and interesting pictures.

2 Use a mix of cadmium orange and cadmium yellow for the body; and lemon yellow for the eye. Add shading with French ultramarine and highlights with white gouache once the orange areas are dry.

3 Put the animal in its natural habitat by suggesting a watery background. I've used French ultramarine here, but you could use a jade green or similar.

ABOUT THE GOLDFISH

The goldfish is a small member of the carp family. They are believed to have been selectively bred in Ancient China, more than 1,000 years ago – an example of artificial selection (see page 23). Very much like Darwin's pigeons, goldfish fanciers have selectively bred characteristics such as large tails or googly eyes to create a great variety in body shape and coloration.

Like modern dogs, there are several distinct breeds of goldfish alive today, all with the same common ancestor.

2

3

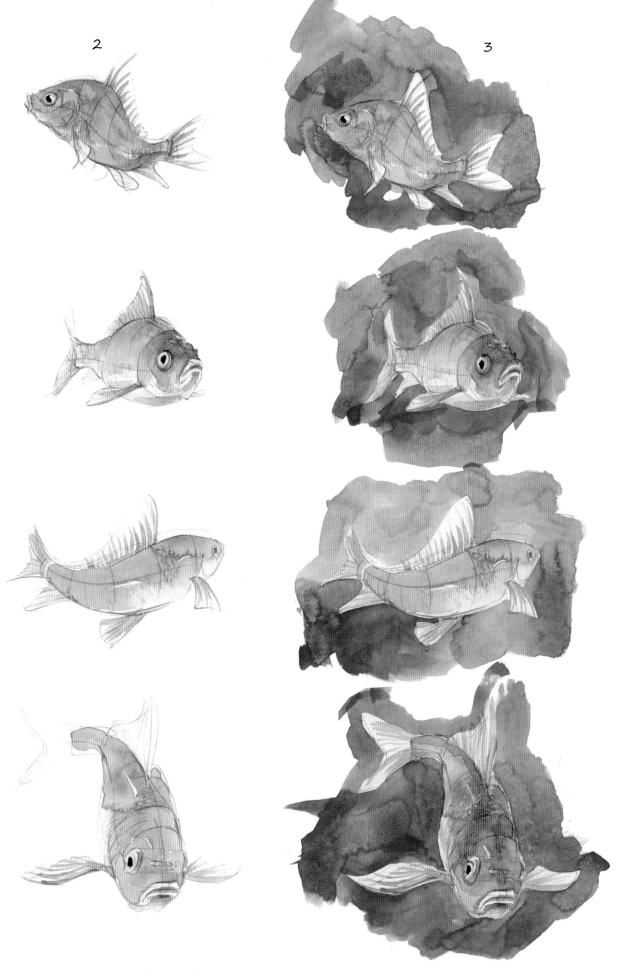

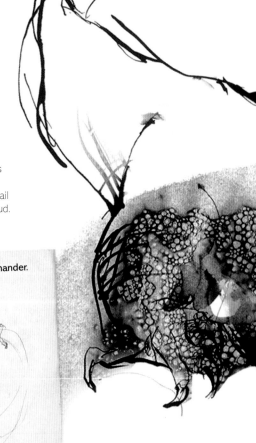

AMPHIBIANS AND REPTILES

Herpetology is the name given to the branch of zoology that studies the cold-blooded reptiles and amphibians; groups which include the frogs, salamanders and newts as well as tortoises, lizards and terrapins.

AMPHIBIANS

Amphibians are cold-blooded vertebrates that are born in water and breathe with gills. They evolved from fish about 400 million years ago, expanding onto dry land. The first vertebrate animals to make it onto the land, amphibians have adapted very successfully to life out of the water; and have since spread all over the world in some 7,000 identified species.

As amphibians grow into adulthood they develop lungs and the ability to breathe air, giving them the opportunity to live on land. The moist skin of an amphibian is able to absorb both water and oxygen, but is also vulnerable to dehydration. For this reason, most amphibians are found close to a water source, though some tree frogs and toads, with their drier warty skin, are able to stay away from water for longer periods.

Most amphibian species lay eggs into pools of water – sometimes in jelly-like masses, as with frog- and toad-spawn. Amphibian eggs do not have a hard shell, and would quickly dehydrate if they were not laid in the water. However, not all amphibians follow this pattern of reproduction strictly: some amphibians lay their eggs in moist areas of the forest floor; while some salamanders live on land for their entire life cycle and give birth to fully-formed live young.

They are split into three main categories: frogs, salamanders and caecilians. Limbless, caecilians look like a cross between an eel and earthworm. Most are burrowers, living in tunnels underground. Besides losing their limbs, most caecilian species have either tiny, vestigial eyes, or have lost the ability to see altogether. As a result, it can be hard to tell which is the head or tail at first glance. They have a hard pointy snout, which effectively acts as a drill bit through the mud. Caecilians range in size from less than 7.5cm (3in) to almost 150cm (5ft) long.

Japanese salamander.

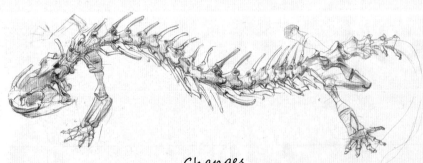

Changes

The name amphibian, meaning 'double life', refers to the animals' ability to live both in water and on land; and also the dramatic physical changes many amphibians adults undergo from their juvenile state – such as the seemingly-miraculous development of a tadpole into a frog.

'It is their habit of sitting still, absorbing the energy of the sun, which allows us to approach sketching reptiles and amphibians in a completely different manner to faster-moving animals.'

REPTILES

Reptiles evolved from amphibians about 310 million years ago. The word reptile means 'crawling' and their characteristic gait — with legs at right angles, as though halfway through a push up — still reflects that lumbering motion which brought animals onto land in the first place.

Reptiles differ from amphibians because they developed waterproof skin, which allowed them to live away from the water and migrate into undiscovered habitats. Unlike amphibian eggs, reptile eggs have a hard protective shell, suited to reproduction on land.

To be able to live away from water and keep the moisture inside their bodies in dry arid climates of deserts. Reptiles have waterproof skin so that the water inside their bodies doesn't evaporate if the weather becomes very hot. Reptile skin differs from the generally smooth skin of amphibians in that it is covered with scutes or scales. This characteristic quality can be captured in a great variety of media.

The resemblance of modern reptiles to dinosaurs is very apparent. This is because the dinosaurs were reptiles. In fact, the earliest known proto-reptiles originated around 310 million years ago.

Reptiles have spread to every continent of the earth except Antarctica — and some, like the sea turtles have returned to the sea, though the females come ashore to bury their eggs on sandy beaches.

Reptiles are cold-blooded animals that need the warmth of the sun. Although they are classed as tetrapods (four-limbed vertebrates), reptiles are diverse in both shape and size. Reptiles such as crocodiles, turtles and lizards retain four obvious legs, but some, such as snakes, have evolved to have no legs at all, allowing them to move through small holes, travel across sand and water with a wave like-undulatory movement.

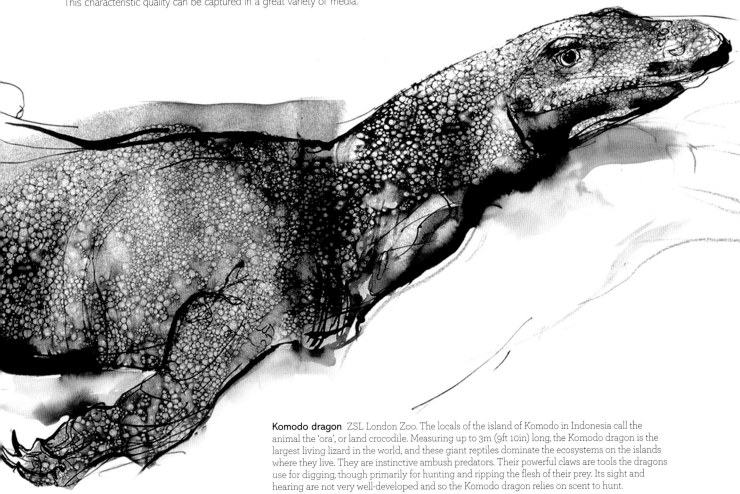

Komodo dragon ZSL London Zoo. The locals of the island of Komodo in Indonesia call the animal the 'ora', or land crocodile. Measuring up to 3m (9ft 10in) long, the Komodo dragon is the largest living lizard in the world, and these giant reptiles dominate the ecosystems on the islands where they live. They are instinctive ambush predators. Their powerful claws are tools the dragons use for digging, though primarily for hunting and ripping the flesh of their prey. Its sight and hearing are not very well-developed and so the Komodo dragon relies on scent to hunt.

Frogs and toads

Frogs are amphibians, which means two lives, as they spend their lives both in the water and on the land. This gives frog's skin in particular a moist and smooth character, which can lead to an interesting illustration challenge. Both frogs and toads fall into the order of *Anura*, which means 'without a tail'. In taxonomic terms, toads are also frogs, but were so named before the taxonomic classes were created.

There is a fantastic diversity of species of frogs. The world's smallest known vertebrate is a frog at 7.7mm (¼in) long, the size of a ladybird, which inhabits New Guinean rain forests. Compare this with the African goliath frog at an incredible 32cm (12½in).

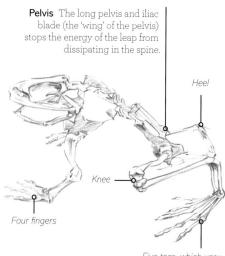

Pelvis The long pelvis and iliac blade (the 'wing' of the pelvis) stops the energy of the leap from dissipating in the spine.

Heel

Knee

Four fingers

Five toes, which vary considerably in length.

Metamorphosis

Like all amphibians, frogs are cold-blooded and begin their lives in water. Even when they are on land, frogs need to be near water or in a damp place. Most frogs begin their lives as spawn, from this they develop into a tadpole where they have gills and a tail, and as they mature they develop lungs and legs for the land. Four frog species in New Zealand retain an older characteristic; their young emerge as tailed froglets rather than tadpoles.

Sketching frogs

As you sketch, you will notice two large beady eyes that sit on top of the head. These can stick out of the water giving them vision forwards, backwards and upwards, all at the same time. These eyes are set in a broad head; they appear to have almost no neck at all. Frogs have a very characteristic snout with two nostrils.

A long pelvis creates the hunchback look of a frog; the sacral hump will appear bigger on frogs more adapted for jumping. Think of this a large sprung hinge. Muscles act as elastic bands and when the energy is released, a top jumper can reach distances twenty times the length of its body. The long iliac blade and pelvis stop the energy of the leap from dissipating in joints of the vertebrae.

Interesting oval-shaped pupil

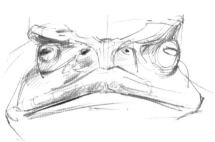

Eye positioning Frogs (above) tend to have their eyes set higher than toads (below).

Nostrils: air in

Eardrum *Sacral hump*

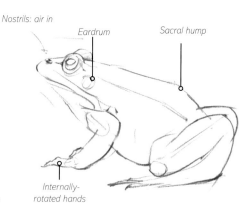

Internally-rotated hands

Capturing character

All frogs have fantastic character that illustrators have drawn on in children's literature. Toads tend to look a little grumpier than frogs. When sketching, it is worth looking at Ernest H. Shepard's illustrations of Mr Toad for the classic story The Wind in the Willows, as they capture the frog's character so brilliantly.

Toads Toads are frogs, but have their own set of unique qualities. Their snouts are shorter, their eyes tend not to stand out so much and they have a dry, warty texture to their skin, which means that they can venture further from water. They lay their eggs in strings.

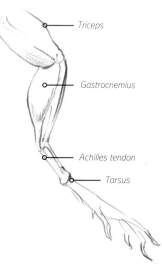

Triceps

Gastrocnemius

Achilles tendon

Tarsus

Foot adaptations Most tree frogs are small, in order to enable them to climb and sit on thin branches and leaves. They have evolved suction pads that allow them to grip trees. The angle of the tarsus creates characteristic shape at the heel of the foot.

POISON DART FROGS STUDY SHEET

Work on more than one frog at once to help you capture different positions and poses.

Poison dart frogs ZSL London Zoo.

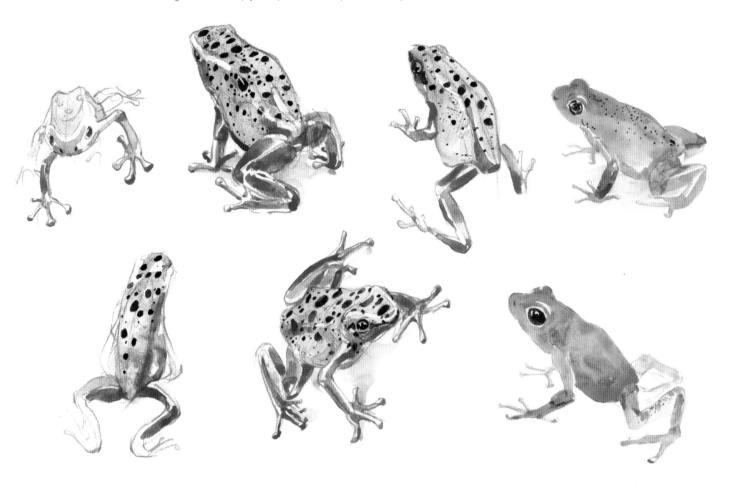

Poison dart frogs in watercolour

Poison dart frogs are from Central and South America. As their name suggests this species can have a high level of toxicity, derived from their diet, which includes ants and termites. This group of frogs often have brightly coloured bodies, which make them a great subject for watercolour.

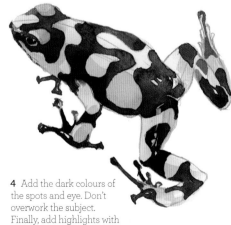

1 Begin by sketching to capture the posture and character.

2 Paint the lightest and brightest colours first across the entirety of the frog. Where you see differences in coloration above the eyes, leave white gaps for highlights.

3 Overlay the shading once dry using yellow dulled slightly with a touch of its complementary colour, purple.

4 Add the dark colours of the spots and eye. Don't overwork the subject. Finally, add highlights with white gouache.

Green iguanas

The iguanas and their relatives are some of the most striking of the lizard family. They make a fantastic subject to sketch as they will remain motionless for a long time basking in the sun or underneath warm lamps in zoos. Being cold-blooded, iguanas cannot maintain a constant body temperature and are dependent on their environment. It is the behaviour of basking that allows the artist to approach sketching them in a straightforward linear fashion and this can come as a welcome relief from sketching animals in continual motion.

Scales

Reptiles evolved from amphibians. While their forebears filled a variety of niches – some amphibians grew as large as fully-grown crocodiles, others as small as a newt – they all had one limitation: they had to live near enough to the water to lay their eggs and reproduce. Reptiles appeared some 20 million years later, laying land-based hard-shelled eggs and possessing scaly waterproof skin that stop their bodies from drying out and provide the animal with a suit of armour. Like the scales of fish, reptile scales wrap around the animals' form and can help express the volume. Their overlapping nature means there are no weak points where a tooth of a predator could break through.

The labial scales are the scales of snakes and other scaled reptiles that border the mouth. These vary in number on different animals. The large round scale on the cheeks of green iguanas is called the subtympanic shield. It is possible its large size helps to dissuade predators by fooling them into believing it is a large eye or it may help to break up the iguana's shape amongst the trees.

Creating an X-wrap By criss-crossing light lines over the form, you can create a mesh (A) that will help guide you as you sketch the scales in more detail (B). Notice how the scales appear smaller as the form turns away from you.

GREEN IGUANA STUDY SHEET

Remember to look at your subject more that the paper as you practise drawing the characteristic lines of the animal. Imagine that your tip of your pencil is like an insect walking around the contours of the animal itself rather than the paper. Aim to get your pencil to 'bite into' the quality of shapes that create the iguana's character. Vary the pressure of your mark-making intuitively.

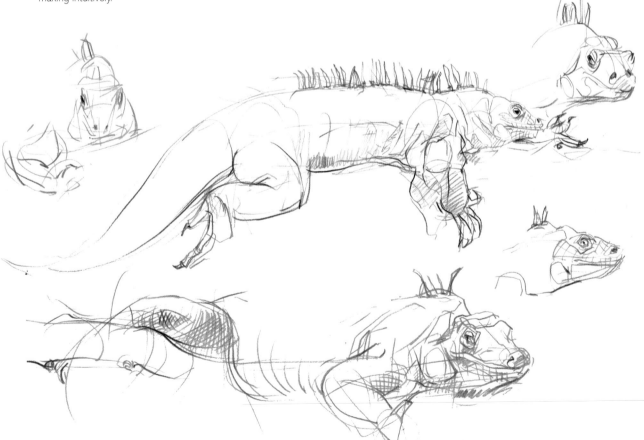

ABOUT THE GREEN IGUANA

The green iguana is one of the largest lizards found in the Americas, growing up to 1.8m (6ft). Green iguanas are unusual reptiles as they only eat plants and have a surprising tiny 'third eye' on their heads. This photoreceptive (light-sensing) organ is known as the parietal eye. The organ is difficult to see and is found in the centre of the forehead.

Green iguana in pen and wash

Complete a linear study (right) before adding a chiaroscuro – that is, heavily contrasted light and shadow – wash of ink. Create sharp concave marks to capture the character of the claws.

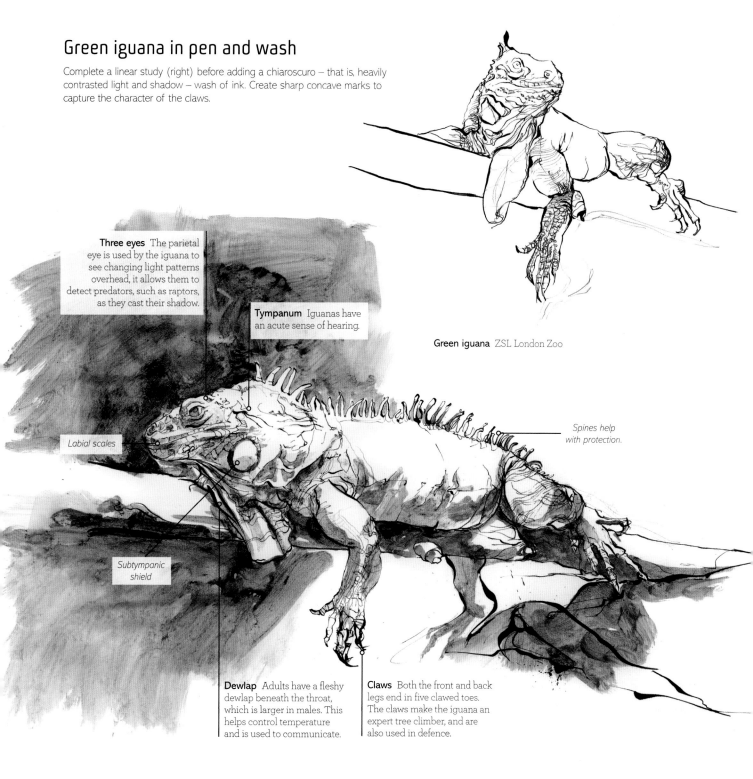

Green iguana ZSL London Zoo

Three eyes The parietal eye is used by the iguana to see changing light patterns overhead, it allows them to detect predators, such as raptors, as they cast their shadow.

Tympanum Iguanas have an acute sense of hearing.

Labial scales

Subtympanic shield

Spines help with protection.

Dewlap Adults have a fleshy dewlap beneath the throat, which is larger in males. This helps control temperature and is used to communicate.

Claws Both the front and back legs end in five clawed toes. The claws make the iguana an expert tree climber, and are also used in defence.

CROCODILIANS

This group of large predatory reptiles are survivors from the time of the dinosaurs, having changed little over the past 66 million years. Alligators, caimans, crocodiles and one species of the gharial are known collectively as crocodilians, an offshoot of the archosaurs, or the 'ruling lizards'. The evolution of the crocodilians goes back some 225 million years to the early Triassic period.

CROCODILIAN LIFE

In some ways, crocodilians are similar to birds: they raise their young in nest-like mounds of vegetation or mud (sometimes underground), and they also cry out to and take care of their young, something that snakes and lizards do not do. Unlike birds, crocodilians are semiaquatic, most of them living in freshwater habitats, while some live in brackish and tidal areas; some even swim freely in the shallow waters of the sea. Crocodilians are found across the world. Alligators and caiman (with the exception of the Chinese alligator) are found in the Americas, while crocodiles inhabit Africa, Asia, Australia and also Central and South America.

Humans have a rich and complex relationship with crocodilians; we both revere and fear them – and for good reason. Historically, crocodiles have been important cultural symbols from Africa to Australia, and were also associated with fertility in the ancient world. The Egyptians worshipped the crocodile-headed Sobek and mummified thousands of dead crocodiles for their journey into the afterlife. Perhaps to make themselves feel safe from such a dangerous animal, amulets would be worn by children playing on the banks of the Nile.

Modern culture has a similar uneasy relationship with crocodilians; admiring and fearing them in equal measure. They can be seen as a cruel and crafty monster, as depicted by the crocodile in J. M. Barrie's *Peter Pan*. Conversely, their skin is turned into fashionable luxury accessories. We have even brought crocodilians into our modern vocabulary: to shed 'Crocodile tears' is to show insincere sorrow. The root of the phrase is a physical mechanism: when crocodiles eat, their muscles push fluid up into their eyes.

Crocodiles are not fussy carnivores and eat a variety of live prey and carrion. Only six of the twenty-three species of crocodilians are considered dangerous to humans; but of those species some, including the Nile and saltwater crocodile, actually prey on humans. To them are attributed many of the often-unrecorded deaths in sub–Saharan Africa. Yet it is important to understand the world from the perspective of the crocodilian. The adaptation of the crocodilians is to conserve energy. Crocodiles are ambush predators, and can wait as long as a year for a single meal. They float, motionless, appearing like a half-submerged log, then strike out at any unsuspecting animal that has come to the water's edge to drink. Underwater, crocodiles can silently drift towards shoals of fish or waterfowl. This stealth hunting is shared by all the crocodilians: they catch their prey off-guard. Surprise is behind their long survival on this planet.

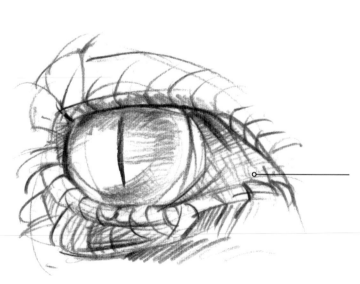

Third eyelid Crocodilians have a transparent third eyelid, called the nictitating membrane, which can be closed to give the eye additional protection underwater. Unlike the upper and lower eyelids, the nictitating membrane moves horizontally across the eyeball.

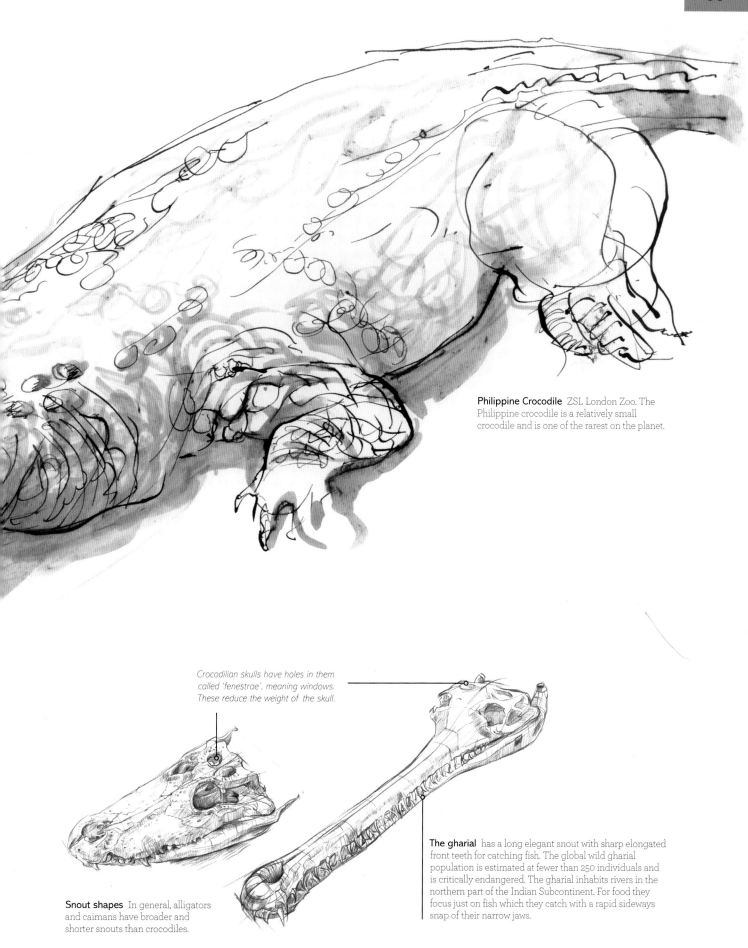

Philippine Crocodile ZSL London Zoo. The Philippine crocodile is a relatively small crocodile and is one of the rarest on the planet.

Crocodilian skulls have holes in them called 'fenestrae', meaning windows. These reduce the weight of the skull.

The gharial has a long elegant snout with sharp elongated front teeth for catching fish. The global wild gharial population is estimated at fewer than 250 individuals and is critically endangered. The gharial inhabits rivers in the northern part of the Indian Subcontinent. For food they focus just on fish which they catch with a rapid sideways snap of their narrow jaws.

Snout shapes In general, alligators and caimans have broader and shorter snouts than crocodiles.

Crocodiles

Crocodiles can remain stationary for hours, as they need to regulate their body temperature by basking in the sun. This makes them the perfect life model and creates a great opportunity for big line drawings.

MOVING ON LAND

On land, crocodiles have two modes of locomotion. During the belly walk, they hold and move their limbs very much like a typical lizard would, dragging their stomach across the ground (see page 101).

The high walk is the second mode. Here, the crocodile lifts its entire body trunk from the ground, supporting itself in a push-up style stance, its elbows bent. While faster than the belly crawl, the high walk is still a relatively slow gait in comparison with animals who can lock their elbows straight – such as yourself. While such animals can move at a greater speed and for longer distances than a crocodilian in the high walk, this second mode enables crocodilians to run over short distances – which, generally speaking, is all they need!

Scutes or scales?

Scutes wrap around the body and legs of crocodilians. Similar to scales, scutes serve the same function. Scutes are formed in the lower vascular layer of the skin, unlike the scales of lizards and snakes, which are formed from the epidermis. Scutes are a heavier form of horn-like armour plating than scales and do not form the same sort of overlapping structure as snake scales.

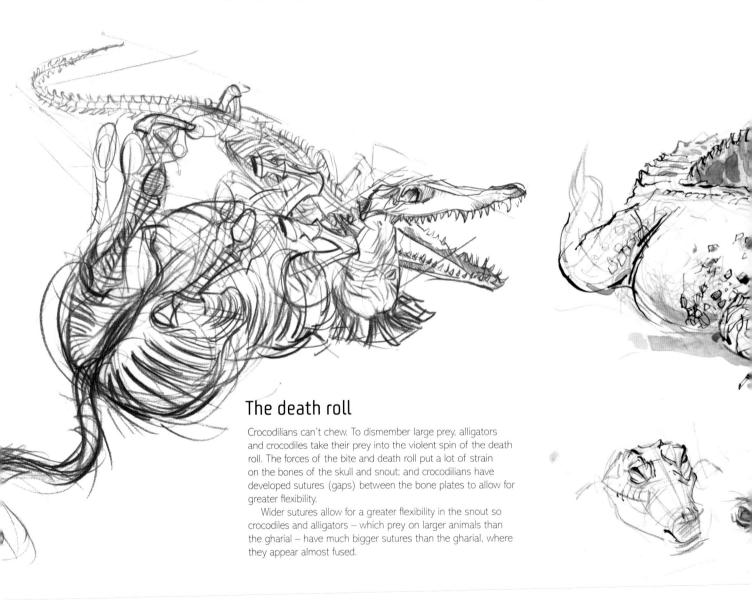

The death roll

Crocodilians can't chew. To dismember large prey, alligators and crocodiles take their prey into the violent spin of the death roll. The forces of the bite and death roll put a lot of strain on the bones of the skull and snout; and crocodilians have developed sutures (gaps) between the bone plates to allow for greater flexibility.

Wider sutures allow for a greater flexibility in the snout so crocodiles and alligators – which prey on larger animals than the gharial – have much bigger sutures than the gharial, where they appear almost fused.

MOVING THROUGH WATER

When swimming, the crocodile swishes its long, muscular tail from side to side to create forward propulsion. The powerful tail is armoured with carapace scales and has a pair of raised keels that run to the tip.

Like an iceberg, most of the crocodile remains submerged beneath the water's surface in order to help it sneak up on its prey.

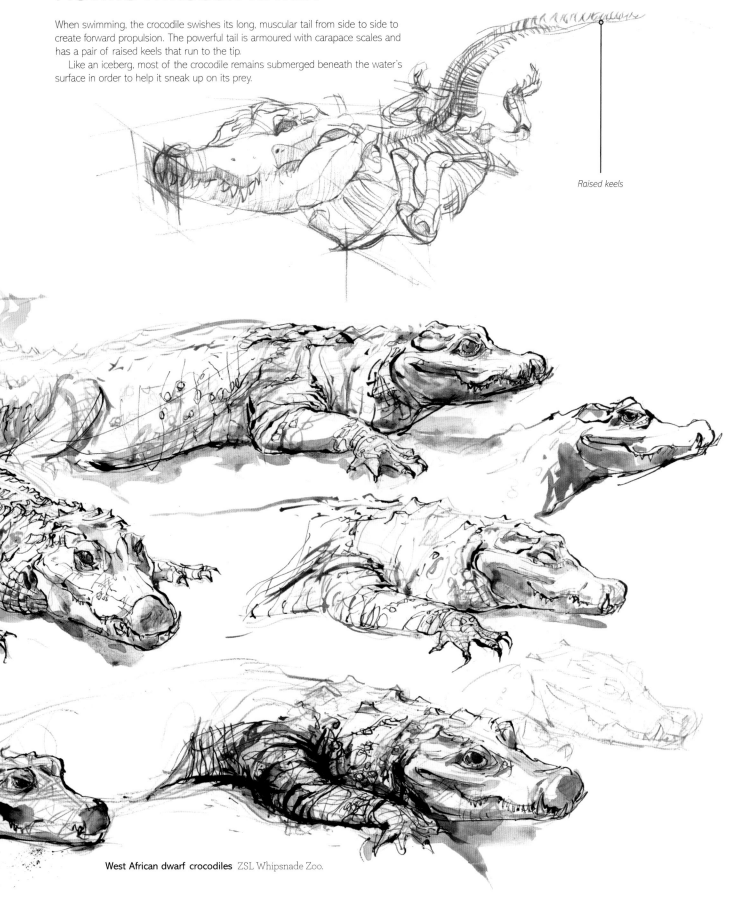

Raised keels

West African dwarf crocodiles ZSL Whipsnade Zoo.

Tortoises, turtles and terrapins

Tortoises and turtles are easily recognizable by the distinctive shape of their shells, which provide them with a moveable shelter. Tortoises live on the land, whereas turtles and terrapins spread their time between the water and land. Tortoises tend to have high-domed shells, whereas turtles and terrapins have smoother, more streamlined shells to make swimming through water easier.

These animals are of the order *Testudines*, a group of reptiles which has flourished and diversified into a wide range of different species over 220 million years. The name comes from the Latin *testudo* which was the Roman soldier's shield.

The testudines are some of the most ancient reptiles alive and have changed little from their prehistoric ancestors. Over generations, repeated behaviour within a species can lead to evolutionary adaptations of the skeleton and muscles. As artists sketching animals, we can bear witness to these repeating behaviours and create fleeting sketches, essentially capturing evolution in action. Of course, evolution doesn't happen in the lifetime of a single animal, but in incremental steps over tens, hundreds or millions of years. These steps have been studied by scientists and have enriched our understanding of the tree of life.

Revealing details

How can you tell if a giant tortoise eats from the ground or from leaves hanging above his or her head? When Charles Darwin reached the Galápagos Islands in 1835 he noticed that the giant tortoises on different islands have distinctly different shell shapes. Each shape has adapted for different feeding habits (see left).

The young Darwin began to wonder if the giant tortoise species had reached the Galápagos Islands from the mainland and then changed as they adapted to new environments. The idea that species could change over time depending on their habitat eventually led to Darwin's theory of evolution by natural selection.

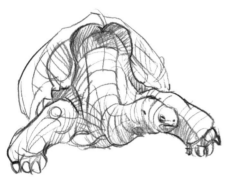

Saddle-backed shells These evolved on the islands in response to the lack of available food at ground level. The front of the shell has a high upward bump, which allows the tortoise to extend its head higher to reach plants growing from above.

Dome-shaped shells Tortoises with dome-shaped shells live on islands where there is an abundance of vegetation close to the ground, making it less necessary for the animals to raise their heads to feed. Domed tortoises tend to also be much larger in size.

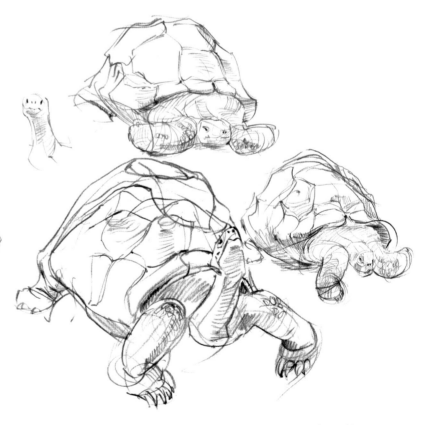

Galápagos tortoise ZSL London Zoo. Galápagos tortoises are the largest in the world. They can live for over 150 years.

The shell

Tortoises and turtles are the only reptiles to have evolved a shell, made up of specialized scales called scutes. These fuse together to create the upper shell or carapace and the flatter bottom shell called a plastron. The ribs and the backbone vertebrae of testudines have become fused. The ribs splay out to create a protective wall of bone. The carapace sits on top of this.

 The rigid, immobile shell means that testudines have very little muscle beyond the neck, arms and legs. These few soft parts can be retracted into the shell, to keep the soft flesh of the tortoise safe from predators. All tortoises and turtles have this keratin shield, except for some turtles (soft shell turtles, pig-nose turtles and the leatherback sea turtle) whose fused vertebrae are instead covered in rubbery skin to save on weight. These turtles may appear to have more scutes, but what you are looking at is actually the fused vertebrae.

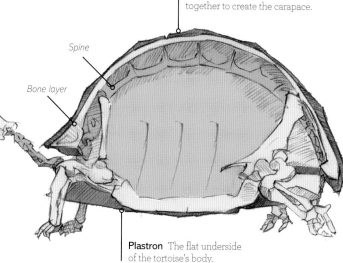

Carapace Horny scutes join together to create the carapace.

Spine

Bone layer

Plastron The flat underside of the tortoise's body.

Vertebral scute

Costal scute

Keel A ridge that runs from front to the back of the shell in some species, the keel is commonly a single row of five scutes, but can be two or even three rows.

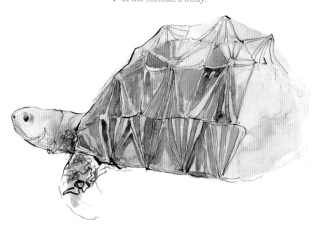

Radiated tortoise ZSL London. The radiated tortoise is considered to be one of the world's most beautiful – and most endangered – tortoises. It has a high-domed carapace with beautiful yellow and black markings.

Flippers While many turtles have webbed feet for swimming, the pig-nosed turtle is the only freshwater turtle with flippers in the place of feet, like marine turtles. Another unusual feature of this species is that their eggs hatch underwater.

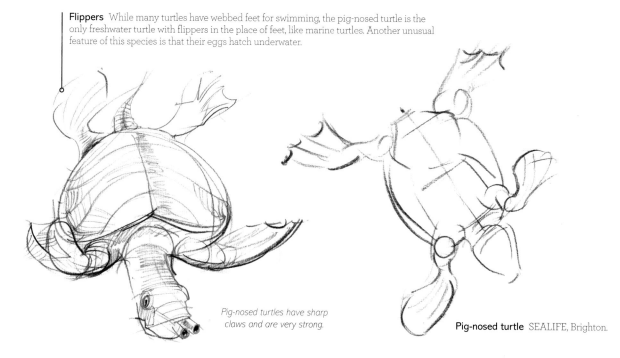

Pig-nosed turtles have sharp claws and are very strong.

Pig-nosed turtle SEALIFE, Brighton.

DINOSAURS

The dinosaurs thrived on the Earth for 170 million years. Contrary to their of popular image as being primitive, their anatomy evolved to the highest degree in the time they walked the planet.

Take advantage of your local Natural History Museum to spend a day sketching these prehistoric animals. Museums are fantastic places to find subjects to draw; and are often the only places you can find close-up examples of certain creatures – whether that is because they live in locations that are impossible to get to or, as with many species, are extinct.

The first dinosaurs – small, two-footed omnivorous animals – evolved from a single lineage of archosaurs, which means 'ruling lizards'. What separated the dinosaurs from the other prehistoric reptiles is that they walked with their legs beneath them. Modern reptiles, such as crocodiles and lizards (also descended from

'Use your sketchbook to feel like a traveller in time and go back more than 200 million years.'

archosaurs), still have legs that either sprawl out to the side or hold their body in a push-up stance. The posture of having their limbs straight beneath them, created a more efficient form of movement for dinosaurs, allowing them to run faster and with greater endurance than other reptiles. This is one of the factors that allowed the dinosaurs to grow so large. All dinosaurs inherited and exploited this upright stance in their various forms, whether on two or four legs.

The dinosaurs lasted until 66 million years ago, when an asteroid or comet, some 10–15km (6–9 miles) in diameter, hit the Yucatán peninsula in Mexico, wiping out many forms of life, including all of the dinosaurs – which were thriving at the time – except birds. This mass extinction event killed some three-quarters of all the earth's species of plants and animals and left a scar on the landscape now known as the Chicxulub crater.

Markers A quick and efficient medium, these are great for speeding up your shading. I use cool light greys 1 and 2 in a variety of different makes, with both brush and chisel tips.

ABOUT THE STEGOSAURUS

Stegosaurus, which means 'roofed lizard', is a dinosaur that lived around 155 million years ago, during the Jurassic era. The stegosaurus was a plant eater, or herbivore. It was armoured with vertical plates for protection along its back.

Using the head as a starting point, create a structure of light lines. Then on this ghost-like armature, sketch on the bones by moving from shape to shape, and nose to tail.

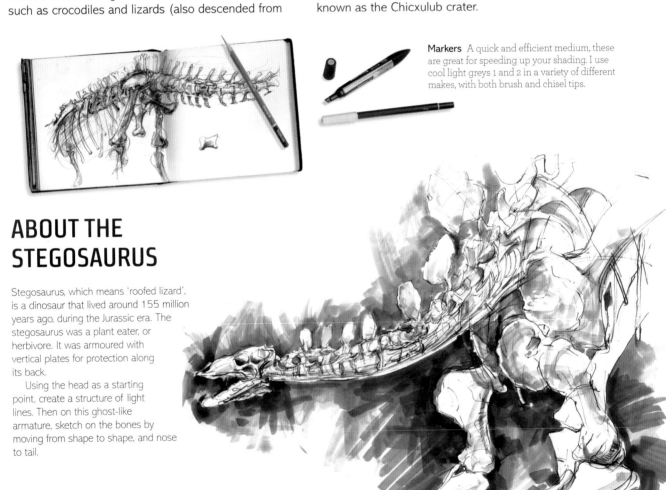

Stegosaurus Natural History Museum, London.

ABOUT THE ICHTHYOSAUR

The ichthyosaurs, which literally means 'fish-lizards', were not one of the dinosaurs, thought they lived around the same time. Icthyosaurs appeared around 250 million years ago and died around 25 million years before the Chicxulub extinction event, though the reason for this remains unexplained.

Ichthyosaurs were air-breathing, bore live young, and even had the appearance of a dolphin. However, unlike modern sea mammals, their rear tail flicked from side to side to give forward propulsion, just like fish and crocodiles.

*Paddles with
many digits.*

REPTILIAN STANCES

Lizard stance or belly walk Lizards normally sprawl with their legs outspread. However, there are exceptions, Chameleons have adapted to climb branches and have a high stance, although with bent legs and toes that grab onto branches. Chameleons even rock to emulate the motion of leaves swaying in the breeze.

Crocodile stance Like dinosaurs, crocodiles evolved from archosaurs, which had locked legs. Having re-evolved to swim, crocodilians have legs that either sprawl out to the side or hold their body in a push-up stance. They have a higher gait than most lizards, and use a more efficient 'high-walk', when they want to move at speed on land.

Dinosaur stance All dinosaurs stood on straight legs, the most efficient method of locomotion. This is one of the reasons that they could grow to enormous sizes. The pillar-like legs of the colossal sauropods can be compared to that of our largest land mammal, the elephant.

Dinosaur descendants

Some dinosaurs still walk and fly on this earth – in the shape of the birds!

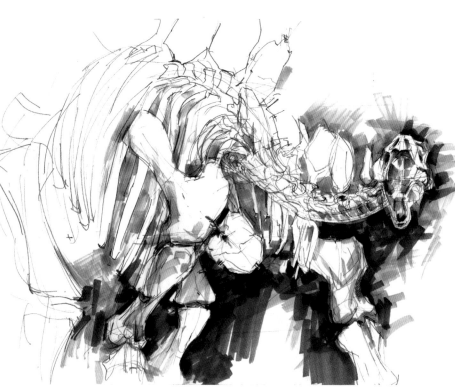

Chiaroscuro

Museums often use dramatic lighting that can enhance the monumentality of form. Using only grey markers, concentrate on the effects of light and shade – the artistic term for this is chiaroscuro.

Start with your lightest grey marker and then build into the darker shades by overlapping the tones. Markers can be used in the background to increase the illusion of light and shade.

Stegosaurus Natural History Museum, London.

MAMMALS

Whilst some mammals lived alongside the dinosaurs, after the extinction event (see page 100), this group flourished to fill the niches left open by the loss of the dinosaurs. There are now more than 5,400 different species of mammals alive on the planet, from tiny nocturnal slow loris, to enormous blue whales, which can measure up to 30m (98ft). The majority of mammals are terrestrial, but some are aquatic; and there are even flying mammals, in the form of bats.

Incredibly diverse, mammals have evolved and adapted to live on every continent on the planet, and can be found in the polar regions, grasslands, jungles, desert and even in the ocean; where they have adapted to the aquatic environment and become creatures like seals, manatees and dolphins. Despite this incredible diverisity, mammals do share some common characteristics. For example, all mammals breathe with lungs, even if they live in the sea.

The skeletal and muscle groups of mammals are highly comparable and by learning some basic bones and muscle groups, we can really advance our sketching skills. All mammals are vertebrates, which means that they have an internal backbone. Every mammal also has four limbs – though they use them variously to walk, swim, hop, fly, run and climb – and have evolved a host of hand and feet adaptations; from hooves, paws and claws to fins. Sloths have even evolved toes that act like hooks to hang upside-down from trees.

With the exception of the platypus and the echidna, which lay eggs, all mammals are viviparous, meaning that they are born from their mother's womb. When born all mammals nurture their young with milk, from mammary glands, hence the name. Mammals produce fewer offspring, but their chances of survival are greater because of the level of care that the parent provides.

Because mammals have warm blood, they can maintain their internal body temperature. This has enabled them to colonize a great variety of different climates around the globe. Maintaining a constant body temperature does have its costs: it means that mammals have to eat more. Mammals get that energy in different ways. To help maintain their body temperature all mammals have hair. Even a baby dolphin is born with small whiskers on its snout, but these soon fall out as the baby starts to swim alongside the mother. Capturing hair, from the shaggy pelt of a bear to the tufts of a colobus monkey's tail sets the artist a new set of challenges.

As mammals ourselves, we have a close connection with this group of animals. We have a history of domesticating mammals for both the farmyard and home. Some mammals, such as dogs and cats, are very popular at home – and their mix of familiarity and novelty makes these creatures particularly rewarding subjects to sketch.

Slow Loris

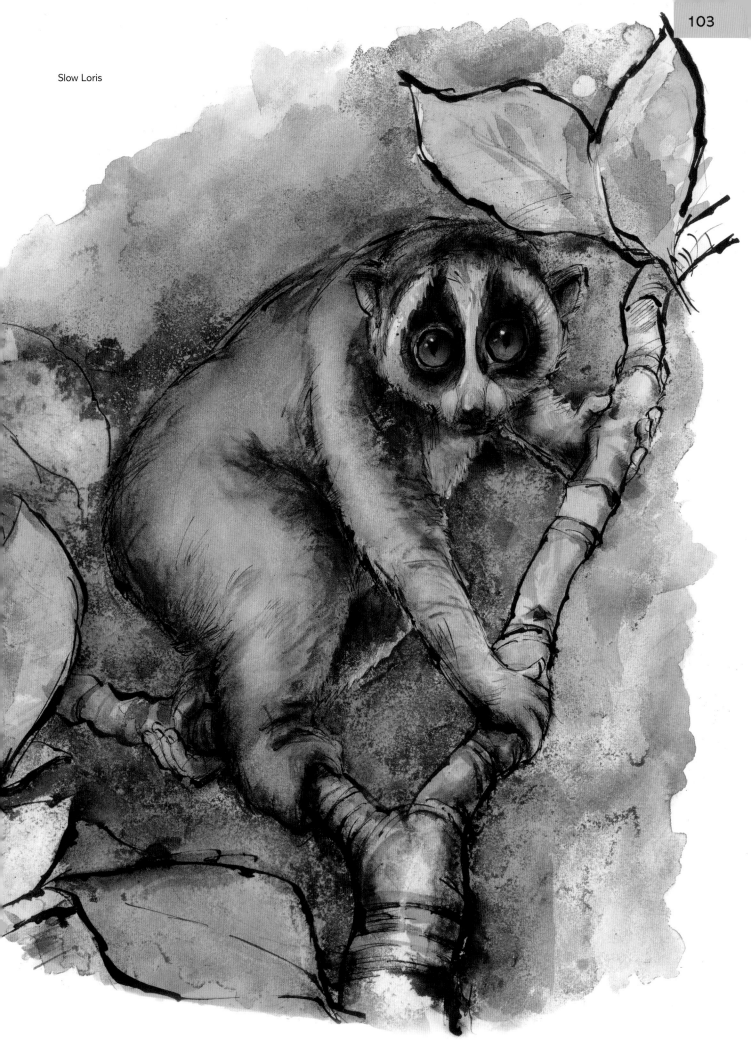

Red river hogs

CAPTURING THE QUICK

One of the most attractive wild pigs to sketch is the West African red river hog. Their rust-red coloured coat makes them instantly recognisable. This wild pig occupies western and central Africa. Snuffling their snouts in the mud, grunting and squealing, red river hogs display all the normal behaviour we associate with pigs.

Red river hogs move around so quickly. The best approach to take is to create a study sheet. A stocky body, long leaf-shaped tufted ears are some of the elements that go to create the character of the red river hog. There is a distinctive tufted white stripe that runs the length of the spine. As you sketch notice how the hair on the flanks is longer than the rest of the body. The head is highly distinctive with its cone-shaped skull, white rings circle the piggy eyes and long white whiskers descend from the snout. The long ears are incredibly powerful and can hear the quietest paw of an approaching leopard.

'Pigs have a special place in the history of art – the earliest known artwork was of a pig.'

RED RIVER HOG STUDY SHEET

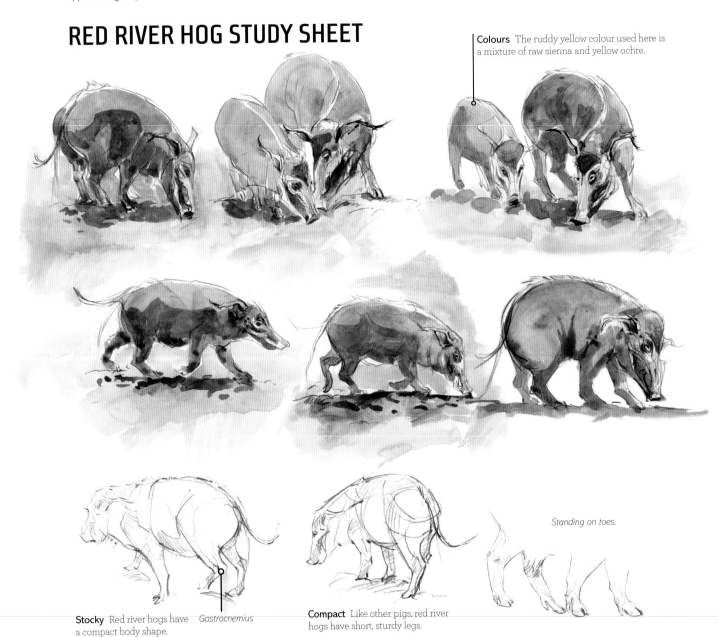

Colours The ruddy yellow colour used here is a mixture of raw sienna and yellow ochre.

Standing on toes.

Stocky Red river hogs have a compact body shape. *Gastrocnemius*

Compact Like other pigs, red river hogs have short, sturdy legs.

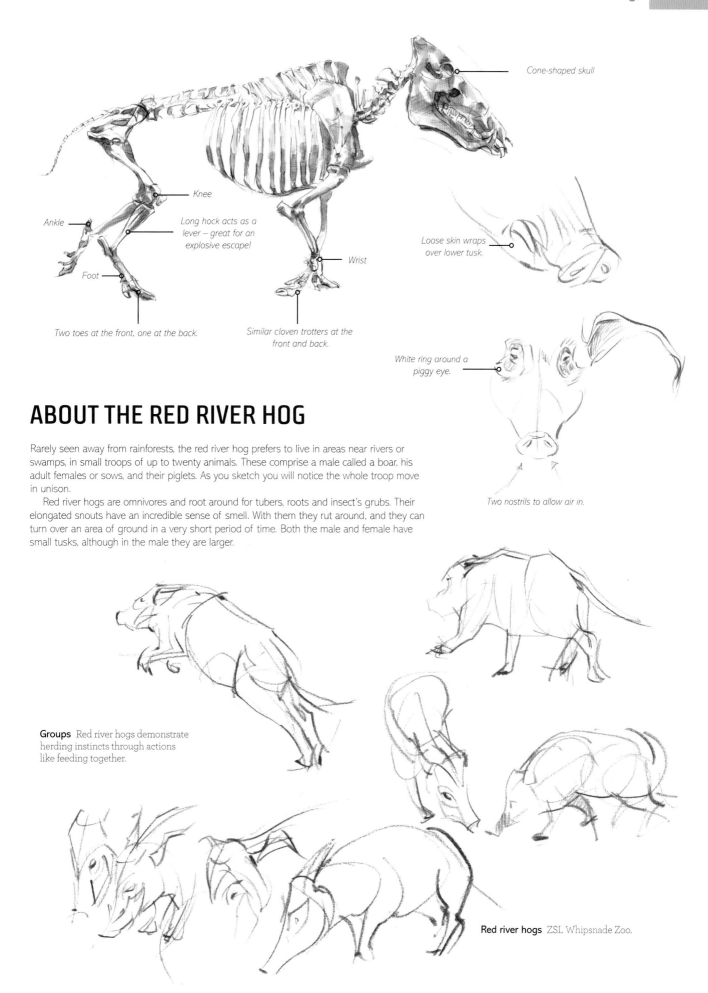

Cone-shaped skull

Knee

Ankle

Long hock acts as a lever – great for an explosive escape!

Foot

Wrist

Two toes at the front, one at the back.

Similar cloven trotters at the front and back.

Loose skin wraps over lower tusk.

White ring around a piggy eye.

ABOUT THE RED RIVER HOG

Rarely seen away from rainforests, the red river hog prefers to live in areas near rivers or swamps, in small troops of up to twenty animals. These comprise a male called a boar, his adult females or sows, and their piglets. As you sketch you will notice the whole troop move in unison.

Red river hogs are omnivores and root around for tubers, roots and insect's grubs. Their elongated snouts have an incredible sense of smell. With them they rut around, and they can turn over an area of ground in a very short period of time. Both the male and female have small tusks, although in the male they are larger.

Two nostrils to allow air in.

Groups Red river hogs demonstrate herding instincts through actions like feeding together.

Red river hogs ZSL Whipsnade Zoo.

Warthogs

Warthogs (*Phacochoerus africanus*) are long-legged and sturdy hogs, protected by four sharp tusks that emerge from the front of the nose beneath the upper lip. The two upper tusks, attached to the skull, are used to ward off predators such as lions, cheetahs and crocodiles. The two smaller lower tusks are attached to the lower mandible and are primarily used to dig up roots and bulbs.

Warthogs have a very large head that is full of characterful shapes that make them a fantastic subject for sketching. Both the males and females have protective 'warts' on their faces, which give them their name. The male's 'warts' are bigger to cushion blows during fights with other males.

Found in the grasslands and woodland of Sub-Saharan Africa, warthogs can run up to 48km/h (30mph). This incredible speed helps them outrun predators. They can enter their dens rear first, with their tusks sticking out of the entrance for added security.

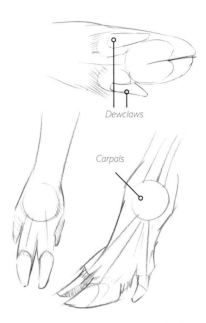

Dewclaws

Carpals

Warthog feet Warthogs have toes on both front and back feet. There are two larger digits and two smaller dewclaws on either side of the feet.

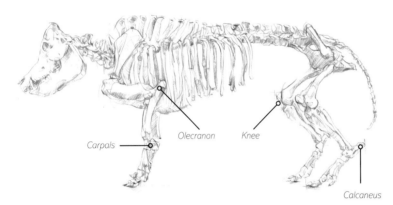

Carpals

Olecranon

Knee

Calcaneus

Domesticated pig skeleton RVC, London. Despite their spectacular warty appearance, warthogs are members of the pig family. As such, we can use our understanding of pig anatomy to help us sketch them.

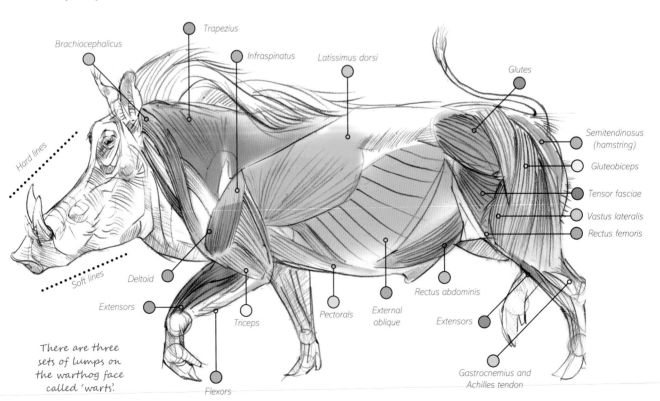

Brachiocephalicus

Trapezius

Infraspinatus

Latissimus dorsi

Glutes

Hard lines

Semitendinosus (hamstring)

Gluteobiceps

Tensor fasciae

Vastus lateralis

Rectus femoris

Soft lines

Deltoid

Extensors

Triceps

Pectorals

External oblique

Rectus abdominis

Extensors

There are three sets of lumps on the warthog face called 'warts'.

Flexors

Gastrocnemius and Achilles tendon

DRAWING WARTHOGS

On a bright, sunny day, *chiaroscuro* lighting – strong contrasts between light and dark – helps to model the form.

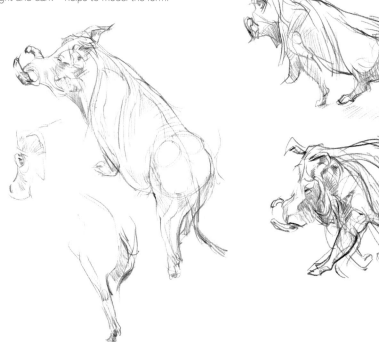

Be sure to include the long hairy mane.

1 Working quickly and with fluidity, try to create marks that capture the knobbly character of the head. Notice that the eye is mounted high up on the skull with long eyelashes.

2 Use ink or a black watercolour to develop the tone. Vary the amount of water to create a range of tonal values.

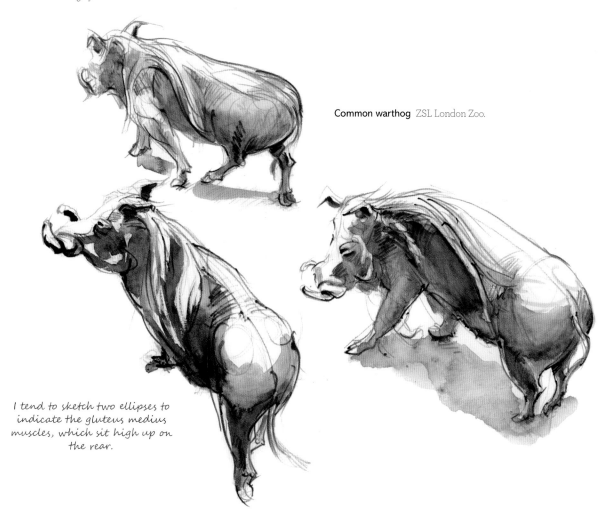

Common warthog ZSL London Zoo.

I tend to sketch two ellipses to indicate the gluteus medius muscles, which sit high up on the rear.

Hippopotamuses

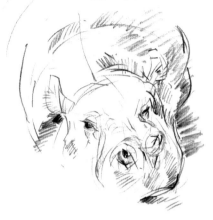

There are only two different species of hippopotamus, both sharing a very similar semi-aquatic lifestyle. Probably the more familiar is the common hippopotamus, which is the large, wallowing species. Hippopotamuses don't really swim but push off rocks to project themselves through the water. Despite its massive bulk a hippopotamus is able to move with some speed and grace, either walking underwater or trotting on land. Scientists have been surprised to record the common hippopotamus running up to speeds of 30km/h (19mph); making their name very apt: it comes from ancient Greek and translates as 'river horse'.

Despite their somewhat pig-like appearance, hippopotamuses are believed to be more closely related to whales, which are mammals that have a fully submerged water life-cycle. Evidence suggests that hippopotamuses and whales shared a common ancestor some 54 million years ago.

ABOUT THE PYGMY HIPPOPOTAMUS

Feeding Both the pygmy hippopotamus (above) and common hippopotamus (opposite, top) forage at night. Common hippopotamuses follow well-worn trails, marked with dung piles that lead them to their grazing areas.

The lesser known pygmy hippopotamus is a critically endangered, forest dwelling hippopotamus. Usually found in small social groups, the pygmy hippopotamus is only one-fifth of the weight of its huge cousin. The pygmy hippopotamus is specially adapted to be able to move through dense forest of western Africa.

While they do make use of the forest's swamps and rivers, pygmy hippopotamuses spend less time in the water than the common hippopotamus. As a result, they have less need to have their eyes perched right on top of their head.

Both species of hippopotamus have their ears, eyes and nostrils on top of their head to be able to hear, see and breathe whilst remaining cool in the water during the heat of the day. In the common hippopotamus, they are perched right on top, allowing it to submerge virtually its whole head, leaving just its features exposed.

Pygmy hippopotamuses ZSL Whipsnade Zoo.

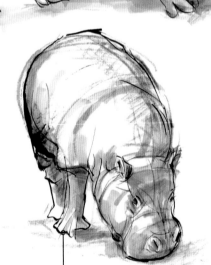

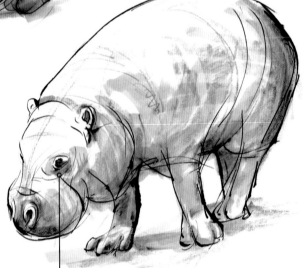

Nose Less bulb-like than that of the common hippopotamus, the pygmy hippopotamus' snout is designed to push through thick undergrowth.

Land feet Pygmy hippopotamus feet are narrower, and with less webbing between the toes, than those of their common cousins. Both species have four toes on both front and back feet.

Eye placement Whilst sketching a pygmy hippopotamus, you will notice that the eyes sit lower down the head than those of the common hippopotamus.

Common hippopotamuses ZSL Whipsnade Zoo.

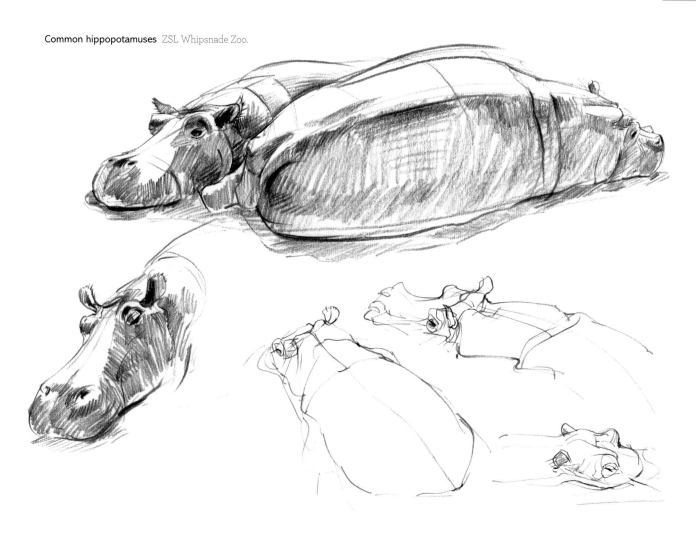

HIPPOPOTAMUS ANATOMY

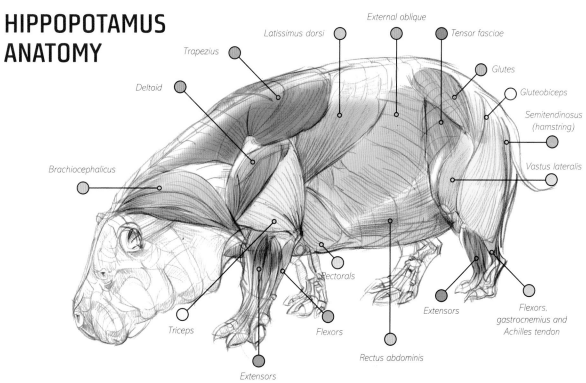

Trapezius

Deltoid

Latissimus dorsi

External oblique

Tensor fasciae

Glutes

Gluteobiceps

Semitendinosus (hamstring)

Vastus lateralis

Brachiocephalicus

Triceps

Extensors

Flexors

Pectorals

Rectus abdominis

Extensors

Flexors, gastrocnemius and Achilles tendon

Red deer

GETTING STARTED WITH FIELD SKETCHING

There are many approaches to sketching and different ways of starting out. This approach, which involves starting with the head, is one that I regularly use. It is easier to get the body in proportion by getting the head down first, rather than trying to fit a head to a body.

Deer inhale from the front of their noses and exhale from the sides.

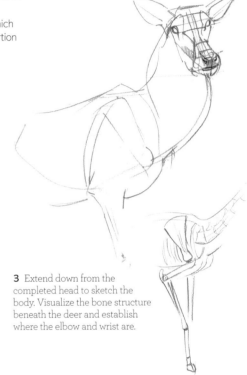

1 Start out by sketching the eye, aiming to capture the almond-like character. As a prey animal the eyes are on the side of the skull, so imagine a tube joining them together. Find the bilateral line of symmetry that runs through the middle of the head.

Critical angles Look carefully for the angles as you make these initial marks. As humans we like things to be simple, and there is a tendency to simplify to verticals and horizontals. When sketching we must be aware of the host of different angles.

2 Using construction lines, draw the structure of the skull. It is important to get a sense of the nose having depth, so start with a rectangular box in space, then pay careful attention to the shape of the nostrils. With light falling from above, place the front in shadow.

3 Extend down from the completed head to sketch the body. Visualize the bone structure beneath the deer and establish where the elbow and wrist are.

4 As you fill out the body, look at the horizontal and vertical relationships to help guide you. For example, the chin, back and hips are all at the same height. First assumptions might lead us to believe that the head would be higher.

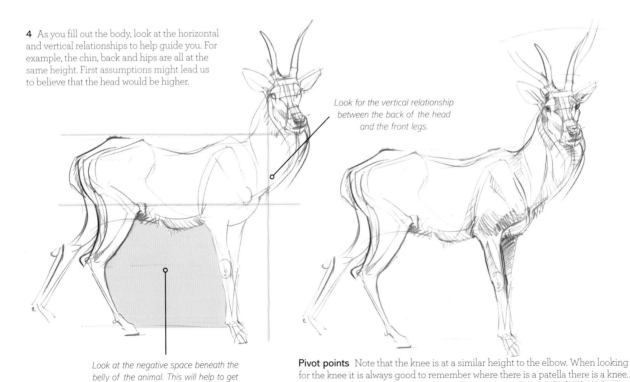

Look for the vertical relationship between the back of the head and the front legs.

Look at the negative space beneath the belly of the animal. This will help to get the length of the body in proportion.

Pivot points Note that the knee is at a similar height to the elbow. When looking for the knee it is always good to remember where there is a patella there is a knee. This is true of the vast majority of vertebrates, except for animals that have lost their hind legs such as whales.

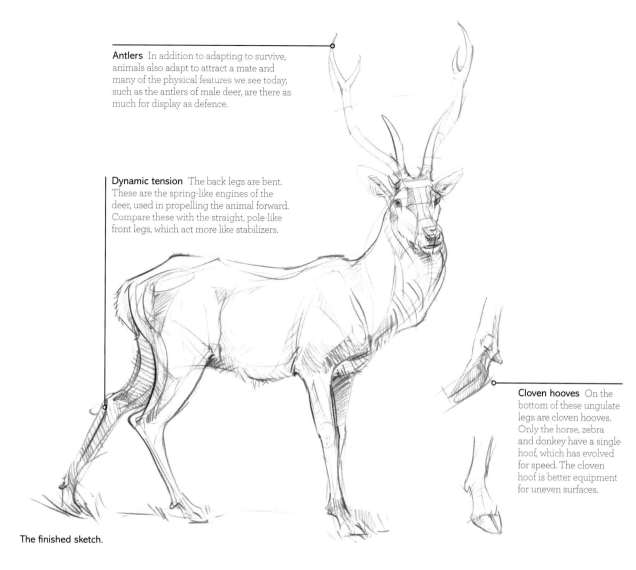

Antlers In addition to adapting to survive, animals also adapt to attract a mate and many of the physical features we see today, such as the antlers of male deer, are there as much for display as defence.

Dynamic tension The back legs are bent. These are the spring-like engines of the deer, used in propelling the animal forward. Compare these with the straight, pole-like front legs, which act more like stabilizers.

Cloven hooves On the bottom of these ungulate legs are cloven hooves. Only the horse, zebra and donkey have a single hoof, which has evolved for speed. The cloven hoof is better equipment for uneven surfaces.

The finished sketch.

Adaptation: Water deer

The appearance of the water deer led it to be misleadingly nicknamed 'the vampire deer'. The water deer is the only species of deer in which males don't have antlers. Instead they are armed with long, curved, and sharp upper canine teeth teeth which are used in display to ward off rival males, just like the antlers in other deer species. Native to China and Korea, there are two subspecies: the Chinese water deer and the Korean water deer.

To evade predators, water deer rely on hiding and on bursts of quick, bounding flight. Its skeleton has evolved to give the quick acceleration of a blade runner.

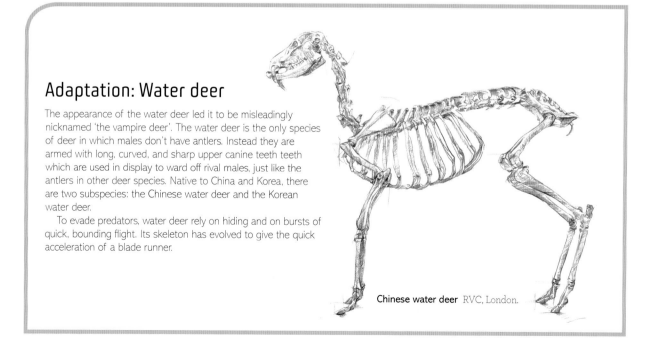

Chinese water deer RVC, London.

Fallow deer

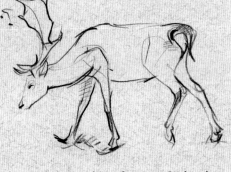

The fallow deer is a ruminant mammal belonging to the deer family, or *Cervidae*. As with most deer, they grow and shed new antlers each year. The fallow deer has fantastically splayed antlers that create rich shapes to sketch.

Drawing on midtone brown or grey paper can help you to use a wider range of values from light to dark; the paper itself offering the mid-range value. This gives you the opportunity to go darker or lighter. Using a quality oily white colouring pencil can help your drawings pop out of the page.

Even-toed ungulates

Even-toed ungulates like deer are sometimes thought of as cloven-hoofed. The tip of each phalange or toe has its own 'shoe' which the bone fits into. This is a hard rubbery sole which creates a thick nail, suitable for walking on. These hooves wear down with continual use, but grow through-out the animal's life. Most ungulates are herbivorous, getting their nutrition from plants, and have a multi-chambered, fermenting stomach.

Deer in Great Britain

The Romans introduced these elegant deer to Britain, but they went extinct following the collapse of the Roman Empire. It was not until the 11th century that fallow deer were reintroduced, this time from the eastern Mediterranean.

Form without tone Try to create a feeling of form without using shading by overlapping the lines. When one line is in front to the other, the implication is clear, that one thing is in front of the other. The viewer understands this convention; it is a way of reading a three-dimensional form without shading.

Simplicity By not painting all the spots with the same contrast, you will create a more impressionistic feeling of the animal in the open air. By squinting at your subject, you can reduce the amount of detail you are seeing. Look for the shadow of form (the shadow on the animal itself) and the cast shadow.

Initial linework Aim to quickly draw the position and posture of the animal with line, in order to the character of a deer's features. Use marks sparingly, to suggest hair. The eye can be indicated with a single mark.

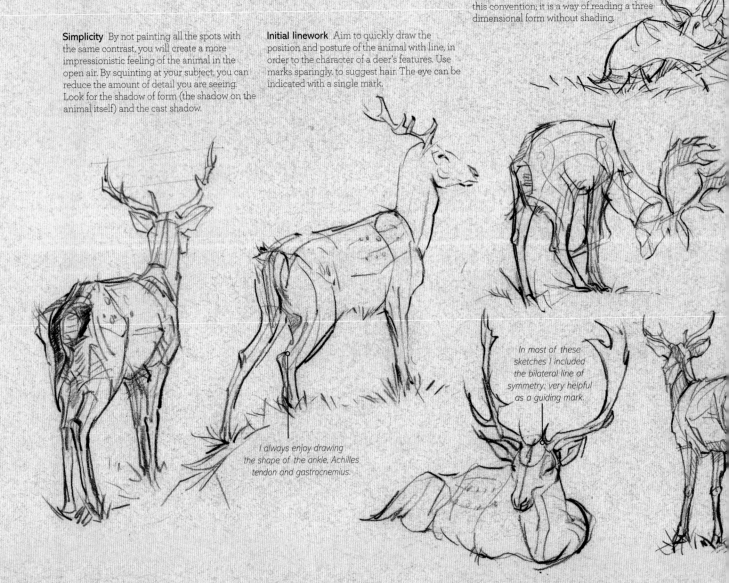

I always enjoy drawing the shape of the ankle, Achilles tendon and gastrocnemius.

In most of these sketches I included the bilateral line of symmetry; very helpful as a guiding mark.

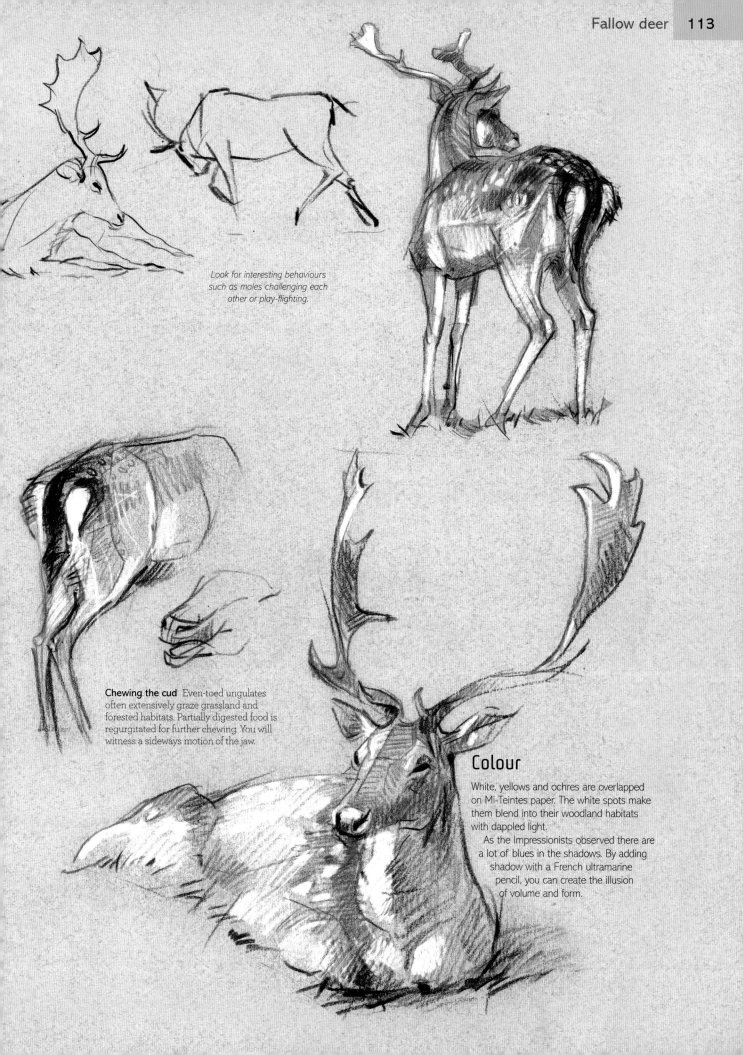

Look for interesting behaviours such as males challenging each other or play-flighting.

Chewing the cud Even-toed ungulates often extensively graze grassland and forested habitats. Partially digested food is regurgitated for further chewing. You will witness a sideways motion of the jaw.

Colour

White, yellows and ochres are overlapped on Mi-Teintes paper. The white spots make them blend into their woodland habitats with dappled light.

As the Impressionists observed there are a lot of blues in the shadows. By adding shadow with a French ultramarine pencil, you can create the illusion of volume and form.

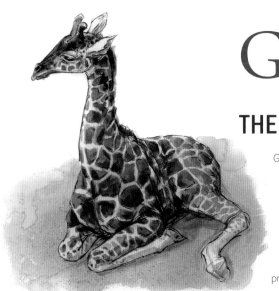

Giraffes

THE WORLD'S TALLEST GENTLE GIANT

Giraffes, the tallest living mammals in the world, are animals that we all have to look up to. Yet their height is not the only reason we should all admire the majestic giraffe. They are one of the most beautiful animals in the world. They are one of the most wonderful animals to sketch because of their beautiful shapes and character. Giraffes move gently and with grace, and so are great animals to sketch from life.

They have very feminine eyelashes and a black line around their eye gives them the appearance of having been outlined with eyeliner. The arabesque shape of their head and their long necks give them a unique and iconic look. Their long leg bones, besides being beautiful to draw, are also a fearsome weapon that can kick out at lions and other predators and knock them out dead.

ABOUT THE GIRAFFE

Seeing the world from the highest point of view of any animal on earth, and weighing up to 2 tons (4,410lb), giraffes may appear a strangely put-together animal, but they are remarkably well-adapted to their life on the plains of Africa, since they are able to reach food sources beyond those of other animals.

The ossicones are two residual horns that form conical protuberances between the ears. When a giraffe is born these ossicones lie flat against their head and start out as cartilage, so as to avoid hurting the mother. As the giraffe matures, the cartilage ossifies into bone, hence 'ossicones'.

GIRAFFE STUDY SHEET

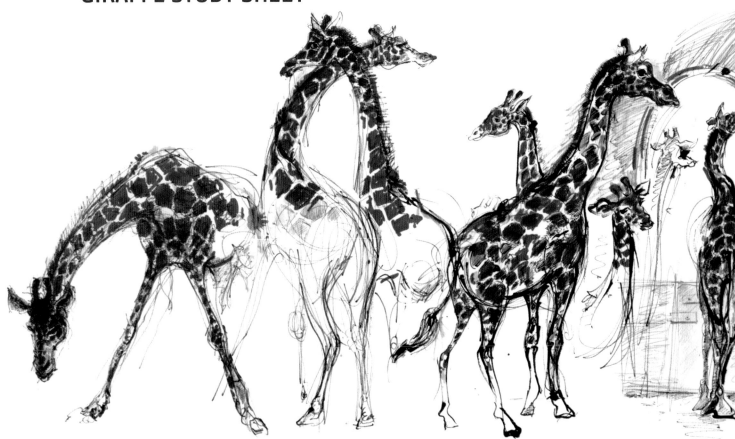

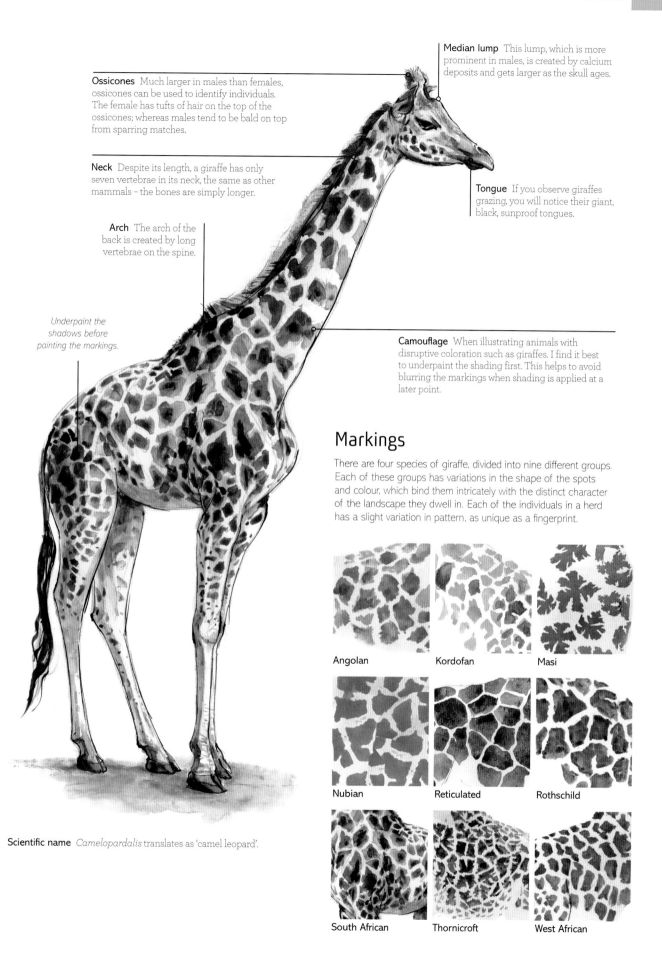

Median lump This lump, which is more prominent in males, is created by calcium deposits and gets larger as the skull ages.

Ossicones Much larger in males than females, ossicones can be used to identify individuals. The female has tufts of hair on the top of the ossicones; whereas males tend to be bald on top from sparring matches.

Neck Despite its length, a giraffe has only seven vertebrae in its neck, the same as other mammals – the bones are simply longer.

Tongue If you observe giraffes grazing, you will notice their giant, black, sunproof tongues.

Arch The arch of the back is created by long vertebrae on the spine.

Underpaint the shadows before painting the markings.

Camouflage When illustrating animals with disruptive coloration such as giraffes, I find it best to underpaint the shading first. This helps to avoid blurring the markings when shading is applied at a later point.

Markings

There are four species of giraffe, divided into nine different groups. Each of these groups has variations in the shape of the spots and colour, which bind them intricately with the distinct character of the landscape they dwell in. Each of the individuals in a herd has a slight variation in pattern, as unique as a fingerprint.

Angolan

Kordofan

Masi

Nubian

Reticulated

Rothschild

South African

Thornicroft

West African

Scientific name *Camelopardalis* translates as 'camel leopard'.

PIVOT POINTS

Where two or three bones meet, there are joints, which allow the skeleton to move. Having an understanding of where the pivotal points are beneath the skin of the animal can really help give your sketch's structure. They are very useful reference points, particularly when sketching animals in movement.

There are a variety of types of joint that create these pivot points. As artists we only need to consider hinge joints and ball and socket joints. These two types of joints are what allows our bodies free movement.

Hinge widget Hinge joints allow movement in one direction allowing flexing and extending motion. The elbow and knee joints are examples of hinge joints.

Ball and socket widget These joints are found at the shoulder and the hip and allow movement in three dimensions.

Lion pivot points Paying attention to pivot points will lend even the quickest sketch anatomical accuracy.

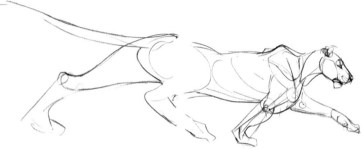

Example pivot points of the horse Try identifying the labelled pivot points on the sketches at the bottom of this page.

Hip joint

Shoulder joint

Wrist

'Hand'

Elbow

Finger joint

Knee

Toe joint

Ankle

Head pivot points As explained on page 25, the first two cervical vertebrae are responsible for the nodding and rotation movements of the head. The Atlas (C1) helps create up and down movements and the Axis (C2) from side to side.

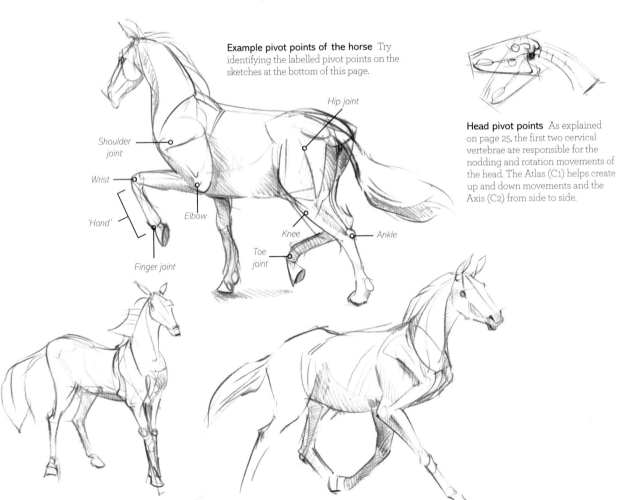

USING PIVOT POINTS

Once you are aware of pivot points, they will help you to draw animals from different angles. Start by identifying the pivot points and then build your sketch up around them. Awareness of which type of joint (see opposite) each pivot point represents will help, as it will provide an idea of where any other pivot points in the limb will sit.

When drawing mammals or birds, look for similarities with your own body: if you know your shoulder and hip are ball and socket joints, you know that a fox or antelope will also have ball and socket joints on their shoulders and hips. When drawing arthropods, you can look for gaps in their armoured exoskeletons – these will tally up with the joints.

Wings Pivot points apply to all jointed limbs; including wings, as shown here.

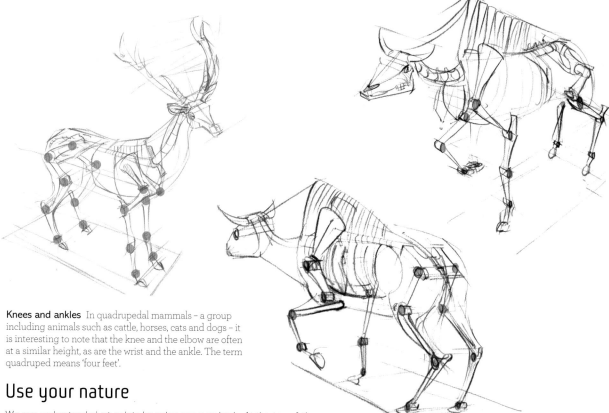

Knees and ankles In quadrupedal mammals – a group including animals such as cattle, horses, cats and dogs – it is interesting to note that the knee and the elbow are often at a similar height, as are the wrist and the ankle. The term quadruped means 'four feet'.

Use your nature

We can understand pivot points by using our own body. At the top of the arm you have a ball and socket joint. Try rotating your arm in the wide arcing circle that this joint enables. The next joint is your elbow, a hinge joint that allows you to move the lower part of your arm up and down. After that, your next pivot point is the wrist. Combined with the rotational possibilities created by the bones of your forearm (the radius and ulna), the wrist gives your hand incredible dexterity and finesse. Finally, your hands have multiple smaller pivot points: your knuckles, the pivot points in your fingers! This beautifully simple structure, some scientists believe is related to the evolution of our big brain, as 'man the tool maker'. Animation companies attach white dots to these pivot point when capturing live action footage. You can also find a very similar structure in your leg.

'I merely draw what I see. I draw what I feel in my body.' Barbara Hepworth

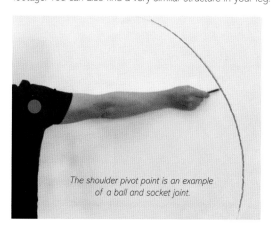

The shoulder pivot point is an example of a ball and socket joint.

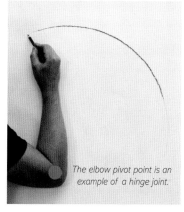

The elbow pivot point is an example of a hinge joint.

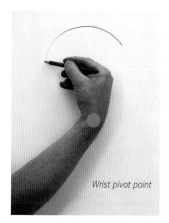

Wrist pivot point

Malayan tapirs

Tapirs look something like pigs with trunks, but they are actually related to horses and rhinoceroses. Having changed little over the last 35 million years, tapirs appear almost prehistoric – a striking combination of an elephant and pig. When fully grown, they have a large body with relatively long, slender legs. These animals are adapted to forest and jungle areas in both Central and South America and Southeast Asia, and are never far from water. There are considered to be four new world species in the Americas and one old world species, the Malayan tapir, which has a striking black and white coloration.

Tapirs are often called the 'gardeners of the forest', as they play an important role in dispersing seeds. Requiring a large range for foraging, tapirs take seeds of the fruits and berries they eat with them in their digestive tract, and disperse them as they defecate. This helps to boost the genetic diversity of plants in the forest.

When sketching at a local zoo, you will need to work quickly to capture both the overall shape and the impression that the weight is being carried along supported by the structure of the legs. There will be moments when the tapir you are sketching sits still for a while, giving you the opportunity for a more complete study – but be prepared for a lot of unfinished studies. Your quick pencil lines are trying to capture these fleeting moments on the page.

'The tapir lineage is an ancient one. These animals have changed little over tens of millions of years.'

MALAYAN TAPIR STUDY SHEET

Although tapirs have a large body, it is streamlined to be able to move through dense undergrowth. The Malayan tapir is black with a white saddle over the back and rump, which helps break up the outline shape of the body to predators.

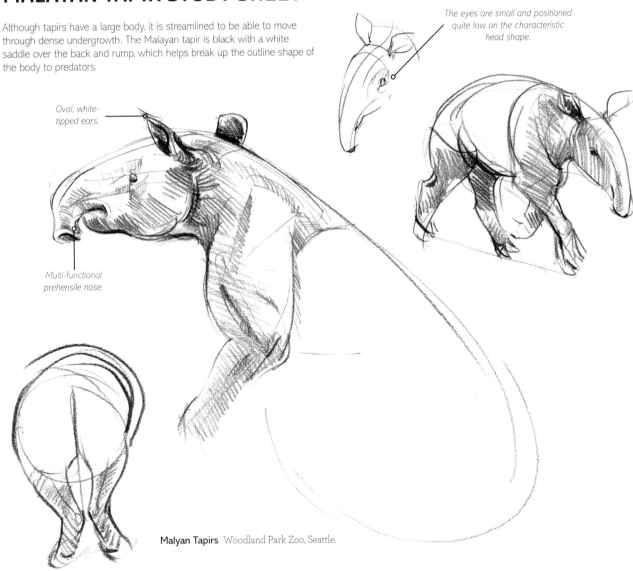

The eyes are small and positioned quite low on the characteristic head shape.

Oval, white-tipped ears.

Multi-functional prehensile nose.

Malyan Tapirs Woodland Park Zoo, Seattle.

Habitat adaptation

Their wide-splayed feet help tapirs to walk on the muddy and soft ground of their jungle and woodland homes. It helps to stop them from sinking.

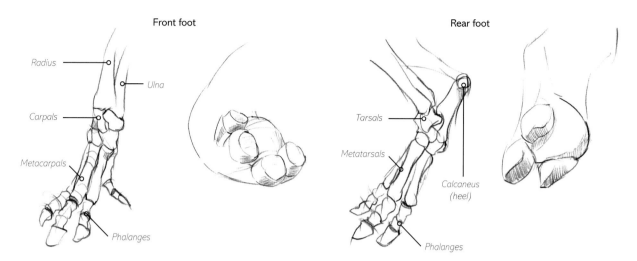

Front foot

Radius
Ulna
Carpals
Metacarpals
Phalanges

Rear foot

Tarsals
Metatarsals
Calcaneus (heel)
Phalanges

NOSE TO TAIL: TAPIR CALF

Camouflaged young Like many other animal species, their colouring at birth is part of a survival strategy. In the jungles and forests where tapirs live and forage, the striped and dotted coat of the calves matches the dappled sunlight of the understorey, helping the babies blend into their surroundings. Leave white areas to create this pattern, whilst not letting this dominate the form beneath.

Ears Tapirs' large cone-shaped ears are able to rotate. They are good at picking up the sounds of an approaching predator.

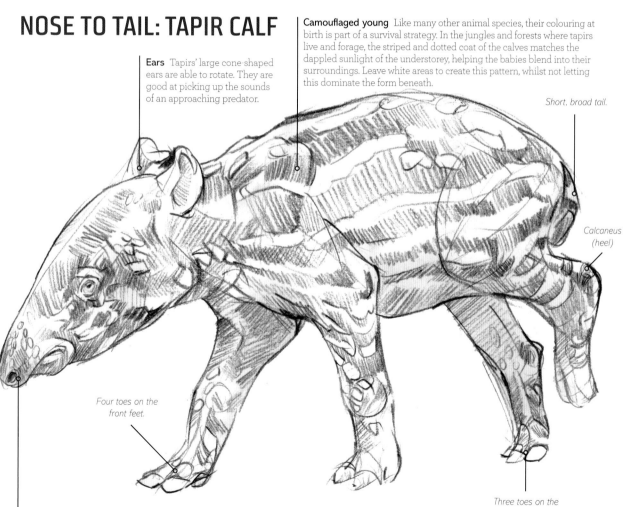

Short, broad tail.

Calcaneus (heel)

Four toes on the front feet.

Three toes on the rear feet.

Prehensile nose Tapirs use their noses to grab fruit, leaves and other food. Much like an elephant, tapirs can stretch their nose up to wrap around leaves and buds that would be out of reach to other animals, and pull them down to eat. The extra-long nose is also multifunctional – the tapir can use it as a snorkel. Much of a tapir's time in spent in water to keep cool and to escape predators.

Rhinoceroses

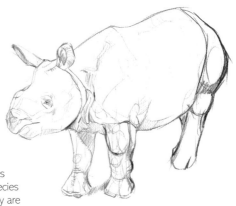

The name rhinoceros comes from Greek, meaning 'nose-horned'. There are five species alive today, all of which are highly endangered, primarily due to illegal hunting by humans. The white and black rhino live on the savannahs of Africa, while the Indian, Javan and Sumatran rhinoceros are found in the tropical forests and grasslands of Asia.

Members of the rhinoceros family are some of the largest remaining megafauna (large or giant animals), with all species able to reach or exceed 1 ton (2,205lb) in weight. The white rhino may weigh up to 2.3 tons (5,071lb). Although often regarded as aggressive, the rhino is a timid animal and will only charge to scare off an intruder. All species of rhino need a large intake of plant food to be able to sustain their massive bodies. They are one of the most fascinating creatures to be found alive on the earth today.

Bali, Nepalese rhinoceros calf Reminiscent of a Samurai warrior's armour, all species of rhinoceros are heavily protected by their thick skin.

NEPALESE RHINO STUDY SHEET

Memory drawing and having a short hand method of sketching is vital when the amount of time it takes to create the drawing is longer than the animal remains in the pose. I tend to simplify the legs down to tubes and see the body as a combination of plates. Look at the shapes of the armour plates and work from one shape to another to assemble the overall shapes.

At first it will seem impossible to recall the position, but with practice you will be able to recall the gesture. If you forget completely, leave the drawing and return to it when you witness a similar pose.

Parenting skills Particularly important in mammals, you can witness the bond between mother and calf whilst you sketch. At birth, the maternal impulses kick in: the mother behaves highly protectively towards her infant calf, sheltering it from dangers as the child plays and explores the new world it has been born into. Gradually, as the calf grows, the mother pushes the calf to independence.

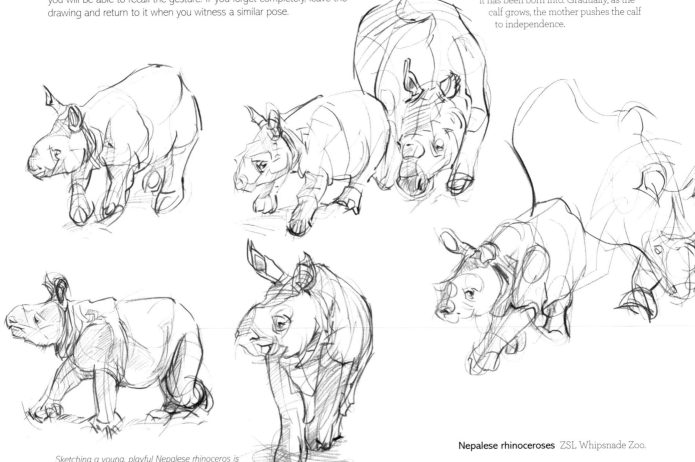

Sketching a young, playful Nepalese rhinoceros is extremely challenging. Developing a visual memory can help you to get the gesture down on paper.

Nepalese rhinoceroses ZSL Whipsnade Zoo.

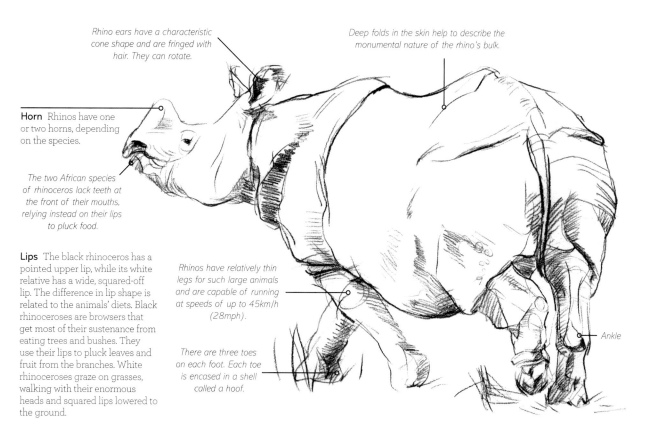

Rhino ears have a characteristic cone shape and are fringed with hair. They can rotate.

Deep folds in the skin help to describe the monumental nature of the rhino's bulk.

Horn Rhinos have one or two horns, depending on the species.

The two African species of rhinoceros lack teeth at the front of their mouths, relying instead on their lips to pluck food.

Lips The black rhinoceros has a pointed upper lip, while its white relative has a wide, squared-off lip. The difference in lip shape is related to the animals' diets. Black rhinoceroses are browsers that get most of their sustenance from eating trees and bushes. They use their lips to pluck leaves and fruit from the branches. White rhinoceroses graze on grasses, walking with their enormous heads and squared lips lowered to the ground.

Rhinos have relatively thin legs for such large animals and are capable of running at speeds of up to 45km/h (28mph).

There are three toes on each foot. Each toe is encased in a shell called a hoof.

Ankle

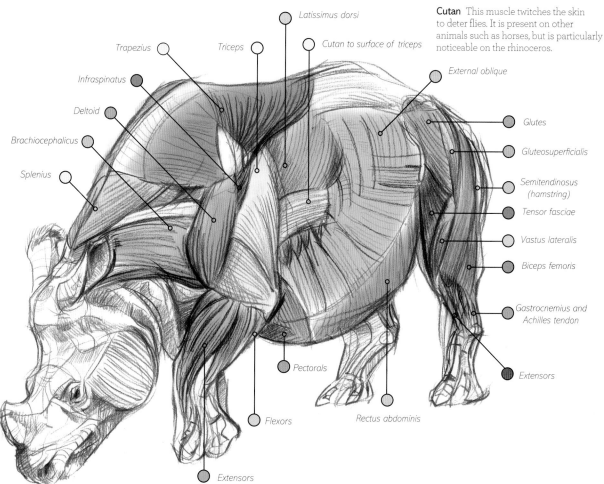

Latissimus dorsi

Cutan This muscle twitches the skin to deter flies. It is present on other animals such as horses, but is particularly noticeable on the rhinoceros.

Trapezius

Triceps

Cutan to surface of triceps

External oblique

Infraspinatus

Deltoid

Glutes

Brachiocephalicus

Gluteosuperficialis

Splenius

Semitendinosus (hamstring)

Tensor fasciae

Vastus lateralis

Biceps femoris

Gastrocnemius and Achilles tendon

Extensors

Pectorals

Flexors

Rectus abdominis

Extensors

Zebras

Zebras are an African member of the horse family; these are ungulates or hoofed animals. As such, we can use our understanding of horse anatomy to help us sketch the key pivotal points and musculature. Unlike horses and donkeys, zebras have a slightly grumpy temperament, which has made them impossible to tame – perhaps millennia of living on the daily life-threatening plains of Africa have led to the zebra evolving the strongly independent character of a hard-wired survivalist.

THE STRIPED EQUID

There are three species of zebras: the plains zebra, the mountain zebra and the Grévy's zebra. The latter belongs to its own sub-family, has its own particular characteristics, and are more donkey-like in appearance. The Grévy's zebra, found in both Kenya and Ethiopia, is the most endangered of all the zebras.

The bold black and white stripes of the zebra confuse its predators. Scientists have created computer models that emulate the optical illusions that the stripes create, and found that this is a very successful form of disruptive coloration that confuses not only their big cat predators, such as lions, but also smaller predators such as mosquitos. No two zebra stripes are exactly the same. As a result, their unique patterns can be used by scientists in the field to identify individuals.

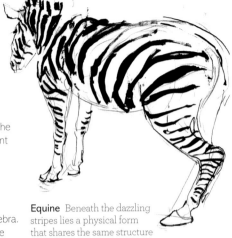

Equine Beneath the dazzling stripes lies a physical form that shares the same structure as a horse.

Long ears Zebras have acute hearing. Their ears can rotate to locate the source of the sound without having to turn their body.

Swift Although their legs are not as long as that of a horse, zebras can run at great speed of up to 70km/h (43mph) for short periods, and have great stamina.

SKETCHING HERD ANIMALS

Zebras herd, for there is safety in numbers. Their already effective disruptive camouflage is enhanced further when the individual is surrounded by other zebras in a herd.

While sketching, you will often find other zebras walking in front of the individual you are observing. Take this potential frustration of drawing wildlife in your stride and simply add it in your sketch, overlaying the old animal with the new, just as the cave artists did. This helps to capture the sense of the group.

There is a proverb:
'If you want to go further, go together!'

NOSE TO TAIL: GRÉVY'S ZEBRA

The engines of the front and back legs and their muscle groups work in unison on either side of the animal to create motion. Knowing where these and other important muscles groups are can help with your grooves and shading, to sculpt the form beneath the stripes. Understanding the muscles in a standing pose (above) will help you imagine them in movement (below).

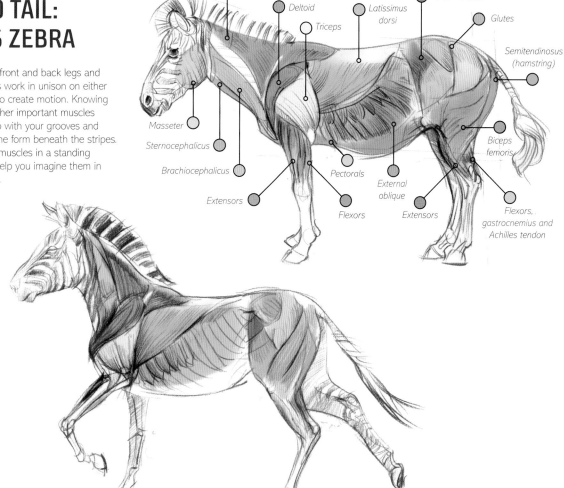

Trapezius
Deltoid
Triceps
Latissimus dorsi
Tensor fasciae
Glutes
Semitendinosus (hamstring)
Masseter
Sternocephalicus
Brachiocephalicus
Extensors
Pectorals
Flexors
External oblique
Extensors
Biceps femoris
Flexors, gastrocnemius and Achilles tendon

ABOUT THE ZEBRA

The ancestor of all horses was small – the forest-dwelling *Eohippus*, meaning 'dawn horse'. This was a tiny dog-sized horse that stood between 25–45cm (10–18in) in height. The evolution of the horse goes back 50 million years, though the common ancestor for the group that includes horses and zebras diverged around 4 million years ago. Zebras were amongst the first of the Old World horses.

The equines (the horse, zebra and donkey) are the only living animals with a single toe. The primitive horse, *eohippus*, had four hoofed toes on the front feet and three hoofed toes on each hind foot. In modern species, these toes have reduced down to the single equine toe for speed. Scientific research has revealed that as the horse's body mass increased, the central toe became larger and more robust, a particularly great escape mechanism on relatively flat surfaces. Interestingly, the modern South American tapir (a distant relation to the equines) has the same arrangement of the toes as *eohippus*.

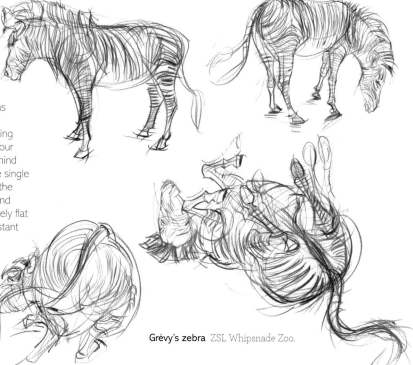

Grévy's zebra ZSL Whipsnade Zoo.

HABITAT: THE FARM

Spending a day sketching at a farm is a wonderful experience and a good way of learning to sketch animals. The docile nature of the animals means they are not afraid.

DOMESTICATED ANIMALS

Our recent period of evolution has seen us become farmers; and we have formed allegiances with other animals during this period. Our ancestors were hunter-gatherers, with our food been dependent of successful hunts of wild animals and the gathering of wild fruit, grains, vegetables and tubers. At this time we were nomadic: when supplies ran out, these hunter-gatherers moved on to fresh terrain and resources.

About 10,000BC, agriculture began independently in different parts of the globe. Farming meant that people did not need to travel to find food and they created settlements and a less dangerous environment for a family to grow up in. Seeds were scattered to grow tall grasses such as wheat and barley. Farmers then selected and planted only the best seeds from their last crop. Wild animals such as cattle, sheep, pigs and goats and horses were selectively bred to create more docile animals. People tamed other animals, like dogs and cats, along the way.

Wolves have become dogs. This relationship goes well back into the ice age. Dogs were one of the first animals to be domesticated. They descended from wild wolf cubs that had learned to live with human families, who fed and petted them. It is partly this sociable element of certain animals that has allowed us to tame them. Not all animals are tameable. Tigers and rhinoceroses, for example, remain dependent on their natural habitats for their very survival.

Food and sustainability

Much of the world's wildlife depends on farmland. Food production cannot be at the expense of the wild. The diversity of our wild species needs to be preserved alongside our domesticated animals. Many farmers are leading the way to address this, farming in a way that meets our food needs while also giving wild species a home; supporting a diverse and thriving environment.

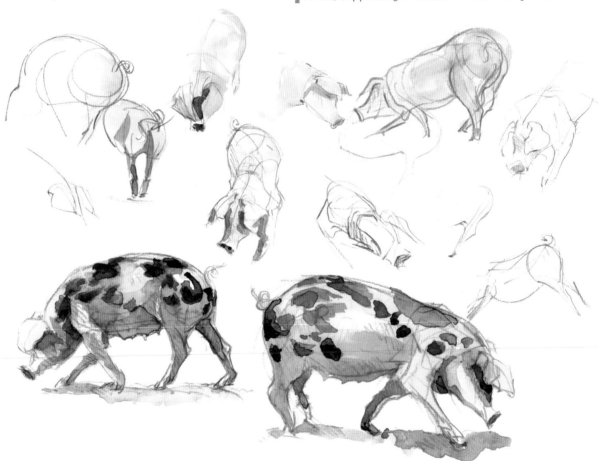

'I love pigs. I don't care if they're little pigs or big pigs, with long snouts or short snouts, with ears that stick up or ears that flop down. I don't mind if they're black or white or ginger or spotty. I just love pigs.' Dick King-Smith

Sketching at the farm

Farmyard animals tend to move more slowly than their wild
ancestors and are less timid; you might even find a goat
chewing the corner of your sketchbook!

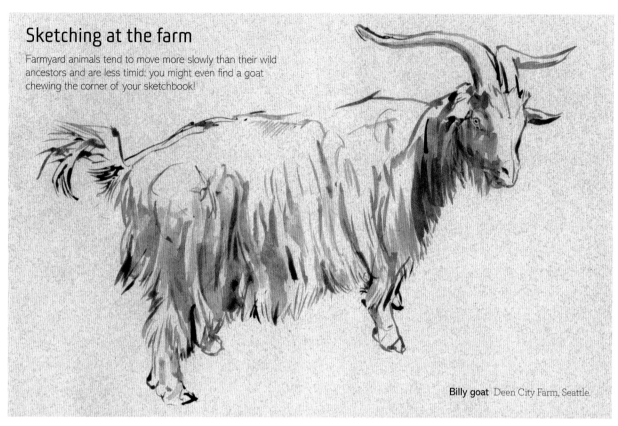

Billy goat Deen City Farm, Seattle.

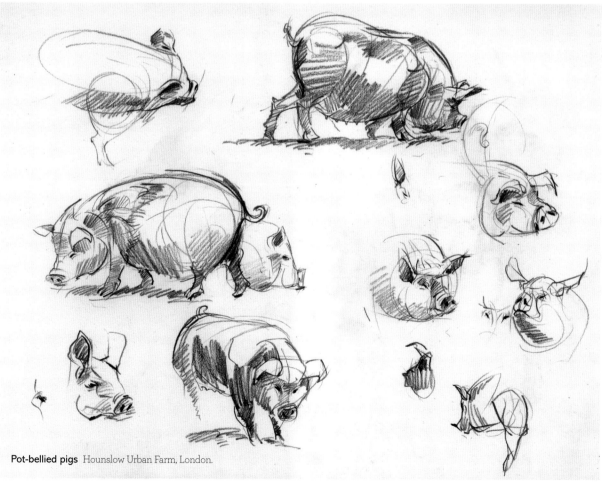

Pot-bellied pigs Hounslow Urban Farm, London.

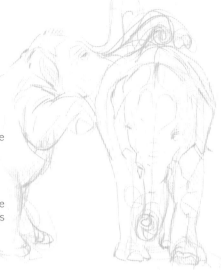

Elephants

Elephants have followed their own individual evolutionary track. With their unusual appearance and long trunk, it sometimes seems incredible that they exist alongside us. You feel that they have been here for eternity, their creased lines of skin suggesting age, wisdom and a repository of long memories stretching back in time. You can't tell what an elephant is thinking, but they appear to be thinking about something very deeply.

By and large, elephants seem to be gentle souls; easy-going and not at all selfish. They live in social family groups just like we do, and cannot be kept individually. They enjoy each other's company, are ambassadors of maternal and paternal care, and mourn the loss of their young and companions.

ABOUT THE ELEPHANT

Elephants are herbivorous, ungulate hoofed mammals, of the order *Proboscidea*. Their distinctive trunk is an elongation of the nose and upper lip. A modern elephant's trunk is long and incredibly dextrous – thousands of muscle pairs allow it to twist and turn in all sorts of directions. With this trunk, elephants can investigate their surroundings, pull down branches to get at nutritious leaves, squirt water, strip foliage, and rip up grasses.

The largest land animal alive today, elephants have an average life expectancy of sixty years, a little shorter than humans. However, whereas we stop growing in our late teens, elephants appear to keep growing throughout their life: a fifty year-old bull is notably larger than a twenty-year-old. A male African elephant may grow as tall as 4m (13ft) and weigh anything up to 7 tons (15,432lb); the weight buttressed by their thick, pillar-like legs. It is their sheer size which means that elephants have no natural predators.

A group of elephants is known collectively as a herd. Led by a female matriarch, herds usually consist of females of various ages and their young. Adult male elephants, known as bulls, tend to wander on their own and only join the herd when the female is sexually active. Elephants are very protective of their young, which stay very close to their mothers. Other females and males will assist in seeing off predators. Communication within the family group takes a variety of forms, one of which is vocalisations. Their deep reverberating sounds can travel miles, and can be picked up as vibrations through the fatty pad of the elephant's feet.

The three species of elephant

African elephants live in sub-Saharan Africa, the rain forests of Central and West Africa and the Sahel desert in Mali. Asian elephants live in India, Nepal and Southeast Asia in scrub and rain forests. African elephants have recently been split into two distinct groups, those that live mainly on the savannah and the African forest elephant which primarily live in rainforest areas. While the debate still goes on, there are generally thought to be three distinct species.

African elephant *Loxodonta Africana* This species inhabits a wide range of habitats, from deserts and savannah, to bush and rainforest. The largest elephant species, African elephants must forage across a large area for the substantial amount of food that is required to keep them alive. Both male and female African elephants have large forward-curving tusks.

African forest elephant *Loxodonta cyclotis* Formerly regarded as a sub-species of the African elephant, this elephant is now thought to be a separate species entirely. The African forest elephant is characterized by beneficial adaptations to forest life: it is smaller and darker-skinned, with smaller, more rounded ears. The tusks are yellowish to brown in colour and point downwards, which help with moving through dense vegetation. The trunk is hairier

Asiatic elephant *Elephas maximus* Asiatic elephants have smaller ears than both African species; less likely to snag and tear on the branches of their forest environment. Their tusks are also smaller and may be absent in females. Their molar teeth show that they are more closely related to the extinct woolly mammoth than the African elephant. This species has a long relationship with humans and all of the four sub-species have been tamed.

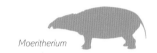

Moeritherium

Elephant ancestors Walking the earth 37 million years ago, the pig-sized Moeritherium had an appearance more like a pygmy hippopotamus than a modern elephant. It had a short, stubby trunk, like that of a modern tapir. As elephants evolved they grew bigger, leaving their mouths further and further from the ground. To take up water and food, the animals needed longer and longer trunks.

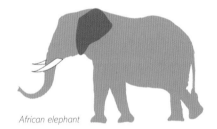

African elephant

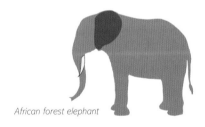

African forest elephant

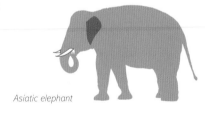

Asiatic elephant

Asiatic elephant

African elephant

Telling the difference

Asian elephants have one 'finger' at the tip of their trunk, while African elephants have two. The large ears of elephants, which are used to keep cool, are another good way to distinguish between the different species: the African elephant has large ears in the shape of Africa, while the Asian elephant is smaller and has smaller ears.

ANATOMY OF THE ELEPHANT

Before going to spend a day sketching elephants it is a good idea to have a review of this page. Having an understanding of the main pivot points and underlying musculature can really help field sketching.

Pivot points The pivot points (see pages 116–117) of the elephant can be difficult to see within the sheer bulk of the animal. They are highlighted here in pink.

Lightweight skull The huge dome-shaped skull of the elephant is a sculpture in its own right, beautifully rendered by artists such as Henry Moore. To reduce weight, the skull is full of air cavities.

Teeth and tusks Elephants use their enormous molar teeth for grinding up fibrous roots and other tough plant material. The tusks are extended incisor teeth, used for defence, digging and even stripping the bark from trees.

Leg bones The leg bones of an elephant are the largest of any land animal. The column-like structure support the massive bulk of the elephant.

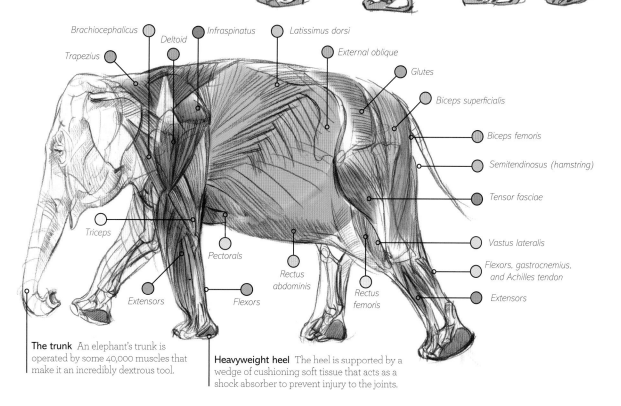

Atlas (C1) Axis (C2) Scapula Humerus Radius Ulna Carpals Olecranon Phalanges Femur Fibula Tibia

Brachiocephalicus Deltoid Infraspinatus Latissimus dorsi External oblique Glutes Biceps superficialis Trapezius Biceps femoris Semitendinosus (hamstring) Tensor fasciae Triceps Vastus lateralis Pectorals Flexors, gastrocnemius, and Achilles tendon Rectus abdominis Extensors Extensors Flexors Rectus femoris

The trunk An elephant's trunk is operated by some 40,000 muscles that make it an incredibly dextrous tool.

Heavyweight heel The heel is supported by a wedge of cushioning soft tissue that acts as a shock absorber to prevent injury to the joints.

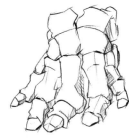

Toes

The number of toes varies between different species of elephants:
African elephant Four toes on the front, three on the back.
African forest elephant Five toes on the front, four on the back.
Asiatic elephant Five toes on the front, four (rarely five) on the back.

ELEPHANT STUDY SHEET

Spending time sketching elephants from life is a joy! Taking a break from our hectic lives to sketch elephants can be a relaxing, even cathartic, experience. Nothing you do will ever impress an elephant, so have a break from life's expectations. Settle in and watch the elephants for a while before you start sketching. Simply observe the elephants and listen to the noises they make, take a moment to get into their world. The heavy body mass of the elephant seems to almost hang off the pillar- like structure of the legs.

I don't dive in too darkly at first with my mark-making implement, this allows me to make changes as the drawing develops. Work up towards the dark notes, like a piece of music starting quietly and working to a crescendo. Explore the variations of your mark-making your implement can create. Elephants move fairly slowly, at times, but their trunk is in continual motion. As a result, I recommend that you sketch the head first and then freeze the trunk in a gestural position you have witnessed.

Key behaviours and features

Dust baths African elephants regularly take a dust bath. They use their trunk to suck up dust which they then blow onto their backs. The layer of dust acts like a sunscreen, protecting the elephant's skin from the strong rays of the African sun, and also acts as a good insect repellent. All elephants enjoy bathing and the dust bath is just as important as those in water to maintain health.

Adult elephants The dignified adults are relatively slow, with gentle movements, so they are a great animal to draw to get you started.

Play Young elephants always seem to want to have fun and play; this is a great challenge for your gestural drawing ability.

Weight You will be able to see the fatty pad spread out as the elephant places its weight on the foot.

Skin An elephant's skin is etched with deep, form-wrapping wrinkles that can be sketched to help express the monumental nature of these enormous creatures.

Trunk While sketching, you will notice the trunk is in continual movement. Decisive action is necessary to freeze-frame this inquisitive organ into one position.

Interaction See how the different members of the herd behave around one another.

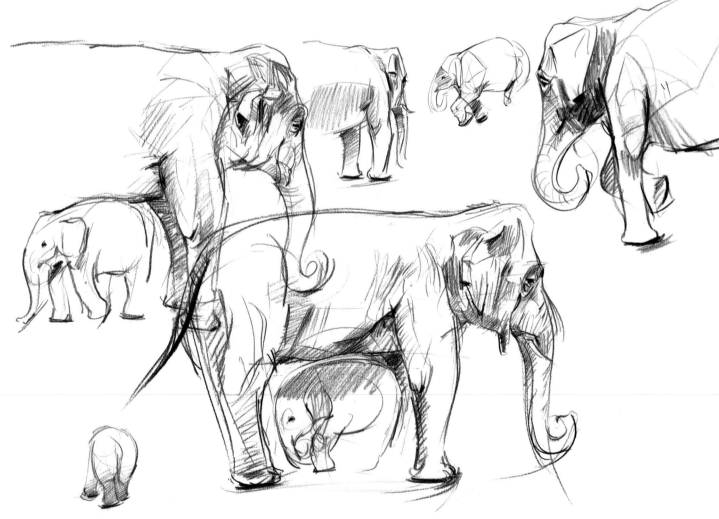

Create quick sketches of behaviour you witness. Young elephants stay close to their mothers for protection. Here, a calf finds shade beneath the mother's stomach.

Negative space

When sketching the legs of an elephant look at the shape of the space between the legs rather than the legs themselves. This will help you judge the length of the body. Makes adjustments if this is too short or long at the early stages of your drawing.

Example of negative space between legs.

Example of blocking in.

Masterwork

The shadowy eyes of elephants seem to hold a million memories. This can teach us what separates a technically good drawing from one that moves us. Rembrandt's drawings of elephants capture not just what is physically present, but also the thoughts and memories of the subject.

Asian elephants ZSL Whipsnade Zoo.

Going further Initial sketches can be worked into and developed. Explore mixed media such as dip pen and ink to sculpt the monumental form of elephants on the page.

Blocking in with pencil

By squinting at the elephant, you can reduce down the detail. Look for the main areas of light and shade. To block this in quickly try using the side of the pencil tip by holding the pencil flat.

Sloths

A LIFE UPSIDE DOWN

Sloths are a tropical group of mammals that inhabit the Americas. They move through their rain and cloud forest habitats while hanging underneath the branches. They are related to anteaters and both share a coarse coat of hair, but rather than snorting up insects, sloths prefer leaves. Like anteaters, sloths lack the normal mammalian dentition. Instead, they have a number of cylindrical, rootless teeth, to grind up food that may take as long as a month to completely digest.

There are six different species of sloths in total, broken into two main families: the two-toed and three-toed. Both have three toes on the back, but the two-toed sloths have just two digits on their forelimbs. The two-toed sloth is also slightly bigger than their three-toed cousins. In all species, the claws acts as hooks, allowing sloths to hang from branches without having to waste energy grasping. While other monkeys and tamarins use the branches by running on top, the sloth hangs upside-down below – they are unique in exploiting the underside of tree branches. For this they have evolved their own set of curious adaptations.

Sloths are primarily arboreal, although the three-toed sloth is also a good swimmer, allowing it to move across mangrove swamps. As the name suggests, everything in a sloth's life works slowly from its movement to it's their extremely slow metabolism. The scientific name for sloths is *bradypus*, which is the Greek for 'slow feet.' A sloth on the ground is almost helpless so they spend the majority of their lives in the trees.

Easy to sketch Create an animation-like sequence of a sloth moving along a branch by sketching the same sloth in different positions. You will need to check the feeding time at the zoo – in captivity, sloths can sleep anything up to twenty-one hours a day. In the wild their sleep patterns are more similar to our own.

SLOTH ANATOMY

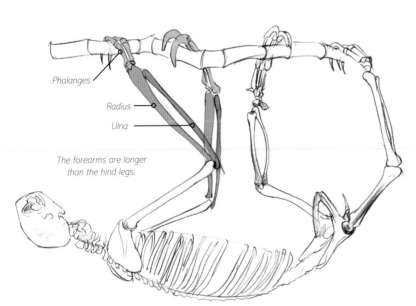

Phalanges

Radius

Ulna

The forearms are longer than the hind legs.

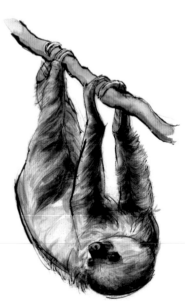

Fur The fur on a sloth forms clumps of wavy hair, that grow backwards, helping rainwater to flow off its body easily. Sketch the hair in the directions that it grows.

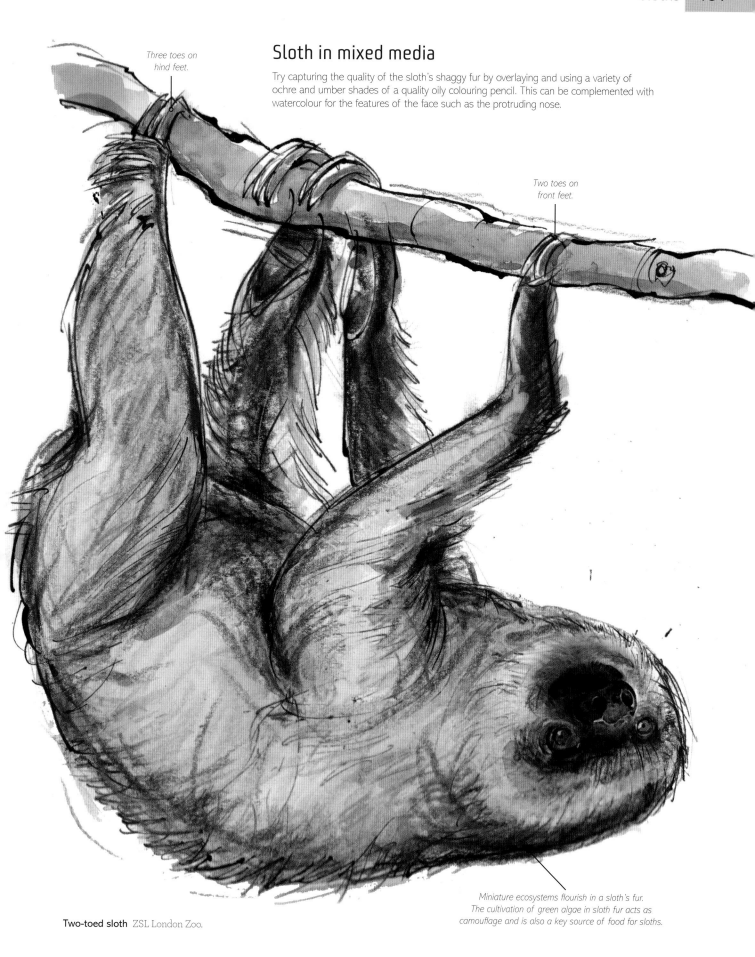

Three toes on hind feet.

Sloth in mixed media

Try capturing the quality of the sloth's shaggy fur by overlaying and using a variety of ochre and umber shades of a quality oily colouring pencil. This can be complemented with watercolour for the features of the face such as the protruding nose.

Two toes on front feet.

Two-toed sloth ZSL London Zoo.

Miniature ecosystems flourish in a sloth's fur. The cultivation of green algae in sloth fur acts as camouflage and is also a key source of food for sloths.

CATS

Sleek, lithe and highly agile, cats can be a challenging subject to get down on paper. Their flexible spines allow for fluid motions and swift, springing movements. Capturing the shapes of their distinctive features – the muzzle, legs, paws and whiskers – can be a challenge. However, cats all share a similar body plan and muscular structure, familiarity with which can help us. This body plan, known as 'digitigrade', evolved to allow cats to sneak quietly up on prey. It is similar to us walking on our tiptoes. We can scale this body plan larger or smaller, depending on the species of cat. This allows us to identify the structure of the pivot points and draw the various muscles we might see underneath the surface of the skin, regardless of the sort of cat we are drawing.

'All cats are carnivores and as such are predators.'

In addition to physical similarities, the cats also share a unique set of behavioural characteristics. These are so distinctive to cats that our language has words that we primarily associate with these creatures, such as 'purring' or 'stalking'. All cats are carnivores and as such are predators. Meat is their food of choice – they have evolved no sweet receptors on their tongues. Wherever they are, whatever the species, cats stalk their prey with intense focus and graceful movements, before they pounce for the kill.

The relationship of predator and prey is ancient, unforgiving and relentless. On the plains of Africa, this is dramatically shown in the relationship between the predatory big cats, animals such as lions, cheetahs and leopards and their prey, such as impala. Both try to out-compete one another with a host of adaptations. Impalas' legs have lengthened over the generations to create long 'vaulting poles' that enable them to run away with explosive speed. The cats, meanwhile, have evolved keen binocular vision by having their eyes mounted on the front of their heads, to help judge the distance of their prey; and have sharp teeth and claws for grappling and finishing the job.

Some big cats, like tigers, hunt on their own. Others, like lions, hunt in packs. This gives them the ability to take down the massive animals of the African savannahs, such as giraffes, which would be impossible for a single lion. The whole pride then shares the prize. This is a good strategy as all members of the group get a meal; which ensures the future of the pride. Other feline species find success in catching smaller animals and keeping the meal to themselves.

Hunting can be a lot of work for relatively small rewards and a lot of hunts end in failure. For prey animals it is enough for them to escape the chase and live another day; while for predatory cats, their prize of winning a hunt is a meal to refuel their muscular bodies.

FAMILY FELIDAE

All cats are members of the Felidae family. Within this family are two sub-families. The first, the Pantherine, includes the really big cats. Four of this sub-family – the lions, tigers, leopards and jaguars – have the ability to roar. Scientists have speculated that cats with the ability to roar use it to scare away rivals or to mark out their territory.

The other sub-family is called the Felinae, includes ocelots, cougars, cheetahs, lynxes and even the domestic house cat. These cats can create a comforting purring sound, a sort of self-comforting behaviour, similar in aspect to a dog wagging its tail or a human smiling. Because of the structure of the vocal cords, cats that purr never roar; and vice versa. The snow leopard is an exception; in that it neither truly purrs nor roars.

These two sub-families have descended from a single ancestor, a cat called *Proailurus* might have been one of the first felids. This animal evolved cat-like characteristics some twenty-five million years ago. The domestication of cats began before the Egyptians and may be as long as ten thousand years ago, when perhaps wild cats started to hang around human camps to forage for scraps of meat from a hunt.

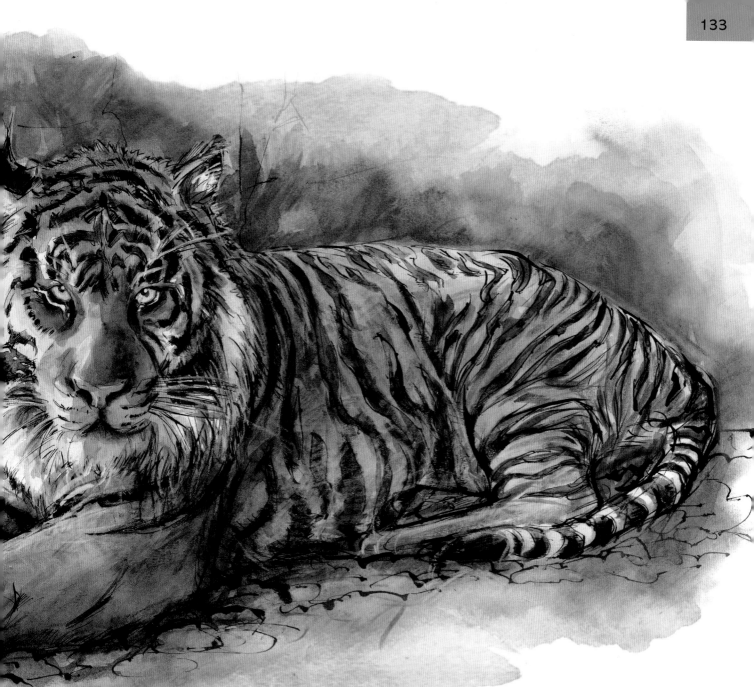

Jae Jae, male Sumatran tiger ZSL London Zoo.

*'The earth becomes an amphitheatre for all life and
the struggles of each adaption a play, to be played
out in the game of life itself!'*

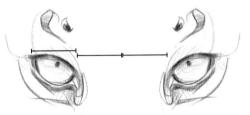

Jaguars

ICONIC

These elusive cats stalk and ambush prey in the Americas. Their beauty and power has made them icons; creatures that appear in the legends of the region. In an area along Mexico's Yucatán Peninsula, depictions of a jaguar god can be found in the ruins of Mesoamerican civilizations. In these ancient myths, the jaguar is depicted as an animal that can move between worlds. This may be due in part to the jaguar's ability to move and hunt freely between the trees, ground and water, during both the day and night.

The jaguar is an apex predator, meaning that it is at the top of the food chain no other animals prey upon it. It is the only big cat found in the Americas. The jaguar is the Americas' equivalent of the leopard; although it is more heavily muscled than the leopard, both cats share a similar place in their respective ecosystems. Both can climb trees, taking advantage of this as a safe place to sleep, ambush predators and to return with a meal, away from other carnivores and scavengers.

Part of the mythical qualities associated with jaguars might well be due to their solitary nature. Except in the mating season, each hunts entirely alone, in territories of 50–130km² (20–50 square miles). These territories or home ranges are presided over by a male who aggressively protects both his territory and female from other males. The cats leave claw and scent marks as they roam their territory to let other jaguars know that the area is taken. In these home territories, the females bring up the young entirely alone.

Jaguars have incredibly powerful jaws and can kill their prey, animals such as deer, monkeys, tapirs and even crocodiles with a crushing bite. Sometimes jaguars take advantage of height, pouncing down from branches of trees on their unsuspecting victims. Unlike most cats, jaguars enjoy water, where they can swim to hunt for fish and anything else they can catch. Like other members of the Pantherine subfamily of cats, the jaguar can roar. It is thought that roaring might help a male attract a female mate as well as warning off intruders into its territory.

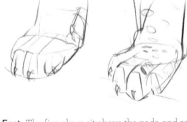

Keen observer The gap between the jaguar's forward-facing eyes helps with their binocular vision. When sketching, leave a distance equal to two eye widths between the jaguar's eyes for the correct spacing.

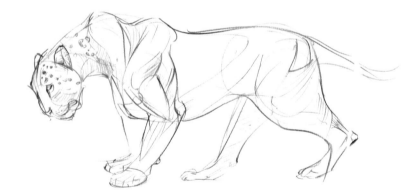

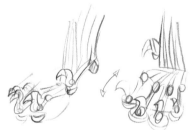

Feet The five claws sit above the pads, and are retractable. Notice that the first digit, equivalent to our thumb, does not touch the ground. As a result, a cat's paw print will show marks only for four digits – the fifth toe is raised off the ground, and the claws are drawn in.

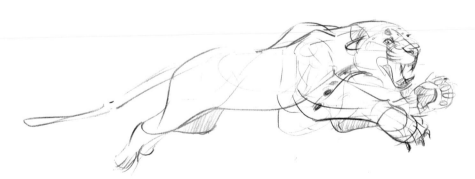

Jaguar anatomy

The jaguar has a compact muscular body, capable of both huge explosive power and fluid, dextrous movements. Knowing where these muscles are can help with your shading.

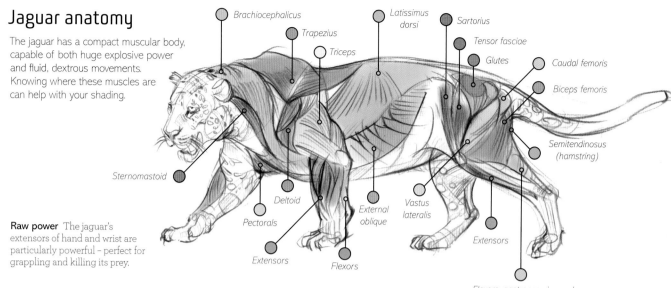

Brachiocephalicus

Trapezius

Triceps

Latissimus dorsi

Sartorius

Tensor fasciae

Glutes

Caudal femoris

Biceps femoris

Semitendinosus (hamstring)

Sternomastoid

Deltoid

Pectorals

Extensors

Flexors

External oblique

Vastus lateralis

Extensors

Flexors, gastrocnemius and Achilles tendon

Raw power The jaguar's extensors of hand and wrist are particularly powerful – perfect for grappling and killing its prey.

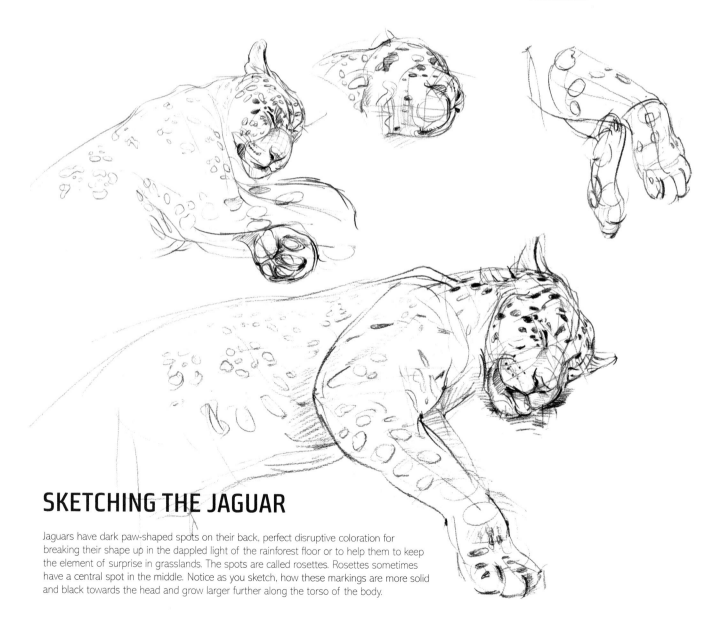

SKETCHING THE JAGUAR

Jaguars have dark paw-shaped spots on their back, perfect disruptive coloration for breaking their shape up in the dappled light of the rainforest floor or to help them to keep the element of surprise in grasslands. The spots are called rosettes. Rosettes sometimes have a central spot in the middle. Notice as you sketch, how these markings are more solid and black towards the head and grow larger further along the torso of the body.

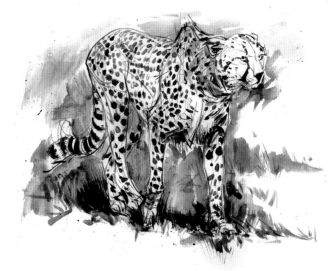

Cheetahs

The cheetah is the world's fastest land mammal. With acceleration that would outstrip most sports cars, a cheetah can reach 96km/h (60mph) from a standing start – in just three seconds. On average, cheetahs have to go out two and half times on a hunt to achieve a kill.

These are the sprinters of land animals, with highly specialized athletic bodies evolved to catch prey. Their size is also optimal for maximum speed. Cheetahs, like lions, have a speed advantage over their prey in a straight line, so antelopes can never directly out-run the cheetah. Prey animals can, however, survive the chase if they twist and turn sharply at the last minute – though even this is no guarantee of safety, as cheetahs have evolved a long balancing tail to aid in quick turns.

CHEETAH ANATOMY

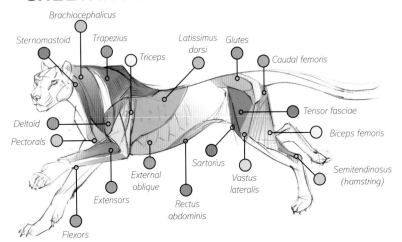

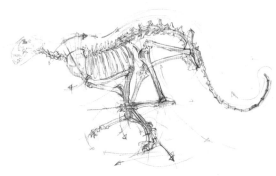

Gait When running, the back legs pass in front of the front legs in order to achieve the maximum distance and fastest speed possible.

CHEETAH STUDY SHEET

To achieve such high speeds, cheetahs demonstrate an incredible coordination of bones, muscles and tendons, and show fluidity of movement, which must be captured in your sketch.

Flexible spine Look for the cheetah's long, highly flexible backbone. This coils and uncoils like a spring, helping to propel the animal forward.

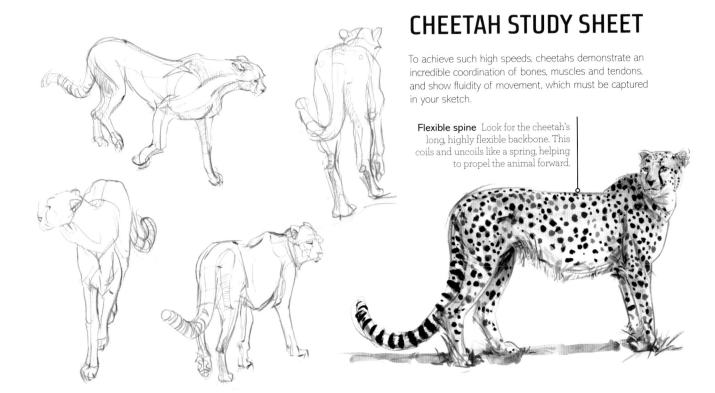

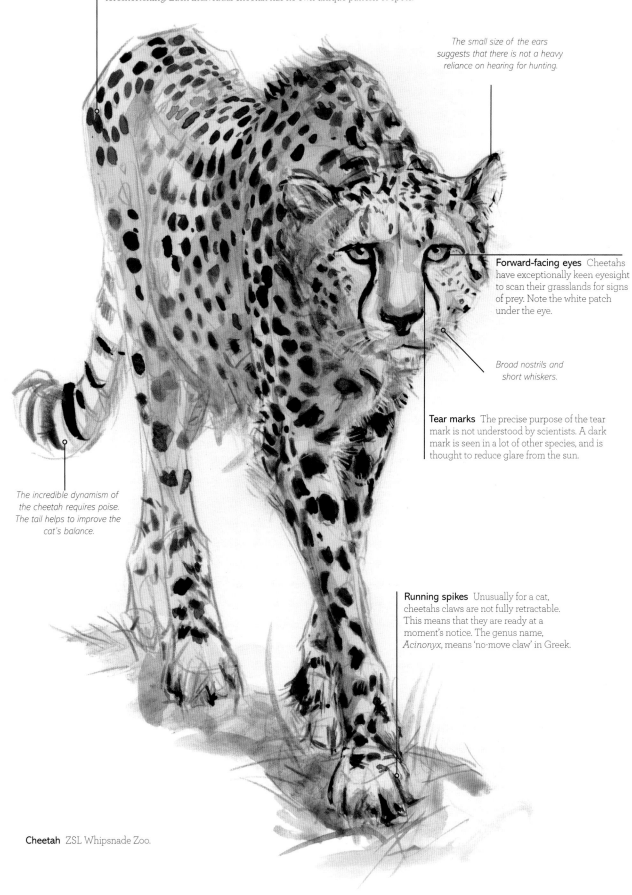

Spots The spotted fur of the cheetah helps it to blend into its surroundings so that it can stalk and hunt its prey more effectively. When sketching a cheetah, try to visualize these spots as ellipses that wrap around the form. This can help with foreshortening. Each individual cheetah has its own unique pattern of spots.

The small size of the ears suggests that there is not a heavy reliance on hearing for hunting.

Forward-facing eyes Cheetahs have exceptionally keen eyesight to scan their grasslands for signs of prey. Note the white patch under the eye.

Broad nostrils and short whiskers.

Tear marks The precise purpose of the tear mark is not understood by scientists. A dark mark is seen in a lot of other species, and is thought to reduce glare from the sun.

The incredible dynamism of the cheetah requires poise. The tail helps to improve the cat's balance.

Running spikes Unusually for a cat, cheetahs claws are not fully retractable. This means that they are ready at a moment's notice. The genus name, *Acinonyx*, means 'no-move claw' in Greek.

Cheetah ZSL Whipsnade Zoo.

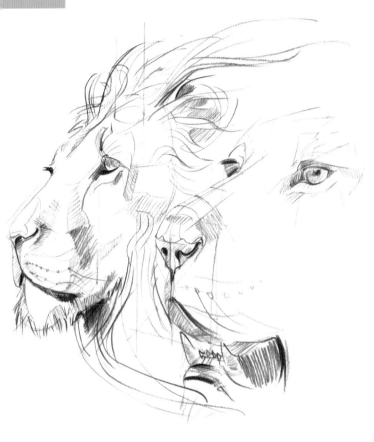

Lions

Lions have captured our imagination for centuries. Traditionally regarded as the 'king of beasts', the lion symbolizes courage, nobility, royalty, and strength.

Lions are unique in the cat family in term of their close social groups called prides. An African lion pride generally consists of up to three males, around a dozen females, and their young, although this number can vary widely with groups of up to forty.

The female lions or lionesses are the core of the pride, they have strong bonds and hunt together. Lions are the only cats to hunt co-operatively and with strategy. The role of the male, meanwhile, is to protect his pride and territory from other male lions. His powerful roar can be heard from up to 8km (5 miles) away, and he will scent mark the pride's territory with urine to ward off other rival males.

Today lions are found in only two areas of the world. They are classified into two subspecies: Asiatic lions live in India's Gir forest, while African lions live in central and southern Africa.

Heraldry

The lion has appeared in heraldic coats of arms for centuries, and is one of the few animals to have different heraldic terms for the position of its body. For example, a 'lion rampant' is depicted in profile standing erect with forepaws raised.

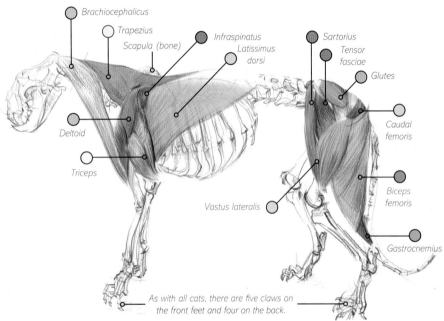

Brachiocephalicus
Trapezius
Scapula (bone)
Infraspinatus
Latissimus dorsi
Sartorius
Tensor fasciae
Glutes
Deltoid
Caudal femoris
Triceps
Biceps femoris
Vastus lateralis
Gastrocnemius

As with all cats, there are five claws on the front feet and four on the back.

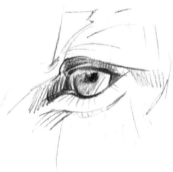

Eyes The eyes are outlined by a short dark stripe leading to the nose. A half-moon patch of lighter fur circles this at the base of the eye.

LION ANATOMY

An important note to make when sketching cats is that the scapula is higher that the thoracic vertebrae. This is what allows such a fluid motion at the shoulders. As the leg goes backwards, the scapula rotates forward, and as the leg goes forward the scapula angles back towards the body. On the leg that is taking the weight, the scapula is pushed higher. This fluid motion is particularly noticeable when a cat is slowly stalking.

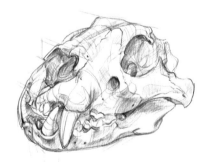

Teeth Two smaller canines on the lower jaw fit inside the two larger downward-pointing canines on the upper jaw.

African lion in watercolour

Field sketches can be worked up at home. Creating the sketch on the spot captures more life than working from a photograph. The colour of lions' fur varies from light buff to silvery grey, to yellowish red and dark brown. Male lions have a majestic mane, which covers most of the head, neck, shoulders, and chest. The mane is typically brownish and tinged with yellow, rust, and black hairs and waves in a theatrical manner in the wind. Both male and female lions have a tuft on the end of their tail, which is thought to be used in signalling to other lions.

Spike, male African lion ZSL Whipsnade Zoo.

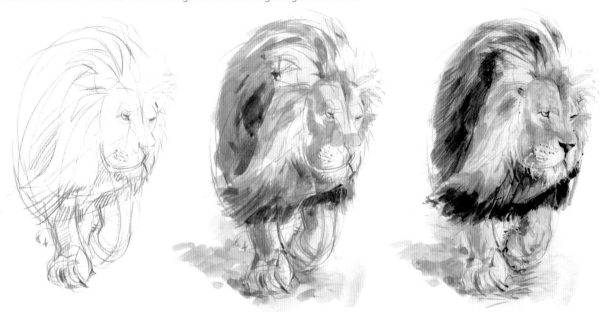

1 Start by making your field sketch using a permanent medium – you don't want the lines to run.

2 Add the lightest and brightest colours first. Here I have used a combination of yellow ochre and raw umber for the darker shades.

3 Build the tone with darker colours, and develop the detail.

Barbary lions Howletts Wild Animal Park. The Barbary lion subspecies previously inhabited Egypt, Tunisia, Morocco, and Algeria. It is extinct in the wild due to indiscriminate hunting.

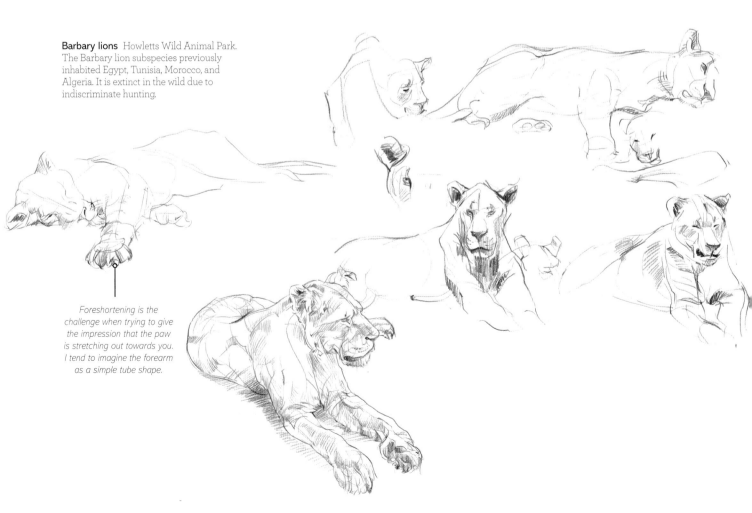

Foreshortening is the challenge when trying to give the impression that the paw is stretching out towards you. I tend to imagine the forearm as a simple tube shape.

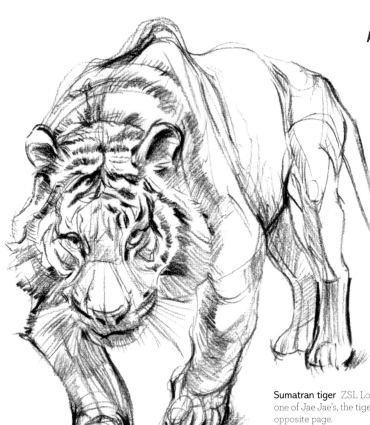

Tigers

Tigers are carnivorous mammals of the genus *Panthera*. They are the largest and most striking of all the big cats. Their orange coat is broken with dynamic striped markings, and white patches on the face and underbelly. Apex predators, tigers are a sign of a healthy ecosystem: being at the top of the food chain signifies that all the animals beneath them are in place.

Tigers are a highly endangered species, with three of the eight sub-species becoming extinct over the past seventy years, and the others vulnerable. Tigers live alone, and as a result, any fragmenting of their natural habitats leads to a loss of corridors in which they can meet each other for reproduction. Their habitats once stretched as far as eastern Turkey, but now isolated populations are restricted to southern and eastern Asia.

After being born, tiger cubs remain with their mothers until the second year. They grow up fast, quickly learning to kill prey of their own. Tigers are one of the few species of cats to enjoy water and are good swimmers.

Sumatran tiger ZSL London Zoo. This cub is one of Jae Jae's, the tiger in watercolour on the opposite page.

ABOUT THE SUMATRAN TIGER

The Sumatran tiger is the smallest of all the tigers, being around the size of a jaguar. Deforestation has pushed this, one of the most beautiful tiger species, to the edge of extinction, and only about 600 are thought to exist today. The orange fur is darker in colour than other tigers, and has lavish thick stripes in greater density. Males have a prominent white ruff around their neck and lower jaw, making them a beguiling beautiful cat to sketch.

Sumatran tigers prefer wild forest areas, and stay away from areas with human influence. Their habitat ranges from lowland forest to mountain forest and includes evergreen, swamp and tropical rainforests. Agricultural growth has fragmented natural habitats. This need for adequate wild vegetation is a requirement for all tigers.

Sumatra is a large island in western Indonesia, and the only place where tigers, rhinoceroses, orangutans and elephants live together. The island has a wide range of different animal species that depend on its tropical rainforests and uncultivated habitats. The continuing presence of the Sumatran tiger is an important indicator of the forest's biodiversity.

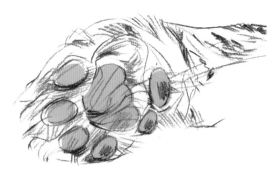

On the front feet, five claws sit centrally above the pads. Being digitigrade, the 'thumb' does touch the ground in a walking stance.

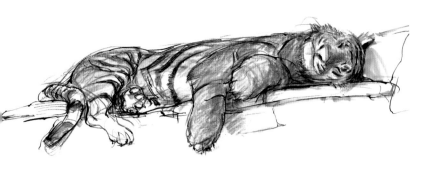

TIGER ANATOMY

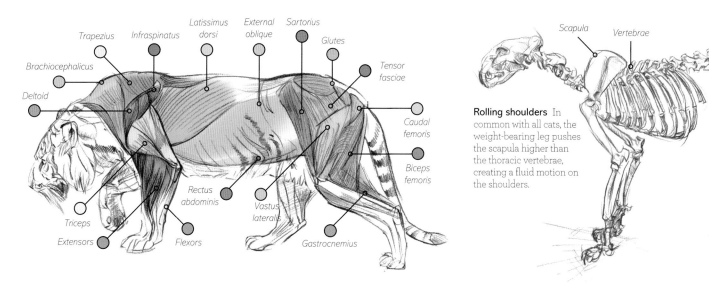

Trapezius
Infraspinatus
Latissimus dorsi
External oblique
Sartorius
Glutes
Brachiocephalicus
Tensor fasciae
Deltoid
Caudal femoris
Triceps
Biceps femoris
Extensors
Flexors
Rectus abdominis
Vastus lateralis
Gastrocnemius

Scapula
Vertebrae

Rolling shoulders In common with all cats, the weight-bearing leg pushes the scapula higher than the thoracic vertebrae, creating a fluid motion on the shoulders.

Sumatran tiger in watercolour

As always when painting, decide on your light source and remain consistent. Cadmium orange, or a combination of yellow with cadmium red can create the rich fiery base colour of the pelt. Make sure to keep your water clean to achieve a fresh finish. The black stripes can be added after the base orange colour is laid down. Add complementary French ultramarine to dull down the colour in the shade, and white gouache to help pull out the white fur in the light.

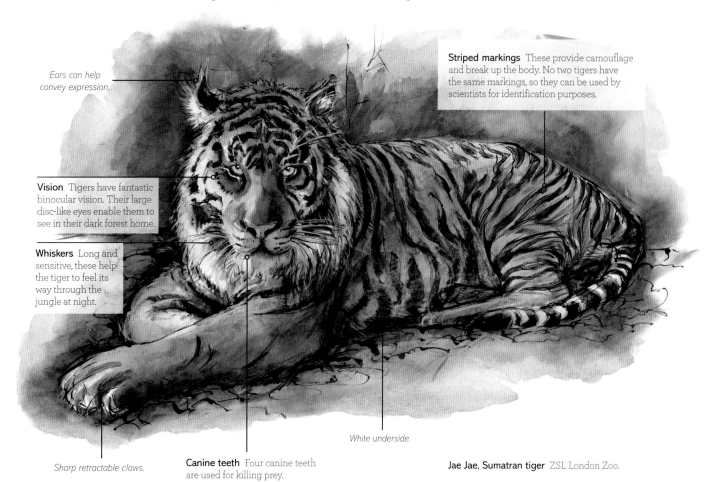

Ears can help convey expression.

Striped markings These provide camouflage and break up the body. No two tigers have the same markings, so they can be used by scientists for identification purposes.

Vision Tigers have fantastic binocular vision. Their large disc-like eyes enable them to see in their dark forest home.

Whiskers Long and sensitive, these help the tiger to feel its way through the jungle at night.

White underside.

Sharp retractable claws.

Canine teeth Four canine teeth are used for killing prey.

Jae Jae, Sumatran tiger ZSL London Zoo.

HABITAT: WOODLANDS

Forests and woodlands are areas of land covered by trees and vegetation. The difference lies in size and density: a forest is larger and denser than a wood. Natural sunlight is barely able to make it to the forest floor through the dense canopy of leaves, while woodland is a more open environment, sometimes broken with patches of grass.

From boreal forests of coniferous trees near the poles, to tropical rainforests near the equator; forests are startlingly diverse. I worked in one in Mexico where the trees literally shut down for six months of the year and the forest appeared to be dead.

Woods and forests are full of life and provide both food and shelter for a host of creatures from the large to microorganisms, each one playing an important part in the life cycle of wooded areas. The inhabitants of these dark leafy worlds have evolved a range of adaptations.

MULTI-STOREY ECOSYSTEMS

Woodlands and forests can be considered multi-storey ecosystems with a variety of different living spaces. These are niche environments to which animals have adapted. Both woods and forest can be broken down into four basic layers. From top to bottom, these are:

Canopy Tree tops let in different levels of light depending on their species. The canopy is the home for flying and climbing animals such as birds, monkeys, butterflies.

Shrub layer and field layer Shrub plants and sapling growth beneath the shade of the taller trees. Beneath these are field plants, low growing ferns, flowers, grasses and mosses.

Woodland or forest floor Covered with fallen plant debris and leaf litter: a haven for beetles and bugs.

Soil Rotting foliage breaks down into nutrients and minerals and is the home to such animals as worms and moles.

For tropical forests, you can add an additional two layers:

Emergent This layer rises above the canopy; it is where the tallest trees protrude.

Understorey just beneath the canopy is an additional layer of growth largely made up of vines, palms and ferns.

Canopy and other levels: the dead leaf butterfly

While most animals stay in their preferred storey, some venture between different layers. The dead leaf butterfly, found in the tropical forests of Asia and Japan, feeds on rotting fruit and plants. This extraordinary butterfly is one of nature's breathtaking adaptations. It can remain hidden in the canopy, by hanging upside down and looking like a leaf that is just about to fall. They can also simply fly down to the forest floor and close their wings and become perfectly camouflaged with the litter of dead leaves on the forest floor.

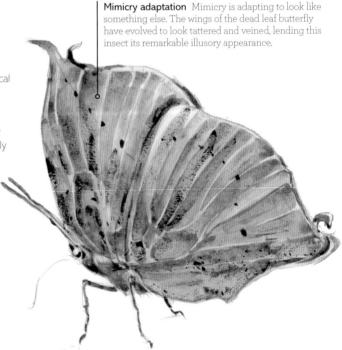

Mimicry adaptation Mimicry is adapting to look like something else. The wings of the dead leaf butterfly have evolved to look tattered and veined, lending this insect its remarkable illusory appearance.

The shrub layer: okapi

24–25 million years ago, the spread of savannahs allowed some of the deer-like ancestors of modern giraffes to walk out onto the grasslands. Without the hindrance of branches, they became larger and evolved into giraffes as we know them today. Those giraffids that remained in the woodland environment, however, evolved into the only other living member of the group, the okapi.

The Ituri Rainforest, a dense forest in central Africa, is the natural habitat for the okapi. It is an extremely shy animal and was not discovered by scientists until the 1900s. The okapi is so highly adapted to its rainforest environment that it is hard to separate it from its surroundings.

While sketching the okapi you will start to notice some resemblances to the giraffe. They share similarly-shaped (although smaller) cranium and the males have the same ossicones. The okapi also has the long, black prehensile tongue to strip branches of their leaves, the tongue also acts as an important grooming tool to keep their sophisticated coat in good shape. They are very close anatomically, although the okapi is smaller. With all the branches and roots to dodge in a rainforest, there is no benefit to being tall. The okapi also has some special adaptations all of its own for the forest environment, explained here.

Fur In contrast to the spots of a giraffe, the okapi has a dark reddish-brown fur that helps to camouflage the okapi in the dense foliage of the rainforest. This fur has the texture of velvet; it is also oily so that water runs off it and keeps the okapi dry in the environment.

Ears The size of an organ or body part can tell us something about its importance. The okapi's very large, cone like ears, can be pointed in different directions to pick up even the slightest of sounds. Okapis are extremely timid creatures that use shyness as a benefit in keeping well hidden from leopards.

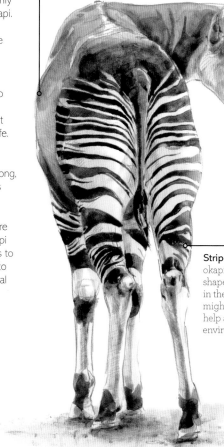

Stripes The disruptive striped patterns of the okapi's hindquarters help to break the silhouette shape of the okapi. In the filtering rays of sunlight in the rainforest, stripes are advantageous and might confuse a predator. The stripes may also help a young okapi follow its mother in the dense environment of the rainforest.

Woodland or forest floor layer: pine wood snake

Tan brown snakes adapted to the environment of the forest floor, pine wood snakes are found in Florida where they live in damp woodlands, seeking shade and shelter under rotten logs and stumps.

African hunting dogs

ALLEGIANCE AND STRATEGY

Tough and agile, African hunting dogs, also known simply as 'wild dogs', are a cooperative hunter that hunts in packs, which makes them formidable predators. Through allegiance and strategy, wild dogs have evolved to chase down prey on the open plains and sparse woodlands of Sub-Saharan Africa. The very strong social bonds and cooperation of the pack turns the African wild dog into an incredibly successful hunter. As an illustration of this, around seventy per cent of all wild dog hunts end in a kill, while lions are only successful around thirty per cent of the time.

As with domestic dogs, African hunting dogs are distant cousins of wolves. Indeed the Latin name for the African hunting dog, *Lycaon pictus*, means, 'painted wolf' and refers to the animal's mottled coat, which acts as disruptive coloration and camouflage. Each animal has its own unique pattern of black, brown and yellow fur, which makes him or her identifiable by scientists studying them in the field.

Normally nomadic, the African hunting dog, adopts complex strategies in its hunting grounds. They stake out their prey by day, (the cheetah is the only other large diurnal predator in Africa), such as impala and warthogs. They fan out in a skirmish line, often with a lead dog to head off the prey. It is here on the hunting grounds that the benefit of the tight social bonds really comes into play, as they communicate to the final kill.

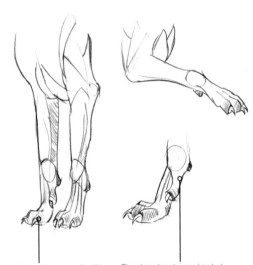

Incisors
Canines
Shearing molars
Carnassials

Meat-eating teeth As carnivores, all dogs rely on energy-packed meat for their sustenance, using their killing teeth to take down and devour their prey.

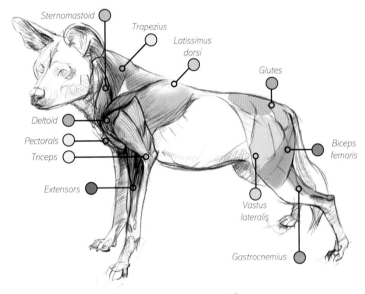

Sternomastoid
Trapezius
Latissimus dorsi
Glutes
Deltoid
Pectorals
Triceps
Biceps femoris
Extensors
Vastus lateralis
Gastrocnemius

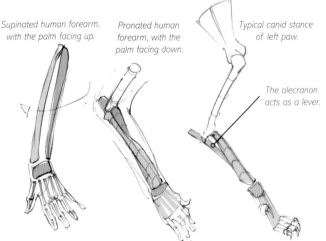

Supinated human forearm, with the palm facing up.

Pronated human forearm, with the palm facing down.

Typical canid stance of left paw.

The olecranon acts as a lever.

In digitigrade stance (walking on the toes) the 'thumb' is lifted off the ground.

The dewclaw is used to help grip on to bones.

Forearms

Compare your arm to the wolf's foreleg. **Supination** is the term for when you twist your arm and the palm is facing upwards. The radius and ulna are straight in line. **Pronation** is the term for when the palm is facing down, with the 'thumb' towards the body. Many museums pose their skeletal exhibits in a pronated stance.

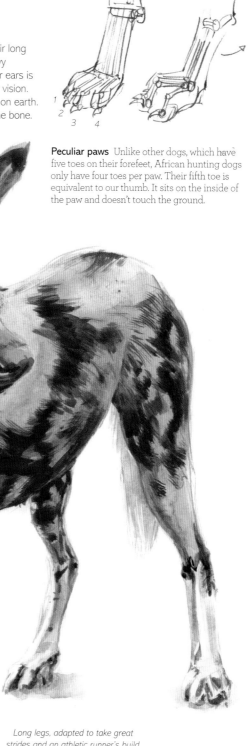

ABOUT THE AFRICAN HUNTING DOG

Every individual is well equipped for hunting – as you sketch them you will notice their long legs, adapted to take great strides and an athletic runner's build with a powerful heavy muzzle. They also have highly-developed senses that assist the hunt: the size of their ears is an indication of how keen their hearing is, and their eyes afford them sharp binocular vision. Relative to its size, the African hunting dog has the most powerful bite of any animal on earth. Behind the carnassial teeth there are shearing molars, used for stripping flesh from the bone.

Ears Large round ears form part of the distinctive character of a hunting dog.

Peculiar paws Unlike other dogs, which have five toes on their forefeet, African hunting dogs only have four toes per paw. Their fifth toe is equivalent to our thumb. It sits on the inside of the paw and doesn't touch the ground.

Muzzle The heavy shape is created by a powerful set of jaws, with a very large lower mandible.

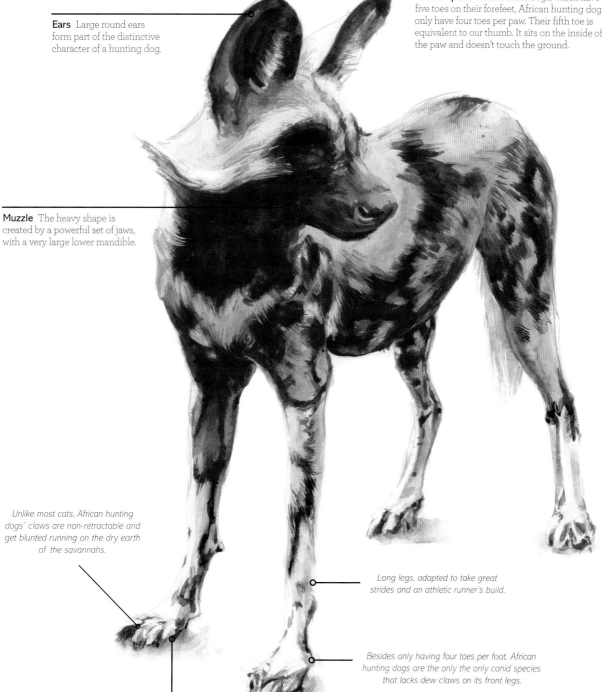

Unlike most cats, African hunting dogs' claws are non-retractable and get blunted running on the dry earth of the savannahs.

Long legs, adapted to take great strides and an athletic runner's build.

Besides only having four toes per foot, African hunting dogs are the only the only canid species that lacks dew claws on its front legs.

The middle toe pads are also fused together at the back.

Goldie, female African hunting dog ZSL London.

AFRICAN HUNTING DOG STUDY SHEET

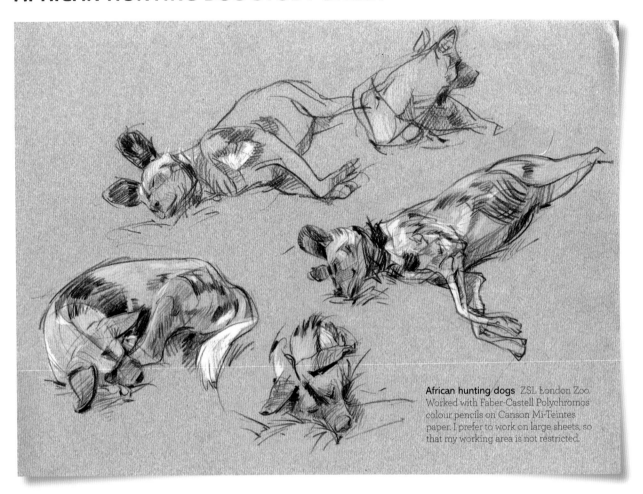

African hunting dogs ZSL London Zoo. Worked with Faber-Castell Polychromos colour pencils on Canson Mi-Teintes paper. I prefer to work on large sheets, so that my working area is not restricted.

Sleeping

When you start a day sketching, look for a slow or sleeping animal to warm up your own eye-to-hand coordination. Start with the head, lightly drawing a widget made up of a box-like cranium with an attached box to house the muzzle. Work from shape to shape along the body of the animal until you reach the tail.

As you sketch return to check the horizontal and vertical relationships of the limbs and body to that of the head. This can be done by holding up a pencil and shutting one eye. The limbs are at a set of angles; these can be checked in a similar way by holding up a pencil vertically or horizontally and measuring the angle with an imaginary protractor.

Wild dog head widget

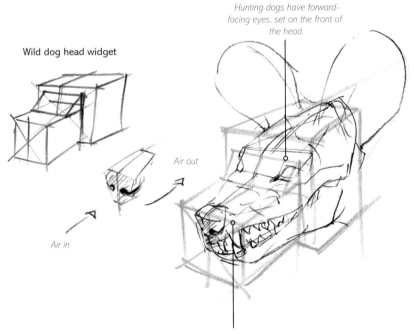

Hunting dogs have forward-facing eyes, set on the front of the head.

Air out

Air in

When a dog growls, the skin wrinkles up on the bridge of the nose.

Standing

Once you feel comfortable with sketching sleeping animals you can graduate to sketching them standing. To be able to do this I find it useful to know where the joints or pivot points are. You can try this with your own body. Start with the leg; flex your toes, ankle, knee, and hip. Now the arm, fingers, wrist, elbow and shoulder.

Dog foot gizmo

1 Start by drawing a stretched pentagon.

2 Draw a cross through the middle.

3 Add the pads. Notice that the two central toes are in front of the rear two.

Pivot points

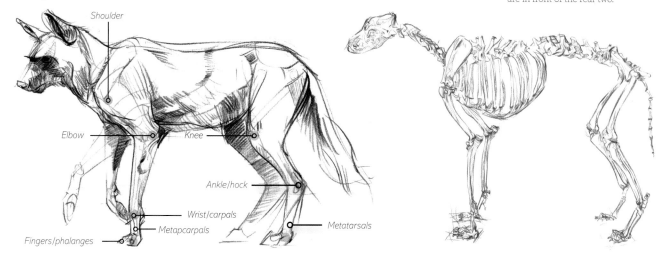

Shoulder

Elbow

Knee

Ankle/hock

Wrist/carpals

Metapcarpals

Metatarsals

Fingers/phalanges

Weight and texture To help give the impression that the legs are supporting the weight of the animal, try to create a slight concave arc shape. Add hair marks to give an impression of the fur texture; placing them along the base of the neck and at the elbow. Hair marks are created to show gaps in the masses of fur rather than sketching each individual hair.

Dog skeleton comparison Note that the scapula is higher than the thoracic vertebra, resulting in an almost 'liquid' movement when a dog is running. On the leg that is supporting the weight, the scapula will be higher.

Running

Try to create the illusion of motion by rotating the limbs at dynamic angles from the body. Start with the side view then try to explore foreshortening, by having the animal running towards and away from you.

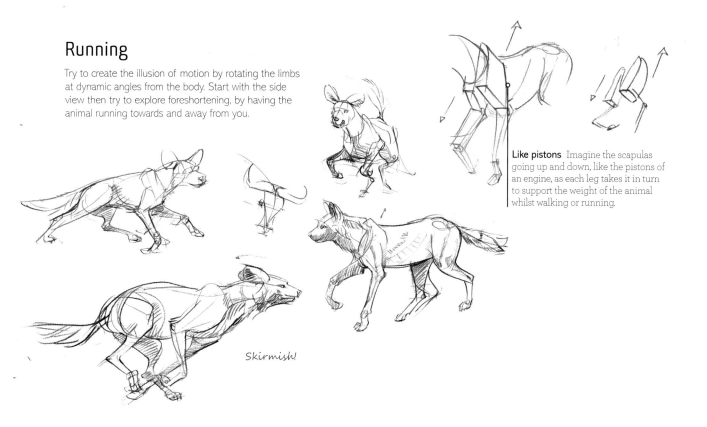

Like pistons Imagine the scapulas going up and down, like the pistons of an engine, as each leg takes it in turn to support the weight of the animal whilst walking or running.

Skirmish!

Bears

There are eight species of bears, which live in a wide range of different habitats. All bears have a powerful body, large disc-shaped face, thick muscle-packed legs and a short tail. Like us, they walk with a plantigrade stance, with their heels and wrists planted on the ground. While bears are generally considered carnivores, six of the species are actually omnivorous and eat large amounts of berries, nuts and insects. Only the polar bear lives exclusively on meat and fish, while the giant panda is almost entirely vegetarian.

Every species has its own unique characteristics. The brown bear is the largest terrestrial carnivore, vying for this status with the polar bear. The smallest of the bear species is the sun bear. Living in the warmer climate of tropical South East Asia, the sun bear also has the shortest fur of all the bears. It has extremely long, curved claws for climbing, to dig for worms and insects, tear up logs and extract honey from wild bees' nests.

Another bear with long claws is the sloth bear. These shaggy and reclusive bears make their home in the forests of South Asia. Like other bears, the sloth bear can stand up on its back legs in order to get a clearer view of its surroundings – or to have a good scratch up against a tree. There are black bears in both America and Asia; while the only bear from Latin America is the spectacled bear.

Polar bear forepaw Bears are digitigrade, with five toes on the front and back foot. These toes line up in a fairly straight line. In some species, such as the black bear, these are curved in an arc shape. Unlike the cats, bears' claws are non-retractable. Polar bears are able to swim across open water, paddling with their huge front paws.

GIANT PANDA STUDY SHEET

When sketching any bear, start with the basic shapes. Do not start with all the detail; instead, simplify what you see. Build up a range of hoop-shaped marks, and start from one of your more successful head shapes to add the body.

For pandas, try a midtone paper rather than sketching on white. This will allow you to use white as a contrast for the higher values, so you can sketch in the white saddle of the back and the facial features. Observe and draw with the colour itself, rather than simply filling in.

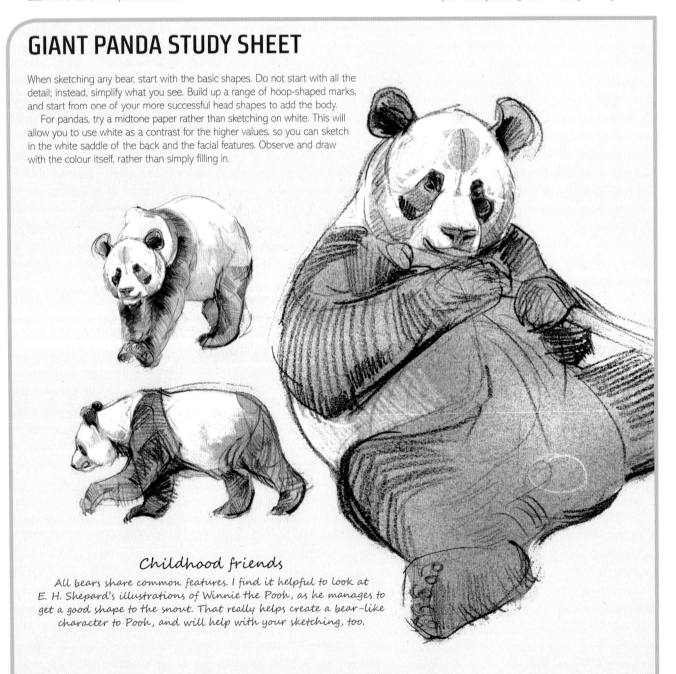

Childhood friends
All bears share common features. I find it helpful to look at E. H. Shepard's illustrations of Winnie the Pooh, as he manages to get a good shape to the snout. That really helps create a bear-like character to Pooh, and will help with your sketching, too.

SKETCHING FUR

Once you have created a solid structure that reflects the posture, proportions, and angles of the body, you are ready to draw in the details and fur texture. The secret to drawing fur is this: do not draw the hairs themselves but rather the cracks in the fur; suggest clumps of hair instead of individual hairs. This tip really helps when sketching bears or other animals with shaggy pelts.

The thicker and deeper the fur, the more prominent these cracks will become. Many mammals have particularly deep fur behind the thigh, along the belly, in the front of the chest and along the base of the neck. Look for deep cracks in these areas. Create these marks all along the contour of the body and do not make them symmetrical either in size or spacing. Be consistently inconsistent.

Imagine if you were to draw a real hair at life-size. Your pencil stroke would be thicker than the hair itself! Now think of drawing a mammal from a long distance away. How much real hair detail can you see?

The strength of simplicity

Why shouldn't we draw every hair or every brick in an architectural illustration? The answer is simple: if we draw every single detail, it can take away from a sense of what we actually see. If you have ever looked at an HDR (high dynamic range) photograph, they do not look real, because by nature we focus on certain parts of what is in front of us. What to put in and what to leave out is the work of the artist. This is one of the hardest parts of wildlife drawing.

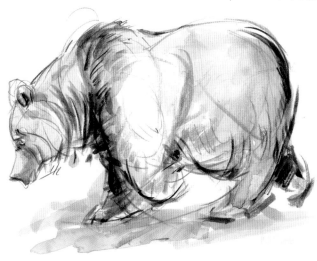

European brown bear ZSL Whipsnade Zoo.

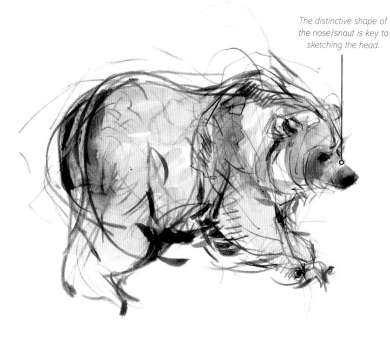

The distinctive shape of the nose/snout is key to sketching the head.

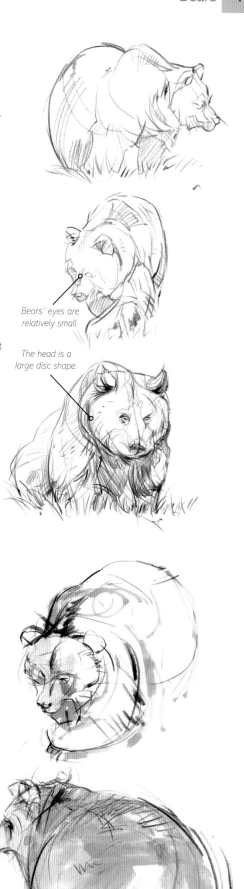

Bears' eyes are relatively small.

The head is a large disc shape.

South American coatis

The South American coati is a member of the raccoon family, and shares a similar distinctive banded tail that they use for balancing when climbing trees and for signalling to other members of the group. Other members of the group can even follow this long tail when in long grass.

These incredibly agile animals have a striking character with long mobile snouts, brown backs and a light coloured underbelly that makes them enjoyable to draw and sketch. The principles for sketching them can be used for similar swift-moving, inquisitive animals like their cousins, the racoons.

COATI STUDY SHEET

Study sheets are one of the best ways to capture the character of fast-moving animals like coatis. The movement captured lasts a shorter period than the time it takes to put that information down on the paper, so rather than aiming for anatomical accuracy, a gestural shorthand can be employed, capturing the line of action and a sense of the movement of these highly active animals.

Before you start to draw, spend some time simply observing the coatis. When you work from life, you experience your subject matter in way that a photograph could never allow you to. At a zoo enclosure, you can almost touch your subject, smell it, listen to the vocalizations and see the subject from lots of different angles and dynamic positions. This overall sensory experience is vital to your understanding of the animal and will always translate into your study sheet.

In your mark-making, look to create lines that capture the charismatic nature of the coati. Remember: the objective is not to create one perfect drawing, but a range of visualisations, each one capturing a moment that you glimpsed and wanted to get down on paper. Work on several drawings at once, returning to a previous sketch if an animal adopts a similar pose.

Facial markings Look for a characterful black line that goes from the eye to the tip of the nose.

Coatis noses are almost pig-like in character; very flexible and with a fantastic sense of smell. Highly mobile, it can be rotated up to 60° in any direction, and is used to push up objects from the ground and to investigate interesting opportunities for food in nooks and crevices in fallen logs.

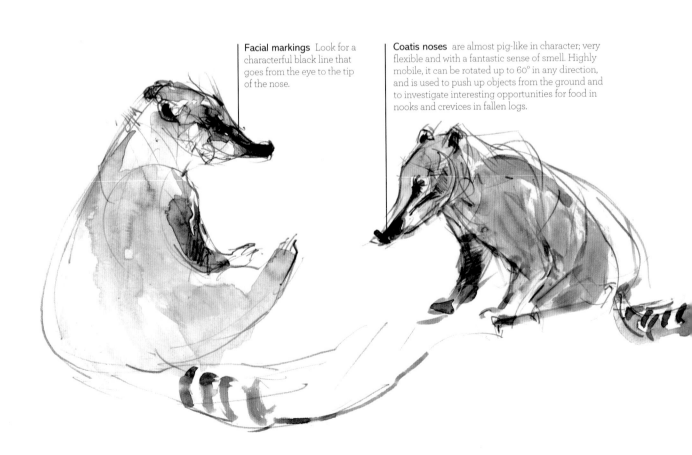

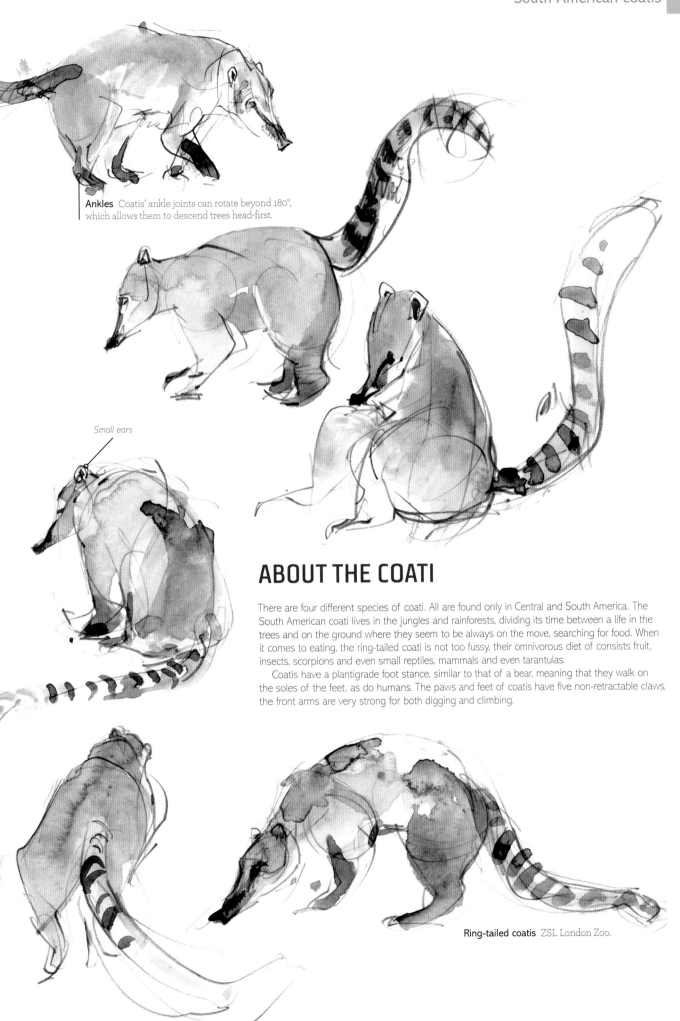

Ankles Coatis' ankle joints can rotate beyond 180°, which allows them to descend trees head-first.

Small ears

ABOUT THE COATI

There are four different species of coati. All are found only in Central and South America. The South American coati lives in the jungles and rainforests, dividing its time between a life in the trees and on the ground where they seem to be always on the move, searching for food. When it comes to eating, the ring-tailed coati is not too fussy, their omnivorous diet of consists fruit, insects, scorpions and even small reptiles, mammals and even tarantulas.

Coatis have a plantigrade foot stance, similar to that of a bear, meaning that they walk on the soles of the feet, as do humans. The paws and feet of coatis have five non-retractable claws, the front arms are very strong for both digging and climbing.

Ring-tailed coatis ZSL London Zoo.

Red kangaroos

Both a continent and the world's largest island, Australia has its own curious species that have evolved in isolation. Marsupials are found in the Americas, but most famously in Australaisa. A distinctive characteristic common to these species is that most of the young are carried in a pouch. A lot of Australia's vast territories are made up large expanses of hot, dry desert called 'the Outback'. With such distances to travel, one type of marsupial has evolved a unique method of locomotion: that of hopping with great bounds.

The kangaroo is a member of the marsupial family of macropods, meaning 'big foot'. The smallest of this family is the dwarf wallaby, weighing in at 1.6kg (3½lb) and reaching a height of 46cm (18in).

The red kangaroo is the largest of all kangaroos and the largest of all terrestrial mammals found in Australia. There is also the tree-kangaroo, another genus of macropod, which inhabits the tropical rainforests of New Guinea, far north-eastern Queensland and some of the islands in the region.

No kneecaps! The patella is a sesamoid bone. Sesamoid comes from the Latin and literally translates as 'sesame seed'. These small bones provide a smooth surface for tendons to slide over at angular joints. Although present in almost all species of mammals and birds, it has been found to be absent in the red kangaroo and two wallaby species.

Feet While appearing to have only three toes, the hind feet actually have four: two tiny toes used for grooming; a third, huge toe with a strong, sharp claw that can be used as a weapon; and an outer toe. Hopping requires more reliance on the third and fourth toe.

Movement The tail and front legs make contact with the ground at the same time. The tail acts as a third leg, enabling the kangaroo's hind legs to lift off the ground and swing forward.

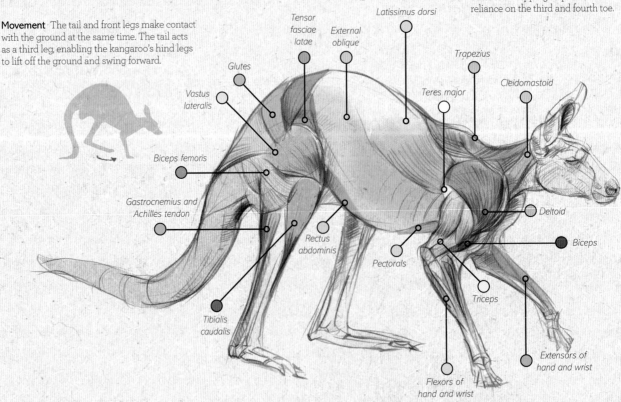

Tensor fasciae latae

External oblique

Latissimus dorsi

Trapezius

Glutes

Teres major

Cleidomastoid

Vastus lateralis

Biceps femoris

Deltoid

Biceps

Gastrocnemius and Achilles tendon

Rectus abdominis

Pectorals

Triceps

Tibialis caudalis

Flexors of hand and wrist

Extensors of hand and wrist

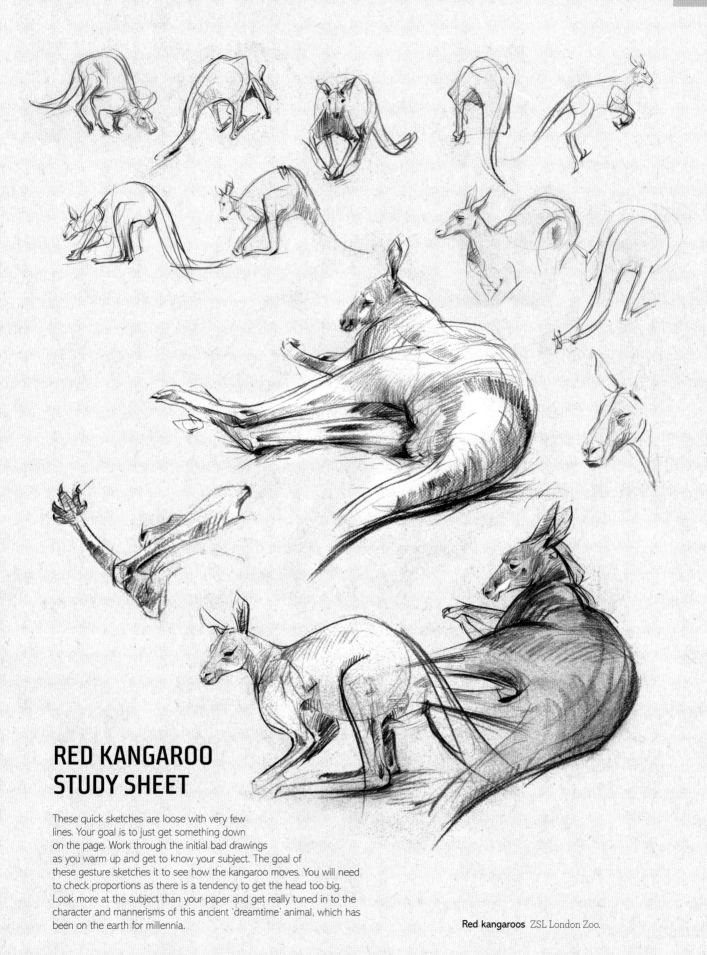

RED KANGAROO STUDY SHEET

These quick sketches are loose with very few
lines. Your goal is to just get something down
on the page. Work through the initial bad drawings
as you warm up and get to know your subject. The goal of
these gesture sketches it to see how the kangaroo moves. You will need
to check proportions as there is a tendency to get the head too big.
Look more at the subject than your paper and get really tuned in to the
character and mannerisms of this ancient 'dreamtime' animal, which has
been on the earth for millennia.

Red kangaroos ZSL London Zoo.

PRIMATES

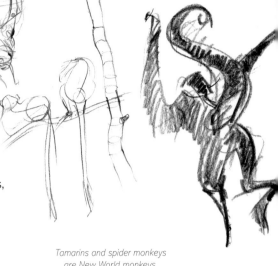

Primates are a highly evolved group of animals that share sophisticated social structures and come in all shapes and sizes. Only orangutans, a few of the lemur species and galagos lead primarily solitary lives.

These mammals share features characteristic of their tree-living ancestors, even in those species that have adapted to living on the ground. Hence the hands and feet of most primates are grasping, adapted to an arboreal, or tree-living lifestyle. Monkeys, apes, lemurs, lorises and bush babies are all primates – as are humans; who evolved a bipedal stance in the trees. We have taken this form of locomotion to inhabit every continent on earth. However, most primates live in the rainforests of the tropics and subtropics.

Tamarins and spider monkeys are New World monkeys.

SKULL CHARACTERISTICS

Primates share similar cranium characteristics. They have forward-facing eyes, beneath a brow ridge and a large domed braincase. The primate brain is larger than that of other terrestrial mammals in relation to body mass. They have binocular vision enabling them to judge the distance of branches in their complex three-dimensional environments and also to judge the distance of food, such as fruit or even ants. Some primates are famously toolmakers; chimpanzees use a simple tool such as a stripped twig to stick into termite mounds, which they then lick off like a termite lollipop.

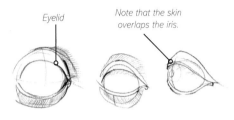

Eyelid

Note that the skin overlaps the iris.

Primate eyes Humans are the only primates where you can clearly see the whites of the eyes. This is believed to help in social communication.

Our place

We are an African Ape. In 1871, through observing nature alone; in the absence of any fossil evidence, Charles Darwin wrote:

> *'In each great region of the world the living mammals are closely related to the extinct species of the same region. It is, therefore, probable that Africa was formerly inhabited by extinct apes closely allied to the gorilla and chimpanzee; and as these two species are now man's nearest allies, it is somewhat more probable that our early progenitors lived on the African continent than elsewhere.'*

Scientists have demonstrated this to be true, tracking the evidence for human evolution by studying fossilized skeletons and new methods including DNA analysis.

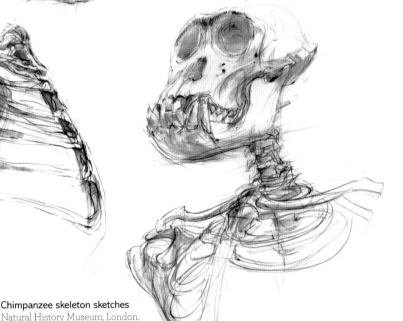

Chimpanzee skeleton sketches
Natural History Museum, London.

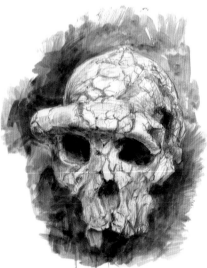

A new hope A distant ancestor to modern humans, *Sahelanthropus tchadensis* walked the Earth about 7 million years ago. This specimen's nickname, Toumaï, translates as 'hope of life'. Interestingly the foramen magnum – the large opening at the base of the skull – suggests that our earliest ancestor had a bipedal stance; and was walking around in the trees.

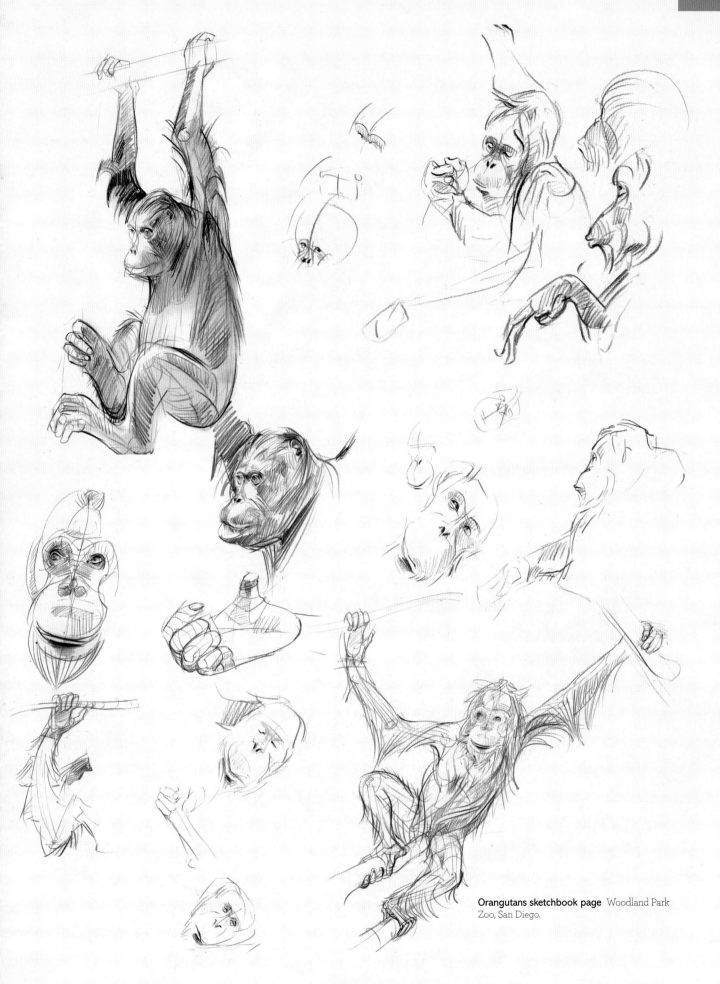

Orangutans sketchbook page Woodland Park Zoo, San Diego.

Monkeys

Monkeys originated in Africa, and their ancestors split into two main groups. One group migrated some 40 million years ago and now live primarily in tropical South America. These are known as the New World monkeys. Those remaining in Africa divided further into two lineages; leading to both modern Old World monkeys, and also the apes and hominins, from which we descend.

Old World monkeys have spread to live both in the trees and on land throughout Africa and Asia, and into Europe. They tend to be larger in overall size than their New World cousins. They have fingernails that are flat instead of sharp; and nostrils that point downwards, rather than forward-facing nostrils of the flatter-nosed New World monkeys. Old World monkeys have buttocks without hair but with padding that they can sit on. New World monkeys are the only monkeys with prehensile tails.

ABOUT DIANA MONKEYS

Diana monkeys, also known as Diana guenons, are very charismatic and engaging animals to sketch. These Old World monkeys spend most of their lives in the trees of mature tropical rainforests in West Africa. Their crescent-shaped brow markings are said to resemble the bow the Roman goddess Diana carried; and it is from her that they take their name.

Diana monkeys have distinct markings with a white brow, cheeks, beard and front with diagonal stripes across the rear legs. The rest of the fur is a grey-black colour with a red rump and thighs. They have a long slender tail. Diana monkeys live in large groups of up to thirty individuals, made up of a single male with around ten females and their offspring. Living in a group helps the monkeys to spot and deter predators – and Diana monkeys have become so good at alerting each other to predators that other primate species, such as red colobus monkeys, will associate with the group to benefit from their warning system.

Getting in the flow

Spending time at an animal enclosure and drawing the animal will make you feel that you know it better. Study sheets are a fantastic way of helping you, as the observer, to feel connected to the animal. The quality of line you are creating and the sensitivity for shape should relate to the feeling that you have for the subject. Explore the outline of the subject, its silhouette, shape and inner contours. Try to vary the depth of the pressure and the thinness or fatness of what you are drawing.

Practise drawing characteristic lines of the animal without looking at your paper. All monkeys, for example, have a distinctive protruding muzzle and an obvious brow ridge. You can see these features in the sketches here. Capturing these diagnostic features will ensure that your sketches are immediately identifiable as monkeys.

Note that study sheets made in this way will not necessarily end up in a complete drawing but rather abstract patterns of the animal that you are drawing. Monkeys are often highly mobile, and not all your sketches will be successful. The purpose of the process is to aim for points where your mark-making connects with your subject. Treat these occasional victories as encouragement to carry on.

'Fill up your sheet with lots of sketches. Don't worry if they overlap each other. You are involved in a process of learning to look; ignore the pressure of trying to make a perfect drawing.'

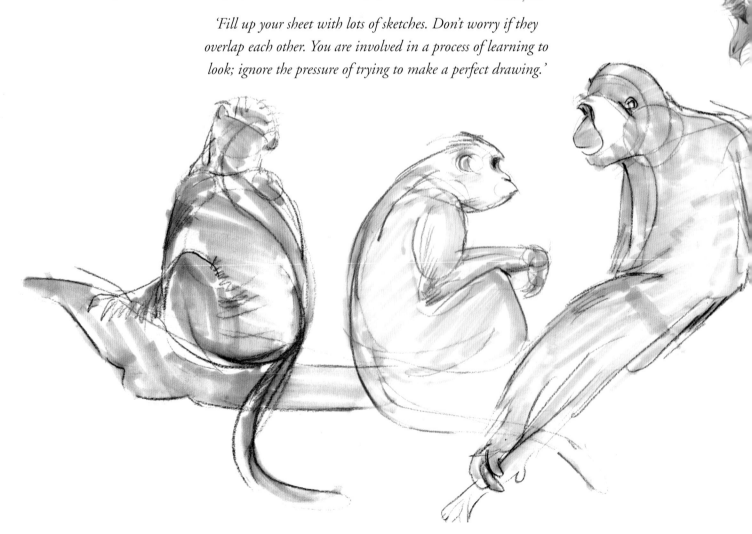

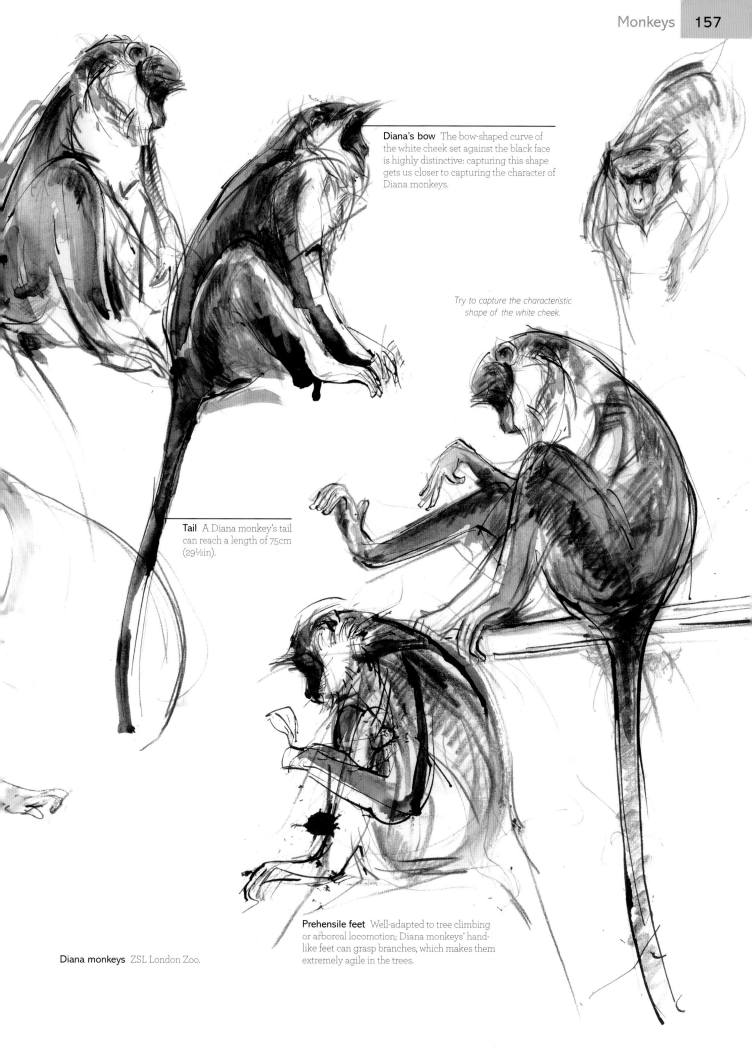

Diana's bow The bow-shaped curve of the white cheek set against the black face is highly distinctive: capturing this shape gets us closer to capturing the character of Diana monkeys.

Try to capture the characteristic shape of the white cheek.

Tail A Diana monkey's tail can reach a length of 75cm (29½in).

Prehensile feet Well-adapted to tree climbing or arboreal locomotion; Diana monkeys' hand-like feet can grasp branches, which makes them extremely agile in the trees.

Diana monkeys ZSL London Zoo.

Lemurs

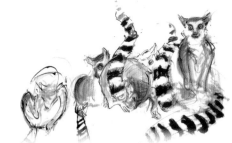

Named after the *lemures* of Roman mythology, meaning 'ghosts' or 'spirits', lemurs characteristically have a highly agile body and long limbs capable of athletic movement in the trees. Somewhere between 35–55 million years ago, a handful of lemur ancestors made their way to the island of Madagascar, perhaps on a log or floating vegetation. Those that arrived on the shore moved inland, their descendants diversifying as they adapted to their new habitats. These castaways have now evolved into more than 100 different species.

When an animal diversifies into many new species to fill different ecological niches in a new habitat, the process is known as 'adaptive radiation'. The finches studied by Darwin on the Galápagos Islands are another example of a species diversifying through adaptive radiation.

Lemurs and lorises are also found in Africa, in the form of galagos (sometimes called bushbabies) and pottos and the lorises of Asia. All species outside Madagascar are nocturnal; meaning that these prosimians do not compete directly with their simian rivals. As a result, they have distinctive large disc-shaped eyes.

Lemur troops Ring-tailed lemurs live in intimate groups called troops, of between six and thirty individuals. On sleepy sunlit mornings, they almost appear joined together. Both sexes live in troops, but a dominant female presides over all.

ABOUT THE RING-TAILED LEMUR

Ring-tailed lemurs are fast-moving and a challenging species to sketch. It is best to begin by drawing them basking in the sun, or curled up asleep when they use their tail as a warm fluffy scarf (see right). Ring-tailed lemurs sunbathe, a behaviour not common amongst other lemur species. Sunbathing lemurs look almost like they are meditating.

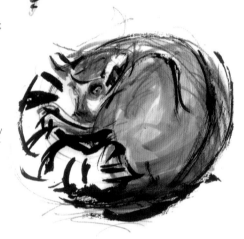

Using markers Markers are a good fast medium for capturing the smoky greys of a ring-tailed lemur's pelt. Ink and a brush can be used with calligraphic marks to capture the stripy tail.

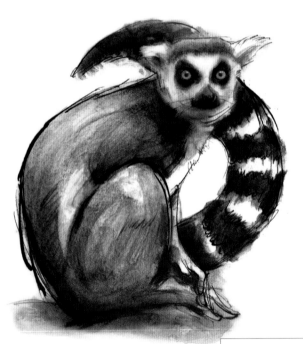

Face Lemurs have a long muzzle and it is important to try and get a sense of the nose projecting forward.

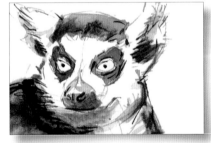

Ring-tailed lemur in charcoal

After a day getting to know the characteristics and behaviours of the ring-tailed lemurs at your local zoo, try sketching up a full studio portrait from your reference. Not all of your study needs to be highly detailed: here I have focussed the attention on the face, but sketched the rest of the body in more loosely.

Dry brushing A painting technique using a paint brush that is relatively dry. Splay the bristles of the brush out between finger and thumb. The resulting brushstrokes have a characteristic hairlike appearance.

Tonal gradation Charcoal is applied using the side of the stick and then brushed with lighter fluid to create a soft fur texture. By pressing harder, you can create a graduation. in tone.

ABOUT THE BLACK-AND-WHITE RUFFED LEMUR

This enigmatic species inhabits the eastern rainforests of Madagascar, spending most of their time high up in the treetops of the canopy. The term for animals that have evolved to live in trees is 'arboreal'. These lemurs have a complex social structure and can be heard before being seen with their unique, raucous chorus of calls.

Black-and-white ruffed lemurs are also known as the world's largest pollinators, as they have the unique ability to open the flowers of the traveller's palm tree. Lemurs enjoy the nectar within the flowers while the tree's pollen gets transported to other trees on the lemurs' faces. It is a mutually beneficial relationship.

These delightful creatures are striking in appearance, which makes them an attractive subject for illustration. Whilst sketching them from life you will notice a lot of activity, including dexterous leaping and suspensory behaviour, which involves hanging the body below the branches to feed.

The black-and-white ruffed lemur has three subspecies and unfortunately all of them are critically endangered. They have a small population that is spread out across Madagascar, with a consequence that reproduction is limited. Protection of their habitat is vital for the continued survival of this unique species.

Storm, black-and-white ruffed lemur ZSL London Zoo.

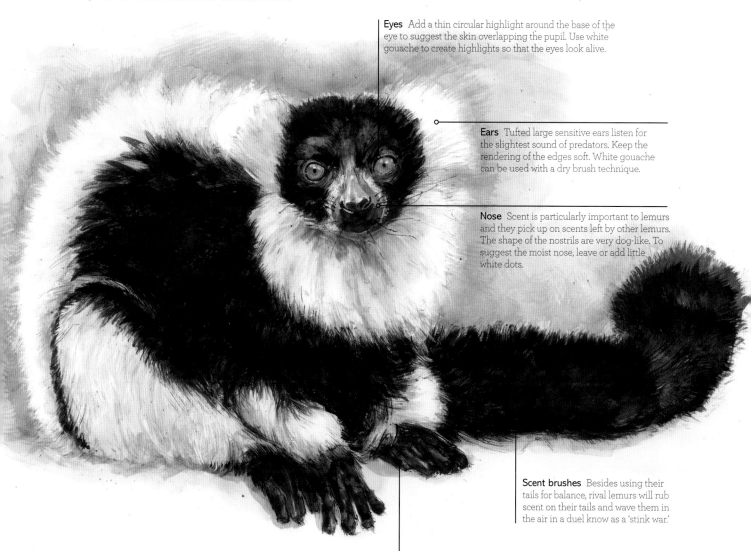

Eyes Add a thin circular highlight around the base of the eye to suggest the skin overlapping the pupil. Use white gouache to create highlights so that the eyes look alive.

Ears Tufted large sensitive ears listen for the slightest sound of predators. Keep the rendering of the edges soft. White gouache can be used with a dry brush technique.

Nose Scent is particularly important to lemurs and they pick up on scents left by other lemurs. The shape of the nostrils are very dog-like. To suggest the moist nose, leave or add little white dots.

Scent brushes Besides using their tails for balance, rival lemurs will rub scent on their tails and wave them in the air in a duel know as a 'stink war.'

Noisy Black and white ruffed lemurs have an array of vocalizations. When alarmed, they can produce a deep, barking call to a wailing howl when defending their territory or being attacked.

Diurnal Black-and-white ruffed lemurs are active during daylight hours, spending most of their time foraging for fruit, which makes up nine-tenths of their overall diet; the rest being a combination of nectar, flowers, fungi, leaves and seeds.

Hands Lemur hands appear very like our own, with opposable thumbs. Males have scent glands on their wrist which they use to mark their territories and smear on their bodies and tails.

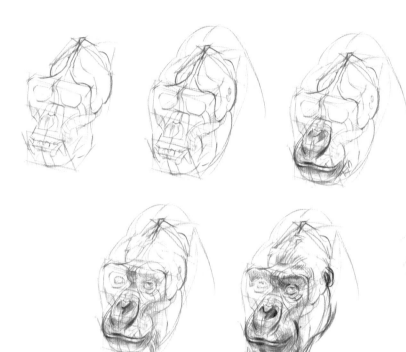

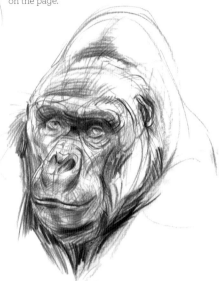

Forms and texture The mountain subspecies of the eastern gorilla has long shaggy hair. On both the eastern and western gorilla, only the facial features lack hair. The leathery skin is wrinkled. Use these lines to help sculpt the form on the page.

Gorillas

Gorillas are the largest of all the primates. Ground-dwelling and predominantly herbivorous, they share around ninety-five per cent of our DNA. It is thus perhaps unsurprising that, along with the other great apes, gorillas display many human-like behaviours and emotions, such as laughter and sadness. They even make their own tools to help them survive in the forest.

Found in the forests of sub-Saharan Africa, they are split into two main groups: eastern and western gorillas, which are in turn broken down into four or five subspecies. Gorillas usually move around by knuckle-walking, and occasionally walk on two legs.

When sketching the head of a gorilla it is important to capture the sheer mass along with the sculptural form. A gorilla's jaw juts out further than its cheek, and their thick brow ridge places the eyes in shadow when light is falling from the canopy. At the top of the skull is a prominent sagittal crest, which creates a domed cranium. With a diet of heavy fibrous plants, gorillas need to do a lot of chewing to break up the coarse plant matter, muscle attachments join the crest for industrial processing.

If this adaptation were solely about food, you would expect to find it in both sexes. However, females have smaller crests than males. The reason for this is that a large sagittal crest is a sign of male dominance, and it plays a part in sexual selection. The crest forms a base for a fatty pad of tissue that acts as a display signal to females. A bigger crest is a sign of a strong healthy individual, and males with larger crests tend to attract more females.

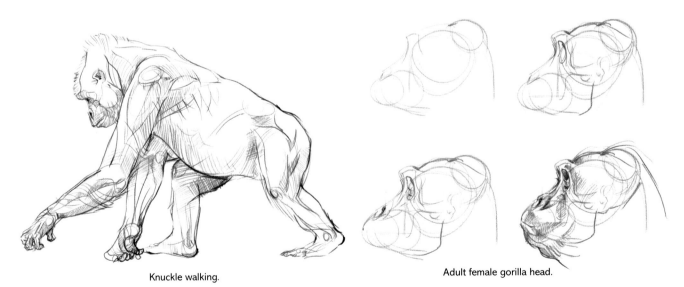

Knuckle walking.

Adult female gorilla head.

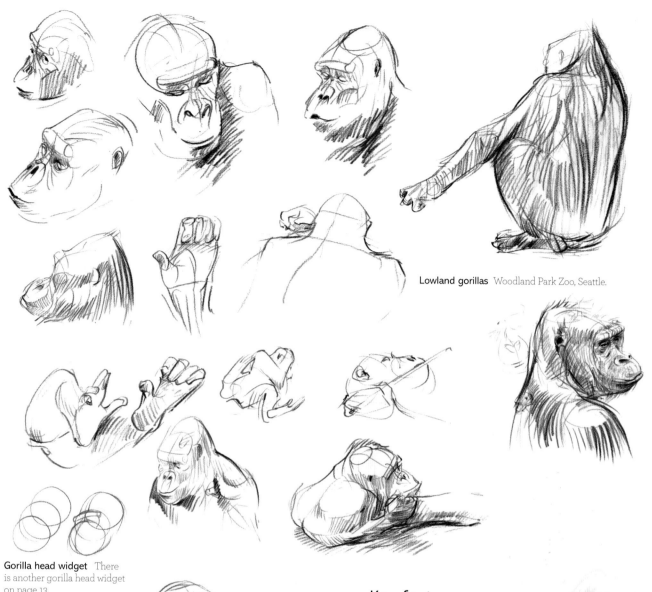

Lowland gorillas Woodland Park Zoo, Seattle.

Gorilla head widget There is another gorilla head widget on page 13.

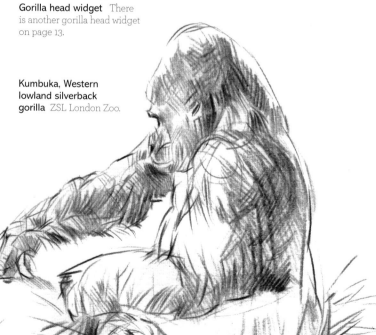

Kumbuka, Western lowland silverback gorilla ZSL London Zoo.

Key features

Head The skull defines the appearance of the head. In comparison to a human head, apes have a more projecting face, a larger brow ridge and a heavier jaw. Gorillas in particular have a very heavy brow ridge.

Torso Gorillas have especially large, barrel-shaped chests, which help to balance the centre of gravity when knuckle-walking.

Spine Most apes have a relatively straight backbone. The human spine is curved into an S-shape for walking on two legs.

Arms Arm length is characteristically longer than leg length in all apes. These arms are strong as well – it has been said that gorillas have the upper arm strength of six adult human males.

Imposing appearance One of the most striking features about gorillas is their sheer size and the blackness of their fur.

Chimpanzees

Chimpanzees are one of four types of great ape, a group made up of chimpanzees, bonobos, gorillas, and orangutans. Together with humans, the great apes are part of the family Hominidae which means 'the great apes'.

As with all the apes (including us) chimpanzees are highly intelligent creatures. They are one of the few animal species that employs tools, such as stems and sticks to retrieve termites from their nests or dig grubs out of logs; and stones to smash open nuts. Living in African rainforests, chimpanzees have a highly varied diet, made up primarily of plants and fruit, they will also eat insects, meat and carrion.

Normally chimpanzees walk on all fours (knuckle-walking), but they can also stand and walk upright. They have wonderfully long arms and really short legs. It is the anatomy of a climber: even their feet have a grasping ability that makes their feet look like hands. Their long powerful arms enable chimps to swing from branch to branch, where most of their feeding is done. Chimpanzees usually sleep in the trees as well in nests of leaves.

CLOSE RELATIVES

Sharing ninety-eight per cent of our DNA, chimpanzees are one of our closest relatives. Despite this, they must not be confused with being our ancestor: they are a modern ape.

Ever since Darwin's theory of evolution, mankind's connection with chimpanzees has been one of both fascination and wariness. Between 6 to 13 million years ago, a single ape ancestor gave rise to the human line and the chimpanzees. Along with other apes humans share many similar characteristics, such as the greying of hair. The social life of chimpanzees also has much in common with our own; individuals create special bonds and greet each other affectionately. They have an elaborate range of over thirty different calls and can be taught to use some basic human sign language.

Flexibility Chimpanzees have fantastic dorsal flexion (the angle between the foot and the lower leg), and are able to bend their foot up against their shin. This helps them when climbing.

Chimpanzee widgets

This simple widget combines primary forms and helps create a sense of dimensionality. It is useful when sketching heads at different angles.

The nose can be visualized as a pad like this.

Random hair marks can be added, without the need to draw every single hair

Chiaroscuro Canopy light from above. Use strong tonal contrasts between light and dark to model three-dimensional forms to create a dramatic effect.

The brow ridge places the eye sockets in shadow.

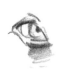

The eyelids are similar to those of humans. Note the way the skin overlaps the bottom of the eye and catches the light.

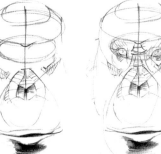
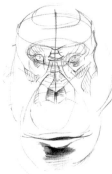

Shadow below the bottom lip helps give the characteristic pout of a chimpanzee.

Wrinkle lines in the skin echo the shape of the eyes.

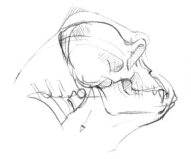

Core character Capturing the jutting jaw and heavy brow ridge can really help establish the character of the head.

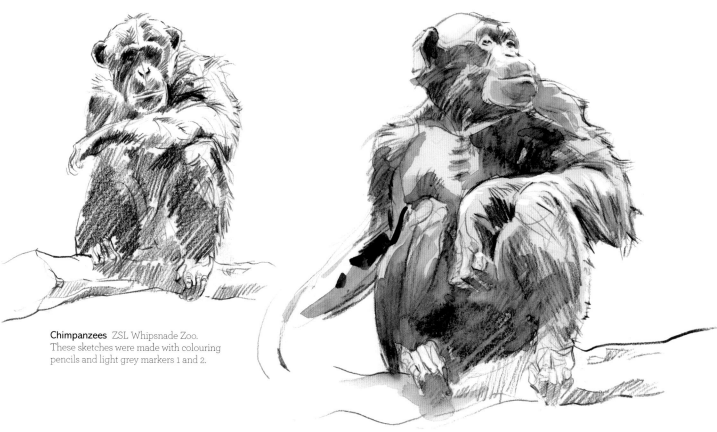

Chimpanzees ZSL Whipsnade Zoo.
These sketches were made with colouring
pencils and light grey markers 1 and 2.

Chimpanzee portrait in pencil

1 Begin by creating two ellipses, one for the
cranium and one for the muzzle. Next, add an
additional ellipse for the eye area: as though the
chimpanzee is wearing a snorkelling mask.

2 Create a start and stop point for each eye.
On humans the distance between the eyes
is the same as the width of one eye. On a
chimpanzee, however, the distance between is
slightly further than the width of one eye.

3 Begin to develop the eye area. Unlike
humans, where we can see the whites of the
eyes, the chimpanzee's iris fills the eye opening.

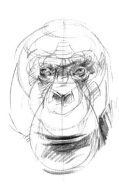

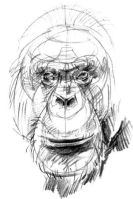

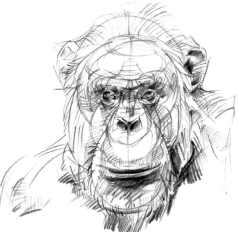

4 Develop the mouth area. In this example,
with light falling from the canopy above, the top
lip is in shadow.

5 Add the nose as a raised pad, then
build up the fur (see opposite).

The finished sketch.

MOVEMENT THROUGH WATER

The line between the sea, freshwater and land can be thought of as strict, but in truth it is much more blurred than it first appears. Animals have been coming onto land to breed for at least 400 million years, while returning to the sea to feed. It is this dynamic tension between the increased safety for their offspring on land and the necessity of feeding in the water that has created evolutionary drivers for adaptations that have led to the aquatic mammals.

There are various classes of mammals that have gone back into the water after living on land. Aquatic mammals are not a taxon (a biological group), because they are not unified by any distinct biological groupings; rather they are simply species who share a dependence on water as part of their lifestyle. As such, although many share homologous structures (see page 24) such as streamlined bodies; broad, flattened forelimbs; and various skeletal adaptations, they do not have an immediate common ancestor.

These animals either partly inhabit or immerse themselves entirely in bodies of water, yet still breathe air. They include those that live in the oceans and seas, and those that live in fresh water.

All aquatic mammals depend on aquatic life, either partially or fully. Some, such as the seals, rest and breed on land, whereas the Amazonian manatee and river dolphin, that reside in fresh and brackish waters, remain immersed all their lives.

River horse

Depending on how you define this slippery term, the hippopotamus may also be considered an aquatic mammal, as it spends much of its time in the water, venturing out onto land at night for food. The name even translates as 'River horse'!

The pentadactyl limb in the sea

Aquatic mammals, like all land vertebrates today, are ultimately descended from a common ancestor that had four legs, with five toes on each foot. Some species have subsequently fused these fingers into hooves, lost them altogether, or developed them into wings. Aquatic mammals are no exception, and their limbs have also developed over time to help them move in the water.

Seals have developed their feet into powerful flippers. This makes them, together with sea lions and the walrus, pinnipeds, which means 'fin-footed' in Latin.

Darwin noticed how widespread the pentadactyl limb (see page 26) was when he wrote, in *On the Origin of Species*:

'What can be more curious than that the hand of a man, formed for grasping, that of a mole for digging, the leg of the horse, the paddle of the porpoise, and the wing of the bat, should all be constructed on the same pattern, and should include similar bones, in the same relative positions?'

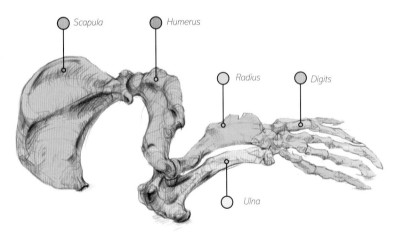

Scapula · Humerus · Radius · Digits · Ulna

Beneath the surface This illustration of the seal's limb bones shows that, although the flipper looks like a single structure, the five digits of the ancestral pentadactyl limb remain hidden within. Remember this when sketching to help you get the planes of the flipper correct.

MARINE AQUATIC MAMMALS

All dolphins, porpoises and whales are cetaceans, a group that includes the blue whale, the largest animal that has ever lived. Cetaceans are aquatic mammals that have streamlined bodies highly evolved for swimming.

Over time, these 'born again' sea creatures gradually streamlined their bodies to take on more fish-like characteristics, transforming their limbs into paddle-like flippers and flukes for swimming. Their hind legs have entirely disappeared as part of this streamlining. However, despite these drastic physiological changes, they still retain the homologous skeletal structure of a tetrapod.

Cetaceans share some convergent adaptations (see page 24) with sharks, such as a dorsal and pectoral fins.

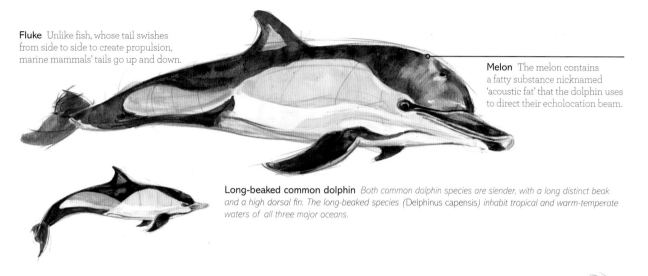

Fluke Unlike fish, whose tail swishes from side to side to create propulsion, marine mammals' tails go up and down.

Melon The melon contains a fatty substance nicknamed 'acoustic fat' that the dolphin uses to direct their echolocation beam.

Long-beaked common dolphin *Both common dolphin species are slender, with a long distinct beak and a high dorsal fin. The long-beaked species (Delphinus capensis) inhabit tropical and warm-temperate waters of all three major oceans.*

FRESHWATER AQUATIC MAMMALS

Mammals including otters, river dolphins, beavers and even the fascinating platypus live in freshwater environments. The freshwater aquatic mammals also include species like the Amazonian manatee and hippopotamus, with particularly fascinating adaptations to life in the water. The Eurasian otter is a member of the mustelids family, which includes weasels and badgers.

Harbour seal Seattle Aquarium.

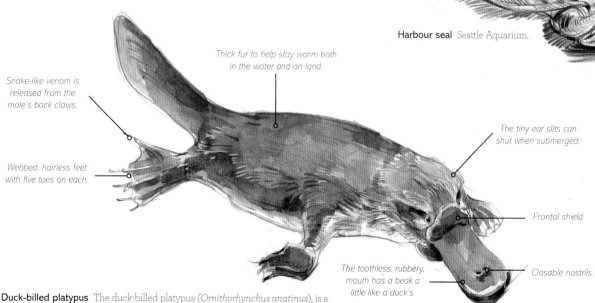

Snake-like venom is released from the male's back claws.

Thick fur to help stay warm both in the water and on land.

Webbed, hairless feet with five toes on each.

The tiny ear slits can shut when submerged.

Frontal shield

The toothless, rubbery, mouth has a beak a little like a duck's.

Closable nostrils.

Duck-billed platypus The duck-billed platypus (*Ornithorhynchus anatinus*), is a semiaquatic mammal endemic to Eastern Australia. They belong to a subgroup of mammals called monotremes, meaning 'single opening', referring to their single opening for anus and urino-genital system, like reptiles and birds. Producing milk like other mammals, but laying eggs like reptiles, it is often joked that monotremes are the only animals that can make their own omelettes.

Pinnipeds

Seals and sea lions, together with the walrus, manatees and dugongs, are pinnipeds, which means 'fin-footed' in Latin. Millions of years ago, the ancestors of these creatures moved from the land back into the sea and evolved special characteristics to adapt to their environment.

The sea lion has a wide gait on its back legs and they splay outwards to allow land locomotion with their knees turned outward. 'True seals' have their feet turned backwards for swimming, but gives them poor mobility on land.

SEALS

Their clumsiness on land belies their supreme elegance when swimming underwater, where they are skilled hunters of fish and other marine prey. These fin-footed creatures have streamlined bodies and four limbs that are modified into flippers (see page 164). Although not as fast in the water as dolphins, seals are more flexible and agile. Seals dive for up to an hour to depths of more than 200m (650ft), and occasionally go down deeper, to 500m (1,640ft), without surfacing for breath.

There are thirty-three species of seals alive on the planet today, which live all over the world, from the frozen polar regions to the tropical beaches of Hawaii, and almost everywhere in between.

Seals are a challenging subject when in the water, as their torpedo-shaped bodies, highly adapted for swimming, can move with athletic speed and agility. While slumbering in the sun on land, however, they can give rewarding sketching challenges with their big brown eye and dog-like features. Seals are mammals, and as such enjoy strong bonds between mother and pup.

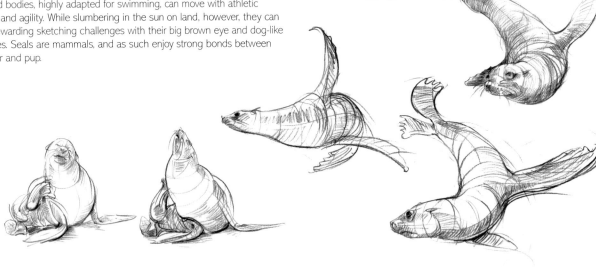

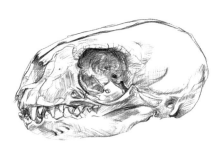

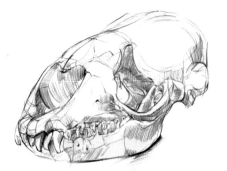

Grey seal skull The powerful jaws of this seal contain sharp teeth similar to those of a dog. Their behaviour is also quite dog-like, in that they are curious and playful – though they remain potentially dangerous.

Crabeater seal skull Rather than eating crabs, as the name might suggest, the crabeater seal feeds on the abundant krill of its Antarctic habitat. Its scientific name translates as 'lobe-toothed' and refers to the almost frilly appearance of the teeth. Adapted to filtering their small crustacean prey – just like the baleen of certain whales – these teeth are an example of convergent evolution (see page 24).

ABOUT THE DUGONG

The dugong (*Dugong dugon*) is one of four living species of the order Sirenia, which also includes three species of manatees. Dugongs are the only herbivorous strictly-marine mammal, as all species of manatee utilize fresh water to some degree.

These gentle seacows, as they are sometimes called, enjoy warm coastal regions and are related to elephants. Dugongs dwell in the shallow waters of the Indian and Pacific oceans. They are a little smaller than their manatee cousins, who live in the Atlantic marshy coastal habitats and freshwater habitats.

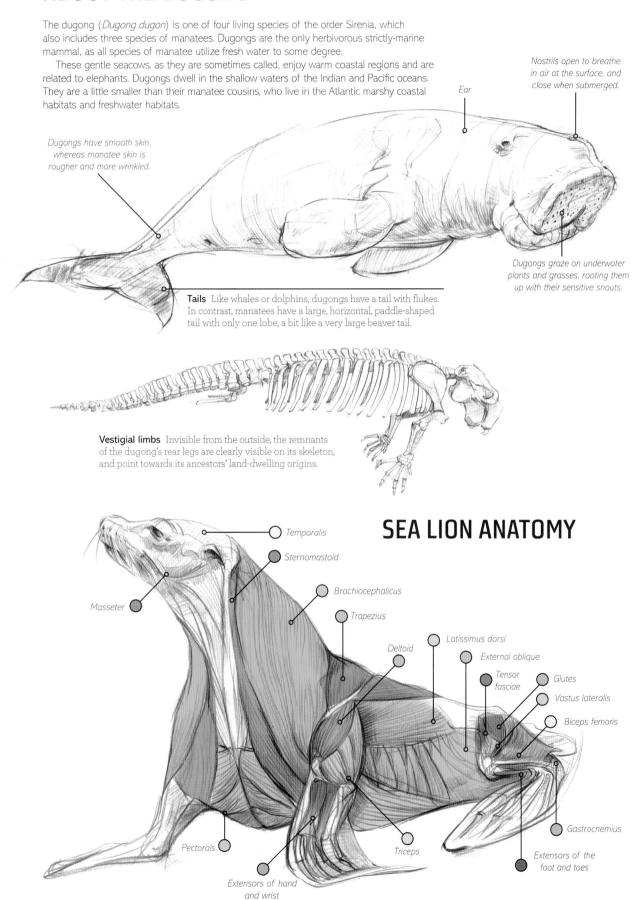

Nostrils open to breathe in air at the surface, and close when submerged.

Ear

Dugongs have smooth skin, whereas manatee skin is rougher and more wrinkled.

Dugongs graze on underwater plants and grasses, rooting them up with their sensitive snouts.

Tails Like whales or dolphins, dugongs have a tail with flukes. In contrast, manatees have a large, horizontal, paddle-shaped tail with only one lobe, a bit like a very large beaver tail.

Vestigial limbs Invisible from the outside, the remnants of the dugong's rear legs are clearly visible on its skeleton, and point towards its ancestors' land-dwelling origins.

SEA LION ANATOMY

Temporalis

Sternomastoid

Masseter

Brachiocephalicus

Trapezius

Deltoid

Latissimus dorsi

External oblique

Tensor fasciae

Glutes

Vastus lateralis

Biceps femoris

Gastrocnemius

Pectorals

Triceps

Extensors of the foot and toes

Extensors of hand and wrist

Blue whales

The dinosaurs were giant animals, but the biggest animal to have lived on the planet is with us today. These are the magnificent blue whales; these marine mammals can weigh up to 200 tons (45,000lb) and grow to a length of 30m (100ft). Their tongue alone can weigh as much as a fully-grown female elephant. Air-breathing mammals, blue whales can dive to more than one hundred metres (330ft) in the search for food.

Another astonishing fact about these enormous whales is that their diet is almost exclusively of some of the smallest animals: tiny shrimplike crustaceans called krill. A vital part of the food chain, krill average just 6cm (2¼in) in length. To fill up their bellies, blue whales can eat as much as 4 tons (9,000lb) of krill in a single day. It is a relationship which clearly shows the importance of the health of our oceans, with some of the smallest organisms providing sustenance to the biggest ever to have lived.

Whales belong to a class called cetaceans, which are all fully aquatic mammals. Whales are thought to have taken to the water about 50 million years ago, but all were originally terrestrial, and hence they breathe air rather than having gills. Whales are divided into two categories or sub-families: the toothed whales and the baleen feeder whales. Blue whales are baleen whales, which means that they have characteristic fringed lines, or pleats, under their chin, and feed by sieving krill through a bristly material in their mouth called baleen.

Under the water, blue whales are some of the loudest animals on the planet, able to communicate over long distances with other whales, with their whale songs that can be heard up to 1,600km (1,000 miles) away.

NOSE TO TAIL: BLUE WHALE

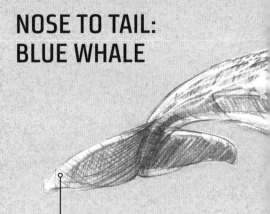

Fluke The fluke is the tail fin of aquatic mammals. It swishes in an up-and-down motion to create forward propulsion. This is unlike sharks and ray-finned fishes, which use a side-to-side action.

Reflected light Reflected light from the membrane of the sea's surface between air and water environments can be created by scanning splatters of white gouache paint and wrapping these around the sculpted forms in Photoshop.

SKETCHING BLUE WHALES

While we can't sketch blue whales from life, it seems a shame not be able to draw them. Here is a sketch-up technique that will allow you to create an illustration of a blue whale from photographic reference material.

1 Start by placing a box in two-point perspective as shown. For ease, use the three-quarter angle beneath the eye line (see page 12).

2 By combining forms, place a second box for the nose, in front of the first box. Use the cross to cross method to ensure that it is central and symmetrical.

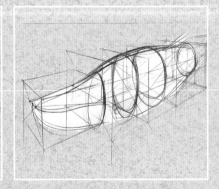

3 Use these boxes as architectural structure (see page 12) within which to build an organic form in space. Imagine a series of ellipses receding in space that capture the form of the torso and rough in the snout.

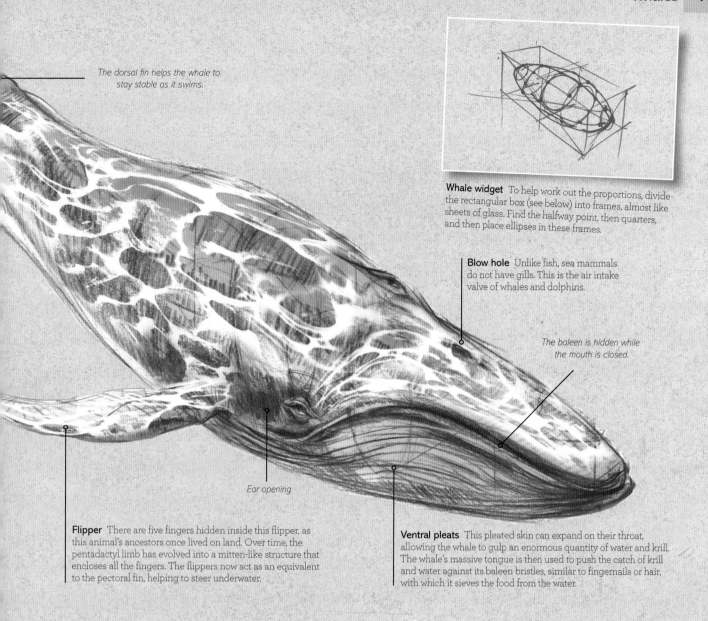

The dorsal fin helps the whale to stay stable as it swims.

Whale widget To help work out the proportions, divide the rectangular box (see below) into frames, almost like sheets of glass. Find the halfway point, then quarters, and then place ellipses in these frames.

Blow hole Unlike fish, sea mammals do not have gills. This is the air intake valve of whales and dolphins.

The baleen is hidden while the mouth is closed.

Ear opening

Flipper There are five fingers hidden inside this flipper, as this animal's ancestors once lived on land. Over time, the pentadactyl limb has evolved into a mitten-like structure that encloses all the fingers. The flippers now act as an equivalent to the pectoral fin, helping to steer underwater.

Ventral pleats This pleated skin can expand on their throat, allowing the whale to gulp an enormous quantity of water and krill. The whale's massive tongue is then used to push the catch of krill and water against its baleen bristles, similar to fingernails or hair, with which it sieves the food from the water.

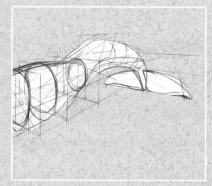

4 Add the fluke (tail) as a tube, at the back of the torso box. I have added mine in a flexed-down motion. The tail fin can be roughed out as a plane moving to the vanishing point on the left.

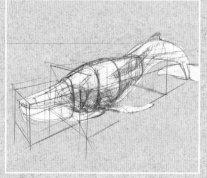

5 Using photographic reference, start to construct the organic form of the blue whale, judging the important relationship between the eyes and the blow hole. The pectoral fin can also be added as a plane, receding to the left vanishing point.

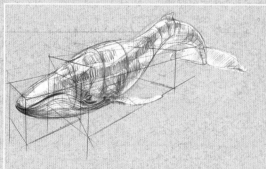

6 Sculpt the form of the whale by creating marks that wrap around the form of the blue whale in a series of planes.

Otters

All species of otter are carnivorous mammals with thick fur and webbed feet. The collective noun for a group of otters is a 'raft', because of their behaviour of joining together for warmth and protection.

Otters almost always swim in a dog paddle. They have long, flattened tails that move sideways to help propel them through the water. The tail is also used as a rudder. River otters have webbed digits and strong, non-retractable claws on all four feet, with the exception of one species. On the Asiatic otter, which have a sleek appearance and a weasel-like profile, these claws are small.

Otters have been on Earth for some 23 million years; but it is thought that the sea otter we know today evolved significantly between 5–7 million years ago. Whilst most otters share their time between land and water and have a set of adaptations for both. Sea otters predominantly spend their time in the water, but in some locations, they come on land to rest. I was first introduced to this lovely species whilst working as an expedition artist in Prince William Sound, Alaska.

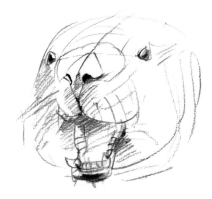

Aquatic adaptation Sea otters' nostrils and ears can close to stop water going in.

ABOUT THE SEA OTTER

Sea otters inhabit the coastal regions of the Pacific Ocean in both North America and Asia. These aquatic mammals are members of the weasel family that have adapted to thrive in the cool waters of the ocean. They are beguiling creatures with a host of adorable behaviours and are wonderful to sketch.

Whilst sketching sea otters you will notice their continual preening of their waterproof fur. There is a good reason the sea otter takes such care of its coat, as it the only barrier of insulation between this warm-blooded animal's body and the icy waters. Sea otters have little fat to keep them warm.

Sea otters are so comfortable in the water that they are the only otter to give birth in the water. Mothers nurture the young while floating on their backs, and also teach them to hunt and fish: the youngsters have to grow up fast.

Sea otters, also have a unique feeding strategy. Besides taking a clam or mussel from the ocean floor they will also craftily bring up a rock or pebble. This rock is placed on their chest and acts as a sort of anvil for the sea otter to smash the shellfish onto to break into the nutritious food inside. Sea otters also enjoy a wide range of seafood including, crabs, octopus, fish and squid.

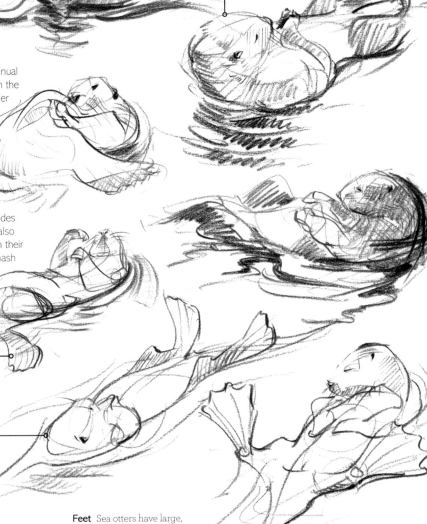

Insulation A thick coat of water-repellent fur helps keeps these animals warm in cold conditions.

Preening It is this behaviour that you will likely find yourself sketching the most, because sea otters are meticulous in keeping their fur clean, grooming themselves with both their paws and teeth.

Lying back Sea otters are unique in that they float on their backs and even sleep this way, joined up as a raft with other members in their group. If there is a strong current, then they wrap kelp or giant seaweed around themselves like a scarf, to provide an anchor.

Feet Sea otters have large, webbed, flipper-like feet

Asian small-clawed otter in mixed media

As semiaquatic creatures, ink and watercolour are fitting media to use for sketching otters. Use a fine rigger brush and white gouache to add the whiskers as the final touches to the illustration.

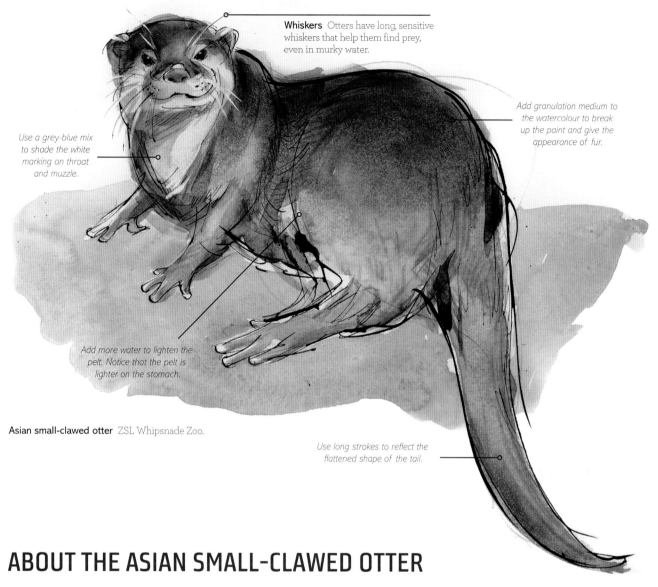

Whiskers Otters have long, sensitive whiskers that help them find prey, even in murky water.

Add granulation medium to the watercolour to break up the paint and give the appearance of fur.

Use a grey-blue mix to shade the white marking on throat and muzzle.

Add more water to lighten the pelt. Notice that the pelt is lighter on the stomach.

Asian small-clawed otter ZSL Whipsnade Zoo.

Use long strokes to reflect the flattened shape of the tail.

ABOUT THE ASIAN SMALL-CLAWED OTTER

A relative of the weasel family, the Asian small-clawed otter, *Aonyx cinerea*, is the smallest otter species in the world. Semiaquatic mammals, they inhabit mangrove swamps and freshwater wetlands in their native South and Southeast Asia.

The Asian otter lives in extended family groups with only the alpha pair breeding; offspring from previous years help to raise the young. Its paws are a distinctive feature, with claws that do not extend beyond the fleshy end pads of its partially webbed fingers and toes. This gives it a high degree of manual dexterity so that it can use its paws to feed on molluscs, crabs and other small aquatic animals.

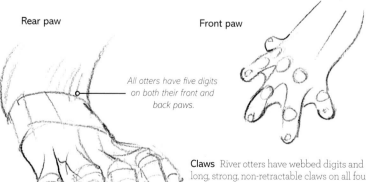

Rear paw

Front paw

All otters have five digits on both their front and back paws.

Claws River otters have webbed digits and long, strong, non-retractable claws on all four feet. The Asian otter has more dexterous fingers to forage for their prey, and do not have the long claws which most otters have. Because of this they also have less webbing between their digits than other otters.

MOVEMENT THROUGH AIR

Powered flight is a form of locomotion that has enabled animals to take to the air for sustained periods of time. Insects were the first to conquer the challenges of taking to the air, and remain the only arthropods to use this type of movement. Many modern insects' small, light bodies are well-adapted to flight – as shown by the sheer variety of this group – but they are not the only animals in the skies.

DEVELOPMENT OF VERTEBRATE FLIGHT

Over the course of the Earth's long history, there have been three fundamental designs of vertebrate 'flying machines' – pterosaurs, birds and bats. Understanding the structures of each can really help the accuracy of your sketching from life.

Fossil records show that, in all three different flight adaptations, flying lineages quickly radiate into a diverse range of niches once powered flight is attained. This accounts for the great diversity of our modern birds and bats, as flight allows the animal to colonize an enormous range of different habitats.

The blueprint of the wing – whether bird, bat or pterosaur – can be seen in all vertebrates. This blueprint is the pentadactyl limb (see page 26). No vertebrate on earth has more than five fingers, although some have less – it is an evolutionary rule that it is easier to lose something than it is to regain it.

The different groups evolved to use their limb in different ways to achieve flight, as shown opposite. When sketching birds or bats, look for the equivalencies between your arm and the animal's wing.

Timeline of vertebrate flight

Pterosaurs developed flight around 220 million years ago, while primitive flying birds emerged 150 million years ago.

The Cretaceous–Paleogene extinction event happened 66 million years ago, when an asteroid hit the Yucatán Peninsula. This caused the majority of all plant and animal species to die, including all of the pterosaurs. In their absence, mammals developed flight around the same time.

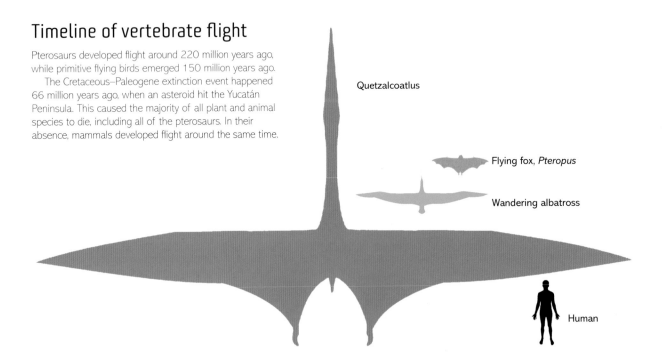

Quetzalcoatlus

Flying fox, *Pteropus*

Wandering albatross

Human

Pterosaurs

Pterosaurs, also known as pterodactyls, were the first vertebrates to develop the ability to fly. Some 220 million years ago, in a period known as the Cretaceous, the movement of the continents broke up the northern and southern land masses and also pushed up sea levels, opening up new sea ways and shorelines. The resulting cliff faces became the homes of these new winged reptiles, and the pterosaurs would rule the skies for 140 million years, flourishing and spreading around the globe. Some were as small as a sparrow others while others were simply gigantic – the biggest, quetzalcoatlus, was staggering in size. The great variety of their jaws tell us that some of the pterosaurs were specialist feeders, while others were scavengers capable of gobbling up almost anything they could find for dinner. As with the birds who would follow – and eventually out-compete – them, pterosaur bones were hollow.

The first vertebrate masters of the air were cumbersome on land, with their hands joined to their legs by their flight mechanism. Pterosaur wings are the simplest in construction of the three 'flying machines'. Thin membranes of skin stretch from a massively elongated forth finger to the end of their ankles. They are named after this finger: *pterosaur* comes from the Greek and translates as 'wing finger'. In this adaptation to flight, pterosaurs have lost their fifth finger.

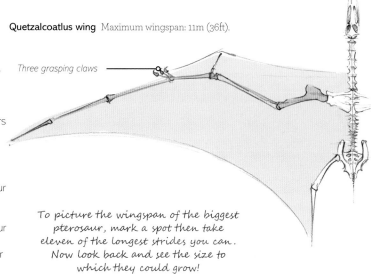

Quetzalcoatlus wing Maximum wingspan: 11m (36ft).

Three grasping claws

To picture the wingspan of the biggest pterosaur, mark a spot then take eleven of the longest strides you can. Now look back and see the size to which they could grow!

Birds

The most successful of all the animal flying machines are the birds, and surely the king of them all is the albatross. There are twenty-two different species of albatross, all highly adapted to become high performance gliders of the skies. Able to lock their enormous wings in an open position, albatrosses can achieve speeds of up to 108km/h (67mph), by literally sailing the skies. This allows them to circumnavigate the earth in forty-six days – rather better than the character Phileas Fogg, hero of Jules Verne's novel *Around the World in Eighty Days*!

Scientists have attached GPS trackers to the largest of these – the wandering albatross, whose wingspan can reach 3.5m (11½ft) – and have chartered their epic travels. They are capable of staying airborne for an incredible 10,000miles (16,100km) in a single journey.

Rather than being hindered by the wind, albatrosses exploit the wind's energy using a technique of dynamic soaring. In a sophisticated display of aerodynamics, albatrosses angle their wings into the wind and use the force of the oncoming air to soar up to 100m (330ft). It is this form of self-renewing energy that allows the albatross to stay out at sea for periods as long as five years.

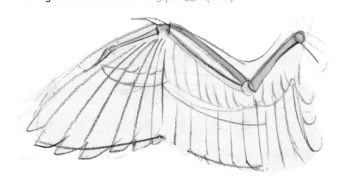

Wandering albatross Maximum wingspan: 3.5m (11½ft)

Bats

The asteroid strike 66 million years ago in the Yucatan peninsula, spelt the end of the pterosaurs' reign. With the sky no longer terrorized by these flying reptiles, one other group of animals took to the air: the mammals!

In this flying machine, the thumb becomes a hook-like hand and the four other digits stretch out wildly, to become long flexible bones that act as struts to give great aerodynamic control when chasing prey or hovering in front of a flower. All the bones in a bat's skeleton have become incredibly thin and light.

Bats are the only mammals to be able to fly. As with all animals that take to the air – insects, birds and the now-extinct pterosaurs – the power of flight opened up a vast array of new habitats and feeding possibilities for these creatures, which in turn created great diversity within the group. There are more than 900 accepted species of bat; and some experts believe that this number could be over 1,200, meaning that bats make up an incredible one-fifth of all mammal species on earth.

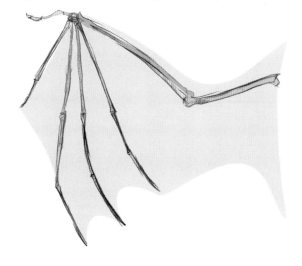

Flying fox, *Pteropus* Maximum wingspan: 1.5m (5ft)

Bats

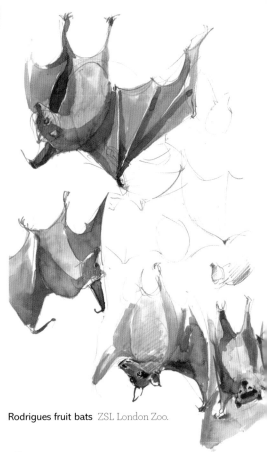

THE FLYING MAMMAL

Considering the sheer number of bat species (see page 173), it is unsurprising that there is great variety between them. Bats vary hugely in size, from flying foxes with wingspans of up to 1.5m (5ft), to one of the world's smallest mammals, the bumblebee bat, which weighs only 2g ($\frac{1}{16}$oz). The scientific name for the order of this class is Chiroptera. Within this class there are two sub-families, megachiroptera (megabats) and microchiroptera (microbats). The megabats are fruit bats. They mostly roost in trees and shrubs and only those that possess echolocation venture into the dark caves, where there is no light to see. Microbats make up all other bats. They mostly feed on insects, but not exclusively: some will eat small lizards and fish – or even drink blood, as in the case of the vampire bat. Megabats and microbats share similar flight dynamics and share a common ancestor.

The evolution of flight has enabled bats to live all over the world, except for the colder climates of the Arctic and Antarctica. Most bats prefer warmer climates closer to the equator. Bats can be found in rainforests, mountains, farmland, woods and even urban habitats.

Mostly nocturnal, bats sleep during the day in a place called a roost, keeping warm by wrapping their wings around them like a blanket. Bats will roost in structures available to them; ranging from caves to trees and even in the roof spaces of buildings. Waking at twilight, sometimes in swarms thousands strong, they fly out to feed.

Rodrigues fruit bats ZSL London Zoo.

BAT ANATOMY

Most mammals are entirely earth and water bound – flying is a tricky thing to do. To be able to fly, bats' skeletons have become incredibly thin and flexible. Bats have a very thin and lightweight pelvis for flight and so the bat doesn't have a heavy weight hanging over its head when it is hanging upside-down.

The distinctive arc shape of a bat's wing is created by the long metacarpals – the same bones as those in your fingers. Think of the wing as an elongated hand, and you will quickly understand the structure.

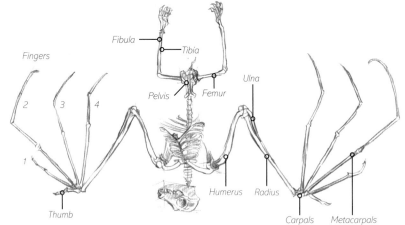

Fingers

Fibula

Tibia

Pelvis

Femur

Ulna

Humerus Radius

Carpals Metacarpals

2 3 4

1

Thumb

The wing

The bat's arms and fingers create the wing; another incredible adaptation of the pentadactyl limb (see page 26). The fingers of the limb have become greatly elongated, thin and flexible; with a double layer of skin between them stretched along the architecture of the fingers, and joined to the leg and ankle (microbats generally have a tail to which the skin attaches).

Echolocation

Over half the species of bats can echolocate, which means they can produce high-pitched clicks in their larynx, and emit them through their nose or mouth. The noise echoes off nearby objects – such as insect prey – and is then picked up by the bat's sensitive ears. As well as helping with avoiding obstacles, the time it take to receive the echo reveals to the bat the size and location of the prey. These calls are usually pitched at a frequency too high for adult humans to hear naturally, although sometimes it is possible to hear these ultrasound squeaks. This adaptation is primarily found in microchiroptera; very few fruit bats can echolocate.

Vampire bats Vampire bats are bats whose food source is blood. They have evolved a specialist mouth and nose. The common vampire bat is a small, leaf-nosed bat that is squat in shape.

Lesser short-nosed fruit bat in watercolour

The lesser short-nosed fruit bat (*Cynopterus brachyotis*) is an unusual species because they construct roost tents out of the leaves of palms and other large-leaved plants and flowers. By chewing the stems and veins, the bats collapse the leaves and use them to form well-engineered roosting shelters. These shelters protect them both from the rain and from predators.

Paint the lightest and brightest colours first. Remember to draw with the brush and follow the form of the glistening bats wings.

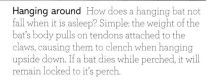

Hanging around How does a hanging bat not fall when it is asleep? Simple: the weight of the bat's body pulls on tendons attached to the claws, causing them to clench when hanging upside down. If a bat dies while perched, it will remain locked to it's perch.

Bat-hand A short clawed thumb, similar to your thumb, remains usable as a hook-like 'hand'.

Texture Leave flecks of white paper to suggest the leathery quality of the skin.

Wing This leathery wing gives the bat incredible manoeuvrability to chase insects and in some cases to hover in front of flowers to feed on the nectar.

Fruit bats Roosting fruit bats remain still during the day, making great subjects to sketch. When sketching fruit bats, try to create the illusion of the nose projecting forward.

Sketching bats in flight

Bats fly with a motion similar to swimming through the air. The movement reminds me of the butterfly stroke. The powerful pectoral muscles, attached to the sternum and humerus, pull the wing downwards. The metacarpals form an arc shape, which can help guide your sketching.

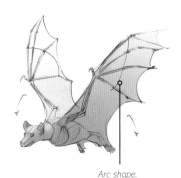

Arc shape.

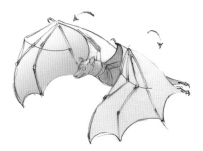

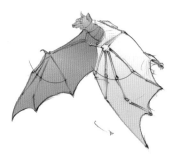

BIRDS

Like us, birds are a class of vertebrates, and they also walk bipedally. Our front limbs have become our arms, while on birds they have become wings. The skeleton has enabled vertebrates to do many things, but perhaps the most incredible is flight, which allows them to escape predators and move from one place to another swiftly and safely.

Over history, many animals have tried to get-airborne with various degrees of success and proficiency. The so-called flying fish and squirrels are considered to be using gliding techniques rather than true flight. Mammals have taken to the air in the form of bats, but the true masters of winged flight are undoubtedly birds, which have very light, yet strong skeletons, with large air pockets inside the bones themselves.

'The sketchbooks of Leonardo da Vinci (1452–1519), reveal that he was looking at the anatomy of bird and bat wings in his quest to create a mechanical device that would allow man to soar in the air.'

Over millions of years birds, with their special adaptation of the front limb into a wing, have evolved to live everywhere from forests to mountains – and their domain of the sky, of course, through which they can circumnavigate the world. The diversity of this species is immense, with around 10,000 different species ranging in size from the giant-winged wandering albatross, to the bee-sized booted racket-tail hummingbird.

Many birds have striking or unusual appearances: the extraordinary plumage and behaviour of the birds of paradise; the magnificent male frigatebird, which has a bright red inflatable throat-sack to attract a mate; and New Zealand's flightless nocturnal kakapo, the world's rarest and – at up to 3.5kg (7lb 11oz) – heaviest parrot.

HOW DID BIRD FLIGHT EVOLVE?

Fossil evidence can have a profound influence on our understanding of the evolution of life on planet earth. In 1861, just two years after Charles Darwin published his seminal work, *On the Origin of Species*, there was a discovery that confirmed this great work: a near-perfect skeleton of a transitional species between dinosaurs and birds, termed *Archaeopteryx*, which translates as 'ancient feather or wing'. Now regarded as the oldest known bird, eight or so fossils that date to the late Jurassic period (approximately 150 million years ago) have been discovered in limestone in an area that is now southern Germany.

Halfway there: Archaeopteryx

Archaeopteryx was discovered with feathers attached to its body and anatomy that indicated that it walked and perched on tree branches like a bird. Its teeth, however, were very reptilian with bony jaws and snout rather than a beak. It had a bony tail like that of a reptile, that also had feathers attached.

On all modern birds the thoracic vertebrae are fused to prevent energy being wasted in flexible joints. On Archaeopteryx they are not, so perhaps this transitional species used its feathers – which are clearly capable of supporting flight – to simply glide from the trees, which is easier to do than climbing down with three toes.

Archaeopteryx had more shared characteristics in common with the dinosaurs than modern birds: their jaws had sharp teeth instead of a bird's distinctive keratin-coated beak; the three 'fingers' are actually claws; and Archaeopteryx retained a lizard-like long bony tail. Birds have fused trunk vertebrae for stability, while Archaeopteryx still had a flexible spine. For all these differences, however, we can also clearly see well-developed and bird-like flight feathers, with barbs that would have allowed the feather to create lift. However, it remains unclear if these feathers were capable of flapping flight or just used for gliding.

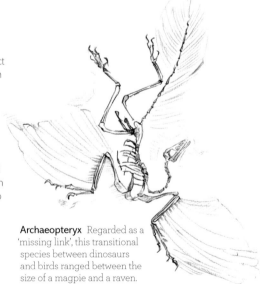

Archaeopteryx Regarded as a 'missing link', this transitional species between dinosaurs and birds ranged between the size of a magpie and a raven.

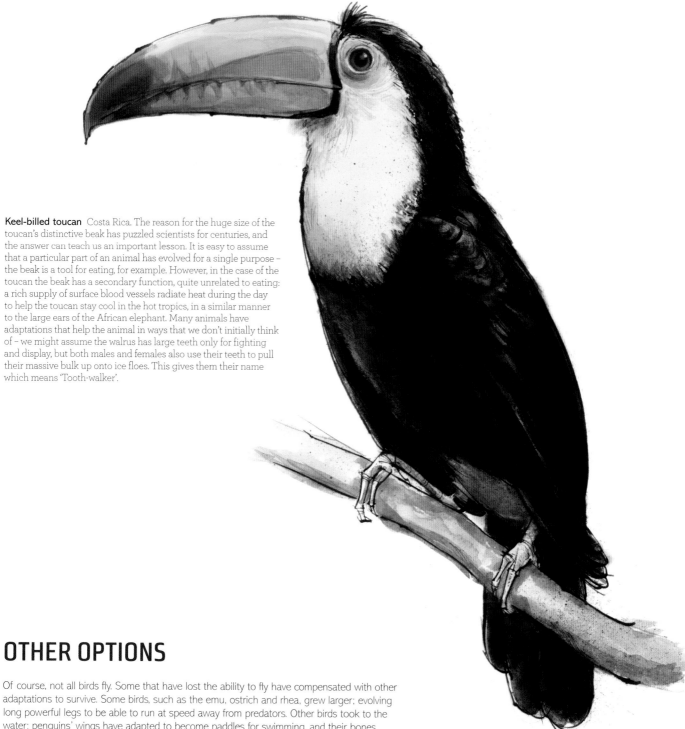

Keel-billed toucan Costa Rica. The reason for the huge size of the toucan's distinctive beak has puzzled scientists for centuries, and the answer can teach us an important lesson. It is easy to assume that a particular part of an animal has evolved for a single purpose – the beak is a tool for eating, for example. However, in the case of the toucan the beak has a secondary function, quite unrelated to eating: a rich supply of surface blood vessels radiate heat during the day to help the toucan stay cool in the hot tropics, in a similar manner to the large ears of the African elephant. Many animals have adaptations that help the animal in ways that we don't initially think of – we might assume the walrus has large teeth only for fighting and display, but both males and females also use their teeth to pull their massive bulk up onto ice floes. This gives them their name which means 'Tooth-walker'.

OTHER OPTIONS

Of course, not all birds fly. Some that have lost the ability to fly have compensated with other adaptations to survive. Some birds, such as the emu, ostrich and rhea, grew larger; evolving long powerful legs to be able to run at speed away from predators. Other birds took to the water: penguins' wings have adapted to become paddles for swimming, and their bones have thickened.

However diverse these species, there are common traits. All birds are oviparous animals, meaning that they lay eggs. The female sits on these eggs till they hatch. All birds are warm-blooded and have a covering of feathers, even penguins. All birds lack teeth; instead having beaks or bills which are specially adapted to the food that they eat (see page 181).

It is their diets that allows us to put birds into different classes. Birds that feed on seeds, grasses and grains are called herbivores; while birds who live on a diet solely of grains and seeds, such as game birds, sparrows and finches, are called granivores. Opportunistic birds, like pigeons and hens, are in a group called omnivorous birds, which can eat almost anything. Finally, there are carnivorous birds that hunt and kill other animals. Carnivores include birds of prey, specialized insectivores that only eat insects, and piscivores that only eat fish. Examples of the latter are kingfishers, puffins and pelicans.

Astonishing ostriches

Ostriches lay the world's biggest eggs. Although adult ostriches can run at speeds of up to 72.5km/h (45mph) – the top land speed of any bird – in order to escape predators, they don't always need to – an ostrich's kick is powerful enough to kill a lion.

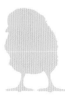

BIRD ORIGINS

Not all dinosaurs are extinct – the ones with us today are in the shape of the birds. All birds, from the roast chicken for your Sunday lunch to the penguin in the zoo, are in every sense still dinosaurs. Scientists believe that no animal bigger than a labrador made it through the last extinction event, some 66 million years ago.

Fossil records indicates that birds evolved from a group of dinosaurs known as the theropods, which comes from Greek and means 'wild beast foot'. This dinosaur suborder is characterized by hollow bones and three-toed limbs, such as we can find on some birds today.

Archosauria (A) The ruling reptiles, from which crocodilians, pterosaurs, other dinosaur groups and modern birds are descended.

Crocodilians (B)

Pterosaurs (C) 228 million years ago, these were the second group of animals to take to the air, after insects. Pterosaurs are not considered to be dinosaurs.

Dinosauromorphs (D) These first appeared around 244 million years ago, being small and walking on two legs, with their legs beneath their body.

Ornithischians (E) A group of 'bird-hipped' and mainly herbivorous dinosaurs that includes the triceratops. Despite the name, modern birds are more closely related to theropod dinosaurs.

Saurischians (F) The lizard-hipped dinosaurs.

Theropoda (G) A primarily carnivorous group; these were the dinosaurs that walked on two legs that evolved into the birds.

Modern birds (H) The true birds are thought to have evolved 130 million years ago.

The bird family tree

Meaning 'bird metatarsals', the Avemetatarsalians are the strand of dinosaurs also known as the bird-footed. It encompasses those groups which are closer to birds than to crocodiles.

Sexual dimorphism

Sexual dimorphism is the condition where the two sexes of the same species exhibit different characteristics beyond the differences in their sexual organs. Feathers originally evolved to keep the dinosaurs warm. Later on, though still millions of years before they adapted to the function of flight, they became pigmented, perhaps for courtship displays. Female birds often seem to have a preference for bright colours in males as an important indicator of health and vitality; while they themselves are often dull in colour to be camouflaged while they sit on nests and incubate the young.

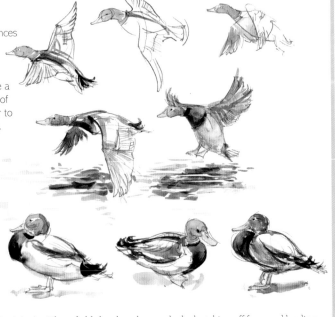

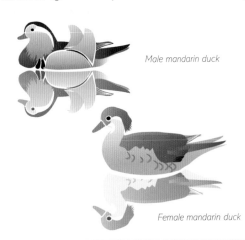

Male mandarin duck

Female mandarin duck

Mallard ducks These field sketches show male ducks taking off from and landing on water. The distinctive green and barred plumage is a result of sexual selection.

ANATOMY OF THE FEATHER

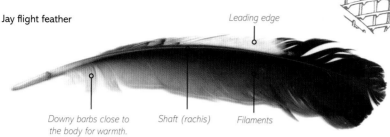

Jay flight feather

Leading edge

Downy barbs close to the body for warmth.

Shaft (rachis)

Filaments

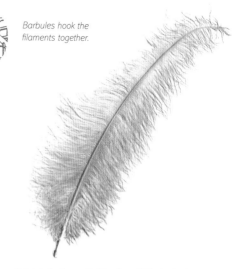

Barbules hook the filaments together.

Over millions of years these descendants of the dinosaurs have become the masters of the skies. Their flying apparatus, the wing (see pages 182–183), allows birds to perform the most remarkable aerial acrobatics and even fly in formation. But where did the most intrinsic component, the feather, come from?

The next time you find a feather, pick it up and have a look at the structure. If it is a flight feather, it will feel stiff, and you will be able to peel back the barbs – the filaments that attach to the central shaft (the rachis) – and feel the barbules that zip them together. The filaments of a flight feather are shorter on the leading edge that breaks into the wind. To be able to create lift, the filaments are stronger and zipped together by barbules. Hollow in the middle, they are both very light and strong – flight feathers are stiff enough to be cut to create a quill nib for drawing.

Ostrich feathers Unlike the stiff flight feathers of flying birds, ostrich feathers are fluffy for display, warmth and incubating eggs. While they are incapable of flight, ostriches use their wings as stabilizers when running. We use down feathers today in duvets to keep us warm, too.

Evolution of the feather

Feathers are one of the miracles of evolution and have a history that goes back more than 150 million years. They are made of keratin; the same material as the scales that birds have on their legs, and that cover reptiles bodies. It is from scales that feathers have evolved.

A good way to understand the evolution of the feather is to think of a baby chicken. Chicks are born covered in feathers that are more like filaments for warmth, rather than feathers ready for flight. Very

similar filaments appeared on the dinosaurs. As the chick develops, their filament-based wings cannot be used to fly, but they can still use them to gain a little lift when climbing, and they act as a wind break when jumping down, to make the landing softer.

Stage 1 A feather bud from a reptile scale.

Stage 2 Tubular bristle-like shaft develops.

Stage 3 Branched feather.

Stage 4 The central supporting rachis evolves.

Stage 5 After the development of the rachis, the next stage in feather evolution was the development of barbules.

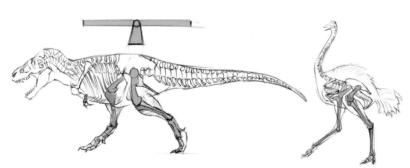

Balancing Dinosaurs like *Tyrannosaurus rex* had a heavy head and a long tail to help balance. The only dinosaurs alive on the planet today that use walking as their primary form of locomotion are the flightless birds, including the ostrich, emu and kiwi.

Tails While they have lost their reptilian tail, birds still use their feathery tails to balance today. Different species naturally hold their bodies at different angles when in repose.

BIRD ANATOMY

A bird's body could be seen as a mechanism for getting the bird's beak to food, whether this is through the air, water or on land.

Birds have evolved specialist adaptations: a stork has long legs to keeps its feathers dry above the water, so that it can spear fish; a penguin preens its feathers with an oily secretion that make its feathers waterproof so that it can swim and catch fish; woodpeckers have two toes pointed forward, and two toes pointed backward to be able to climb trees to peck for grubs.

Birds have more cervical or neck vertebrae than many other animals, consisting of thirteen to twenty-five vertebrae compared with our seven allowing for a wider movement of the head, which is of particular importance when feeding.

THE CAPTIVATING DODO

Although the dodo has historically been considered fat and clumsy, it is now thought to have been well-adapted for its ecosystem. Despite being flightless and having a comical appearance, it is a great bird to introduce us to some of the underlying structure of a bird's anatomy. These underlying blueprints are found in all birds.

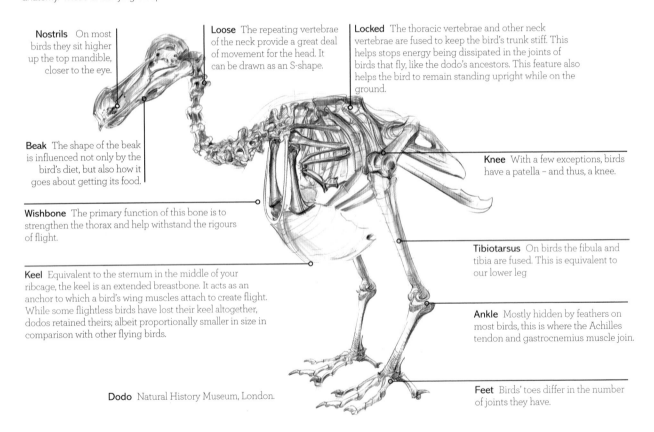

Nostrils On most birds they sit higher up the top mandible, closer to the eye.

Loose The repeating vertebre of the neck provide a great deal of movement for the head. It can be drawn as an S-shape.

Locked The thoracic vertebrae and other neck vertebrae are fused to keep the bird's trunk stiff. This helps stops energy being dissipated in the joints of birds that fly, like the dodo's ancestors. This feature also helps the bird to remain standing upright while on the ground.

Beak The shape of the beak is influenced not only by the bird's diet, but also how it goes about getting its food.

Knee With a few exceptions, birds have a patella – and thus, a knee.

Wishbone The primary function of this bone is to strengthen the thorax and help withstand the rigours of flight.

Tibiotarsus On birds the fibula and tibia are fused. This is equivalent to our lower leg

Keel Equivalent to the sternum in the middle of your ribcage, the keel is an extended breastbone. It acts as an anchor to which a bird's wing muscles attach to create flight. While some flightless birds have lost their keel altogether, dodos retained theirs; albeit proportionally smaller in size in comparison with other flying birds.

Ankle Mostly hidden by feathers on most birds, this is where the Achilles tendon and gastrocnemius muscle join.

Feet Birds' toes differ in the number of joints they have.

Dodo Natural History Museum, London.

Eye positioning

As we are used to human faces, there is a tendency to draw the eye too high up. The eye looks down the beak and is on the same level. I find this little gizmo of cross hairs useful. The eye is looking down the beak to accurately catch its food.

Beaks of other animals

The beaks of octopus and squid are primarily made of chitin, the same polymer that is found in insects' exoskeletons, while a bird's beak is created from keratin – the same substance that creates your fingernails.

BEAKS

Modern birds' beaks, which evolved from a keratin coating of the pre-maxilla found in toothed dinosaurs, are fantastic tools that have adapted in a huge variety of ways, some of which are shown here. Beaks evolved to be light, which is important for flight and balance. Tails disappeared about the same time that beaks evolved for many of the same reasons.

Any movement of the beak usually comes from the lower bill dropping, though on some birds, the upper part can also move. Such movement is usually subtle and slight, but certain birds – like parrots – demontrate a dramatic uplift of the top bill, which enables them to handle and break the shells of nuts and seeds.

Hummingbirds Highly varied in length and curvature, their beaks evolved to feed from specific brightly-coloured flowers in their native South America. The shape of each species' beak relates to the specific shape of flowers that the hummingbird is able to feed from.

Diet and strategy

The beak is an economical way of being able to eat a variety of foods. The downside of the inflexible beak is that birds can't chew their food. As a result, many birds eat their food whole. Some, such as the ostrich, eat stones to help grind up the food in its gizzard.
Some birds are generalists, eating a variety of food sources. However, most birds are specialists, which means how they look and behave is determined partly by their preferred choice of food and the strategy they employ to catch and eat that food.

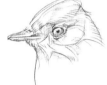 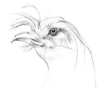

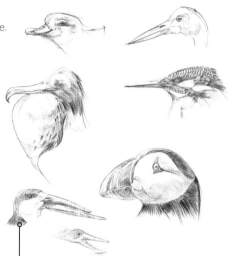

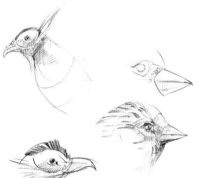

'If you can create the shape of the beak, you can capture the character of the bird.'

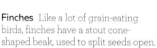

Finches Like a lot of grain-eating birds, finches have a stout cone-shaped beak, used to split seeds open.

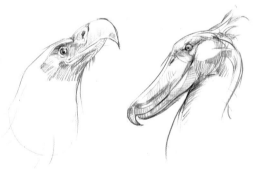

Skimmer This bird flies just above the water, pushing its abnormally long lower beak through the surface to scoop up its food.

Nectar eaters Nectivorous birds like hummingbirds often have long fine beaks that have adapted to reach into the flower to be able to get at the valuable nectar inside.

Fruit and berry specialists Frugivorous beaks are adapted to help to cut through or remove the skin, husk or hull of preferred fruits. They have a multitude of different shapes to be able to do this. Many birds eat fruit, those considered frugivorous – such as orioles, waxwings and toucans – show a substantial amount of fruit in their diet.

Seed-eaters You are likely to be familiar with granivorous birds, particularly if you have a bird feeder. Not all such birds have the typical triangular seed-cracking shape of beak. This group includes pheasants, parakeets, doves and pigeons that have equally well-adapted beaks.

Fish-eaters A subcategory of meat-eating birds, piscivorous birds like kingfishers and puffins have several unique adaptations that help them catch their aquatic prey. Some have a spear-like beak, others have their own unique strategy.

Meat-eaters Birds of prey such as hawks, falcons, eagles – as well as scavengers like vultures – are all meat eaters. This group of carnivorous birds also includes birds such as the shoebill. Specialist beaks As it walks, the kiwi taps the ground with its beak, probing the soil and sniffing loudly. The filter-feeding flamingos also have uniquely shaped beaks.

Shoebill Named after its clog-shaped bill, an adaptation for catching and holding the large, slippery lungfish, its favourite food. This big bird also eats turtles, fish, and even young crocodiles.

Kiwi The only bird to have its nostrils at the end of its beak; kiwis snuffle and snort loudly to clear them of dirt.

WINGS

Birds are superbly adapted for flight. The combination of lightweight, strong bones and the specialised shapes of the bones, beak and feathers are responsible for giving birds their special ability for sustained flight.

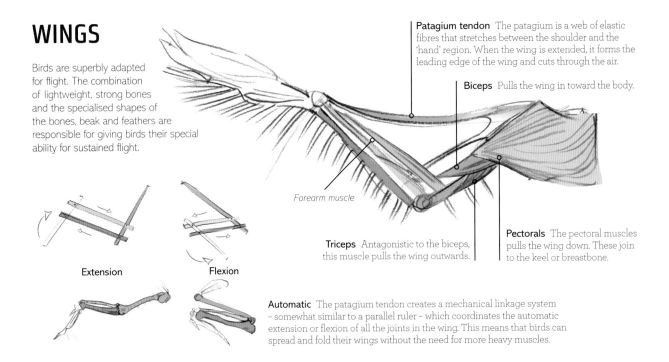

Patagium tendon The patagium is a web of elastic fibres that stretches between the shoulder and the 'hand' region. When the wing is extended, it forms the leading edge of the wing and cuts through the air.

Biceps Pulls the wing in toward the body.

Forearm muscle

Triceps Antagonistic to the biceps, this muscle pulls the wing outwards.

Pectorals The pectoral muscles pulls the wing down. These join to the keel or breastbone.

Extension

Flexion

Automatic The patagium tendon creates a mechanical linkage system – somewhat similar to a parallel ruler – which coordinates the automatic extension or flexion of all the joints in the wing. This means that birds can spread and fold their wings without the need for more heavy muscles.

Flight feathers

Also called *remiges*, from the Latin for 'oarsman', the primary function of the flight feathers is to aid in the generation of both thrust and lift, thereby enabling flight.

▶ **Primary feathers** Primary feathers are the longest on a bird's wing, attached to and radiating out from the 'hand and finger' region like a fan. In flight, they are responsible for thrust to propel the bird forward. Most birds have between nine and eleven primaries, though some have as many as sixteen.

▶ **Secondary feathers** These are attached to the ulna bone in the bird's 'forearm'. The number of secondaries varies from nine to twenty-five, depending on the species. These are fixed and appear straight in both flight and seated position. These feathers provide lift, and are hence extensive on soaring birds.

▶ **Tertials** Birds have three or four feathers called tertials on their 'upper arm'. They are the short, innermost flight feathers on the rear edge of a wing, close to the body of the bird. They are not as important for flight as the primary and secondary feathers and cover the gap between the body and the wing.

Shape Birds have differently- shaped wings: some short for manoeuvrability, some long for soaring.

Alula The alula, which means 'winglet' in Latin, is the freely moving first digit; a bird's 'thumb'. It typically bears three to five small flight feathers, which are held open in slow flight to stop the bird from stalling; and 'ping out' for acrobatics.

Wild duck wing View from underneath.

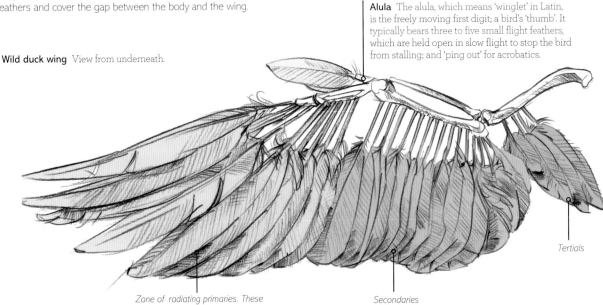

Zone of radiating primaries. These feathers attach to the 'hand'.

Secondaries

Tertials

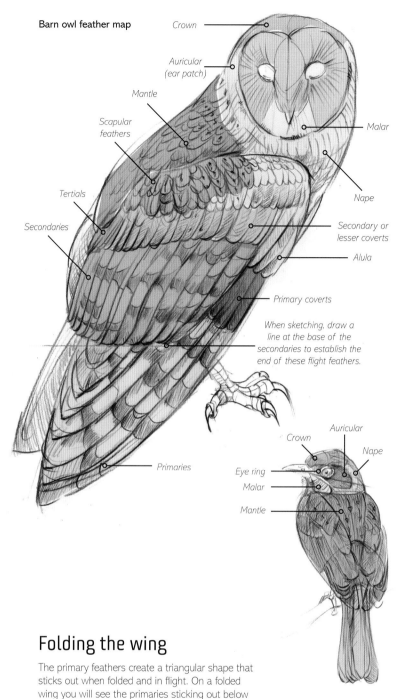

Barn owl feather map

Crown
Auricular (ear patch)
Mantle
Scapular feathers
Tertials
Secondaries
Malar
Nape
Secondary or lesser coverts
Alula
Primary coverts

When sketching, draw a line at the base of the secondaries to establish the end of these flight feathers.

Primaries

Crown
Auricular
Nape
Eye ring
Malar
Mantle

This view of a flycatcher shows how the feathers overlay each other from the back; just like roof tiles – or the scales from which they evolved.

Contour feathers

While flight feathers propel the bird through the air, contour feathers tightly follow the bird's body to make it streamlined, and down feathers trap pockets of air to keep the bird warm.

Feathers are not placed randomly on a bird but are arranged in regions. These are important to learn and can really advance your bird sketching skills.

▶ **Coverts** Small feathers that sit on top of the primary feathers of the wing and help the aerofoil of the wing to be smoother, more streamlined and thus more aerodynamic. The primary coverts are on top of the primaries and the secondary coverts on top of the secondary feathers.

▶ **Mantle** The mantle feathers occupy the middle of the back, these run straight and are often streaked.

▶ **Scapular feathers** Sitting on either side of the mantle, these cover the space where the wings meet the body. They angle outward and overlap the wing.

▶ **Rump feathers** Completely covered when birds fold their wings, rump feathers become visible when birds droop their wings, such as when they are hot. These feathers point downwards.

▶ **Upper tail coverts** With more definition than the softer rump feathers, these are also usually hidden in a seated stance. These stiffer feathers are streaked or dark-tipped in most species.

▶ **Tail feathers** The tail flight feathers (*rectrices*) are mainly concerned with stability and control. Used as a rudder, they help with steering and balance, allowing the bird to twist and turn in flight. They fan outwards for braking, both in flight and when for landing, and fold inwards when the birds is in a seated stance.

Folding the wing

The primary feathers create a triangular shape that sticks out when folded and in flight. On a folded wing you will see the primaries sticking out below the secondaries.

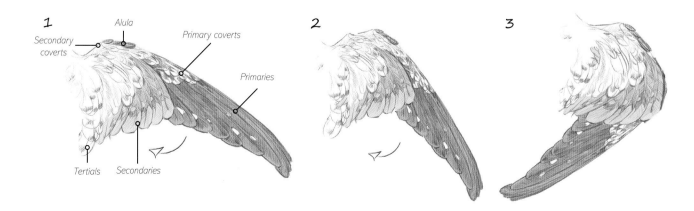

1
Secondary coverts
Alula
Primary coverts
Primaries
Tertials
Secondaries

2

3

Owls

Owls have diversified to take advantage of a myriad of environments around the globe, the majority primarily preferring tree-rich habitats. Most have a thick layer of insulating feathers. On owls that live in cold conditions, this can be up to 2.5cm (1in) thick. Females tend to be larger than males in owl species. They range greatly in size: the smallest is the elf owl, less than 15cm (6in) long, while the largest is the great grey owl, with females growing up to 84cm (33in); although this is deceptive since this species' fluffy insulating feathers extend beyond their body.

There are almost 200 different species of 'true owls'; the remaining dozen or so species classed as the barn owls. The barn owls have a highly distinctive heart-shaped facial disc, but the principles behind drawing the basic shapes, posture and feather tract details apply to all owls.

WORKING FROM LIFE

Owls (and other birds of prey) are often displayed by falconry clubs and groups, which offers a great opportunity for sketching. Spending time with live owls really gets you close to their individual character and quirks, and creates a feeling of kinship with the animal that can't be experienced when working from photographs.

Understanding the structure of what you are drawing can really help, but it is important to remember to look hard at the subject you have in front of you.

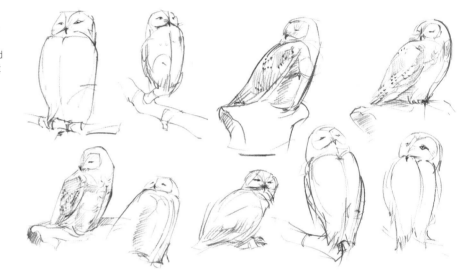

Three-quarter view On a barn owl, the facial disc is shaped like a stretched heart; forming cones in which an eye sits at the centre. As the owl rotates its head away from you, so the division on the far side of the body will appear narrower.

Sketches from life Having some anatomical knowledge can really help with live animals as you can fill in with knowledge on a subject that is continually moving. Once an owl has settled down, they can sit quite contentedly for a long while. But you will notice that the bird is continually looking around, picking up on different sounds with their fantastic directional hearing.

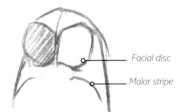

— Facial disc

— Malar stripe

Look for useful feather tracts to guide your sketching.

Developing your sketches

When working from live owls, there is a constant need to get the information down quickly. This can really help to give the drawing vitality and life. I create several starts on a single large study sheet, and return to the relevant sketch as the owl returns to a particular pose.

Look for the auricular (ear patch) and the malar stripe, and the feather tracts that create the facial disc; this is divided into two by a line of symmetry that runs the length of the owl's body.

1 Roughly sketch out the head shape. On a resting owl the head will be sitting on top of the body, rather than lunged forward.

2 Establish the angle of the body. I tend to start lightly, building up my confidence in where the edge of the forms lie. In a seated position the head sits on top of the body rather than in a lunged stance. Use warm curves to sketch out the mass of the owl's body.

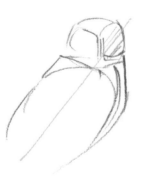

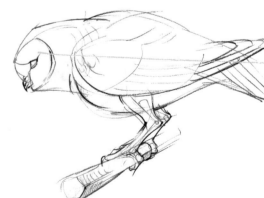

Talons An owl's foot has four toes, three of which face forward, and one backward to allow for perching on branches.

OWL ADAPTATIONS

Owls are carnivorous predatory birds, with a host of adaptations to nocturnal hunting: fantastic eyesight and hearing; powerful talons for grabbing prey; and the majority have feathers adapted for silent flight. All owls share a similar disc-like face, which makes them a characterful subject for sketching. The eyes appear higher up than other birds, because you just see the tip of the beak. Set into the facial disc are large eyes that are forward-facing for binocular vision.

What's that?
The great grey owl's hearing is so highly adapted that they can track and accurately locate their prey without sight: they can track and catch prey, such as mice, running beneath as much as 50cm (1½ft) of snow.

Sound funnel The facial disc guides sound to the ear openings, helping the owl to track prey.

Prey Like hawks, owls tear larger prey apart with their sharp beak and eat smaller prey, such as mice, whole. The parts of the animal the bird cannot digest are regurgitated in the compressed form of pellets.

Lopsided Like most vertebrates, owls have ear openings on either side of their skull. However, on certain species these ears are asymmetrical, which means that the sound reaches the ears at slightly different times. This enables to the owl to judge spatially and detect prey by sound alone.

Stealth To be able to approach their prey silently, most owls have soft, fine comb-like filaments on the leading edge of wing feathers to break up the turbulent air that creates the typical swooshing sound of bird flight. Sound recordists have used a professional studio to see if they were able to get a recording, but were unable to detect any sound even at very sensitive settings.

Camouflage Many owls are highly camouflaged to be able to blend into the environment during their daily roosts, with speckled grey and brown plumage.

Flexible neck An owl's eyeballs are tubular in shape, and so cannot rotate to look in different directions. Instead, they move their heads to be able to track prey: owls can rotate their head more than 270° from side to side, and even rotate vertically to 180°. To achieve this, they have a long flexible S-shaped neck, concealed by their thick plumage.

Great eagle owl The scientific name for this bird is *Bubo bubo*.

OWL STUDY SHEET

Owls have the ability to blink their upper eyelid. Combined with their forward-facing eyes – probably the most frontally situated of any of the birds – this gives them an appealing, human-like quality. Owls are superbly adapted as night hunters. Their huge eyeballs are shaped like tapering cylinders, which means they offer the greatest possible retinal surface for light, giving them fantastic night vision. Owls that hunt at other times of the day have different coloured eyes.

Diurnal Owls with yellow eyes are diurnal, which means they prefer to hunt in the day time.

Crepuscular Owls active around dawn and dusk, known as being crepuscular, have orange eyes.

Nocturnal Owls with dark brown or black eyes are usually nocturnal, preferring to hunt at night. The colour doesn't improve their night vision; instead, it helps to camouflage the owl from its prey.

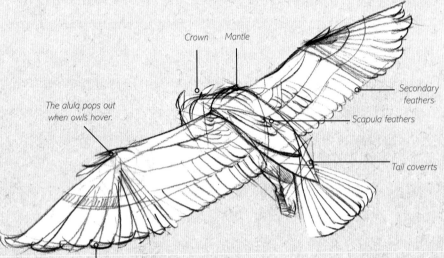

Crown Mantle

Secondary feathers

Scapula feathers

The alula pops out when owls hover.

Tail coverrts

Owls' ten primary feathers are large and rounded.

Rectrices Owls have twelve tail feathers called rectrices. The uppermost feathers are in the middle of the tail.

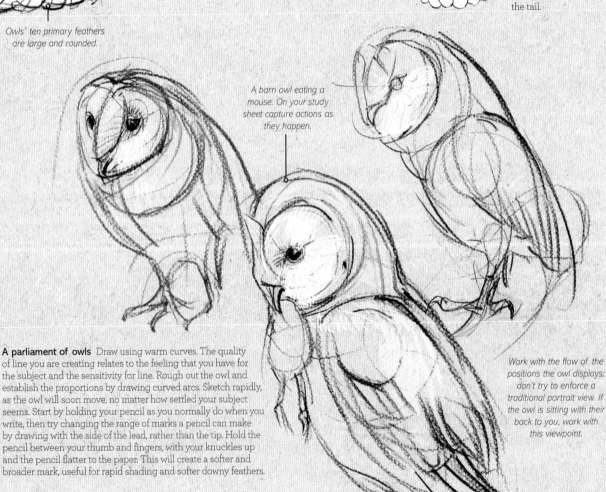

A barn owl eating a mouse. On your study sheet capture actions as they happen.

A parliament of owls Draw using warm curves. The quality of line you are creating relates to the feeling that you have for the subject and the sensitivity for line. Rough out the owl and establish the proportions by drawing curved arcs. Sketch rapidly, as the owl will soon move, no matter how settled your subject seems. Start by holding your pencil as you normally do when you write, then try changing the range of marks a pencil can make by drawing with the side of the lead, rather than the tip. Hold the pencil between your thumb and fingers, with your knuckles up and the pencil flatter to the paper. This will create a softer and broader mark, useful for rapid shading and softer downy feathers.

Work with the flow of the positions the owl displays; don't try to enforce a traditional portrait view. If the owl is sitting with their back to you, work with this viewpoint.

'Every encounter with owls feels like a gift. They present a curious combination: their appealingly rounded facial disc contrasts strongly with the razor sharp talons of a highly adapted predator.'

Fused thoracic vertebrae.

The warm round shapes of owls are created by thick coverings of feathers.

Underlying structure The 'hand' of a bird folds vertically beneath the radius and ulna in a seated position. This causes the tips of the primaries to stick out behind a line of secondary feathers on the folded wing.

'Hand'

Knee

The underside of an owl's foot is covered with a rough, knobby surface that helps to grip its prey or a perch.

Ankle

Use harder, sharper marks on the flight feathers.

Grip As with other birds of prey, owls have a mechanism in their foot that keeps the toes locked around a perch or prey without the need for the muscles to remain contracted. With some of the strongest talons of all birds, owls are capable of seizing and grasping animals from mice to rabbits.

Fur boots Owl species that have adapted to cold climates, such as the snowy owl, have feathered feet for insulation. The feathers may also serve to sense contact with prey and to protect against prey that might bite when seized.

Greater flamingos

CHOREOGRAPHED PINK DANCERS

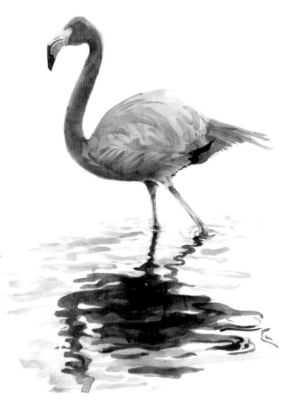

The natural world is full of extraordinary animals, and few more so than the flamingo. With their flamboyant shapes and colour, flamingos are a great subject for sketching.

Flamingos have a bulb-shaped body and long elegant legs and neck, gives them a fragile and feminine quality. Despite their decorative appearance these elegant looking birds are highly adapted to their environment. An example of this is the unusual feathers on the wings of the flamingo, which make them appear different to other birds. This is due to the long carmine-streaked scapular feathers that hang along their backs which have the practical purpose of keeping them warm.

Flamingos have webbed feet and are classed as waders. Individuals can live up to fifty years, and reach flight speeds of 56km/h (35mph). Flamingos mainly fly at night, trailing their long legs behind them.

1 Start out by drawing the bulb-like shape of the body. Aim to use 'rhythmic' lines to start.

2 Draw the crop and capture the rhythmic shape of the neck. Find the angle of the beak.

3 Observe the structure in the legs carefully, noting how they support the weight of the bird, then draw them in. A slightly concave mark, helps to express how the bone is thicker at the joints.

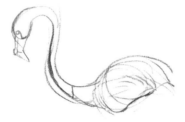

Nineteen neck vertebrae

The upper and lower bills fit together so tightly it is difficult to see the join when sketching.

Femur

Hidden knee

Ankle

Flexible neck Flamingos have nineteen cervical vertebrae in their long, S-shaped necks, which gives them a great deal of flexibility.

Legs The short thigh and the knee are completely hidden on a flamingo as they are both above the lower line of the body. The next joint down is the ankle: although sometimes confused with a backward-facing knee, it bends the same way the human ankle does.

Curious table manners
When eating, flamingos turn their head completely upside-down.

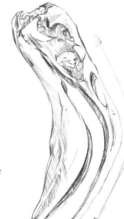

Filter feeder Capturing the unique shape of the flamingo's distinctive beak is particularly important. It has a 130° angle in the middle.

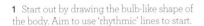
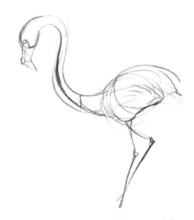
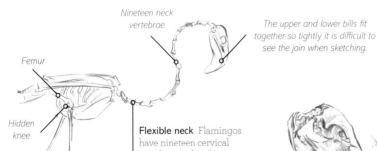

ABOUT THE FLAMINGO

Flamingos span the globe from the Caribbean, Southern America, Africa, the Middle East, and Europe. They are a very social animal and live in groups from a couple of thousands to millions. There are six different species that form brightly coloured colonies, called stands. All flamingos, wherever they are found, share the same anatomy. They are large birds, up to five feet in height, and with a wing span up to 91cm (3ft) across. The natural history illustrator Audubon, who liked to illustrate his birds at life-size, actually bent the neck of his illustration so the head appeared near the feet, as there was no paper big enough to print upon.

Flamingos stir up their food – waterborne algae and small crustaceans – by stamping with their webbed feet, then using their unique and highly-adapted bills to filter feed with their heads upside-down. Their tongue moves up and down hundreds of times each time they feed. The beta-carotene found in their food is what makes the birds pink – the more beta-carotene, the brighter the bird's plumage.

Dancers

The greater flamingo in their effort to attract a mate do something different. In an attempt to stand out from the rest of the crowd a male flamingo will create a flirtatious display. Movements between the males is coordinated, imagine a boy band dancing in unison. Scientists have discovered that they have nine signature moves, created to show off their best assets. One of the tallest and eldest of the males will make the first move onto the dance floor; he will then be joined by younger males to start the performance.

Typically, the dance performance starts by a lead male sticking his neck out, with a signature move called 'head flagging', in which the male will erect his head as high as he can and flip it from left to right. Other males will follow his lead. Observe this and other choreographed manoeuvres as you sketch.

Key features and behaviours

Eating When eating, flamingos turn their head upside-down. The beak is bent in the middle.

Marching While holding their heads high, flamingos march in unison.

The wing salute To show off their feathers to a potential mate, the male will stretch out his wing feathers.

The wing leg stretch Stretching out a wing and a leg on the same side, first outstretched and then backwards.

Eyes All flamingos, regardless of species have yellow eyes. The brain is smaller than the eye.

Feathers The scapular feathers hang like tassels and have carmine streaks, while the flight feathers are black.

Chicks Baby flamingos aren't born pink – it takes time for them to develop their adult plumage. They acquire their colour by digesting microorganisms that contain beta-carotene. As chicks they do not have long legs: these stretch out as they mature. At birth their beaks are like a normal bird, but these too morph as the juvenile reaches adulthood.

GREATER FLAMINGO STUDY SHEET

Greater flamingos ZSL Whipsnade Zoo.

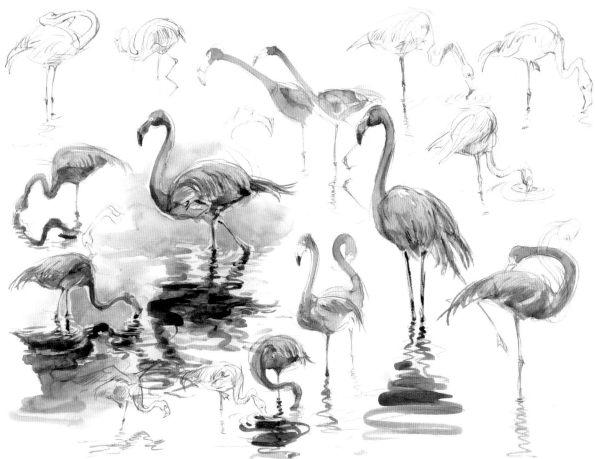

Penguins

Penguins are a personal favourite subject; they always seem happy to be sketched. Whilst working, you will notice different repeated behaviours. One of these is preening, in which oil secreted from the base of the tail is rubbed into the feathers to help them stay waterproof. You will also observe penguins tipping their heads back to give out a wide range of vocalizations, used to communicate with each other.

PENGUIN STUDY SHEET

Remember, the purpose of the study sheet is to familiarize you with the animals, capture its poses and get to know the character of both the group and the individuals.

Stage 1: Observation and initial marks

Before you start to draw simply observe the group. Wait until a penguin seems to settle into a pose, then rough out the shape and establish the proportions in a light line. Drawing lightly gives you the opportunity to gradually work towards defining the contour without having to establish it in one go. It is a good idea to start with the head as this makes it easier to get the proportions correct. Personally, I start with a mark for the eyes and place in a line for the angle of the beak.

Stage 2: Capture the gesture of the body

Work quickly: even though the penguin might be standing still, he or she will soon move. As usual, be prepared to work on more than one drawing at once, returning to a similar pose as the animal does. I tend to work from the head down the body, but this is not a hard rule. As you warm up your hand–eye coordination, you may find yourself beginning with lots of different starting points. I tend to begin with a side view and then push myself to capture other gestures.

 Do not dictate the shapes you believe a penguin should have or the traditional idea of a portrait, but try to capture the shapes the penguin presents to you, even if your subject has its back to you. Remember to start with the basic shapes rather than the detail, and use the side of the pencil lead to shade to speed up blocking in the markings.

PENGUIN ANATOMY

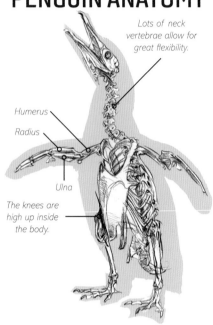

Lots of neck vertebrae allow for great flexibility.

Humerus

Radius

Ulna

The knees are high up inside the body.

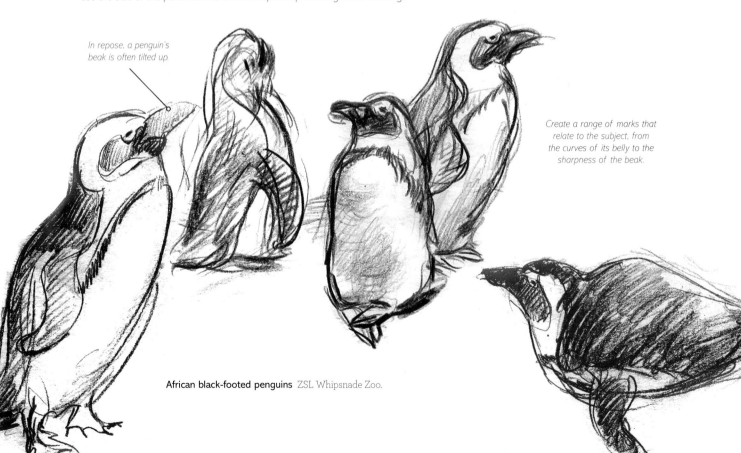

In repose, a penguin's beak is often tilted up.

Create a range of marks that relate to the subject, from the curves of its belly to the sharpness of the beak.

African black-footed penguins ZSL Whipsnade Zoo.

HUMBOLDT PENGUIN

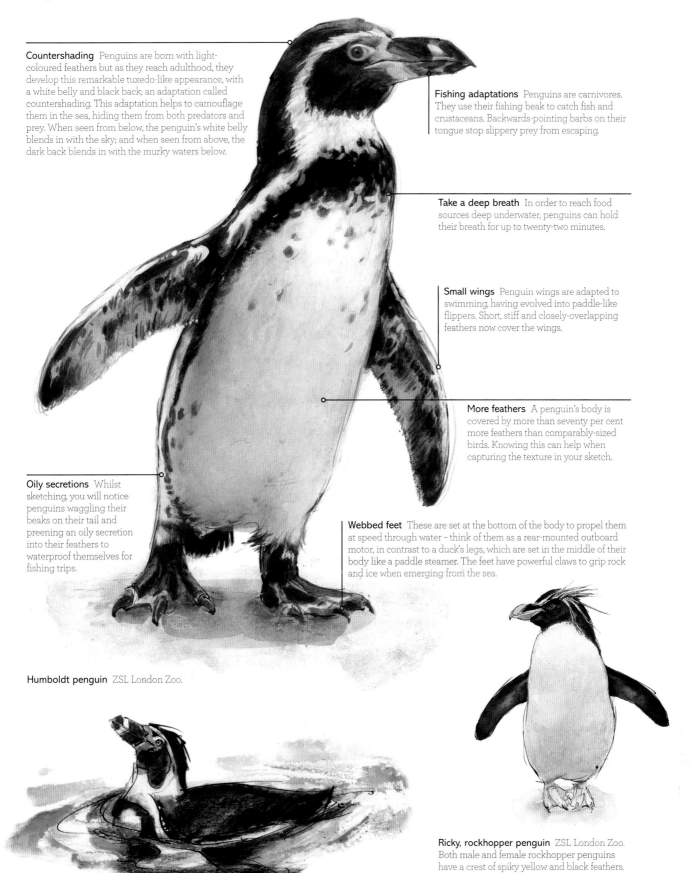

Countershading Penguins are born with light-coloured feathers but as they reach adulthood, they develop this remarkable tuxedo-like appearance, with a white belly and black back; an adaptation called countershading. This adaptation helps to camouflage them in the sea, hiding them from both predators and prey. When seen from below, the penguin's white belly blends in with the sky; and when seen from above, the dark back blends in with the murky waters below.

Fishing adaptations Penguins are carnivores. They use their fishing beak to catch fish and crustaceans. Backwards-pointing barbs on their tongue stop slippery prey from escaping.

Take a deep breath In order to reach food sources deep underwater, penguins can hold their breath for up to twenty-two minutes.

Small wings Penguin wings are adapted to swimming, having evolved into paddle-like flippers. Short, stiff and closely-overlapping feathers now cover the wings.

More feathers A penguin's body is covered by more than seventy per cent more feathers than comparably-sized birds. Knowing this can help when capturing the texture in your sketch.

Oily secretions Whilst sketching, you will notice penguins waggling their beaks on their tail and preening an oily secretion into their feathers to waterproof themselves for fishing trips.

Webbed feet These are set at the bottom of the body to propel them at speed through water – think of them as a rear-mounted outboard motor, in contrast to a duck's legs, which are set in the middle of their body like a paddle steamer. The feet have powerful claws to grip rock and ice when emerging from the sea.

Humboldt penguin ZSL London Zoo.

Ricky, rockhopper penguin ZSL London Zoo. Both male and female rockhopper penguins have a crest of spiky yellow and black feathers.

INDEX

'Look again at that dot. That's here. That's home. That's us!' Carl Sagan, *Pale Blue Dot*, 1994

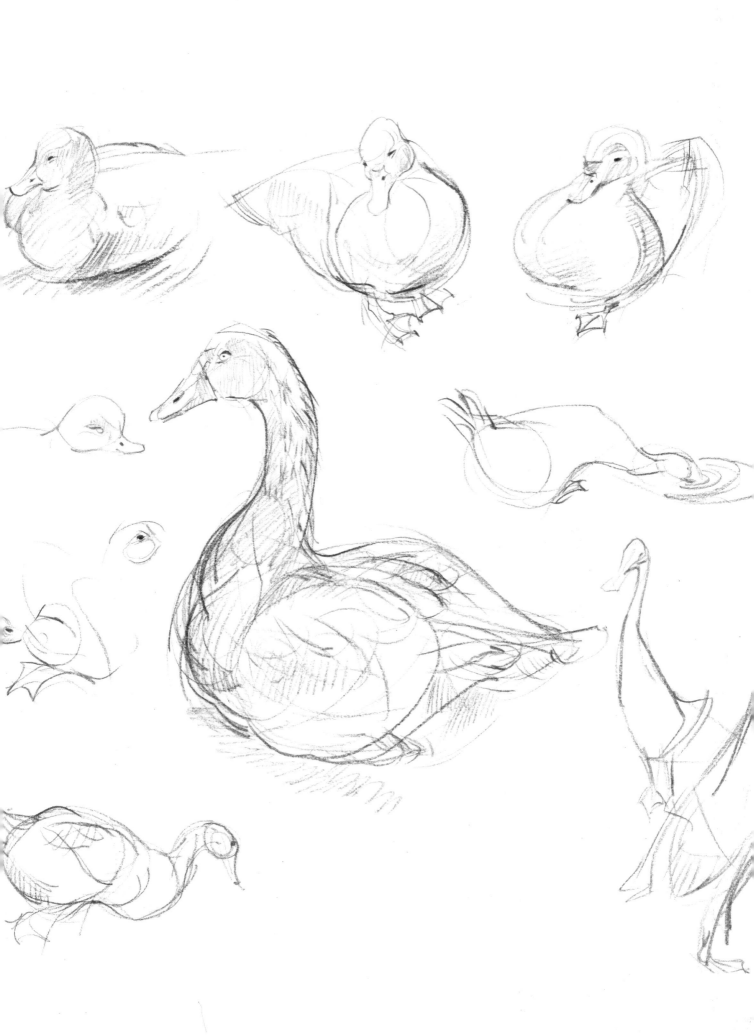

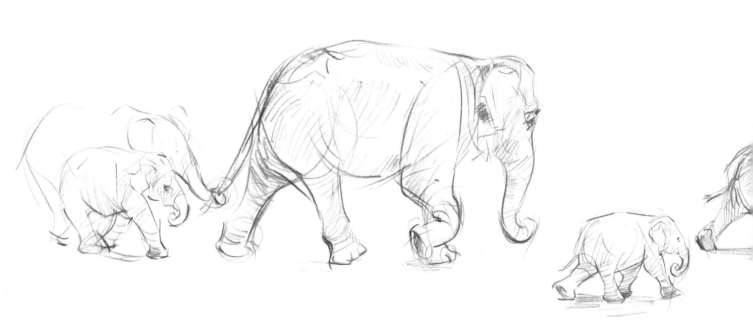